1122

THE ART OF
RESPONSIVE
DRAWING

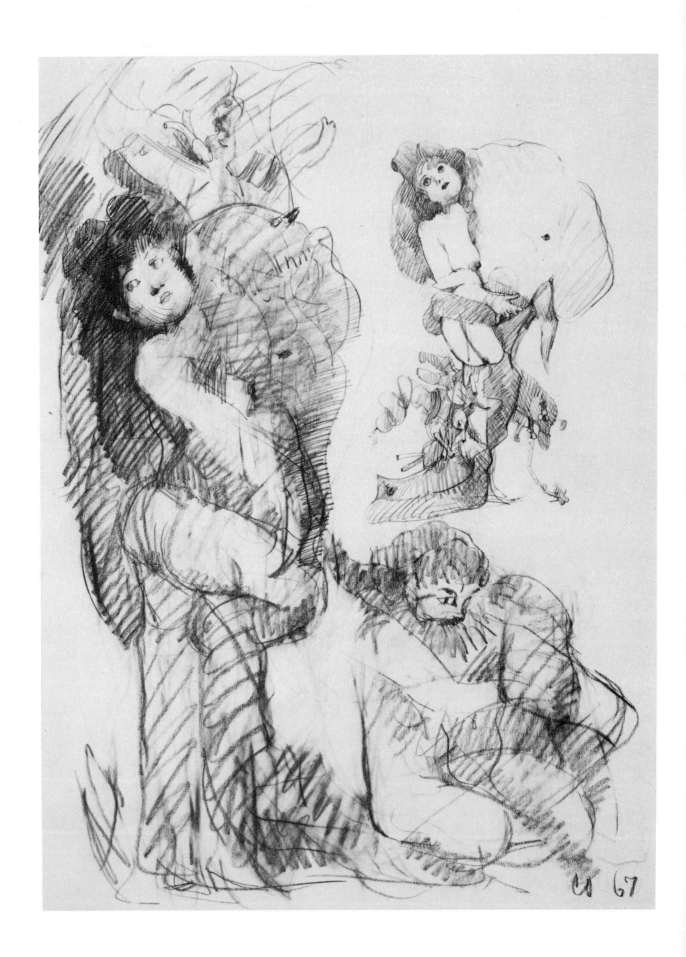

THE ART OF RESPONSIVE DRAWING

fourth edition

Nathan Goldstein

PRENTICE HALL
Englewood Cliffs, New Jersey 07632

Library of Congress Cataloging-in-Publication Data

Goldstein, Nathan.
 The art of responsive drawing / Nathan Goldstein. — 4th ed.
 p. cm.
 Includes index.
 ISBN 0-13-048216-1
 1. Drawing—Technique. I. Title.
NC740.G6 1992
741—dc20
 90-7813
 CIP

Editorial/production supervision: Patricia V. Amoroso
Acquisitions editor: Bud Therien
Cover design: Ben Santora
Prepress buyer: Herb Klein
Manufacturing buyer: Patrice Fraccio

Cover:
CHARLES DEMUTH
Still Life with Apples and Bananas
The Detroit Institute of Arts

Frontispiece:
CLAES OLDENBURG
Image of the Buddha Preaching
The Museum of Modern Art, New York

Printed in the United States of America

10 9 8 7 6 5 4 3 2 1

ISBN 0-13-048216-1

PRENTICE-HALL INTERNATIONAL (UK) LIMITED, *London*
PRENTICE-HALL OF AUSTRALIA PTY. LIMITED, *Sydney*
PRENTICE-HALL CANADA INC., *Toronto*
PRENTICE-HALL HISPANOAMERICANA, S.A., *Mexico*
PRENTICE-HALL OF INDIA PRIVATE LIMITED, *New Delhi*
PRENTICE-HALL OF JAPAN, INC., *Tokyo*
SIMON & SCHUSTER ASIA PTE. LTD., *Singapore*
EDITORA PRENTICE-HALL DO BRASIL, LTDA., *Rio de Janeiro*

for my daughter Sarah, her generation, and her world,
and in memory of Barbara Dworkin

An inability to draw is, to some extent, an inability to see.

RUDOLF ARNHEIM

Art hath an enemy called Ignorance.

BEN JONSON

I hear and I forget, I see and I remember, I do and I understand.

CHINESE PROVERB

O young artist, you search for a subject—
everything is a subject. Your subject is yourself,
your impressions, your emotions in the presence of nature.

EUGÈNE DELACROIX

CONTENTS

3 LINE 44

the indispensable abstraction

4 VALUE 78

light, local tone, and mood

5 PERSPECTIVE 114

the foreshortened view

PREFACE

The public's generous acceptance of each new edition of *The Art of Responsive Drawing* has been both gratifying and informing. Gratifying, because my views on how we may effectively come to understand and function in the great realm of drawing continue to meet with the approval of so many art teachers, students, and professional artists; and informing, because their comments have helped me to reshape each edition in ways that more effectively meet their needs. This new edition too was, at least in part, stimulated by the insights gained in discussions and correspondence with artist-readers about how to strengthen further the book's theme and spirit. Also, my continuing experiences as an artist and teacher have had their inevitable influence on how I present the case for drawings that come alive to communicate in terms that can be understood universally.

Responsive artists are those who want to make permanent their impressions of, and experiences with, something they see or envision. They do so by harnessing those dynamic visual forces that will abstractly support and energize a drawing's depictive manner. The responsive artist's understanding of a subject's depictive conditions *and* of the dynamic forces used to express them create the give-and-take between a drawing's "what" and "how"; it is this give-and-take that shapes the drawing's *content*—the total impact of its configuration. It is the responsive artist's resulting insights and innovations that make the work an invention rather than a report. And it is the quality of the negotiations between these simultaneous and mutually stimulating considerations that creates the union we call art, in which the whole is greater than the sum of its parts.

I have made a number of additions, deletions, and other adjustments throughout the text, including a new chapter on color (Chapter 7). In the visual sphere, there are 65 new drawings and illustrations (21 in color), while 30 were deleted. The last chapter (Chapter 13), now entitled "Finding Your Way," is extensively rewritten to include a number of specific suggestions that address that chapter's theme. A substantial percentage of the new drawings are by contem-

xi

porary artists, and there are also an increased number of student drawings that well illustrate various points in the text.

As before, this book is intended for the art student, the art teacher, the interested amateur, and the practicing artist who want to refresh or broaden an understanding of the main factors and processes of drawing.

All drawings motivated by a wish to inquire and to experience—whether they are interpretations of observed or of envisioned subjects—are *responsive*. Such drawings are neither arbitrary nor willful in execution, but are founded on our intellectual and intuitive judgments about a subject and its organized expression on the page. However, the primary concern of beginning students (and of most amateur and professional artists) is to expand their ability to experience and state their world in visual terms that communicate, and to understand better the options and obstacles that confront them when they are drawing from nature. For this important reason, and because there is no way to test fully the aptness of responses to imaginary stimuli, this book emphasizes drawing as a responsive encounter with our physical world. However, Chapter 11 explores avenues of approach to envisioned images that benefit strongly from the skills and insights gained in drawing from nature.

Here, *responsive* refers to our perceptual, esthetic, and emphatic interpretations of a subject's properties that hold potential for creative drawing. In responsive drawing, comprehending a subject's actualities precedes and affects the nature of our responses. Such drawings do more than recall what our outer or inner world *looks* like. They tell us what our intuitive knowledge informs us it *is*.

This, then, is not a how-to-do-it book; rather, it is a kind of how-to-see-it book. The exercises in the first eleven chapters are designed to help the reader experience the concepts and processes dealt with in each, not to suggest techniques or ready-made solutions. The book explores the disguises and characteristics of shapes and forms in nature; it examines the visual elements and the relational, moving, and emotive forces that constitute (and animate) the language of drawing.

The book begins by examining the factors that enable us to respond to a subject's measurable, structural actualities, its relational possibilities, and its emotive character. It then proceeds to explore the tools and materials of drawing, and the concepts, forces, and "pathologies," or common (but seldom discussed) failings of perception, organization, and expression in drawing. The examination of these pathologies in Chapter 12 is, I believe, the first attempt to catalog the various misconceptions, inconsistencies, and errors that lie in wait for those of us who draw. The pathologies discussed should enable the reader to apply a much wider range of criteria in evaluating his or her drawings—for becoming good "diagnosticians" of the problems in our work is part of learning to draw.

I have not attempted the impossible task of defining all the characteristics of great drawings. I have, however, pointed out those factors which, if left unregarded, make the creating of such drawings impossible.

I wish to express my deep appreciation to the many students, artists, and friends whose experiences, advice, and interest have helped to test, shape, and sustain the forming of this fourth edition. Thanks also to the artist-teachers at the many art schools and departments who contributed outstanding student works. I wish also to thank the many museums and individuals who granted permission to reproduce drawings from their collections.

I especially wish to thank Jonothan Goell, David Yawnick, and Gabrielle Keller, whose excellent photographs make an important contribution to the book's clarity; Bud Therien, of Prentice Hall, for the many considerate and generous ways in which he helped bring this revision into being; Pattie Amoroso, the production editor, and Elaine Rusoff, the art director, for their skill, patience, and care in helping to give this fourth edition its present, attractive form. A special thanks to Harriet and Jessica, whose spirit, patience, and practical assistance figured importantly in the forming of the book.

Finally, my heartfelt gratitude to my daughter, Sarah, for the affection and understanding that have meant so much to me over the years.

NATHAN GOLDSTEIN

1

GESTURAL EXPRESSION

deduction

through feeling

A DEFINITION

Responsive drawing is the ability to choose from among the parts and impressions of an observed or envisioned subject those characteristics that hold meaning for us and to be able to set them down in compelling visual terms. It is the ability to join percept to concept, that is, to merge what we see in the subject with what we want to see in the drawing, and to show this integration of inquiry and intent in the completed work.

To do this we must recognize that one of the most attracting features of any subject is its overall expressive character—its fundamental visual and emotive nature. The French painter Paul Cezanne gave sound advice when he urged artists to "get to the heart of what is before you and continue to express yourself as logically as possible."[1] An important aspect of "what is at the

heart" of any subject is the arrangement—the pattern or formation of its parts. Seeing this general arrangement of the parts is a necessary first step in creating a drawing that would reflect a subject's fundamental visual and emotive character.

Too often, however, beginners start at the other end of what there is to see. Instead of establishing a subject's overall configuration and character, they start by recording a host of small facts. Usually, they are soon bogged down among these details and, like the person who could not see the forest for the trees, fail to see just those facts and forces in the subject that would enable them to draw it in a personal and telling way.

No wonder, then, that when confronted by any subject, whether a figure, landscape, or still life, most beginners ask, "How shall I start?" The complexity of a subject's volumes, values, and

[1]From a letter to Emile Bernard, Aix, May 26, 1904.

1

textures, and the difficulty of judging the relative scale and position of its parts, seem overwhelming. There appears to be no logical point of entry, no clues on how to proceed. If the subject is a figure, many students—knowing no other way—begin by drawing the head, *followed* by the neck, *followed* by the torso, and so on. Such a sequential approach inevitably results in a stilted assembly of parts having little affinity for each other as segments of the whole figure. Regardless of the subject, the process of collecting parts in sequence which should add up to a figure, a tree, a bridge, or whatever is always *bound to fail.*

It will fail in the same way that the construction of a house will fail if we begin with the roof or the doorknobs, or, realizing this is impossible, if we finish and furnish one room at a time. Such a structure must collapse because no supportive framework holds the independently built rooms together. Without an overall structural design in place, none of the systems common to various rooms, such as wiring or heating, can be installed without tearing apart each room. Without such a design or pattern, none of the final relationships of size or location can be fully anticipated.

Every building process must begin with a *general* design framework, its development advanced by progressive stages until the *specifics* of various nonstructural details are added to complete the project. So it is with drawing.

Before the construction of a building can start, there is always the design—the blueprint. Even before the measurements and layout of the building hardened into the blueprint, there was the architect's idea: a *felt* attitude about certain forms and spaces, and about their scale, location, texture, and material as capable of conveying *an expressive order.* An architectural structure, like any work of art, really begins as a state of excitation about certain form relationships.

Similarly, all drawings should begin with a sense of excitation about certain energies and patterns beneath the surface of the subject's forms. Seeing these possibilities in the raw material of a subject, the responsive artist establishes a basis for interpretation. The "answer" to the question, "How shall I start?" is provided by the general arrangement of the subject's forms. Seeing the harmonies and contrasts of large masses, the patterns of movement suggested by their various directions in space, and their differ-

ing shapes, values, and sizes, gives the artist vital facts about the subject's essential visual and emotive nature—what we call its *gesture.*[2]

Gesture drawing is more about the rhythmic movements and energies coursing through a subject's parts than about the parts themselves. That is why such drawings show a concentration more on the essential pattern and form of the parts than on their edges, or *contours.* In gesture drawing, contour is secondary to urgings of motion among broadly stated forms. Such drawings tell about the actions, tensions, and pulsations that issue from the general condition of a subject's masses and their alignments in space—they are about spirit rather than specifics (Figure 1.1).

To draw a subject's gestural expression is to draw *the major moving actions and general form character* of its parts rather than their specific physical characteristics. Like our example of the building put up without an overall supportive framework, a drawing begun without the search for a cohesive gestural pattern "collapses." Likewise, to introduce gestural considerations *after* a drawing is underway would require undoing and reworking nearly all of it.

Experienced artists, even before they ask themselves, "What does the subject look like?" ask, "What is the subject *doing?*" That is, how does the arrangement of the major parts of the figure, the flower, the lamp, or the landscape allude to movement? What suggestions are there in the subject of rhythmic energies coursing through its forms? For virtually everything we see implies some kind and degree of moving action. Such actions are *inherent* in the subject's formation and structure.[3] The gentle curve of a tree limb or a human one, the forceful thrust of a church spire or a schooner, the graceful spiral of a staircase or a seashell, all these suggest moving actions—types of animated behavior; in other words, they all disclose some kind of gestural expression (Figure 1.2).

For experienced artists this is the case even when the subject is an envisioned one. Picasso's *Guernica* (Figure 1.3) is a visual protest against

[2]See Kimon Nicolaides, *The Natural Way to Draw* (Boston: Houghton Mifflin Company, 1941), pp. 14–28.

[3]Throughout this book the term *structure* refers to the constructional, volumetric nature of a subject. See Chapter 6, "Volume."

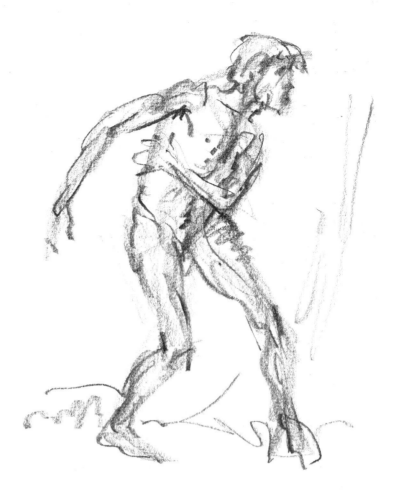

Figure 1.1

Figure 1.2 (*student drawing*)
Lynn Trunelle, Art Institute of Boston
Black chalk. 18 × 24 in.

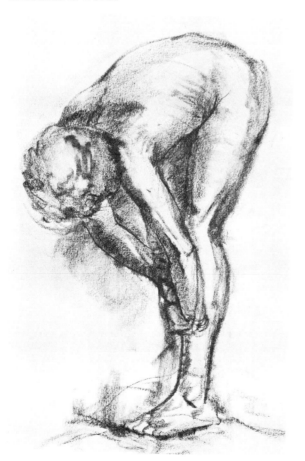

one of the first instances of saturation bombing of a civilian population, carried out in Spain by German forces in support of the Spanish fascists. Yet this arresting masterpiece had its origins in a hasty gestural sketch that captured the essentials of the artist's intended image (Figure 1.4). Note how many of those first, felt responses to his subject survive in the completed work.

Gestural expression must not be understood as simply the rhythmic nature of a subject's components, although such action is always part of a subject's gestural expression. It is not to be found in any one of the subject's visual properties of shape, value, or direction, nor in its type or class, arrangement of parts, or even in its "mood," but rather in the sum of all these qualities. The moving, emotive energy of gesture cannot be seen until it is experienced—it must be *felt*. Empathy—the ability to *feel with* a person, place, or thing—is needed to give expressive meaning to our drawings.

In part, such empathic responses result from our *kinetic* sensibilities—our ability to identify through our senses with the many tensions, movements, and weights among the things we

3

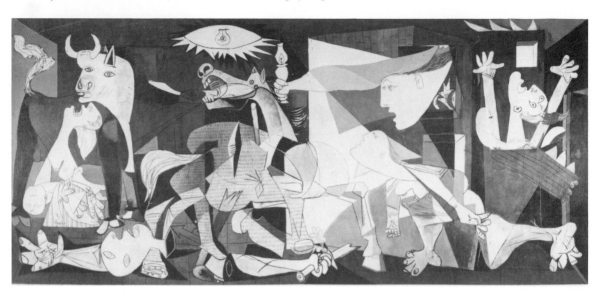

Figure 1.3

PABLO PICASSO (1881–1974)
Guernica (1937)
Oil on canvas. 11 ft. 5½ in. × 25 ft. 5¼ in.
Courtesy of the Prado Museum
Copyright 1991 ARS, N.Y./SPADEM

Figure 1.4

PABLO PICASSO (1881–1974)
First Composition Study for "Guernica" (1937)
Pencil on blue paper. 8¼ × 10⅝ in.
Courtesy of the Prado Museum
Copyright 1991 ARS, N.Y./SPADEM

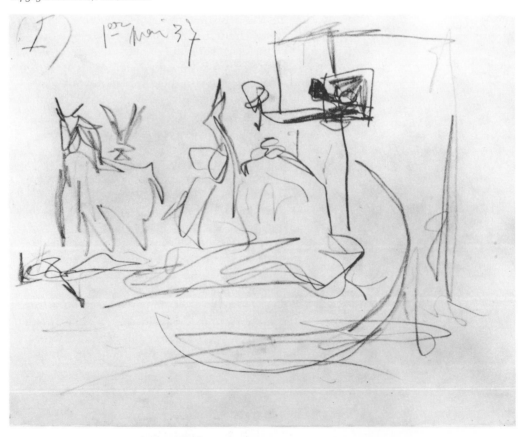

observe. It is such sensory experience that helps us feel the tension in the bending action of the woman in Figure 1.2 and the energy of the great arc that runs from the figure's hands through to the feet. In part, too, we identify with the behavior of our subjects in a psychological way. We attribute human attitudes and feelings to a subject's condition in verbal expressions such as "an angry sea" or "a cheerful fire." In the same way, an artist responding to a subject's gestural expression feels a drape as "limp," a cave opening as "yawning," and a tree as "stately" or "sheltering." The response to a subject's gestural expression, then, is the understanding of the essential nature of its *total* behavior.

Not until we experience a subject's gestural expression do we really understand why (and how) each part serves to convey whatever visual and emotive meanings attract us to it in the first place. For, no matter what else about the subject excites our interest, some formation of moving energies is always one of the attracting features.

The beginner who starts a drawing convinced that if only enough effort is put into the careful rendering of each part's *surface effects,* the subject's form and spirit will somehow emerge, is sure to be disappointed. Good drawings do not result from the accumulation of details; they arise from an underlying "armature" that suggests the subject's basic design and structure. The essential form and spirit of any subject must be first considerations in a work if they are to be found more fully realized in its completed state.

In Figure 1.5, Rembrandt uses gestural means to convey the tired, resting figure of his wife, Saskia. Rembrandt *feels* (and consequently we do too) the essence of her pose as an expression of limp weight. What Saskia is doing and feeling is as important to Rembrandt as the delineation of specific forms and textures. His

Figure 1.5
REMBRANDT VAN RIJN (1606–1669)
Saskia Asleep
Pen, brush and ink. 13 × 17.1 cm.
The Pierpont Morgan Library, New York

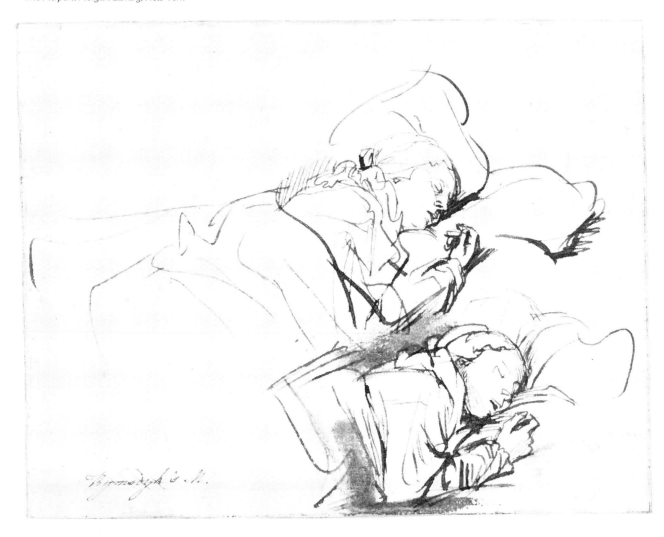

felt perception of her relaxed body pressing into the pliant bedding is intensified by the forceful speed of the lines in the pillow. Their radiating action reveals the tension in strong folds produced by the pressure or weight against soft materials. Those marks *enact* as well as describe the action. And directed movements are the chief means for expressing the action in any drawing, even where, as here, the subject is one of repose.

When the subject itself is in action, a gestural treatment can intensify that action further, as is demonstrated in Figure 1.6, where the artist's attention moves past the subject's surface state to extract the figure's essential action and form character. That the enlivening energy of gesture drawing can animate drawings of subjects other than the figure is evident in Figure 1.7. Note that the gesture drawings we have been looking at show little concentration on contours—the beginner's trusted device for drawing. Although it is necessary when drawing to see a subject's contours objectively, it is just as important to recognize that those contours are shaped by the subject's structure and arrangement, as we shall see in Chapter 6.

GESTURE AND DIRECTION

Closely related to the search for a subject's gesture, and usually running parallel with it in a drawing's development, is the inquiry into each part's axial *direction*—its tilt relative to a true vertical or horizontal direction. Learning to see a part's *exact* orientation as it would appear *on a two-dimensional surface* is one of the most important early skills the beginner must acquire. Just as we cannot endow our drawings with enlivening gestural qualities unless we respond to them at the outset of a drawing, so we cannot draw any form in relation to any other without consciously discovering its exact position in space.

Virtually every form, whether a leaf or a leg, a head or a house, has a length and width of differing dimensions. Every form then, can be imagined as having a straight or curved centerline or *long axis* running in the direction of its longer dimension. Additionally, the edges of all forms are made up of segments oriented at various angles, as we can see in Figure 1.5 in the short, often straight pen lines by which Rembrandt "tracks" the changing directions of his subject's contours. Seeing a part's directions

means seeing both its long axis and the various turnings of its edges. We will more fully explore these considerations in Chapter 6, but here it should be noted that the search for a subject's inner and outer directions generally accompanies or is a natural outgrowth of the search for its gestural expression, and that the need for seeing these two related conditions in our subjects is necessary to any responsive drawing's further development.

Exercise 1A suggests a means by which we can extract a subject's gestural expression and note the axial directions of its forms and at least some of the turnings of its contours.

exercise 1A

MATERIALS: Black or sanguine conté crayon or compressed charcoal. An 18 × 24 inch pad of newsprint or bond paper.

SUBJECT: The human figure, draped or nude. If no model is available, use plants, house pets, simple still-life arrangements, toys, clothing, or some visually interesting or fanciful furniture forms. Even your own arm can be placed in a variety of active poses and used as a subject.

PROCEDURE: If possible, draw in a standing position at an easel or any comparable support. Be sure that your subject and your paper are both well illuminated, preferably by a single light source.

You will make a total of twenty drawings. The first five will be two-minute poses, the next ten will be one-minute poses, and the last five will again be two-minute poses.

During the first half-minute of every drawing, *do not draw*. Instead, search for the most inclusive response to the subject by relying as much on your feelings about the nature of the subject's action and form character as on your analysis of its proportions, directions, and other measurable matters. You may not be able to describe it verbally, but you should get an impression of the subject's overall pattern of movement and of the arrangement of its major segments.

Only when you sense you are responding to both the subject's action and the arrangement—that is, when the subject is seen as "doing," as well as "being"—should you begin to draw.

Use a small fragment of your conté crayon or chalk (about three-quarters to one inch long), holding it loosely by your fingertips. Do not hold it in the manner used for writing. The hard line such a pinched grasp produces is too restricting for gestural drawing. Let your hand and arm swing freely as you draw. Be daring to the point of recklessness in stating the es-

Figure 1.6
Artist Unknown, 16th Century
Dancing Figures
Red chalk
The Metropolitan Museum of Art, Gift of Cornelius Vanderbilt, 1880. All rights reserved, The Metropolitan Museum of Art

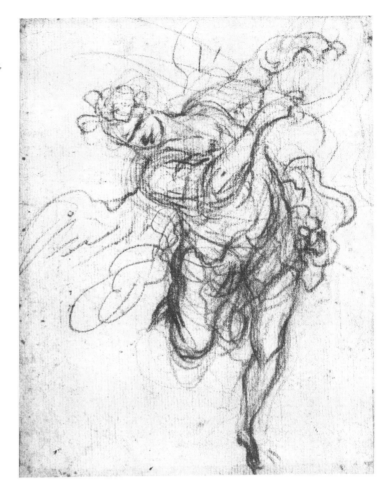

Figure 1.7
CLAES OLDENBURG
Bicycle on Ground (1959)
Crayon on paper. 12 × 17⅝ in.
Collection of Whitney Museum of American Art. Gift of the Lauder Foundation-Drawing Fund.

sence of what you see; but don't make *arbitrary* lines, lines not triggered by perception. If you see a movement running through the entire subject, draw it as one continuous action. Avoid lifting your drawing instrument often. When you stop to make new observations or associations of parts, simply leave your chalk touching the page where your previous mark ended. In this way, you reduce the amount of short, broken segments of line or tone, which imply a faltering in the search for gesture. Here, it is the simplest and most direct summary of the expressive action you want, so avoid the enticements of interesting, smaller considerations. If you leave the mainstream of gesture when the drawing has just begun in order to develop smaller parts, you lose the rest of the gestural qualities of the subject and depart from the *general to the specific procedure*, a step that few seasoned artists would risk or advise.

A gesture drawing is not a fast contour drawing. As you draw, you will almost certainly find that you cannot stay away from the edges of forms. It will require a concentrated effort and discipline to leave the "safety" of the contours and make your drawing describe the path of an arm, branch, or chair leg in space. Occasionally using the side of the small fragment of chalk will help to check the tendency to draw the contour, because the broad, foggy tone thus produced is suited more to describing the core or direction of a form rather than its edges. Using your chalk this way also helps to keep you from being distracted by details— such a tone line is too broad for small particulars. Try to experience the forms moving back and forth in a field of space, because whatever the subject, it exists in space. Imagine your hand actually reaching in and out of the "container" of space that holds your subject as you describe the action of the forms.

In the one-minute poses only half of your time will be spent drawing. This will make it necessary to see, summarize, and state the gesture more aggressively. Now there will be only enough time to perceive the strongest actions and form characteristics. These drawings should be more general in purpose, more direct in handling, as in Figures 1.8 and 1.9. Often, one-minute drawings capture gestural characteristics more successfully than gesture drawings of two or more minutes. You became more aware of the limited drawing time and more intensely see parts massed into generalities of action and form. For example, a side view of a figure, legs straight, leaning over and touching her toes, might be stated as an inverted teardrop form.

Your experience in speeding up the pace and broadening the scope of your summaries during the one-minute drawings will help you use the expanded time better in your last five drawings. Now, a two-minute drawing time feels more comfortable and allows you to see some of the smaller affinities, contrasts, and characteristics that evoke gesture.

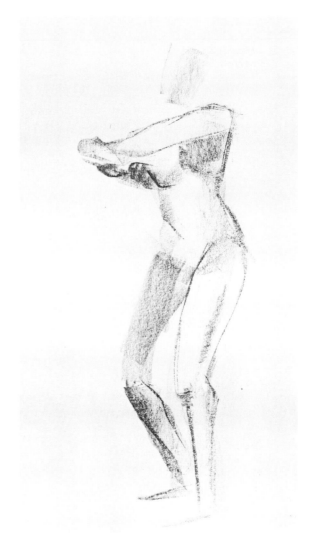

Figure 1.8 (*student drawing*)
Susan Cain, Art Institute of Boston
Red conté crayon. 18 × 24 in.

Although a gesture drawing is neither a contour nor a stick-figure drawing, it is mainly through the general look and feel of mass and direction that a subject's gesture reveals itself. Therefore, in all these quick drawings, remember to concentrate on the subject's essentials, not its embellishments (Figure 1.10).

THE DIVIDENDS OF GESTURAL EXPRESSION

Drawing from the general to the specific leads us from the gestural to the factual. Once a subject's general state has been established, further analysis inevitably leads to smaller, more specific facts

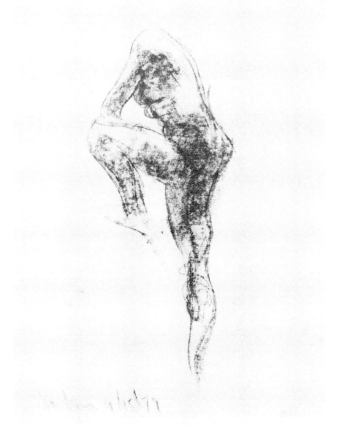

Figure 1.9 (*student drawing*)
Doug Anderson, University of North Dakota (1980)
Charcoal. 18 × 24 in.

Figure 1.10
ANNIBALE CARRACCI (1560–1609)
Studies for a Portrait
Pen and ink. 13.1 × 13.9 cm.
Albertina Museum, Vienna

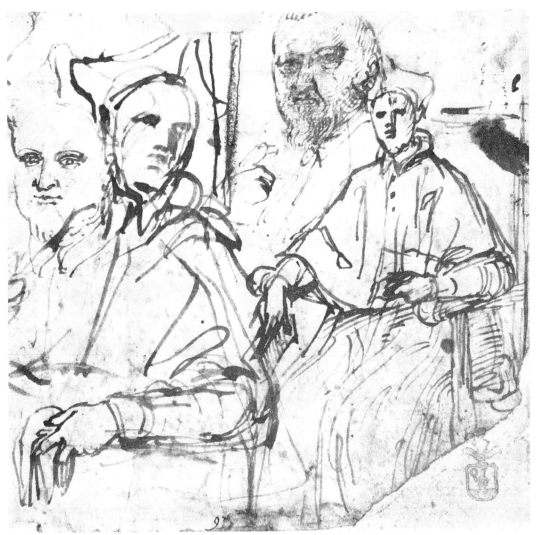

about it. If you continue with a gesture drawing for five minutes or more, your responses will begin to shift from the analytical depths of generalities about character and movement up toward the surfaces of the forms. Like the swimmer who dives to the bottom, we *do* come up to the surface. But the perception of factual details *evolves from* our comprehension of gestural expression and cannot, as we have seen, precede it.

The search for gesture at the outset of a drawing is visually logical for two reasons: it is the necessary basis for all that follows, and it cannot enter a drawing already underway. But this search for a subject's essential masses and movements does more than infuse a drawing with a sense of forms related by movement. Having done Exercise 1A, you may have recognized that seeing the general character of the forms in action provides other kinds of information about the subject.

There are at least ten important ways in which extracting gesture serves to inform and assist us in drawing. It helps us establish: (1) the proportions or *scale relationships* between segments of a subject; (2) the placement or *location* of segments; (3) the particular "tilt" or *position in space* of segments (direction); (4) the general tonal or *value* differences between the segments; (5) the boundaries or *shape-states* of the segments; (6) the abstract or *formal visual order* of the forms; (7) the *economical* and *authoritative* graphic statement; (8) the first general analysis of the volumetric or *structural* state of the forms; (9) the first general considerations of mass, space, shape, line, value, and texture as dynamic elements of the organizational design or *composition* of the drawing; and (10) the drawing's emotive spirit—its *essential expressive nature.*

Many of these insights are natural by-products of seeing *all* the subject within a minute or two. We visually (and empathically) grasp the entire figure almost at once. The likelihood of seeing the relative scale, location, position, and so on is much improved over a piecemeal approach, since we are everywhere in seconds and draw by hovering over the entire image, advancing it on a broad front.

The severe restriction in drawing time serves to increase our awareness of the relativeness of parts. No one intentionally misjudges the scale, location, or value differences of a subject's components. These errors in judgment result from failure to see relationships—associa-

tions. And these failures are most commonly the result of a sequential system of drawing wherein each part is dealt with independently and "finished" with little or no reference to other parts. In such an isolated, piecemeal approach it is mere luck when segments form a unified image.

No one intentionally makes errors in perception, but many artists do alter their drawings, to varying extents, away from the subject's actual state. But these changes are based (or should be) on a knowledge of what the subject's actual conditions are. In responsive drawing, seeing the state of things as they are is a necessary precondition to change.

Since a gestural drawing proceeds from the general to the specific, any line, value, or texture that "works," that is, that helps to establish the artist's intent early in the drawing's development, can be allowed to remain as a completed graphic remark. Because of the fluid and generalized nature of gestural drawing, not many such lines and tones are likely to survive. Some do, and their simple, direct quality serves to influence the artist in establishing other, equally direct graphic inventions. The spontaneous quality of gestural drawing and the subsequent drawing influenced by it tend to convey a sense of resolute directness. These qualities of authority and economy, and the spontaneity they promote, are essential to good drawing, of whatever stylistic or esthetic persuasion.

In Figure 1.11, the gestural expression of the scene tells us much more than "horses–carriage–people"; it evokes the clatter of the carriage, the nervous energy of the animals and their speed. In this sketchbook drawing by Toulouse-Lautrec the economy of means, the authoritative handling, and the quality of spontaneity they create—the energetic *presence* of the subject—were born in the artist's initial grasp of the subject's gesture.

Because we wish to see the expressive action of forms *in space,* gestural drawing requires us to move back and forth in a spatial field denoting not only the tilt, shape, scale, and (where necessary to structure or expression) value of the forms, but also some general suggestions of their volumetric nature. In Rembrandt's rugged drawing *Portrait of a Man* (Figure 1.12), the gestural drawing of the figure also conveys some broad suggestions about the volume of his cloak—we even sense the mass of his right arm beneath it,

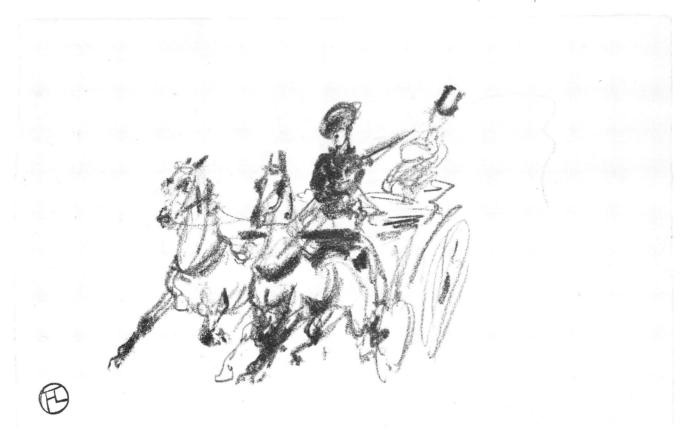

Figure 1.11
HENRI DE TOULOUSE-LAUTREC (1864–1901)
Study for Painting "La Comtesse Noire"
Black grease crayon. 16 × 25.6 cm.
*Collection of The Art Institute of Chicago. The Robert A.
Waller Fund. Photograph © 1990, The Art Institute of
Chicago. All Rights Reserved.*

Figure 1.12
REMBRANDT VAN RIJN (1606–1669)
Portrait of a Man
Pen, brush, brown ink, and white body color.
7⁵⁄₁₆ × 6⅛ in.
*Courtesy of The Fogg Art Museum, Harvard University,
Cambridge, Mass. Annie S. Coburn and Alpheus Hyatt Funds*

as well as the volume of the hat, head, torso, and right hand. Although several areas of the figure are not fully clarified as masses, there is an overall sense of his substance and weight.

Note the bold gestural lines in evidence throughout the drawing, and those that establish the direction of parts and of edges. Here, Rembrandt uses a long-standing means for better seeing the changing directions of a part's edge by restating all such turnings, however curvasive they may be, by short, straight lines. Many poor judgments about the actual nature of a curved edge can be quickly improved by breaking up such curves into straight line segments (see Figure 6.6). Once such lightly drawn notations have been made, the part's more curved boundaries can better be objectively stated.

The compositional state of a subject in a bounded, flat area (dealt with in Chapter 9) is likewise easier to evaluate by gesture's requirement to be "everywhere at once." We can thus see, within the first minutes of a drawing, the placement of the subject on the page, the general divisions of the page resulting from its placement, and the general state of any other matters relating to the drawing's order. The earlier we establish the general state of the *formal* relationships—the system of abstract harmonies and contrast that constitute a drawing's particular organizational system—the more integrated the completed drawing will be. And, for the responsive artist, a drawing's abstract life—that is, its *dynamics*—is as important as its representational state.

In *Two Barristers* by Daumier (Figure 1.13), the general state of a compositional idea is seen in the lines near each figure, which begin to search out the essential action of two more figures. Here, Daumier lets us see his very first gestural and compositional probes. Similar gestural lines underlie the more developed figures of the barristers. Note the character of the action of the

Figure 1.13
HONORÉ DAUMIER (1808–1879)
Two Barristers
Pen and ink. 20.5 × 29.5 cm.
Victoria and Albert Museum, London

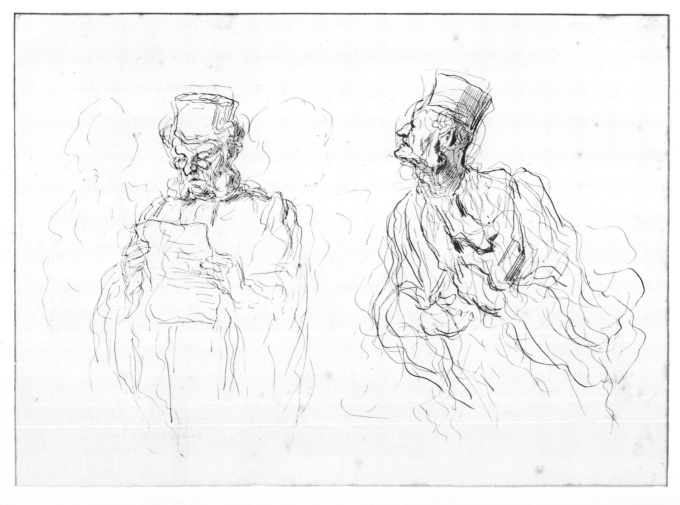

two barristers. It is expressed by the action the figures convey *and* by the animated nature of the lines that define them.

In Exercise 1A the search for the subject's gestural expression and the direction of major parts and edges were your main goals. In the following exercise you will consciously look for the other kinds of information and influence—the "dividends" that the gestural approach provides.

exercise 1B

Use the same materials and subjects as suggested in Exercise 1A. Again, draw in a standing position. Try to *feel* the subject's action and emotive state as you begin to search freely for the expressive behavior of the forms.

One purpose of this exercise is to build upon the ten "assists" provided by the gestural approach, to allow its direct and assertive nature to help you state strong and simple masses and moving actions, and an ordered pattern of visual forces on the page. Another purpose is to experience the shift from drawing the expressive action to drawing the factual state of your subject *and* its immediate environment.

Because compositional design requires an enclosed area, draw a border just inside the limits of your page. The page itself *is* a bounded, flat field, but drawing this inner border will make you far more aware of the limits of the drawing area. The use of such drawn borders is a temporary but helpful device.

You will make three ten-minute drawings and one half-hour drawing. Again, do not draw for the first half-minute or so, but use the time to familiarize yourself with the subject's essential form character, its moving actions, and its general design. This time, also observe the subject's overall shape, or, if it is comprised of a number of separate units, its several large shapes. Decide where you will place the configuration within the page and what its scale will be. Avoid drawing the subject so small that it appears as a "tiny actor" on a large "stage." Instead, use a scale that will make the subject fill a large portion of the page.

Now look around your subject to see what foreground or background material you wish to include. If the background is a blank wall, plan to place your subject on the page so that the surrounding black areas are divided up into interesting shapes. Should there be some other objects, values, or textures around the subject you wish to include in your drawing, consider how their scale, shape, and gestural character may relate with the subject's gestural expression. Plan to omit anything that you feel will conflict with, crowd, or confuse the drawing of your subject.

Those things you choose to include in the drawing are now regarded as an extension of your original subject. For example, if your original subject is a figure and you plan to include a chair, rug, and darkened corner of a room, your subject is now the figure and *all* these.

Begin all four drawings as if they were two-minute gesture drawings. In all four, after the half-minute of study, use the first two or three minutes to state the subject's gestural character (which now includes its immediate surroundings). Next, keep searching for further, smaller gestural actions until the basic gestural nature of all the major and secondary forms have been realized. In the last three or four minutes of the ten-minute drawings, revisit every part of the drawing, this time estimating the scale relationships of the forms, their location in relation to each other, and the direction of each form as well as of its changing edges, as in Figure 1.14. In this drawing the location of the head has been lowered, the right leg moved to one side, the arm adjusted toward the right. In every part, especially in the torso, we can see judgments about the direction of the segments that make up the figure's contours. The student has even extended straight lines that measure the relative location of parts. The drawing shows a disciplined concentration on these first considerations, although some of the earlier gestural lines have been erased or softened. But for this very reason we are better able to see this second stage of development.

In Dufy's *The Artist's Studio* (Figure 1.15) there is an engaging impartiality regarding the components of his subject. Note the animated character of the chairs and the drawings on the wall, the economical and authoritative handling, the suggestions of volume and space, and the drawing's balanced and unified character. Note, too, that even though this is a brush and ink drawing of a linear type, in which an extensive gestural underdrawing is not suitable, some lighter, gestural lines are still utilized.

As Figure 1.14 shows, in making these additions and changes to your earlier gestural perceptions, you are beginning to draw the contours of forms—you are establishing the shapes of forms (dealt with fully in Chapter 2). We saw in Exercise 1A that continuing a gesture drawing eventually brings us to the edges of forms. There it marked the end of the exercise, now it is the beginning of a shift from the concern for what the subject is doing to a search for what it looks like.

Continue to draw the contours of the forms, slowing down somewhat to follow the major changes in the directions of the forms' edges and of inner edges created by abutments between the larger facets, or *planes*, of a form's surface (the important role of planes is explored in Chapter 6). Erase any earlier gestural marks that seem to confuse or obscure the forms. Most of the gestural lines and tones *do* become integrated into the values and textures of the later stages of a drawing. It is surprising how little of the original gesture drawing is visible at the completion of even a ten-minute drawing. Avoid overemphasizing the edges.

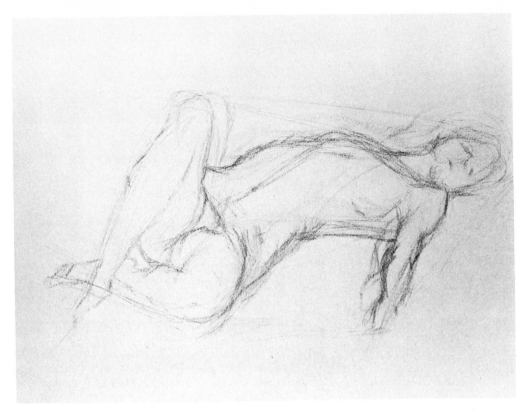

Figure 1.14 (*student drawing*)
Art Institute of Boston
Black conté crayon. 18 × 24 in.

Figure 1.15
RAOUL DUFY (1887–1953)
The Artist's Studio (c. 1942)
Brush and ink. 19⅝ × 26 in.
Collection, the Museum of Modern Art, New York
Gift of Mr. and Mrs. Peter A. Rübel

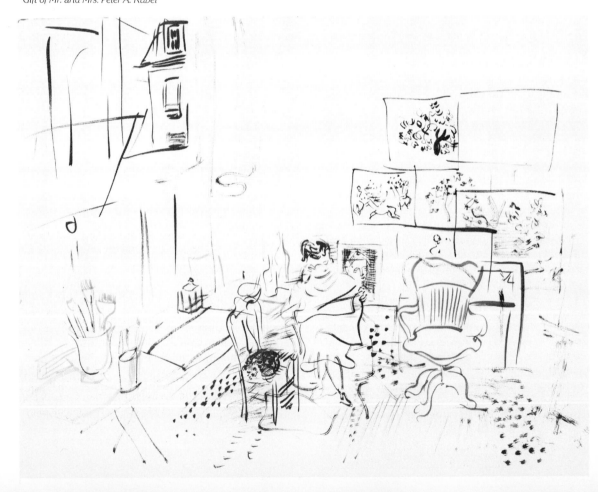

Contours that are heavy or hard tend to stiffen the drawing and weaken the gestural quality.

Use those values you feel are necessary to convey the general sense of the subject's masses. Avoid the "coloring-book syndrome" of adding values after the drawing is developed through line. If you mean to use values, do this early in the drawing, as in Figures 1.2, 1.9, and 1.17.

As you draw, be mindful of the ten ways in which gestural drawing assists perceptions and broadens the range of your responses. It may be helpful to list them in a corner of your drawing board or sketchbook for easy reference. With so much to be aware of—and *do*—ten minutes is not much time. This restriction is intended to keep your attention focused on the subject's major dynamic and structural cues. Kokoschka's drawing, *Portrait of Mrs. Lanyi* (Figure 1.16) provides an example of a drawing emerging from a search for gestural expression to form more substantial abstract and representational conditions. Again, in Lillie's drawing *Standing Figure* (Figure 1.17), subtler relational and structural observations overlay the gestural drawing.

Regard the ten-minute drawings as warmups for the thirty-minute one. At the end of ten minutes you should have developed this drawing as far as the earlier three. At this point, stop drawing for a minute or so. Look at your drawing from a few feet away. You

Figure 1.16
OSKAR KOKOSCHKA (1886–1980)
Portrait of Mrs. Lanyi
Crayon. 26 × 17¹³⁄₁₆ in.
The Dial Collection

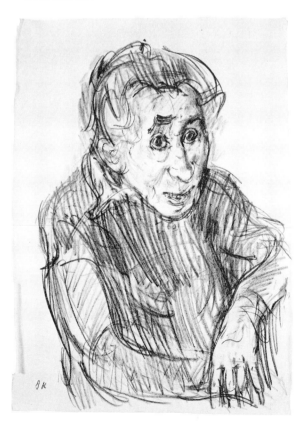

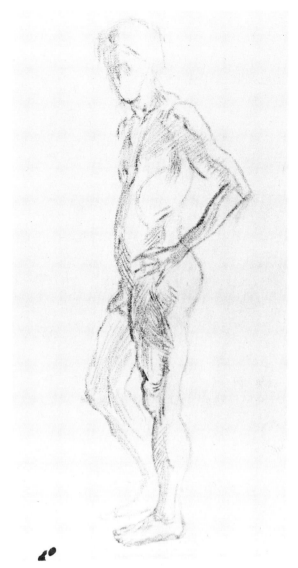

Figure 1.17
LLOYD LILLIE (1932–)
Standing Figure
Pencil. 14 × 17 in.
Courtesy of the artist

will more easily see errors in scale, location, and direction. Additionally, you will see the drawing's gestural and compositional state. Continue drawing for the remaining time, stressing the structural character of the forms. This search for volume should be a natural development of the perceptions you made during the first ten minutes of the drawing, when you felt and evoked the subject's gestural character. Many of these perceptions carried strong clues about the structure of the subject's forms. Now you are building upon the gestural expression rather than strengthening it further. The shift from comprehending what the subject *does* to that it *looks like* (or what you want it to look like)

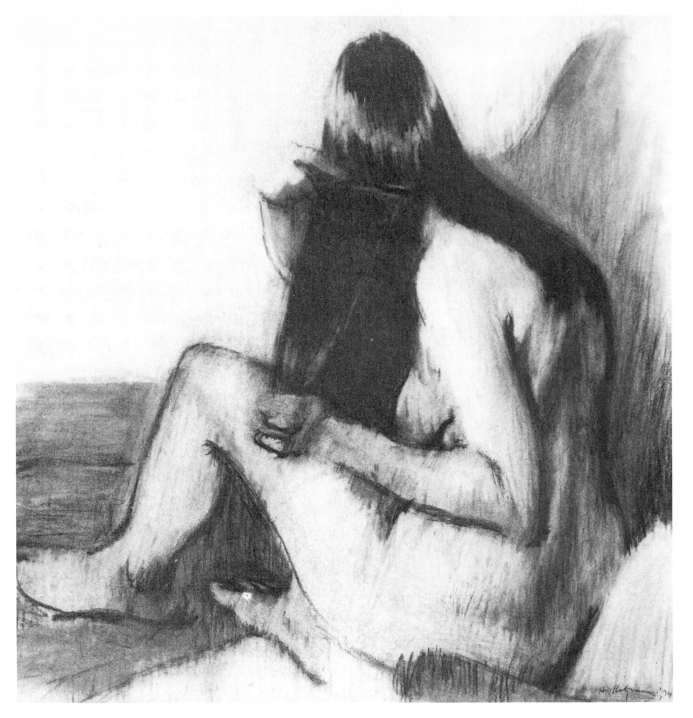

Figure 1.18
HERBERT KATZMAN (1923–)
Nude Brushing Her Hair, I (1974)
Sepia. 28 × 28 in.
Collection, Mr. and Mrs. Norman Pfeiffer

depends on the guidance and influence of the drawing's initial gestural qualities.

In the ten-minute drawings there was about as much time for stating the gestural character of your subject as for its overall structural and surface character. In a thirty-minute drawing, however, the gestural expression often becomes somewhat muted. While personal attitudes will determine whether ges-

tural considerations continue to play a major or minor role, here we use gesture mainly to guide the development of the subject's masses, for which there is now more time (as for example, Katzman does in Figure 1.18).

There is a danger here. If you lose too much of the gestural expression, if you sacrifice too much economy of means, if the felt and analytical quality of the

drawing is too muffled by a meticulous rendering of surfaces, too much of the life and excitement of the drawing may be lost.

The shift from the expressive action to the visual, measurable actualities does not mean that you stop gestural responses. You may see some moving actions late in the drawing. Nor does it mean that some facts about the subject's measurements are not stated early in the drawing's progress. There is no such clean break in responding to a subject. Rather, there is a gradual change in emphasis.

Do some two-minute and ten-minute drawings daily and at least one thirty-minute drawing. Do some of these in your sketchbook. Two-minute drawings can fill a sketchbook page, as in Figure 1.19, where brush and ink are used to extract the gestural essentials of the torso. While our two-minute gesture drawings usually show powerful rhythmic actions, be careful not to modify too many of these enlivening energies in the longer drawings. In Figure 1.20, a drawing of about thirty minutes, there is an engaging gestural strength that reinforces the subject's form and action. Do not regard such drawings as only exercises. The gestural theme has motivated countless drawings of the finest kind (Figures 1.21, 1.22, and 1.23).

This chapter has attempted to suggest not *the* way to draw, but only a way of seeing, feeling, and thinking about the things around us. And this way leads us to an early involvement with the factors of empathy, order, and structure that challenge all serious exponents of responsive drawing. And, while the search for gestural expression is no more the key to sound drawing than any other of the several basic concepts necessary to an understanding of drawing, its mastery is essential and must come early in our development as artists. Whatever visual goals and ideals we wish to pursue, the process will develop through advancing our works from the general to the specific and not through a system of piecemeal assembly. Responsive drawings do not accumulate—they grow.

Figure 1.19 (*student drawing*)
Becky Wronski, Michigan State University
Brush and ink. 18 × 24 in.

Figure 1.20 (*student drawing*)
Claudia Roberts, private study, Newton, Mass.
Black chalk. 14 × 17 in.

Figure 1.21
PAUL CÉZANNE (1839–1906)
Seated Nude
Pencil. 13.1 × 20.9 cm.
Kupferstichkabinett Basel

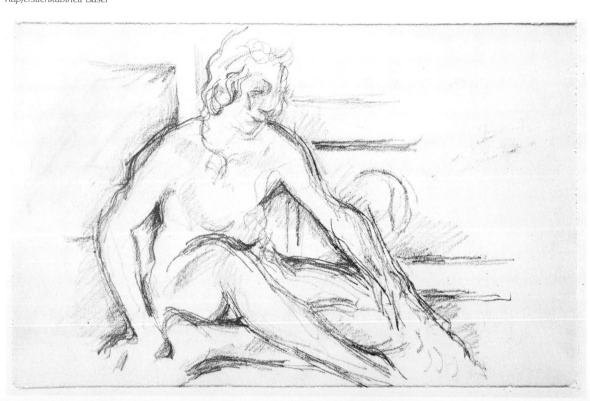

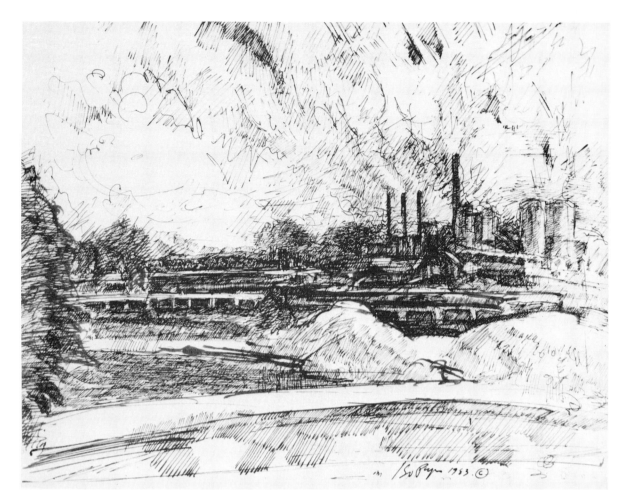

Figure 1.22
ISO PAPO
On the Outskirts of Boston
Pen and ink. 8 × 10 in.
Courtesy of the artist

Figure 1.23
JUDITH ROODE
Guardian Spirit (1988)
Oil paint, oil stick, oil pastel. 29 × 44 in.
Courtesy of the artist

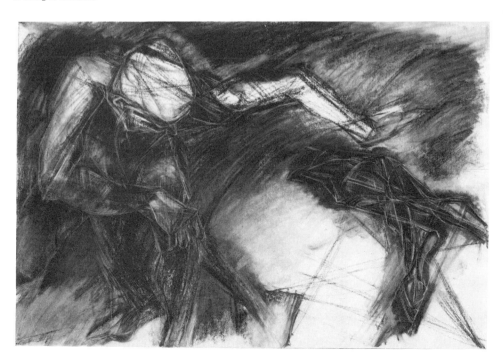

2

SHAPE

an irony

A DEFINITION

Just as every subject possesses gestural energies, so does it possess a system of shapes. Seeing a subject's gesture tells us what the subject does; seeing its shapes tells us important things about what it looks like.

Put simply, a shape is the two-dimensional configuration of a volume or of the interspaces between volumes. It can usefully be thought of as a silhouette (Figure 2.1).

The drawing surface itself, that is, the sheet of paper, board, or canvas, is also a shape. The first shape drawn on the blank shape of the drawing surface, or *picture-plane*, by its presence creates a second shape—the remainder of the picture-plane. This first drawn shape, understood as an area of active "thingness," is called a *figure*, or *positive shape*; the remaining, passive, "empty" area is called a *ground*, or *negative shape*. In this relationship positive shapes are not seen as hovering in a spatial field of depth, nor do nega-

Figure 2.1

tive shapes represent a spatial field of depth. They all should be understood to exist on the same level: the picture-plane. Together, they *are* the picture-plane. Having no volume and intending no recession into a spatial field, shapes have width and height but no depth (Figure 2.2).

All volumes when viewed from a fixed point offer an absolute shape delineation. Perceiving this "flat" state of a form is essential to

20

A B

Figure 2.2

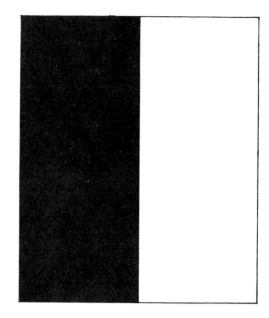

Figure 2.3

understanding its placement, scale, and structure. What its shape *is* will largely determine what its volume and position in space *will be.*

Most beginners are functionally blind to shape. This is so because we are "programmed" to understand the world around us in terms of volume and space; being able to do so is a matter of survival. Students of drawing must learn to see the two-dimensional facts about their three-dimensional surroundings. For artists, both of these are interchangeable considerations, and both ways of seeing a subject are necessary in order to understand it objectively.

Seeing through the camouflage of a subject's volume, color, and surface details to get at its shape actualities is basic to responsive drawing.

A shape, then, is any puzzle-piece-like area bounded by line or value or both. Shapes can be classified in two general families: *geometric* and *organic* (sometimes called biomorphic or amoebic). A geometric shape, as the term implies, may be, for example, a circle, triangle, or the like, or any combination of the angular or curved boundaries associated with pure geometric shapes. An organic shape is any irregular, "undulating" shape in which extensive use of straight or evenly curved edges is minor or absent. Organic shapes tend to echo the contours in nature.

As was previously discussed, shapes may have a positive or negative function. They may be hard-edged or vague. They may be active and gestural, or passive and stable. Shapes may be large or small, totally or only partially enclosed. They may have simple or complex boundaries, and may be consistent or varied in their inner properties.

Because we are conditioned to see *things* rather than the spaces that separate them, learning to see negative interspaces as providing

important visual information requires concentration. For example, seeing Figure 2.3 as a black door slid back far enough to show daylight outside makes us "see" the black area as a positive shape—as a thing of substance—and the white shape as negative—as an absence of substance. Our concentration favors the door, and we pay less attention to the area of daylight. If we now reverse things and regard the white area to be a white door slid back to reveal a night sky, our attention shifts to the white door and the black shape receives less consideration. Similarly, the black vase in Figure 2.4 keeps us from seeing the

Figure 2.4

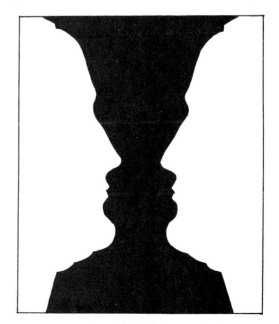

Figure 2.5
CONLEY HARRIS
Doubles/Triples, Italy
Charcoal. 23 × 30 in.
Print Department, Boston Public Library

two white profiles that shape it. Once we find these profiles, it becomes difficult to see the vase as more than an interspace; we concentrate on *things* at the cost of disregarding the areas separating them. While it is almost impossible to hold both readings in mind at the same time, we need to develop the skill to make such reversals with ease, to see the silhouettes of both positive and negative shapes objectively if we are to draw our subjects with any degree of accuracy.

Look around you and notice that the shape of any object you concentrate on, in covering part of its background, creates shapes in the background. Purposely squinting at our object and its environment obscures details and reduces the sense of depth perception. This loss of clarity tends to flatten both volume and space, helping us better to see our object's shape and the background shapes that its presence created. Squinting helps us perceive a sphere as a disk, a foreshortened disk as an ellipse, and a road running back to the horizon as a wedge. Artists, by training themselves to see the shapes of volumes and interspaces objectively, are able to know their subject's shape actualities in a way that greatly enhances their understanding of what they are seeing. In fact, we cannot accurately draw any subject whose shapes we have not objectively examined. Figures 2.5 and 2.6 empha-

Figure 2.6

Figure 2.7

size just this kind of sensitivity to both positive and negative shape.

A form's inner divisions can be seen in the same way. If, for example, we set out to draw the cone in Figure 2.7, we can regard, say, the upper shape to be positive and temporarily regard the lower shape as a negative one. Once the upper shape is drawn, we can consider *it* as a negative one when drawing the shape of the ellipse. This switching of positive–negative identities helps us see all of a form's shapes more accurately. And, after all, it is difficult to think of a subject that doesn't show some kind of inner divisions (shapes) either by overlap, value, interspace, or clearly abutting planes (Figure 2.7).

A useful dividend of seeing adjacent shapes as alternating between positive and negative states has to do with the common tendency to see convexities more accurately than concavities. Too often, beginners' drawings show concavities to be deeper and more pronounced than they really are, giving many of the forms an exaggerated undulating and even withered appearance. For some reason, perhaps because we are conditioned to think of convexities as containing something and concavities as containing nothing, a line drawn to represent a convexity in a contour is more likely to reflect accurately the scale and degree of the observed convex passage than a line that notes a concave one. By switching positive and negative shape orientations, we can always get on the other side of a concavity, transforming it into a convexity.

Exercise 2A presents a drawing challenge that makes it necessary to consciously assess both positive and negative shapes. As you do this exercise, you should begin to experience the interchangeability of positive and negative shapes and recognize that the one cannot be fully comprehended without the other. In all drawings, shapes either enhance or hamper our purposes— none "ride free." Disregarding so basic a concept as discovering the shape-state of a subject's parts blinds us to much of their structural and dynamic condition.

exercise 2A

In doing the two drawings in this exercise, you may erase whenever necessary. In general, too much erasing gives an unpleasant fussiness, but here you can make as many changes and adjustments as you need to complete your drawings.

MATERIALS: A moderately soft pencil (2B or 3B) and a sheet of tracing paper (or any paper thin enough to see through). A ruler, if necessary.

SUBJECT: Invented shapes.

PROCEDURE:

drawing 1 Draw a square approximately five by five inches. Use a ruler if you wish. Inside the square draw, in a continuous line, a simple organic shape as in Figure 2.8A. Draw it large enough to allow some of its projections to touch the borders of the square, causing the remainder of the square to be seen as four or five isolated shape-segments. Leave the organic shape the white of the paper and apply a gray tone to all of the remaining shapes. The completed drawing should look somewhat like a jigsaw puzzle-piece touching each of the square's borders at least once. Avoid making the shape complex and contorted—the simpler, the better.

The resulting ground shapes seem to suggest a spatial field. But to *see* the shapes that comprise this spatial "cavity," disregard its impression of spatial

Figure 2.8

A

depth and treat *all* the shapes within the square as two-dimensional divisions of the picture-plane.

Now take a second sheet of paper and draw another five-inch square. Inside this second square, draw the organic shape again as accurately as you can, using your first drawing as your model. This time you will find that letting your hand flow across the paper will not reproduce the original shape. Your second drawing may be fairly close to the original, but it should reproduce it *exactly.* To do this, you will have to study the original with great care. You will want to see the tilt, or *long axis,* of each projection and indent of the original, as well as their relative scale. As you draw, ask yourself, "What is the axis and shape of this projection? . . . of this indent? Which is the narrowest projection? . . . which the largest?" Examining the several negative shapes bordering on the organic one, you will see differences from your original drawing. In adjusting these in your second drawing, you will be adjusting the organic shape as well. Soon you may find that you no longer regard the organic shape as more important than the shapes around it. You may sense that until *each* shape matches its original, the organic shape will not have been accurately drawn. As you draw, try reversing the figure–ground relationship. That is, imagine the white "puzzle-piece" to be missing from a gray puzzle. Now the white shape is a negative one. Seeing your drawing this way, continue to adjust the remaining "puzzle-pieces." To estimate the angle of a particular projection or indent more accurately, imagine a clock face surrounding the part, as in Figure 2.8B. Try to locate the long axis of a segment by finding its position on the clock. For example, a segment that is vertical would be twelve o'clock (or six o'clock); if tilted slightly to the right, it might appear at one o'clock; and so on.

When you cannot find any further differences between the two drawings, place one over the other and hold them up to the light. You may be surprised at the several differences still remaining. Continue to make further adjustments based on these differences until the two drawings match.

drawing 2 When you drew the several shapes that formed the square, the camouflage of the "squareness" that each participated in may have kept you from

Figure 2.8

B

C

Figure 2.8

considering them as much as you did the organic shape. In this drawing, combine any three shapes that form an irregular outline. Do not enclose them in a square. These shapes can have some geometric properties, as in Figure 2.8C. Again, make as accurate a duplication of this group as you can. Now the shape-state of each will be very evident. They do not contribute to a common shape strong enough to obscure an awareness of each. Instead, these shapes more evenly interact. It is important to be able to study objectively any of a subject's shapes, no matter how actively engaged they are with others. The three shapes you have selected do, of course, collectively produce a fourth. As you draw this group, divide your attention between seeing each of the three shapes separately and seeing the greater shape they make. Recalling the advantages of working from the general to the specific, begin this drawing by roughly searching out the overall gesture and shape of the configuration first. When completed, again match the two drawings and make any necessary changes.

THE SHAPE OF VOLUME

Being two-dimensional, a single shape generally cannot convey the impression of volume convincingly. Only when two or more shapes join or interact do they communicate the idea of structure and mass.

When shapes unite to form a volume, they are seen as straight or curved facets of the volume's surface and are called *planes.* The various ways these planes abut and blend into each other determine and convey the volume's particular "topographical" state.

To interpret a subject's shape and structure we must begin by avoiding *exclusive* attention to its existence as mass in space. Instead, "read" its planes as positive shapes on the same level as the

negative shapes around it. A simultaneous perception of the subject as both two- and three-dimensional then occurs. Figure 2.9 visualizes the dual role of a plane: as a discernible facet of a volume's surface, and as a shape upon the picture-plane. Figure 2.9A tells us nothing about mass or structure. In Figure 2.9B the outline of the shape remains identical: only the interior lines have been added, subdividing the original shape into three smaller ones. Seeing these shapes as planes creates an impression of volume. This volume appears solid because we cannot see any of the boundary lines that would be visible if the structure were made of glass or wire. We now understand the form to be turned to an oblique angle to the right. Further, the three visible planes strongly imply the three unseen planes necessary to our understanding of the volume as a box form. In Figure 2.9C, separating the planes creates three shapes that suggest no more about mass and structure than Figure 2.9A does. Taken as a group, they form a Y-shaped negative area. While not wholly enclosed by boundaries, this is still "readable" as a shape. These "open" shapes occur when encompassing positive shapes provide segments of enclosure greater than segments of separation. The partially enclosed area is seen as a shape since we tend to "complete" shapes that provide strong clues to their simplest totality.[1]

Considering the single-shape limitations of the silhouette, some artists of the eighteenth and nineteenth centuries did quite well in suggesting, to a degree, a sense of volume (Figure 2.10). But their efforts tend to support rather than contest the view that a single shape is understood primarily as a flat configuration and only secondarily suggests some clues about volume.

Shapes, then, tend to "offer" their edges. The simpler their interiors, the more emphasis on boundaries, as Figure 2.11 shows. By stressing her subject's shape-state, the student provides us with a balanced division of the picture-plane that contains as much tension and stability as is conveyed by the resting figure. When a subject (or a part) is rich in textural, tonal, or decorative properties, the unwary beginner is more likely to be diverted from a recognition of its shape-character. Likewise, when shapes combine to form a volume, their individual shape-

Figure 2.9

Figure 2.10
American, early 19th century
Silhouette of Nathaniel West
Cut and pasted on background of tan paper.
11⅞ × 7¾ in.
Gift of Mrs. William C. West
Courtesy, Museum of Fine Arts, Boston

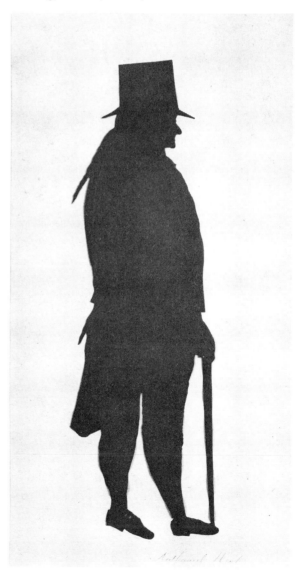

[1]Rudolf Arnheim, *Art and Visual Perception* (Berkeley and Los Angeles: University of California Press, 1954), pp. 54–55.

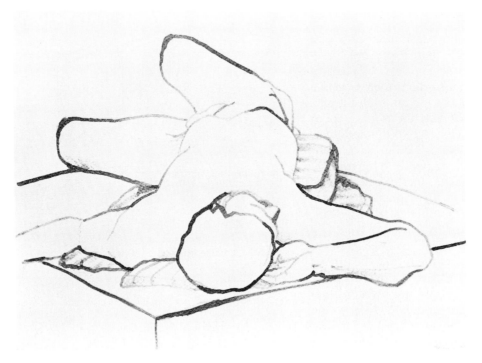

Figure 2.11 (*student drawing*)
Sue Burrus, Art Institute of Boston
Reed pen and brown ink. 14 × 17 in.

characteristics and their collective shape actualities might be missed. Goodman, in his drawing *Eileen* (Figure 2.12), avoids both of these pitfalls. The strong overall shape of the hair is not visually "overruled" by the imposing dark values and rich texture, nor are the planes that "carve" the head and blouse weakened by the demands of modeling the form. In fact, by showing how these planes interjoin, Goodman not only enhances the figure's structural clarity, he also provides a vigorous design of wedgelike shapes that activate the picture-plane.

This is not to suggest that edge, contour, or outline must necessarily be a dominant graphic factor. Many artists avoid emphasizing edges (see Seurat, *Sleeping Man*, Figure 4.5). But learning to search for a volume's shape-state helps us to locate those edges of planes forming the volume's boundaries, and thus to better comprehend its inner structure. We can see that in Figure 2.12, where the contours of the woman's face are the inevitable outcome of the head's surface structure. The head's planes demand just those contours, and the contours demand just those planar turnings.

Nowhere else does the beginner's need to see a form's actual shape configuration show itself more plainly than in the drawing of foreshor-

tened forms. Many beginners find themselves at a loss when confronted by a volume such as an arm or leg that is turned to show itself to be receding sharply into the spatial field. But seeing the shape provided by such telescoped views of forms is among the most important discoveries in drawing them successfully. Seeing that a form *is* foreshortened, they turn their exclusive attention to the problem of explaining it, *before* they have observed its shape actuality. Like the search for gesture, the analysis of a volume's shape components must be an early perception in the act of drawing. To proceed without considering either of these acts of inquiry is to draw preconceived notions of a subject's *class* and is not responsive to a particular subject as seen from a particular view. Seasoned artists recognize that a subject's shape-state will change as they change their position in relation to it. They know that perceiving the outline of a particular form traps both the information that shape provides about structure *and* the form's position in space, for its position creates its shape—its "field of play" (Figure 2.13).

Further discussion of the means available to understand foreshortening volumes will be found in Chapters 5 and 6. The following exercise should help you see a volume's shape-state.

26

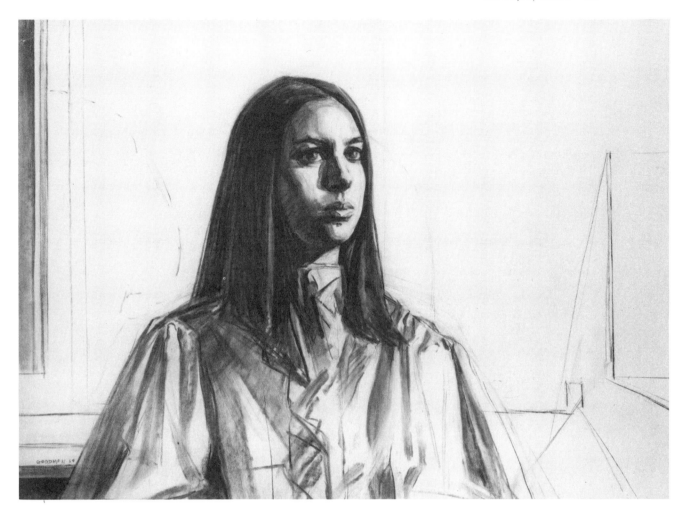

Figure 2.12
SIDNEY GOODMAN (1936–)
Eileen (1969)
Charcoal. 30½ × 42 in.
Courtesy, Terry Dintenfass Gallery, New York

Figure 2.13

A B

exercise 2B

MATERIALS: Pencil and paper.

SUBJECT: Cylinder.

PROCEDURE: Place any cylindrical form (such as a rolled sheet of paper, mailing tube, juice can, etc.) on a flat surface about 12 to 15 inches away, but only 2 or 3 inches below the level of your eyes, so you can see a side view only. If it is correctly placed and centered, neither end plane of the cylindrical object should be visible. Using a pencil, begin your drawing in the middle of the page. Draw the shape you see approximately actual size, trying to estimate carefully the proportion between the shape's height and width. Next, rotate the cylinder about 2 inches in either direction so that you see two shapes: the shape of the end plane and the

now slightly tapering shape of the curved side. To make a third drawing, again rotate the cylinder so that its degree of foreshortening is increased. By continuing to turn the cylinder a few inches for each successive drawing, you should be able to make eight or ten drawings showing a changing ratio between the sizes and shapes of the cylinder's two planes. These can be arranged like the spokes of a wheel or can appear randomly on the page. Note that until you have placed the cylinder in a totally foreshortened position, the end plane will not approach the shape of a true circle. Note, too, that because the cylinder is placed just below your eye level, even a quite long cylinder, when severely foreshortened, will show a smaller shaft than end shape.

Foreshortening exercises warrant frequent practice. Use other forms such as vases, bottles, pipes, carrots, or bananas, and draw them in foreshortened positions. Point a finger in the general direction of your eye and draw it. Place objects before a mirror and draw both the object and its reflection.

Though they are composed of joined planes, simple subjects such as the cylinder, cube, or banana can be seen as a single shape. Even complicated subjects can be seen in this way. Other objects appear as a group of volumes, some of which partially block our view of others—as in a view of a still-life arrangement or a human figure. When studying such a complex of forms it is generally necessary to divide the subject into several shape groupings in a more or less arbitrary way—more or less because the subject itself will suggest groupings according to size, value, placement, direction, or texture. Included in these considerations should be any negative shapes present. Whether the subject is reduced to a single shape or several shape subdivisions, this simplification increases our understanding of the general shape-state of the subject, thus helping us locate the smaller shapes within. When a complex subject's general shape-state is comprehended, all subsequent departures from observed "facts" become intended, subjective choices and not the inevitable results of poor perception.

VALUE SHAPES

If a volume requires two or more shapes, what about the sphere? It would seem to have only one: the circle. But recall that shapes may be hard-edged or *vague.* The sphere, cone, cup, or any other mass formed exclusively or mainly of curved planes offer a preponderance of subtly graduated value changes. Here, the ordering of values into some volume-revealing system becomes necessary.

As we have seen, planes are the basic building unit in the construction of volume, and seeing their shape actualities is as important as seeing those of the parent volume of which they are a part. When, additionally, these planes show a variety of values arranged to suggest light falling upon a volume, the impression of three-dimensional form and space is increased. These differences in value among the planes result from the direction of the light source in relation to the subject's variously turned surface facets, and they change as the planes turn toward and away from the light. The more abrupt the change between the direction of planes, the more abrupt the changes in value will be.

To simplify the organizing of the subject's many values, it is useful to establish a few general value divisions. Considering white as zero degrees and black as 100 degrees, and calibrating a scale in degrees of ten, we have a value scale that is helpful in establishing some order out of a subject's (usually) many and seemingly elusive value changes. Using this scale, we can more easily sort values into several general divisions. A four-division grouping might be: white (or the tone of the paper), a light gray (30 percent), a dark·gray (70 percent), and black. We will, of course, see many more than these four values in most subjects. Each of the "in-between" values should be drawn as belonging to the value division closest to it in degree.

Some artists find it useful to apply such a value-grouping system in tonal drawings, since it quickly provides a pattern of values on the picture-plane that helps in composing a work's order, and as quickly provides a sense of mass and space. Then, after establishing this stage of a drawing, they make whatever adjustments in value they feel are necessary to complete the work. Other artists will do this sorting in the mind's eye. The mental sorting will have influenced their use of value and the completed work will reflect the tonal order of the value-grouping system. Whether or not such divisions of tone appear at some stage in the drawing is less important than their having been consciously searched for. As the observed values are assigned to their appropriate group, larger value-

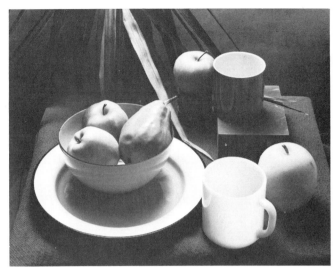

A

Figure 2.14

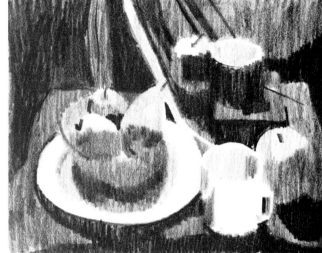

B

shapes spring up. These shapes may be composed of parts of several independent volumes—as would occur if we were to shine a flashlight into a darkened room. A "shape" of light could then include all or parts of several pieces of furniture, part of the floor, wall, and so on. In Figure 2.14 the value shapes in B frequently exist independently of the shapes of the volumes seen in A. Note that B shows a four-value grouping of the still life A. The early perception of these value shapes also serves to establish scale and directional relationships among them, and helps the artist to sense their abstract behavior. Value shapes within a form, like the overall shape that describes the boundaries of a volume, should be seen first as flat areas and not only as existing in space upon advancing and receding terrain. Ipousteguy, in his drawing *Anatomy Study: Breasts* (Figure 2.15), utilizes the value shapes resulting from a harsh light source to create an image in which the pattern of values not only defines the forms, but establishes an engaging two-dimensional design. The artist, by intentionally providing as many clues to shape as to volume, creates in the image a provoking

visual pulsation between its flat and structural properties.

Dine's drawing of awls (Figure 2.16) shows a four-value system in the version on the left and a three-value system on the right. In the former the harsh value shapes and contrasts create an image highly charged with tensions, while in the latter the gentler value shapes and contrasts make for an image of far less tensional energy.

Again, in Cretara's *Spanish Landscape* (Figure 2.17), values are active in both two- and three-dimensional ways: in the former mode they produce a pattern of balanced, harmonious tones, and in the latter, a system of volume- and space-revealing planes. Despite the blurred edges of the variously toned shapes in Dine's and Cretara's drawings, we can still tell that both artists thought in terms of value shapes and patterns.

The following exercise concentrates on searching out a subject's values. It should help you to see that value shapes are an intrinsic part of a subject's visual condition and can play an important role in clarifying and organizing what you see.

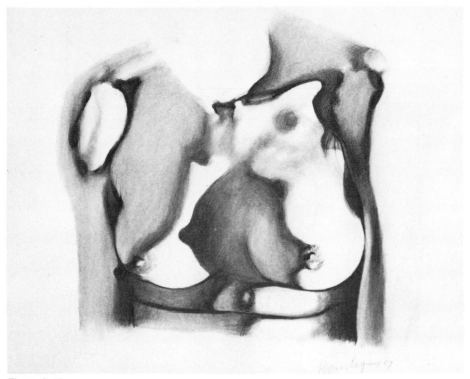

Figure 2.15
JEAN IPOUSTEGUY (1920–)
Anatomy Study: Breasts (1969)
Conté crayon. 18 × 24 in.
Courtesy, Allan Frumkin Gallery, New York

Figure 2.16
JIM DINE
2 Awls (1974)
Litho and direct drawing on paper. ca. 3.4 × 5.7 ×
4.8 cm.
Kunsthaus Zürich. Herbert Distel: The Museum of Drawers,
drawer 11

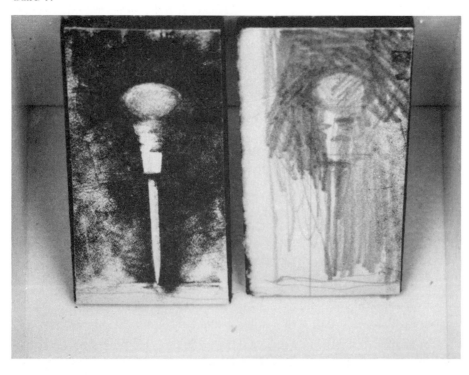

Figure 2.17
DOMENIC CRETARA (1946–)
Spanish Landscape
Graphite pencil, 8½ × 12 in.
Courtesy of the artist

exercise 2C

This exercise requires three drawings. Each will cause you to make a different value grouping, resulting in different value shapes. They will provide progressively greater freedom and control in the use of value. You will also find the modeling of the general masses achieved through the organization of tones progressively more convincing.

MATERIALS: Compressed charcoal, black conté crayon, or India ink, 18 × 24 inch sheets of charcoal paper, or, if you choose to work with India ink, any large-sized heavyweight paper that will not buckle (see The Suitable Support in Chapter 8), and a number 6 or 7 pointed sable brush (see Brushes in Chapter 8).

SUBJECT: Upon a simply draped cloth of one value (towel, pillow case, or the like), arrange a simple still life consisting of nonreflecting surfaces such as unglazed pottery, wood and paper products, or foodstuffs in any combination of three or four you find interesting.

PROCEDURE:

drawing 1 Group ll the observed values into two divisions—white and black. Select any point near

the middle of the value scale and leave any observed value lighter than that point (nearer to the white end of the scale) as the white of the paper; any value darker than that point (nearer to the black end of the scale) should be drawn as black. Use a strong light source and arrange the forms in a way that permits the light to "explain" the basic volumetric nature of the objects.

Selecting a point nearer to the white end of the scale will produce a drawing with fewer white shapes and much larger black ones. Conversely, placing the point of value separation nearer to the black end of the scale will result in fewer black shapes and larger areas of white. By changing the point at which the values will be separated you can create different value shapes which will convey new structural clues about a subject's volume, as well as different light intensity and expressive mood. Figure 2.18 is a good example of the structural strength that this limited value system can yield.

Continue to draw until your drawing suggests at least a general impression of volume. Many students are surprised to find that the sense of volume persists despite the severe tonal restriction. Though many values disappear into the black or white groupings, and many smaller planes are absorbed into them, still the big planes that these value shapes create convey a sense of structure.

Figure 2.18
KÄTHE KOLLWITZ (1867–1945)
The Mothers
Brush drawing, India ink and Chinese white.
18 × 23⅛ in.
Frederick Brown Fund
Courtesy, Museum of Fine Arts, Boston

Now study the drawing to see how the shapes relate on the picture-plane. Notice that they have certain scale, shape, and directional similarities and contrasts that produce a pattern. But does this pattern seem balanced on the page? Rework the shapes to provide a more unified and balanced state among them. But in doing so, try to strengthen the sense of solid mass further, not weaken it.

drawing 2 Draw the same subject from the same view, but use *three* values: the white of the paper to represent the lightest third of the values in the still-life arrangement; a middle tone of approximately a 50 percent gray to represent the middle, darker tones; and black for the very dark values (70 percent or darker). This may still seem to be a severe restriction,

but notice how effectively Degas uses it (Figure 2.19) to create a handsome format for his visual and expressive interests. Here, the three values are used to show value shapes both as pattern on the page and as clearly defined planes that carve the forms with great authority. Notice how, in the figure's back, the artist changes values to indicate changes in the direction of the surface terrain. Note too that Degas takes care to balance the three areas of dark tone. As Figure 2.20 further shows, drawing with three values is hardly the restriction it may at first appear to be. In fact, many tonal drawings, in whatever medium, will be found to be comprised mainly of three values, with perhaps some intermediate tones resulting from the "drag" of the chalk or brush, or the occasional overlaying of these three tones.

Figure 2.19
EDGAR DEGAS (1834–1917)
After the Bath (1890–92)
Charcoal and brush on pink paper. 19¾ × 25⅝ in.
Courtesy of The Fogg Art Museum, Harvard University,
Cambridge, Mass. Bequest of Meta and Paul J. Sachs

Figure 2.20 (*student drawing*)
Roger Duncan, Michigan State University
Compressed charcoal. 18 × 24 in.

These are things to try for in your drawing. As it develops, look for ways in which you can get the greatest yield of volume and dynamic spirit through these three values. As Figures 2.19 and 2.20 demonstrate, this three-value restriction can produce a great sense of volume.

drawing 3 This will again be the same view of the still life but now use the four-value divisions mentioned on page 28. Depending on the nature of your subject's values, the lighting, and your own inclination toward lighter or darker drawings, you may wish to adjust the values. The following variation would result in a darker image (1) white or the tone of the paper; (2) a 25 percent gray; (3) a 60 percent gray; and (4) black. Whichever four-division grouping you choose, you may be surprised by how many of the observed values can now be stated as they actually appear in the subject. Not nearly so many will have to be altered in tone (and most of these only slightly) to join one of the four divisions.

Many artists change the tonal scheme when their subject and medium change. Another drawing by Kollwitz (Figure 2.21) shows a four-value division. Notice that the artist subtly interworks these values to subdue their shape impact but is careful not to lessen their structural function. Similarly, Figure 2.22 shows

the striking results possible through the use of four values. Notice how liberally and effectively the white tone of the paper is used, an outcome of recording an observed (or imagined) strong light source. Note, too, the energetic abstract behavior of these shapes of tone and of the tonal configuration.

Your third drawing can be carried further, since a four-value grouping can distinguish more differences between value shapes and can suggest subtler shape interactions. Try to use this expanded tonal range to establish some of the smaller planes. After the drawing has been carried to a firmer, more volumetric stage, you might wish to abandon the restrictions on values to get at some useful nuances and transitions of tone that will develop the forms further. However, avoid going so far as to lose the sense of shapeness and planar structure.

These three exercises are in no way intended as "how-to-draw" systems (though, as we have seen, a number of notable artists have used the several formats discussed here). They are offered as one more means of organizing your observations. Their primary purpose here is to sensitize you to the value shape as a

Figure 2.21
KÄTHE KOLLWITZ (1867–1945)
Self-Portrait in Profile (1927)
Lithograph. 12⅛ × 11⅜ in.
Courtesy of the Fogg Art Museum, Harvard University, Cambridge, Mass.
Gray Collection of Engravings Fund

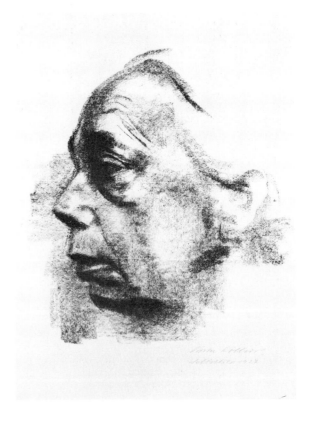

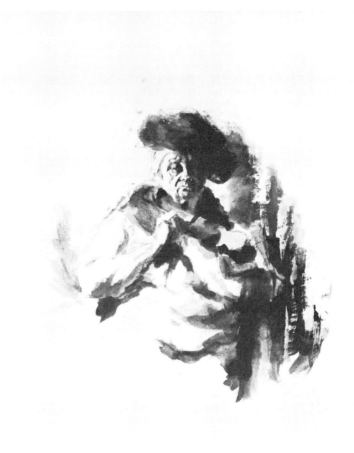

Figure 2.22 (*student drawing*)
Renee Cocuzzo, private study, Newton, Mass.
Brush and brown ink, 14 × 17 in.

unit of volume-building *and* pattern-making. Also, these exercises may help you feel more comfortable with the powerful but less familiar (and thus more feared) element of value. Finally, they will enable you to see the shapes that planes and values offer the discerning artist.

THE INTERDEPENDENCE OF SHAPE AND VOLUME

When volumes emerge from shapes, their third-dimensional quality can affect our degree of awareness to the two-dimensional life of the shapes in a drawing. It is important to recognize the power we have to increase or diminish the viewer's attention to "edgeness." To subdue and

thus deny shape most of its dynamic potential deprives the viewer of picture-plane events of much esthetic worth. For without shapes' surface tensions, their directional play, their value or texture contrasts, and their gestural and structural behavior, an important source of dynamic energy is lost. The absence of a sense of shape activity, then, diminishes the means by which expressive and organizational meanings can be established.

This seeming modification of shape considerations by those of volume is seen by some as creating a dilemma. If emphasis on the third dimension reduces attention to the second dimension, and vice versa, how can one maintain a satisfying activity of both? Some artists make wide swings in emphasis, working in a pro-

nounced two-dimensional or three-dimensional manner according to their expressive purposes. That a rich union of both dimensions can occur is attested to by the drawings of Rembrandt, Degas, Cézanne, Matisse, and many others. Such works show that it isn't the amount of emphasis on one or the other dimension that matters, but the quality of the interplay between them.

This issue is largely absent in the works of those artists who intentionally eliminate structured, volumetric content, thereby clearing the way for the expression of concepts not otherwise possible. Paul Klee, in his drawing *The Angler* (Figure 2.23), could not have probed the playful and dreamlike issues necessary to him if the

Figure 2.23
PAUL KLEE (1879–1940)
The Angler (1921)
Watercolor, transfer drawing, and pen and ink on paper, mounted on cardboard. 20 × 12⅝ in.
Collection, The Museum of Modern Art, New York. John S. Newberry Collection

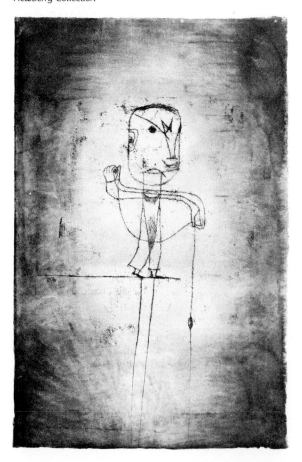

sense of volume continued to be a major factor in the pictorial organization of this drawing. And Rubens, in his *Study of a Male Figure, Seen from Behind* (Figure 2.24), could not have created his powerfully sculpted images if he had insisted on strong shape confrontations as the *primary* visual strategy. But unlike artists who exclude the impression of volumes in space as a goal (although two-dimensionally oriented drawings often impart some degree of spatial depth), no artist who intends a convincing impression of solid masses as part of his or her language of graphic expression is free of the responsibilities of a drawing's two-dimensional activities. For example, note how effectively the shapes in the Rubens drawing reinforce its expressive power. All sound drawings that emphasize the third dimension must be sound drawings in their two-dimensional properties.

Actually, the dilemma disintegrates in the presence of a need to experience fully an encounter with a subject. The need to express this experience (within the framework of a personal esthetic persuasion), not the exploration of both dimensions (or either) *as an end in itself,* is at the heart of responsive drawing. The richest visual and expressive responses result from the richest complemental activity between the dimensions —between the dynamic and depictive forces. In art, one person's dilemma can be another's motive.

SHAPE AS AN AGENT OF DIRECTION AND ENERGY

So far shape has been considered mainly for its role in the structural organization of volume and for its capacity to stress its two-dimensional configuration and its boundaries. As we shall see in later chapters, shape has other functions. In this section we want to recognize that shape is an important agent of direction. The familiar arrow on signs directing us to exits, shelters, and the like aims the viewer toward a particular goal, and the shape itself *inherently* suggests movement. Not only do we understand it as symbolizing an arrow in flight, but its shape character urges us on in the direction it points to with considerable energy. In the first chapter we saw the compelling force of shapes when they were activated to convey a subject's gestural behavior. Our sense of the arrow's "movement" is a response to that

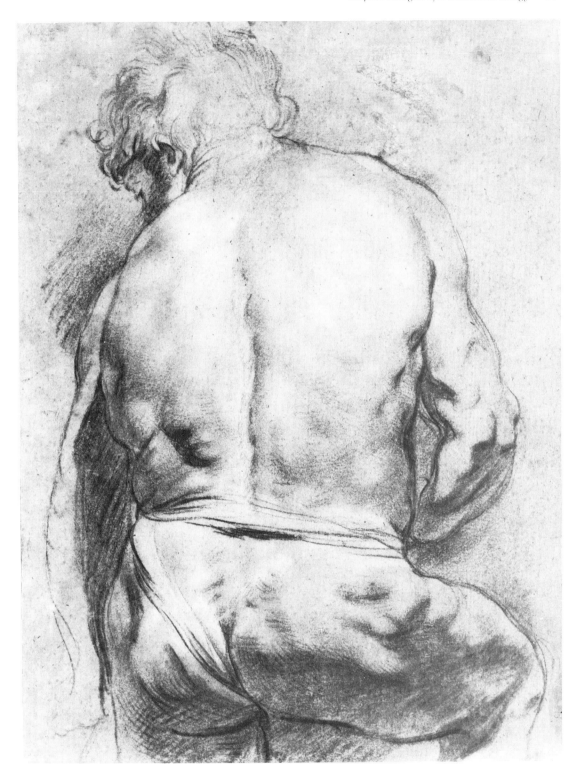

Figure 2.24
PETER PAUL RUBENS (1577–1640)
Study of a Male Figure, Seen from Behind
Charcoal heightened with white. 35.7 × 28.5 cm.
Fitzwilliam Museum, Cambridge

energy. But the role of shape as an agent of direction goes beyond gesture. If gestural expression is understood as the emotive character of movement, then directions provide the "itinerary," the formal pattern of movement.

Shapes, whether as flat configurations only or as stressed edges of volume, do much to guide us in or out of the spatial field or in any direction on the picture-plane. All shapes, except those whose radii are roughly equal, such as circular or square ones, suggest movement in the direction of their long axis (Figure 2.25A).

Generally, the more geometrically simple a shape, the faster and more forcefully it appears to move (Figure 2.25B). Compared with others in a drawing, longer shapes and those with simpler, more sharply defined boundaries appear to have swifter directed movement. When several shapes are arranged in a similar direction they

A B

Figure 2.25

intensify each other's moving energy (Figure 2.26). Conversely, the more complex the shape, the more convoluted and/or diffuse the boundary, the more its directional force is impeded by

Figure 2.26
EL LISSITZKY
Gravedigger (1923)
Color lithograph. 14⅝ × 10⅝ in.
(Totengräber) from the portfolio "Victory Over the Sun"
Collection of Lois B. Torf

Figure 2.27
PABLO PICASSO (1881–1973)
La Sieste (*Les Moissoneurs*) (1919)
Pencil on paper. 12¼ × 19¼ in.
*The Arkansas Arts Center Foundation Collection: The Fred W.
Allsopp Memorial Acquisition Fund, 1984*

shapes moving in contrasting directions, the less active and directional it will appear to be (Figure 2.27).

Exercise 2D will enable you to explore the possibilities for control over the speed of shapes and forms in drawing. Preliminary sketches, roughly in the manner of the last part of the exercise, are useful in planning the pattern of directed energies in more extended works.

A

exercise 2D

MATERIALS: Sketchbook and graphite pencil or pen and ink.

SUBJECT: Geometric and organic shapes.

PROCEDURE: Draw three pairs of squares of the same size, making six squares in all. We will call the first pair A1 and A2, the second pair B1 and B2, etc.

In A1, place at any angle, a straight or simply curved *geometric* shape that appears to move fast. Do not let its boundaries touch any edge of the picture-plane. Fill the rest of the picture-plane with shapes that seem to add to its speed, as in Figure 2.28A.

In A2, redraw the original shape in A1 and try to slow down its inherent speed by filling the rest of the

B

Figure 2.28

39

Figure 2.29

picture-plane with shapes that counteract its movement. These can appear to move faster or slower than the original shape and can cut across or under a small part of it to cancel its speed by moving in an opposing direction, as in Figure 2.21B. You may use both organic and geometric shapes for this purpose.

In B1 and B2, repeat the exercise, using an *organic* shape for your original. First, try to speed it up by adding other shapes; then slow it down. Again, both geometric and organic shapes can be used to influence the speed of the original.

In 3A and 3B, repeat the exercise, using simple geometric and organic volumes, as in Figure 2.29. In 3A, arrange forms to create an impression of vigorous movement as in Figure 2.29A; in 3B, try to slow down each form by contrasting movements in neighboring forms, as in Figure 2.29B.

There are other factors that affect the speed of a shape's direction: the differences of value between shapes, their scale and textural differences, even the haste or deliberateness with which a shape is drawn affects its directional energy. Reexamine some of your earlier drawings to see how changing the directional energy of the forms can improve their relational order and life. Responding to the directional cues of shapes in nature and governing their movement character are important perceptual skills.

THE CHARACTER OF SHAPE

Shape can be a picture-plane component, a facet on a volume, a spatial cavity, and an agent of directed energy all at the same time. Additionally, shape has a quality that does not directly participate in these activities but declares the shapes in a drawing as having certain common "interests." One of these is a familial resemblance. That is, the various shape configura-

tions in a work may show some common features that help to make it seem "more of a piece." Another is an interest in support of expressive as well as formal, organizational matters. That is, the various shape configurations in a work may show traits that serve to amplify the artist's expressive purposes. These characteristics among shapes, their "personality" as being clearly defined or unfocused, curvilinear or angular, boldly or delicately stated, and so forth, and their behavior as agents of expression, must be recognized as another given factor of drawing. Since drawing without shapes is impossible, the need to establish their collective unity—their "oneness"—*and* their suitability to the artist's expressive intent are inescapable.

In the drawing by Degas (Figure 2.19), the feeling of weighty mass, the avoidance of intricate edges, and the forceful energy of these monumental shapes establish their unity of character and expressive mood. How these differ from the character of the shapes in a similar subject is shown in a drawing by Renoir (Figure 2.30). Here the shapes flow in an agile, rhythmic manner. And the shapes influence our reading of these figures. Renoir's subject moves swiftly and effortlessly; in Degas' drawing we sense strain as well as strength.

In Villon's drawing *L'Athlète de Duchamp* (Figure 2.31), the shapes are angular; their various tilts create an agitation that plays across the surface of the entire group. Most of the major shapes contain value-shape subdivisions within them of a wedgelike and hence aggressively energetic character. A large measure of our impression of the figure's strength and action is due to the character and energy of these shapes.

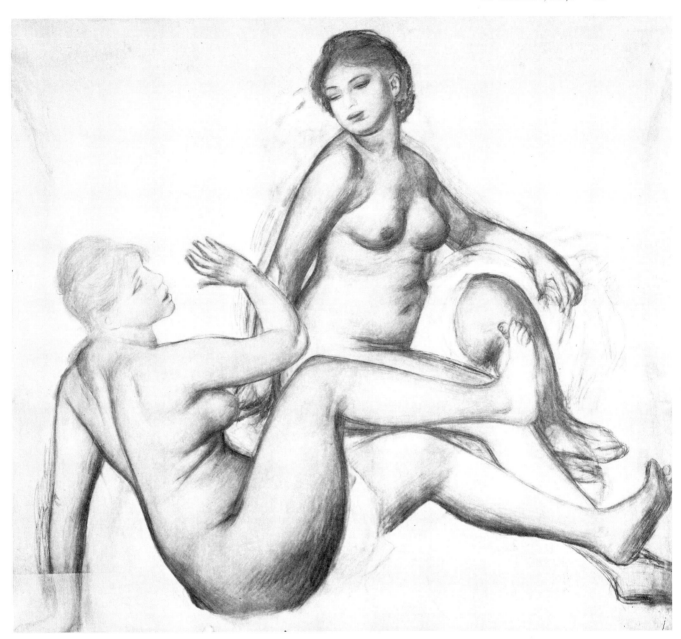

Figure 2.30
AUGUSTE RENOIR (1841–1919)
Two Nude Women, Study for the "Large Bathers" (ca.
1886–87)
Several kinds of red chalk and white chalk on buff wove
paper. 48¼ × 55⅛ in.
*Courtesy of The Fogg Art Museum, Harvard University,
Cambridge, Mass. Bequest of the Collection of Maurice
Wertheim, Class of 1906*

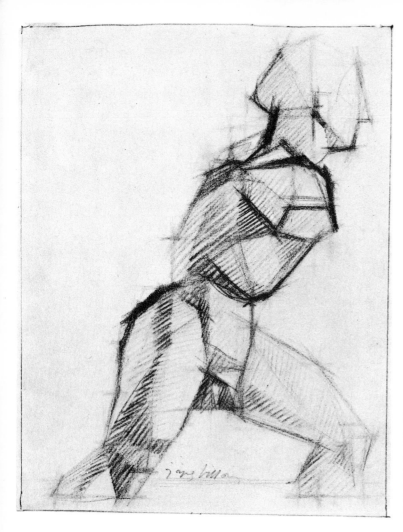

Figure 2.31
JACQUES VILLON (1875–1963)
Torso of a Young Athlete, after sculpture "L'Athlete" by
Raymond Duchamp-Villon of 1910
Black lead pencil touched with blue and red pencils on
white paper. 10⅜ × 8⅛ in.
*George P. Gardner Fund. Courtesy, Museum of Fine Arts,
Boston*

Schiele's *Portrait of a Young Woman* (Figure 2.32) shows a complex interlacing of organic shapes. They are more slow paced and undulating than those of Rubens, Degas, and Renoir. They disclose a pronounced sensuality and a somewhat more subjective attitude to human form. In each of these four drawings the element of shape manifests a different type of "family look" and emotive mood. In doing so it conveys meanings that mere description cannot attain.

Responsive drawing involves a complex of perceptions, feelings, and insights about a subject *and* an emerging drawing in which a sensitivity to the several roles of shape is only one consideration, though a crucial and often overlooked one. How shape considerations fare in the medley of responses to a subject is determined by the artist's creative intent. But if they are to play any active part in drawing, the duality of their nature must first be understood.

Recognizing the "double life" of shape in drawing makes one appreciate the ironies of (1) finding a shape's boundaries by seeing the boundaries of the shapes that surround it, (2) finding a volume's planar structure by seeing the shapes that comprise it, (3) finding a volume's direction and position in space by seeing its shape, and (4) finding a shape's expressive characteristics by feeling its emotive force. The functions of shape, only *potential* in the raw material of the physical world, if perceived by the student, become some of the more important insights in his or her perceptual development. Left unregarded, shapes form unintended unions or stay isolated from the rest of the drawing. Such drawings are generally an assemblage of unrelated details, superficialities that do not refer to the subject's objective and dynamic essentials. They offer the viewer a visual "frosting" with no "cake" inside. And this, it seems, is the ultimate irony: that those for whom a realistic image is an important goal will not reach it until they turn from it to learn the visual and expressive abstractions that constitute the language of drawing. The contributions of shape to the language of drawing are indispensable.

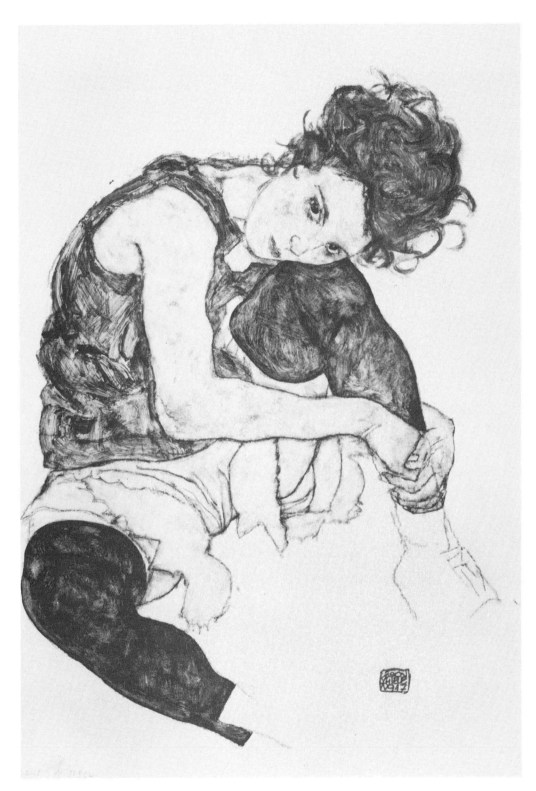

Figure 2.32
EGON SCHIELE (1890–1918)
Portrait of a Young Woman (1912)
Oil sketch. 18 × 24 cm.
National Gallery, Prague

3

LINE

the indispensable abstraction

A DEFINITION

Line is the universal, primary means of drawing. For most people drawing consists of using lines to represent a subject's physical boundaries and to mark off subdivisions within it. Line is a visually concise device for communicating many kinds of visual information. Maps, blueprints, charts, and graphs use line to show concepts of weight, area, mass, cost, and time. Line produces language symbols as well as visual ones—we even doodle with lines.

Our unquestioned acceptance of line as the chief means of producing graphic statements tends to blind us to the fact that line does not exist in the physical world of matter. Virtually everything we regard as a line in nature is, in fact, a thin, solid volume such as a wire, branch, or convex fold, or else a thin depression such as a fissure, interspace, or concave fold. In drawing,

then, line should be understood as a wholly abstract device for conceptualizing a symbol that stands for the thing seen or envisioned. With line, the measurable dimensions of a form can be stated, as can the limits of a color, texture, or value. Abutments of planes can be shown, textures and tones indicated, and the direction and position of forms explained as located before, behind, or alongside others in space. And, like shape, line always suggests some degree of movement—of energy.

In Chapter 1 we found that contours emerged from gestural drawing, and we observed the way edges helped to express the subject's action and basic structure. In Chapter 2 we focused on the importance of edge, as indicated by line, in establishing shape and volume. In this chapter, line as contour will be a major though

not exclusive consideration. As we shall see, line in drawing is by no means limited to the delineation of contours.

A drawn line has certain given properties. It always has direction, interrupts or divides the picture-plane, has along its course one or more values, is consistent or varied in width, and has a certain length. Line is an efficient means for noting a volume's length, width, and depth.

Lines also reveal a "personality," a certain attitudinal character derived mainly from the artist's esthetic and intuitive attitude to line in general, and to his or her visual and expressive responses to a subject in particular. Medium and surface also influence a line's character. The artist using pen and ink will produce a very different kind of line than when using compressed charcoal. Not only does the medium limit the character of a line, it deflects the artist's lines onto certain tracks of usage which influence perception itself.

In responsive drawing the lines that *denote*—that describe what forms look like—also *evoke*; that is, they convey the artist's emotional responses to the forms. Consequently, all lines are partly descriptive, partly emotive. Usually, we describe the character of a line by the nature of its dominant attitude, but we should bear in mind that all lines function in both ways. Lines engaged primarily in measurements of length, width, and depth, and in direction, shape, and structural generalities, are often called *diagrammatic* lines. Lines that more fully explore and emphasize a volume's planar construction and the interjoining of the form units that comprise a complex volume are called *structural* lines. Both kinds of line, being primarily engaged with stating the artist's intellectual analysis of a form's structure and spatial condition, are concerned not so much with surfaces as seen, but rather with their essential constructional nature—their architectural condition. Such lines, then, scan volumes searching out their relative lengths, locations, and directions in space, and the planar arrangements that make up their basic structure, rather than the textural and light effects upon them. Both of these closely related types of line are denotative, but both convey emotive qualities, if only in showing the excitement of the artist's structural discoveries.

Lines of a strongly curvasive and rhythmic quality, often more the result of dynamic rather than structural stimuli, are called *calligraphic* lines. And some lines seem so charged with emotive energy that we regard their dominant role to be *expressive*. All lines, of course, are expressive, but some appear to issue more from an artist's intuition, empathy, and temperament than from either structural or organizational motives.

All four kinds of line may be present in some drawings, and it is possible for a single line to function in several or even in *all four ways at once* (Figure 3.1). Although in practice these qualities always overlap in various combinations, here we will briefly examine them separately, to better grasp the nature of each.

Figure 3.1
GIOVANNI TIEPOLO (1696–1770)
Three Studies of Dogs, After Veronese
Black crayon heightened with white chalk on blue-gray paper. 13⅛ × 9⅞ in.
The Metropolitan Museum of Art, Rogers Fund, 1937. All rights reserved, The Metropolitan Museum of Art

THE DIAGRAMMATIC LINE

The experience and clarification of spatial depth, dimension, shape, direction, and structure are conveyed in Giacometti's *Portrait in an Interior* (Figure 3.2). Here lines measure distance, estimate scale, and weave through space, as well as forms, to explain the environment in which the forms are located. Diagrammatic lines are investigatory and analytical. They reveal the *general* scale, shape, location, and structural nature of

forms in space. As such, they are essentially spatial judgments—decisions about the location and structural condition of parts. Giacometti's need to experience the three-dimensional *actions* of forms and planes in space—the moving, as well as the structural nature of his subjects—and the desire to fuse form and space into a system of rhythms and tensions energize the lines and generate their darting, inquiring activity.

In Toulouse-Lautrec's drawing *Le Père Cotelle* (Figure 3.3), there is again an inquiring,

Figure 3.2
ALBERTO GIACOMETTI (1901–1966)
Portrait in an Interior (1951)
Lithographic crayon and pencil. 15⅜ × 10⅞ in.
Collection, The Museum of Modern Art, New York
Gift of Mr. and Mrs. Eugene Victor Thaw

Figure 3.3
HENRI DE TOULOUSE-LAUTREC (1864–1901)
Le Père Cotelle, the Lithographer (c. 1893)
Charcoal with red and blue crayons. 20 × 13⅝ in.
*Collection of The Art Institute of Chicago. Gift of Mr. and Mrs.
Carter H. Harrison. Photograph © 1990, The Art Institute of
Chicago. All Rights Reserved.*

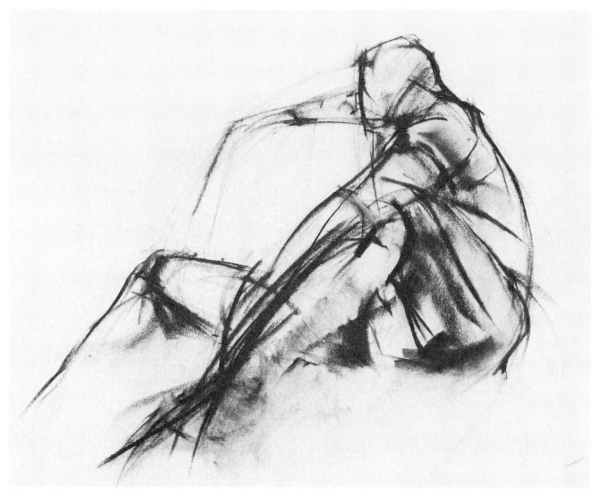

Figure 3.4 (*student drawing*)
Sandy Roebuck, Denver University
Charcoal. 18 × 24 in.

diagrammatic use of line. Again, lines measure and explore the general architectural nature of forms *and* their spatial "container" by moving freely upon, through, and between forms.

All drawn lines immediately and dependably record the artist's judgments, intent, feelings, and even his or her neuromuscular control at the instant they are produced upon the page. In these drawings Giacometti and Toulouse-Lautrec are deeply absorbed with visual inquiry and experience—with exploring and manipulating volume and space—and their lines tell us this. The artists, and consequently the lines they devise, are responsive to the stimuli of visual cues about space, shape, dimension, and volume. And, because these are the issues that excite their interest, the lines, although primarily diagrammatic in function, also manifest an expressive quality. As both show, analytical and emotive attitudes to line are not mutually exclusive. Something of this wish to search out a subject's constructional and spatial nature, and

the zest with which it is stated, are evident in Figure 3.4. Note how certain axial lines, as in the legs and torso, establish direction.

THE STRUCTURAL LINE

Although possessing some diagrammatic qualities, structural lines have some distinctive characteristics. They stem from the same necessity to explore and explain space, shape, dimension, and especially volume, differing most because of their emphasis on volume building. Structural lines, in establishing the various planes of a form, are capable of modeling it with sculptural clarity. Often, groups of lines are used together to create dense values that explain a subject's terrain in planar terms, and even to suggest the presence of light (see Chapter 4). Leonardo de Vinci's and Abeles's drawings (Figures 3.5 and 3.6) demonstrate lines used in just this way.

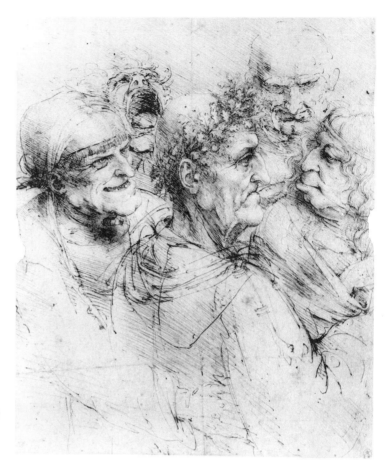

Figure 3.5
LEONARDO DA VINCI (1452–1519)
Five Grotesque Heads
Pen and ink. 26 × 21.5 cm.
Royal Collection, Windsor Castle

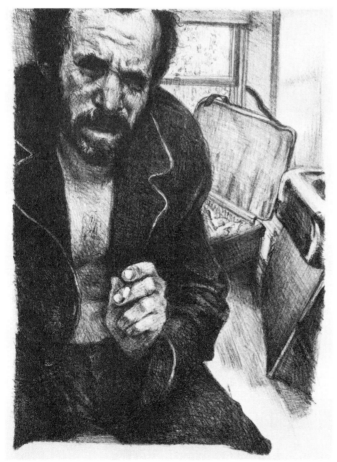

Figure 3.6
SIGMUND ABELES (1934–)
Self-Portrait
Compressed charcoal. 18 × 24 in.
Courtesy of the artist

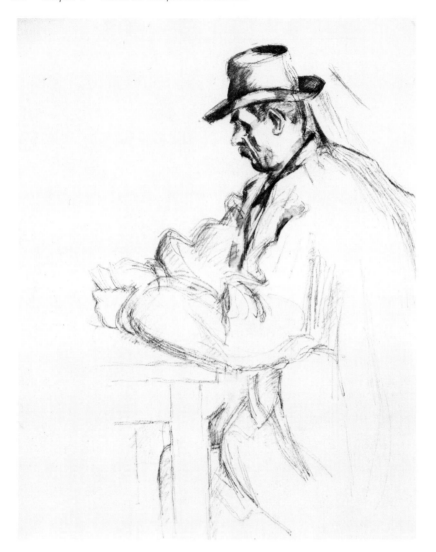

Figure 3.7
PAUL CÉZANNE (1839–1906)
The Card Player
Pencil and watercolor. 19¹⁄₁₆ × 14¼ in.
Museum of Art, Rhode Island School of Design.
Gift of Mrs. Murray S. Danforth

A structural use of line tends to reduce attention to contours and emphasizes instead the substantiality of a form's mass. Not surprisingly, many sculptors, like Moore, draw almost exclusively in structural lines. Because structural line, like diagrammatic line, is exploratory, artists usually combine these two approaches to line.

In Cézanne's drawing of a card player (Figure 3.7), the structural lines in the hat, hand, and sleeves merge with the probing diagrammatic lines that establish the shape-state of those forms. The lines in the drawing's lower half are almost exclusively diagrammatic, suggesting that Cézanne first used lines to explore forms and space throughout the drawing, developing the upper part of the figure on the information so gained. The fact that diagrammatic line can carry gestural information is evident in some of the drawing of the card player's legs, cloak, sleeves, and hat, as well as in the areas around the hat and head. Again, in Papo's drawing *Seated Nude Figure* (Figure 3.8), diagrammatic inquires underlie structural statements. Notice how economical

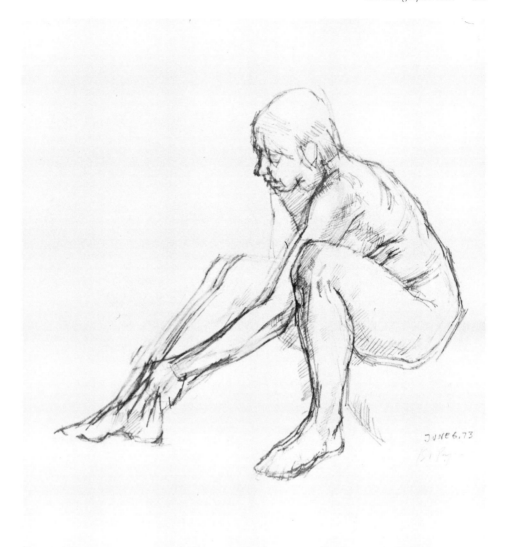

Figure 3.8
ISO PAPO (1925–)
Seated Nude Figure
Pencil. 14 × 16 in.
Courtesy of the artist

and effective the patches of massed lines are in establishing convincing masses. Note, too, that each of the preceding five examples of diagrammatic and structural line drawing is enlivened by felt and forceful responses of an engaging sort. Many students (and some teachers) feel uneasy about stressing a search for dimension and structure, fearing such an analytical approach may lead to tight or dull results. But a strong emphasis on understanding a subject's proportions and structure not only is no danger to creative interpretation and handling, it can uncover a rich

source of dynamic invention, as we shall see in Chapter 6.

THE CALLIGRAPHIC LINE

Because of their rhythmic, tactile nature, calligraphic lines usually have strong gestural qualities.[1] Kokoschka's chalk drawing (Figure

[1]See Roger Fry, "On Some Modern Drawings, in *Transformations* (London: Chatto and Windus, Ltd., 1926).

3.9) contains several kinds of calligraphic line, from the foggy tone-lines of the hair to the forceful lines of the clothing. Kokoschka's lines offer numerous variations of the thick–thin, short–long, flowing–angular, fast–slow, and light–dark line ideas. These all function representationally—they denote the woman—but also reveal an independent play of line variations as a simultaneous abstract theme. And these abstract actions reinforce depictive meanings; that is,

they evoke qualities in the subject that elude mere description. For example, the nature and the relational behavior of these lines help us to feel the firmness of the supporting arm, the differing weights of the woman's clothing, the texture of the hair, and the limpness of the reposing figure. Although, as was noted earlier, all lines evoke, the pronounced activities of those lines we call calligraphic seem to disclose more relational purpose, more expressive potency.

Figure 3.9
OSKAR KOKOSCHKA (1886–1980)
Study of the Artist's Mother
Black chalk. 40.2 × 28 cm.
Albertina Museum, Vienna

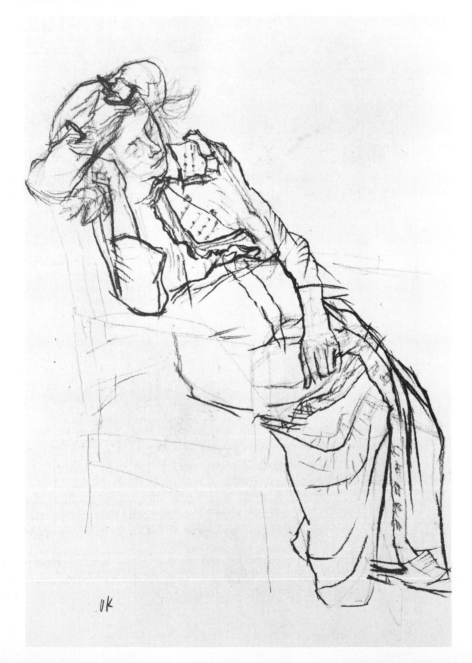

Some of the lines in Kokoschka's drawing, such as those of the chair or the faint lines on and around the head, are as much concerned with diagrammatic searching as with calligraphic exposition. They serve as quiet, inquiring foils for the bolder declarative lines. If the drawing had an unchanging sameness of line character, much of its *type* of calligraphic play would be lost, for one of the drawing's strengths is in its line variety.

Yet an unvarying line, when that is the artist's graphic theme, provides another kind of calligraphic quality. Matisse's line drawing (Figure 3.10) has a consistency of line that helps create a two-dimensionally active design. Unlike Figure 3.9, where a rich variety of line assists the location of planes and edges and establishes solid forms, Matisse's more uniform line tends to flatten the forms somewhat by stressing the cut-out character of the edges. This occurs because contours represent the most distant surfaces of a rounded form. Emphasizing contours brings forward the receding, foreshortened planes they

Figure 3.10
HENRI MATISSE (1869–1954)
Three-Quarter Nude, Head Partly Showing (1913)
Transfer lithograph, printed in black, composition.
19¾ × 12 in.
Collection, The Museum of Modern Art, New York
Frank Crowninshield Fund

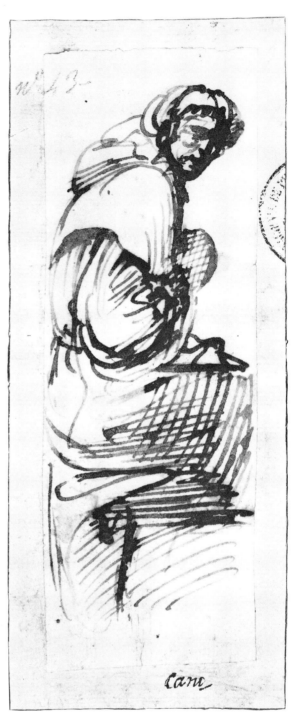

Figure 3.11
ALFONSO CANO (1601–1667)
Study for the Figure of a Franciscan Monk
Pen and ink. 17.6 × 7.5 cm.
Prado Museum, Madrid

are meant to represent. Matisse further accents the second dimension by creating strong, attention-getting shapes.

The lines in Cano's stormy drawing (Figure 3.11) contrast sharply with the dart and flutter of the lines in Picasso's (Figure 3.12), and both these uses of line differ from the rhythmic vigor of the lines in Figure 3.13, yet all are strong calligraphic

53

Figure 3.12
ALEX McKIBBIN
Two Reclining Figures
Black chalk. 24 × 18 in.
Courtesy of the artist

Figure 3.13 (*student drawing*)
Miguel Collazo
Conté crayon. 24 × 18 in.

expressions. In each of the five preceding works the artist utilizes line's capacity for visual and expressive excitation and not its ability for description alone.

THE EXPRESSIVE LINE

As was observed earlier, all lines exhibit *some* expressive characteristics. After all, they represent an artist's intellectual *and* emotional encounter with a subject, resolved by both esthetic and temperamental attitudes to line, and these qualities influence every mark. But we can regard lines as chiefly expressive in their purpose when we sense in a drawing that the artist's need to experience and share feelings pervades all other motives for line's use.

Unlike the artist for whom line's expressive power is triggered mainly by visual stimuli,

some artists, such as Goya (Figure 3.14), come to the blank page with an established expressive intent of another kind. For these artists the expressive character of line, though it may result in part from visual challenges and insights that occur while they are drawing, receives its initial impetus from a need to experience and share feelings *through* and not merely *about* the content of the drawing. In Goya's etching, the first in a series called *The Disasters of War*, it is not the representational matter alone that expresses his ominous warning of impending doom. The character of the lines reveals this through their slashing, cross-hatched clash and the brooding tones they form. That these lines carry the grim message intrinsically can be seen if you cover any portion of the etching. Even small segments cannot be seen as cheerful, gentle, or serene.

Goya's interest in visual phenomena—in structure, design or dynamic activities—exists

Figure 3.14
FRANCISCO DE GOYA (1746–1828)
Sad Presentiments of What Must Come to Pass from *"The Disasters of War"*
Etching, 4th state. 10.5 × 18.7 cm.
Print Department, Boston Public Library

Figure 3.15
JULES PASCIN (1885–1930)
Girl in an Armchair
Charcoal, some yellow chalk. 55.9 × 43.1 cm.
Collection of The Newark Museum
Gift of Mr. and Mrs. Bernard M. Douglas, 1957

only insofar as they strengthen his expressive message. This is not to suggest that these matters were of little importance to him, but rather that they were not important as ends in themselves. They were a necessary means to the clarity of his expressive ends. His lines, then, do not stem from some "policy" concerning the act of drawing, but from a deeply felt emotional force that led him to these graphic strategies.

Pascin's *Girl in an Armchair* (Figure 3.15) shows a use of line that conveys a sensual, even erotic, interest in the female figure. There is honest fascination evident in the slow search of the forms. These lines, *by their nature*, express the pliancy and weight of the body. Pascin delights in experiencing every fold and swell of the figure and of the yielding, receiving character of the sofa. Everything in this drawing is felt as supple and pliant—terms that describe the character of the lines themselves. Again, covering a section of the drawing would show remaining portions capable of communicating Pascin's sensual message.

A very different kind of expression is conveyed by the rugged and resolute chalk lines in Schiele's drawing (Figure 3.16). These lines fully agree with the figure's assertive stance; they evoke as well as depict the subject's assurance.

Figure 3.16
EGON SCHIELE (1890–1918)
Arthur Roessler Standing with Arms Akimbo
Black chalk.
Albertina Museum, Vienna

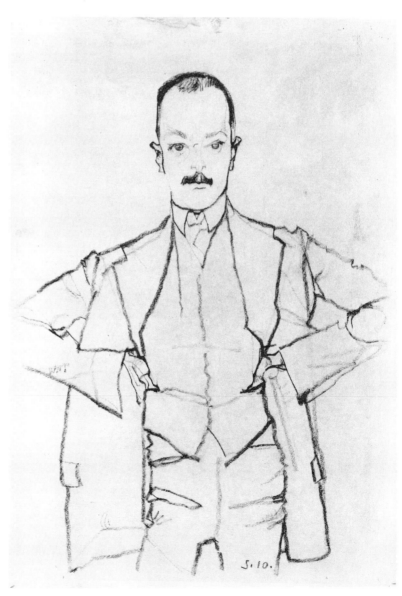

Figure 3.17
WILLEM DE KOONING
Untitled. Woman (1961)
Pastel and pencil on tracing paper. 23¹¹/₁₆ × 18¹¹/₁₆ in.
Hirschhorn Museum and Sculpture Garden, Smithsonian
Institution
Gift of Joseph H. Hirschhorn, 1966

Artists may support the emotive meanings of representational content through line's expressive powers for many reasons. Historical, religious, political, and social issues have been catalysts for such drawings.[2] But many other motives can and have stimulated artists to use line for expressive purposes beyond those triggered by formal visual issues. The aggressive and tension-filled strokes that shape the forms in Figure 3.17 suggest the mood of the figure's menacing attitude. And the lines that reveal Picasso's understanding of a mother's love for her child (Figure 3.18) are themselves gentle caresses.

ON USING LINE

This discussion of the several basic attitudes to line may leave the impression that artists make a conscious choice among them. This is virtually never the case, although the more experience artists have in exploring various line characteristics, the greater their control of line's "vocabulary." Still, because of certain factors, no one has complete freedom in the selection of line.

First, our choice is influenced physiologically, in the same way that we are not altogether free to choose our individual handwriting. Neuromuscular coordination and control imprints certain pathways of line-making and blocks others. These personal idiosyncrasies are not easily overcome. Nor should we struggle to overcome them, for these traits form part of our unique way of drawing (or writing). And our way of using line is just as capable of creating fine drawings as any other. Second, we are influenced psychologically. Our intuitive and intellectual interests—how we like to use and see line—insist on a particular "recipe" based on the options available. This creative imperative may vary with the choice of subject or medium, and as our

[2]For an interesting exploration of such motives, see Ralph E. Shikes, *The Indignant Eye* (Boston: Beacon Press, 1969).

Figure 3.18
PABLO PICASSO (1881–1973)
Mother and Child and Four Studies of Her Right Hand
(1904)
Black crayon. 13½ × 10½ in.
Courtesy of The Fogg Art Museum, Harvard University,
Cambridge, Mass.
Bequest of Meta and Paul J. Sachs

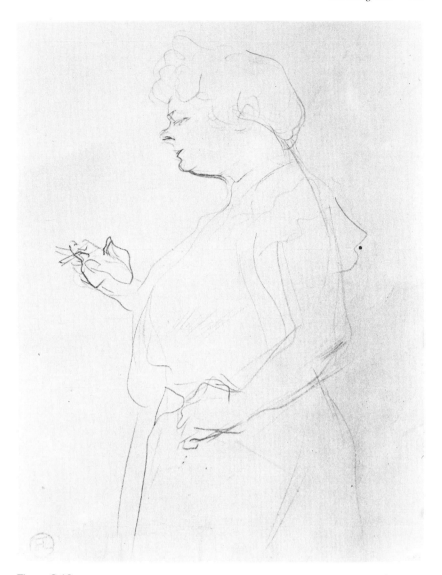

Figure 3.19
HENRI DE TOULOUSE-LAUTREC (1864–1901)
Sketch for "Aux Ambassadeurs"
Pencil. 26.2 × 20 cm.
Albertina Museum, Vienna

moods and interests fluctuate within a certain esthetic point of view. For example, compare Toulouse-Lautrec's use of line in Figure 3.3 with that in his sketch of a music hall figure (Figure 3.19). Although these drawings differ from each other as much as they do from other Toulouse-Lautrec drawings in this book, all of them exhibit variations of line usage that fall within a range determined by his idiosyncratic and creative instincts. All bear the stamp of the artist's temperament and handling.

Some drawings do reveal a weak sense of line's potentialities. Such drawings show that their authors do not respond to line's analytical, structural, or empathic functions. We see none of the dynamic line play so supportive of figural or organizational purposes. Instead, such line-inhibited works generally disclose an exclusive concern with superficial details and appearances. But, because the use of line to symbolize a subject places the drawing well away from the "real" anyway, it is far better to convey our visual

and emotional responses to our subjects through line's ability to explore, enact, and express.

In responsive drawing, line always functions at three levels: it *describes*, it *acts*, and it *interacts* with other lines, producing various dynamic phenomena. If description alone is the only motive for using line, we lose all of line's dynamic potential—its ability to add meanings and activities that support the depiction. Denotation alone skirts all the responsive possibilities of line and is always expressively dull. As we have seen in the previous two chapters, an exclusive concern with a subject's surface appearance blinds us to a subject's gestures and shapes. Here, it blinds us to the many possibilities for creative activity and meaning of the very means being used to make the drawing—line.

The following exercise explores the several line qualities discussed.

exercise 3A

This exercise consists of five drawings. Each should start as a two-minute gestural drawing.

MATERIALS: Use pen and ink on any suitable drawing paper. These drawings should all be about the same size, approximately 10 × 14 inches.

SUBJECT: In each of these five drawings your model will be the same: your own hand, holding a tool, letter, utensil, flower, or anything else that is not much larger than the hand, is comfortable to hold, and has some interest for you as a visual and/or expressive object.

PROCEDURE: Allow about fifteen to twenty minutes for each drawing. The five drawings are:

1. calligraphic emphasis
2. diagrammatic emphasis
3. structural emphasis
4. expressive emphasis
5. unrestricted line drawing

In each try, try to draw actual size, but don't hesitate to work a little larger or smaller if your drawing requires it.

Beginning a pen-and-ink drawing may create some anxious moments for you. The earlier gestural drawings in pencil or chalk seemed "safer." It was like walking a tightrope with a net below. Here, there is no net. The ability to erase and the foggy tone lines, so useful in grasping a subject's broad actions and masses, are not possible in this medium. Obviously we must alter our tactics.

Many artists will first make a practice gestural drawing in pencil *on another sheet of paper.* Such a preliminary pencil drawing helps them become familiar with a subject's essential action and structure, and allows for a more informing and economical use of line in the pen-and-ink gesture drawing. And using the fewest lines possible is now necessary, for almost every mark will be visible in the completed drawing.

This being the case, more effort and time must be given to an analysis of the forms *before* you begin to draw. Where chalks could make broad sweeps in tone, a few short lines, or even dots, must suffice to show the basic action and form character. However, do not hesitate to use continuous lines if you wish. That such a pen-and-ink gesture drawing can convey as much about the action as chalk can is evident in a spirited student drawing (Figure 3.20). Although intended as a final statement, it is an impressive example of how much gestural action can be grasped with a few felt lines, resolutely stated.

Think of these lines and dots as clues—a kind of gestural shorthand—about the expressive action.

Figure 3.20 (*student drawing*)
Anne-Marie Hodges. Art Institute of Boston
Pen and ink. 14 × 17 in.

These clues should also refer to major directions, shapes, and masses.

drawing 1 *Calligraphic.* After the two-minute gestural phase, try to complete the drawing by lifting the pen from the paper as little as possible. Holding your pen upon the paper at the completion of a line, while you look up to make further observations, often leads to discoveries of nearby edges or tangential forms that allow the line to continue. This continuity gives to lines a sense of animation and promotes an economical handling, as in Figure 3.20. Although a shorter, vigorous line like Dufy's (see Figure 1.15) also suggests an energetic calligraphy, as does the rich variety of Kokoschka's lines (Figure 3.9), continuous lines more clearly reveal line's capacity for dynamic activity and demand that you make more conclusive, simpler line judgments. However, do not hesitate to use line ideas

such as those in the Dufy and Kokoschka drawings where you feel they are necessary to your drawing.

There is no one way to draw calligraphically. Your continuing study of the drawings by artists who emphasize calligraphy will reveal the endless possibilities for such linear actions. Calligraphic lines are not "free-born"—to wander where they will—but they can, simultaneously with their representational role, offer design configurations that are esthetically satisfying.

In Oldenburg's energetic drawing (Figure 3.21) gestural and calligraphic line qualities occur throughout. The artist enjoys the sheer act of drawing, as the knowledgeable flourishes of his "handwriting" strongly suggest. These lines depict forms with an easy confidence while simultaneously asserting their own exciting behavior.

Your goal in this first drawing is to interpret the

Figure 3.21
CLAES OLDENBURG
Preliminary study for *Image of the Buddha Preaching*
(1967)
Pencil. 30⅛ × 22⅛ in.
Collection, The Museum of Modern Art, New York
Gift of Mr. and Mrs. Richard E. Oldenburg

subject as a system of forms which offer interesting linear ideas—ideas you feel extract the subject's essential character and allow for a satisfying use of line, much as you use line when writing. The lines in the completed drawing should show not only your understanding of the subject's actualities, but line interactions and contrasts that exist as visual activities in their own right.

drawing 2 *Diagrammatic.* After the gestural phase, explore the planes that comprise the major masses of your hand and object, and the distance separating these volumes from one another. Notice the various tilts of the volumes, their scale relationships, and the shape, scale, location, and direction of any "empty" or negative areas. Do so by a liberal use of light lines.

Your goal in this drawing is to explore and explain the subject's measurable shape, scale, spatial, directional, and general structural nature. This theme must be so insistent that responses to surface effects of texture or light are disregarded to avoid weakening the analytical search (Figure 3.22A).

The calligraphic line is, to some extent, a tactile, sensual line. The sensation of touching forms to feel their terrain helps suggest ideas for line activity. Here,

Figure 3.22 (*student drawing*)
Laura Serifin, Art Institute of Boston
Pen and ink. 14 × 17 in.

the goal is not to caress a form, but to tell us about its basic constructional and spatial condition. The diagrammatic line is primarily intellectually informing. Its expressive properties come from the artist's excitation about the visual inquiries he or she makes regarding the subject's important actualities, and the relational ideas they suggest. When a diagrammatic line defines an edge or "rides" upon a form's surface, it tells about, rather than feels that edge or surface just as the longitude and latitude lines of the globe describe divisions of that form without responding to the undulations of the earth's surface.

Like the lines upon a globe, *cross-section* lines, sometimes called *cage* or *cross-contour* lines, help to explain the *general* nature of a form's surface. Plan to use such lines wherever you feel the need to further explore a form's volumetric character, as in Tovish's drawing (Figure 3.23), where their use evokes a powerfully sculptural image. This is more frequently useful when forms are not comprised of flat planes but are more organic in character.

Although a line can function in more than one way at a time, in this drawing try to use lines only to explore the general "architecture" of the forms and the spaces between them. Helpful, too, is drawing through a solid form to "see" its total structure, as occurs, for example, if we draw a cube of ice. In this way we can better understand its mass, its location to other forms, and something of the spaces that separate them.

In the drawing by Piranesi (Figure 3.24), the liberal use of line helps explain the forms. Piranesi reinforces our understanding of a plane as being flat or curved, a volume's position in relation to others, and the spaces that separate and surround the volumes, by using groups of lines which explore surfaces, placement, and space more fully than a single line can.

In drawing, any kind of line can perform a diagrammatic function. When an artist uses a line to tell us something of a volume's dimensions or position, the space in which it exists, or its physical relationship to other volumes, that line, whether additionally functioning in a calligraphic or any other way, is performing a diagrammatic function.

drawing 3 *Structural.* This time, modify the gestural beginning somewhat in favor of a more diagrammatic search of your subject, as Cézanne does in Figure 3.7. There we saw how the diagrammatic "armature" helped to guide the structural drawing. Concentrate, then, on drawing (in a general and simplified way) the essential architecture of the major masses. But do not sacrifice the search for the gestural expression altogether, or the resulting drawing will appear stiff and lifeless.

In this drawing you will often use groups of lines, as in Figure 3.8 and 3.25. It may be helpful to fill a practice page with such line-groups, called *hatchings,*

Figure 3.23
HAROLD TOVISH (1921–)
Contour Drawing (1972)
Pencil. 19 × 25 in.
Courtesy, Terry Dintenfass Gallery, New York

Figure 3.24
GIOVANNI BATTISTA PIRANESI (1720–1778)
Architectural Fantasy
Pen, brush and ink. 36.5 × 50.5 cm.
Ashmolean Museum, Oxford

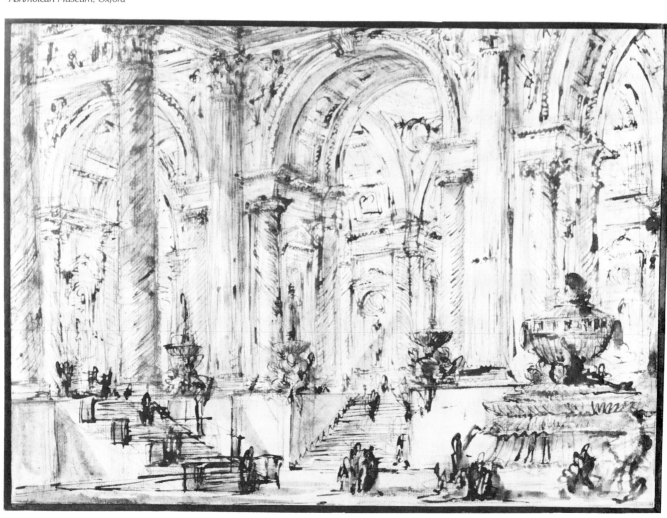

or, when groups of lines overlay each other, *cross-hatchings.* The few moments taken to do this exercise within an exercise will give you better control for making the various line patterns you will use in this drawing.

Now your goal is to explain the structural role of the flat and curved planes of the volumes. Also, try to convey the volumes' sense of weight. If your hand is holding a flower, show through the vigor or delicacy of your lines, and by their width and group density, the lightness of the flower, and the relative heaviness of the hand.

Instead of drawing the outline of each plane, use hatchings as in Figures 3.5, 3.6, and 3.8. Such massed lines produce optical tones which help clarify the planar modeling.

Place your hand with the object in a position that allows a single, diffused light to fall upon them. Avoid cast shadows except for those small, form-revealing ones you feel will strengthen the structure. Daylight, preferably a north light (which changes least during daylight hours), will best reveal the tonal differences of

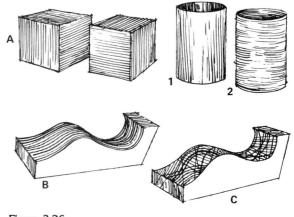

Figure 3.26

the planes and will permit you to see between the forms and into their darker recesses.

Often, a plane's direction can be selected by the artist. In Figure 3.26A the same planes are drawn to carry the eye in different directions. The cubes are equally solid but we "read" them differently. When a form's structure can be stated equally well in any one of several ways, the choice of the direction of the hatching should be one that supports other issues such as compositional or expressive ones. In Figure 3.26, the lines of cylinder 1 direct our eyes along the length of the body, while those of cylinder 2 move around it, implying the existence of the cylinder's unseen back. The first cylinder is seen as moving more forcefully in a direction than the second one but tells us a little less about its volume. Usually, hatched lines drawn as moving around a form or as riding upon its surface undulations (as in Figure 3.26) tell us more about a volume's terrain than lines that go in other directions on it.

Lines can also deny a volume's surface-state by being drawn in some direction structurally illogical to it, as in Figure 3.26C.

In Corot's drawing (Figure 3.27), the direction of the line groups clarifies the structure of the forms. Changing the direction of these lines would only diminish our understanding of the subject's structural nature.

It should be stressed here that using such hatchings and cross-hatchings should be understood not as a particular *style* of drawing, but as a general and universal *process.* Many artists of very different esthetic persuasions have for centuries applied this process of structural modeling to convey volume and space. Developed in the Renaissance (Figure 3.5), it continues to provide artists with an effective means for expressing volume in original ways, as in Picasso's *Sketch of a Nude and Classical Heads* (Figure 3.28) and Goodman's *Study for Woman Holding Sheet* (Figure 3.29).

Figure 3.25
KÄTHE KOLLWITZ (1867–1945)
Hand Studies
Pen and ink and wash. 11¼ × 9 in.
Reproduced by courtesy of the Trustees of The British Museum

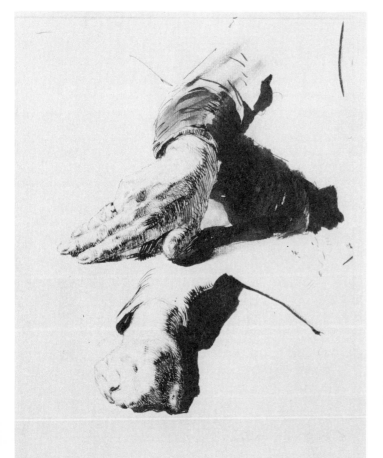

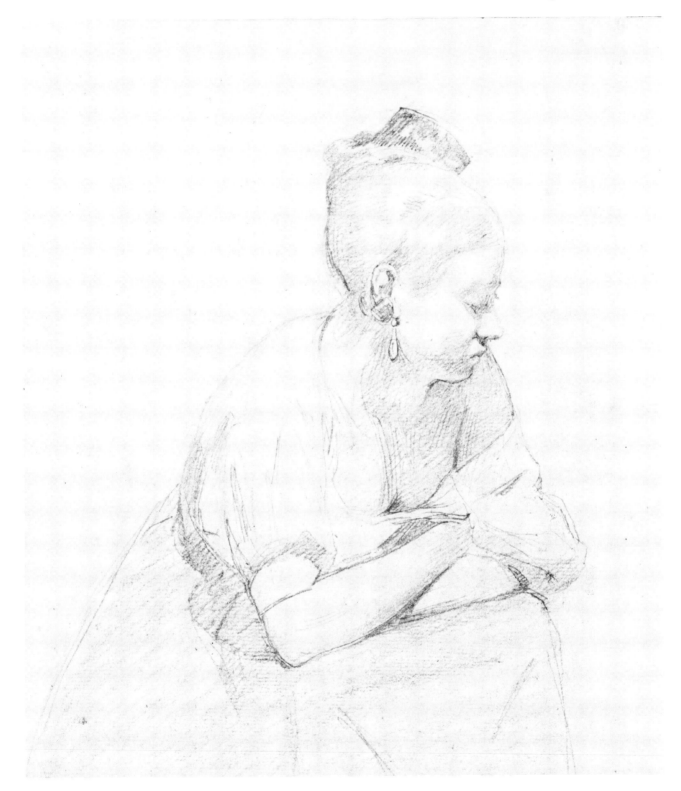

Figure 3.27
CAMILLE COROT (1796–1875)
Young Woman Seated, with Her Arms Crossed
Graphite pencil. $10\frac{7}{8} \times 8$ in.
The Louvre Museum

Figure 3.28
PABLO PICASSO (1881–1973)
Study of a Nude Woman
Gray-brown ink on brown paper. 12¾ × 10 in.
J.H. and E.A. Payne Fund
Courtesy, Museum of Fine Arts, Boston

66

Figure 3.29
SIDNEY GOODMAN (1936–)
Study for Woman Holding Sheet
Pen and ink. 8½ × 11¾ in.
Courtesy, Terry Dintenfass Gallery, New York

Another way to convey the impression of volume uses line groups to show the effects of light upon surfaces. Light waves do not bend; the differing values of a form's planes represent their turnings toward and away from the source of light. When planes abut at pronounced angles, the value change is abrupt, as in Figure 3.30A, but it is gradual when a curved plane turns toward or away from the light source, as in Figure 3.30B. Hatching, then, in addition to establishing the directions of planes, can show the sudden or gradual changes in the surface they collectively produce.

In your drawing, use both of these concepts to carve the volumes. In de Gheyn's drawing *Woman on Her Death Bed* (Figure 3.31), both means have been used effectively. Groups of lines, *by their direction*, explain the angles of planes throughout the drawing. Notice especially how clearly the artist establishes the directions of the planes of the hands, bodice, and collar.

Figure 3.30

A B

Figure 3.31
JACQUES DE GHEYN (1565–1629)
Woman on Her Death Bed
Pen and ink. 14.6 × 19.4 cm.
Rijksmuseum, Amsterdam

De Gheyn leaves as white those planes facing the light source, here falling from the figure's right side. Planes that parallel the direction of a light source receive a raking, weaker light, often called a *halftone*. These de Gheyn states as light values of several shades. The variations of these halftones are determined by the planes' slight turns toward or away from a true parallel with the direction of the light rays. Those turned well away from the light he draws as darker line-groups. Thus, by allowing the light source to determine the *value* of the hatching, de Gheyn conveys his subject's essential structural nature by lines that explain both the direction of the planes *and* the light falling on them.

Note how well the few cast shadows are integrated among the other values, how they contribute to the pattern—the design—of the other values, and

how they help explain the terrain upon which they fall. Despite the liberal use of line in this drawing, nowhere do lines deny the form. They all "earn their keep" through volume-producing tasks.

In thirty minutes of drawing *from the general to the specific*, you should have enough time to establish many of the smaller planes that make up the volumes. Divide the planes into several value-groups as de Gheyn does, or as suggested in Exercise 2C in Chapter 2. Doing this will help you control the many values of your subject more easily. Look for the direction a plane seems to suggest. If it is flat, which direction should the lines take to better explain that plane's union with adjoining ones? If it is curved, should the plane's hatchings move in the direction of the form's axis or wrap around its body? The choice will often depend on the terrain adjoining the plan. Sometimes, as in reflections of

Figure 3.32 (*student drawing*)
David Brower, Art Institute of Boston
Ball-point pen. 14 × 17 in.

highly polished surfaces, driftwood, wrinkled folds of cloth or skin, or in many highly textured objects, the answer is revealed by these surface conditions. Look for such clues, however subtle; they can help make your drawings more structurally lucid.

Your drawing should look more carved than illuminated, as in Figure 3.32. Because you have emphasized planes more than the effects of light, your drawing may seem somewhat rough-hewn or blocky. With practice and experience, such characteristics can be modified or strengthened depending on your intent.

The ability to control line in this sculptural way is essential to our understanding of line and to our ability to analyze and communicate the structural nature of any form. After all, we cannot draw what we cannot fully understand, and we cannot state our perceptions without a process for communicating them.

drawing 4 *Expressive.* As was mentioned earlier, the attitudinal character of *any* line may be primarily expressive. In this drawing, try to advance a felt theme such as strength, delicacy, danger, anger, mystery, or joy. It will now be necessary to look at your

hand and the object in it in a new way. If you have been doing these drawings in sequence, you are by now quite familiar with the forms of your subject. Now respond to its *meaning* for you. You may not be able to express your feelings in words. They may be diffuse or too interlaced with visual responses for language. That is, you may be emotionally stimulated by *visual* as well as psychological responses. But try to draw whatever your emotional response *feels* like. Let anger, joy, and so on affect the choice you make from the raw materials before you—what you will and will not use—as well as affect your "handwriting." Here, the object you selected will surely exert an influence. If you are holding a flower or a seashell, you are not likely to respond to your subject's mood or character in the way you would if you were holding a pistol or a shrunken head. The quality of the light upon your subject may influence your feelings, as may the time of day or your emotional disposition at the time you approach the subject.

Your "handwriting" will reveal your feelings, but these feelings should not supplant sound visual perception. Rather, they should act as a brake on mere copying and serve as a *basis* for selecting those cues that express your theme, as in Figure 3.33, where an explosive energy drives the lines.

You may wish to clarify and emphasize your theme by exaggerating the bigness or littleness of some or all of the forms. You may want to alter your

Figure 3.33 (*student drawing*)
Marsha Warren, Art Institute of Boston
Reed pen and ink. 14 × 17 in.

Figure 3.34
VINCENT VAN GOGH (1853–1890)
Grove of Cypresses (1889)
Pencil and ink with reed pen. 62.5 × 46.4 cm.
Collection of The Art Institute of Chicago. Gift of Robert
Allerton. Photograph © 1990, The Art Institute of Chicago. All
Rights Reserved.

subject's contours, values, or the placement of its parts. Make such adjustments only when the expressive character of the lines cannot themselves intensify the feelings you mean to convey. Or, if the intended theme is conceived in a way that must include such changes, include them from the start of the gestural stage. However, resorting to distortions before expressive lines have had a chance to indicate your intent, or carrying such changes too far from the observed actualities, can create more problems than they solve. Such changes carry with them the greater risk of *unintentional* discrepancies in scale, shape, and structural clarity. Sometimes the drawing drifts so far from the subject's actualities that further references to it become useless. At least in this first attempt at expressive drawing, the prudent course would be to make only modest adjustments of the original, allowing the main responsibility for the expressive intent to be carried by the *nature* of the lines.

The tight time limit for this drawing is designed to promote your first, felt responses to be expressed. Often, in drawings without a time limit, these reactions are "censored" by second thoughts. Here, it is your feelings, advised but not dictated to by your perceptions, that must be revealed through line's character. Modifying your first, intuitive responses for other, less spontaneous ones can weaken or obscure your meanings.

The expressive force of Van Gogh's *Grove of Cypresses* (Figure 3.34) is declared mainly by the swirling lines of the trees, clouds, and nearby undergrowth. Had Van Gogh drawn these trees "correctly," that is, had he held his feelings in check and only reported upon their proportions, textures, placement, and so on, we would have a drawing that testified to the physical characteristics of some cypress trees in southern France, but without the compelling dynamic force of his creative energies. Here Van Gogh shares with us his feelings about movement and growth—the trees' animated swirl. He tells us the entire countryside and sky can be experienced as trembling with flamelike energy.

Compare this drawing with Bresdin's *Bank of a Pond* (Figure 3.35). Like Van Gogh, Bresdin tells us about the growing, animated quality of a spring landscape. But Bresdin's line is more lyrical, less driven. The breezy spring day is evoked by the graceful, rolling nature of the line. In a different mood, Daumier's *Two Barristers* (see Figure 1.13) is also animated by expressive lines that do more than describe physical facts. Their own nervous vibrations reveal the subject's movement and mood.

Again, line can be put to any expressive undertaking—from the grim and moving message of Goya's lines in his *Sad Presentiments* (Figure 3.14) to the playful and provocative lines of Rodin's sportive *Two Female*

Figure 3.35
RODOLPHE BRESDIN (1822–1885)
Bank of a Pond (Bord d'Etang)
Pen and black ink on buff tracing paper.
16.3 × 16.9 cm.
Collection of The Art Institute of Chicago. Gift of the Print and Drawing Club. Photograph © 1990, The Art Institute of Chicago. All Rights Reserved.

Figure 3.36
AUGUSTE RODIN (1840–1917)
Two Female Nudes
Graphite pencil and brown watercolor washes on
gray paper. 30.5 × 19.5 cm.
Albertina Museum, Vienna

Nudes (Figure 3.36). Line imbued with the artist's feelings about his or her subject can summon a dimension of meaning not otherwise possible.

 drawing 5 *Unrestricted.* Begin this drawing as you did the other four, but develop it through any combination of line uses you wish.

 Just as any line that measures space or mass is functioning diagrammatically, whatever its primary attitudinal character may be, so can lines of calligraphic, expressive, and structural qualities simultaneously undertake each other's functions. Here, you should allow lines to convey several of these attitudes at the same time.

 We have isolated and examined these attitudes to better understand their nature and function, but you should not think of line as being neatly sorted into four fixed categories. In all the drawings used here to demonstrate one or another of these line qualities, there are lines that function in other ways. There are diagrammatic functions in Kokoschka's essentially calligraphic drawing, structural properties in the lines of the Goya etching, calligraphic qualities in the Van Gogh drawing. Additionally, we have seen that *every* line is expressive of some motive—is energized by some visual and expressive idea—either depictive, dynamic, or both. Further, bear in mind that lines can change character along their course. A line begun as a gentle inquiry may end as a furious declaration.

 In this drawing your are on your own. Do not dwell on line attitudes; instead concentrate on your visual and expressive responses that are now under none of the influences and restrictions of the previous four drawings. Having worked with each attitude has

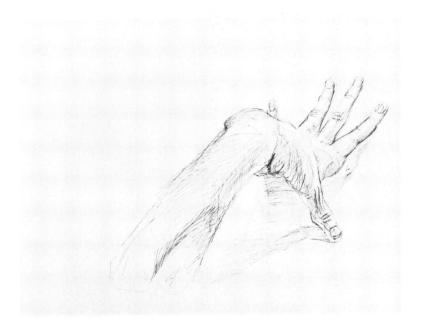

Figure 3.37 (*student drawing*)
David Brower, Art Institute of Boston
Pen and ink. 14 × 17 in.

helped you understand their various qualities better. You made some judgments about their capabilities and their "feel." Much more drawing experience is needed to fully grasp their worth. But let your experiences of the previous four drawings influence your use of line in this drawing, as in Figure 3.37. Compare this drawing with Figure 3.32, by the same student. Your attention should shift from line's uses to what it is you want to explore and convey. But your expanded repertoire of line uses should help you communicate your intent in more effective and satisfying ways.

This drawing may lack the control and clarity of meanings you had hoped for. Even though your primary attention is upon comprehension and response, it will take patience, commitment, and the experience of many encounters with subjects drawn in line before these concepts and procedures, adapted to your interests, become necessary, natural, and satisfying. As William Hazlitt observed, "We never do anything well till we cease to think about the manner of doing it."

DELINEATING CONTOUR

"Delineating" should be understood here as establishing the physical boundaries of a form or plane with any of the four line concepts already discussed. That any kind of line can be used to convey the "edgeness"—the *contours* of forms—is clearly seen in the drawings that illustrate this chapter. The character of their delineating lines is largely consistent with the type of line quality used throughout the drawing. Delineation, then, is a task that *any* type of line can perform. But, unlike the untrained, for whom delineation is only outlining, responsive artists regard delineation as a volume-producing process. For them, the line that creates an edge, regardless of its calligraphic or other properties, is understood as denoting planes seen in full foreshortening, as when a calling card is held in such a way as to reduce it to a line.

This is true whether the drawing consists mainly of contour, as in Figures 3.10 and 3.19, or is densely filled with lines, as are Figures 3.5 and 3.6. Only in drawings that avoid or subdue a sense of edge, as do Figures 3.25 and 3.38, is the issue of form-revealing delineation absent. And even there, despite the negation of a continuous contour, edge as *turning form* is implied.

The tradition of drawings that rely mainly on form-revealing contour dates back to the prehistoric cave artists of France and Spain. In Eastern art the contour line has always prevailed. In Europe the emphasis on contour through use of sharply "focused" line of a continuous nature was a dominant graphic device until the late Renaissance. Contour drawing remains a universally popular means of graphic expression because of its ability to economically state volumetric impressions of a form at its edges and even suggest conditions of the form's terrain well within its edges.

Still, contour drawing is not another attitudinal category of line but, as was mentioned earlier, is an "adopted" function of any of the line qualities already discussed. As such, its function tends to set it apart. For example, in da Vinci's drawing (Figure 3.5) the contours are essentially structural in character, but by their running at a right angle to many of the hatched lines that model the form, and by their continuity, we recognize their somewhat independent nature. That such an independence of contour can be modified is evident in the structural lines of Cézanne's *Card Player* (Figure 3.7).

For beginners, drawings restricted to volume-revealing contours help them see the often complex state of a subject's edges with height-

ened objectivity. Such drawings encourage conscientiousness in the efforts required to "track" the condition of edges, similar to the kind of searching explored in Exercise 2A in Chapter 2. However, here the lines are understood to represent planes in space as seen in total foreshortening and not just the limits of a shape.

Whether or not delineation becomes an unselective tracing of edges—a kind of fussy scrutiny—depends on the artist's ability to recognize what is essential to the impression of volume and what is irrelevant or detrimental to it. Ingres' drawing (Figure 3.38) is a quite faithful denoting of his subject, but not slavish imitation. His choices and changes make each delineating line reveal volume. Also, Ingres is sensitive to the

Figure 3.38
JEAN-AUGUSTE DOMINIQUE INGRES (1780–1867)
Portrait of Madame Hayard (ca. 1812)
Graphite on white wove paper. 226 × 180 mm.
Courtesy of The Fogg Art Museum, Harvard University,
Cambridge, Mass.
Bequest of Meta and Paul J.Sachs

rhythmic flow that organic forms possess, and his line includes that graceful rhythm among the parts. Ingres' drawings have a knowing ease that looks deceptively simple. Far from merely copying, Ingres, despite his close adherence to the subject's actualities, developed a style of delineation so distinct that his drawings are easily recognizable.

Exercise 3B provides some suggestions for delineating contours that will help you experience line as edge *and* volume-maker.

exercise 3B

MATERIALS: Any kind of pen or soft grade of pencil and a sheet of good quality bond or vellum paper, approximately 18 × 24 inches.

SUBJECT: One or more mechanical or manufactured objects that offer an interesting collection of shapes and forms—gears, wheels, cylinders, pipes, or anything else that you would find interesting and challenging to draw. A lawn mower, an eggbeater, or a

bicycle will work well, as will parts of discarded engines or carved furniture.

PROCEDURE: This drawing requires your sharpest perceptual commitment—not for purposes of imitation, but to analyze and understand the volumes you will be delineating. This being the case, try to favor a structural attitude to line. As such drawing becomes more familiar to you, it will reveal your own calligraphic idiosyncrasies about contour. Ingres' drawing shows his "recipe" of structural-calligraphic qualities. Diagrammatic themes being often too schematic, and expressive themes too little concerned with objective analysis, most contour drawings show a blend of structural and calligraphic interests.

Arrange your subject so that parts overlap. This time do not make a gesture drawing, but begin by sighting on some edge of your subject and, drawing in a large scale (where possible, close to actual size), *slowly* follow the edge with a single, continuous line. Lift your drawing tool as seldom as possible, and take all the time you need to complete this exercise. Regard your line to be recording the edges of planes. Because your line helps to explain a form's direction in the spatial field, try to feel the line moving in and out of space as it follows an edge, as in Figure 3.39, which is

Figure 3.39 (*student drawing*)
Dennis Sopczynski, University of Indiana at South Bend
Graphite pencil. 18 × 24 in.

Figure 3.40

somewhat related to the nature of this exercise. By increasing and decreasing pressure on your drawing instrument, you can vary the value and weight of lines to help suggest a form's near and far parts. Additionally, such variations help suggest whether an edge is rounded or not. Thinner, lighter, and/or less sharply incisive lines suggest the edges of rounded forms; heavier, darker, and/or more sharply "focused" lines indicate the edges of flat planes. Do not use lines to suggest values.

Ideally, you should not lift your drawing tool more than seven or eight times during the entire exercise. However, do not hesitate to do so more often if you find this restriction too limiting; or less often, if you can. While most artists do not restrict their contour line in this way, here it will help to increase your awareness of delineation as a distinct graphic activity with its own dynamic potential. A line can be kept going by continuing to find "routes" for it to take. Often, a line, having reached a dead end, can be made to continue by backtracking. Just draw your line (as slowly and as well observed) along the same edge it came up, until you find some way out (Figure 3.40).

As you draw, you will notice that some lines begun at a form's edge have moved into its interior, as may happen with an object such as a spiral-shaped chair leg. Follow such edges with an awareness of their

coming toward and moving away from you. Each time a spiraling edge turns away and out of view, continue your line on the new edge that blocked your view—but recognize that doing this means leaving a form at one level in space to "hop" to another one located nearer to you. Sometimes an edge turns inward—"dies out." When this occurs you can either reverse your line to get back to the outer edge of the form or "legitimately" begin a new line (Figure 3.40).

In contour drawing you will find that the angle of interception of one line by another—the impression of space and volume resulting from perspective principles (see Chapter 5)—is as important as are particular changes along a form's edge. Perspective is a factor in all volumetric drawing, but drawings that rely on contour lines to communicate several kinds of information require the artist to be especially sensitive to the direction of edges in space. Part of the impact of such lines is in being "right" the first time.

The slower the line, the more you will see. Avoid the natural tendency to speed up the line. Doing so usually results in drawing uncertain generalities to represent intricate or subtle passages in the subject. Here your attitude should be "the more difficult or subtle the passage, the more committed my perceptual skills will be to changes and overlappings of edges." An extreme example of this attitude would be

to draw every strand of spaghetti in a dish, just as you see them, avoiding none of their coiled, interlaced complexities. One of the frequent pitfalls for the beginner is to relax his or her perceptual powers when confronting a complex or unusual subject. Just at that critical moment, where continued or even intensified efforts to analyze would cause the breakthrough to the understanding necessary for the control of a demanding passage, there is a retreat to vague generality. Known as "lazy vision," this turning away from visual challenges must always be guarded against.

In this drawing, do not worry about proportions which may be awry or about poor organization. You are extracting one idea only: "Here is what I found about the volumetric properties of my subject that were capable of being stated in a few continuous lines."

Other concepts and uses of line are dealt with in Chapters 9 and 10. While our interest has been focused here on the properties and responsive possibilities of line, we should remember that its unseen presence abounds in everything we see. In Chapter 1 we sensed, in the search for gestural expression, some of the linear forces that forms generate by their direction and rhythms. This sense of directional energy—of "pathways"—moving through a subject, should be permitted to influence all uses of line. We are always aware of directional force, a kind of "invisible" line, even when it runs through several forms, as when we speak of furniture "lined up" or an arm "aligned" with a leg, or when several linear directions form a discernible pattern such as the lifting upward and outward of tree branches from their origin in the trunk. Adding such "felt" lines to the line considerations already discussed, we recognize line's powerful role in the acts of perceiving *and* drawing. We must also recognize that it is inquiry, empathy, economy, and invention, not the desire to imitate nature, that is at the heart of a knowing use of line.

4

VALUE

light, local tone, and mood

A DEFINITION

A children's riddle asks what the subject of a black sheet of paper is. The answer: a coal miner with no headlamp, in a mine at midnight. Why not? A black surface *can* be imagined to be anything—in itself, it *is* nothing. A coal miner *with* a headlamp—and there is no riddle. Forms in nature, as even the children who ask the riddle know, are revealed by light. In drawing, the impression of volume and light is conveyed by values.

If line is the basic visual element in drawing, value is next in importance. Indeed, it is through the use of these two basic elements that the elements of shape, texture, mass, and space are created. And if one of line's chief uses is to delineate, to set boundaries, then value's domain is often within such boundaries. We might think of line as the tool often used to chart a subject's geographical limits (although as we saw

in the previous chapter, it does far more than that), and of value as the tool more often used to explain a subject's terrain and atmosphere.

Values, the many differing tones between white and black, can be produced in just two ways: (1) by variously hatched lines creating optical grays, that is, impressions of value resulting from the collective tone of massed lines, their value resulting from the density of the hatching; and (2) by deposits of actual gray tone by chalk, pencil, or diluted washes of ink or paint.

The use of massed lines to model forms provides important information about their planes and therefore helps us to see the structural aspects of volumes (see Chapter 6). But the application of actual gray tones has its own versatile uses, as we shall see.

Value, whether of massed (usually structural) lines, broad strokes, or washes, is the nec-

essary and (except for color) the only tool for modeling form with light. It gives the artist the means of showing subtle changes in a form's surface-state, and it helps clarify the relative distance between forms. Value also conveys the inherent lightness or darkness of a form—its *local tone*. This is a given quality of all forms. It is affected by, but separate from, the light and dark areas that result from light falling on forms. The local tone is the intrinsic value of a thing—excluding any effects of light. The local tone of a common pearl is very nearly white; that of a lump of coal, nearly black. If we use the value scale described in Chapter 2, the pearl's local tone is about a 10 percent value, the lump of coal's, about 90 percent. Light falling on both would make them lighter and darker in places, but under most lighting conditions the darkest value on the pearl will not be as dark as the lightest value on the coal. Light is incidental to local tone. Values, then, enable us to state a subject's intrinsic *and* incidental tonalities (Figure 4.1).

Values can also suggest expressive meanings. How we contrast, shape, and distribute values, and the amount and manner of tonal changes among them, are potent factors in a drawing's psychological mood. In the powerful seventeenth-century drawing of a triumphant general (Figure 4.2), the amount and manner of application and the bold contrast of values between the configuration and the page suggest strength and grandeur. The forward part of the horse and rider "burst" through the splashy field of tone, asserting aggressive energy. The shapes of the tones, their spontaneous application, only loosely confined by the lines, further signify powerful force.

Like line and shape, value is a versatile compositional tool. Value can increase attention to a form's direction, weight, or importance; it creates visual diversity but also serves as a strong unifying agent.

Unfortunately, most beginners seldom use values. Partly because of a universal tendency to regard drawing as a process limited to line, and partly because of its seeming complexity, they restrict their responsive options by the avoidance of value. When introduced to value, many

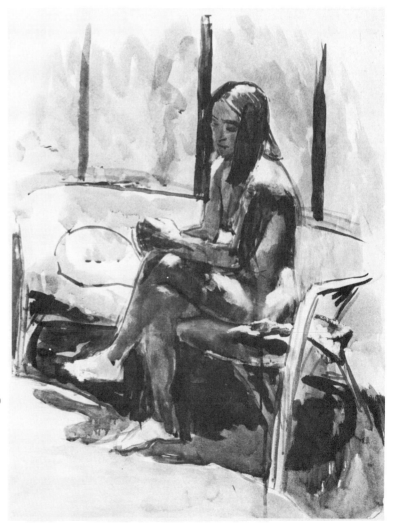

Figure 4.1
DOMENIC CRETARA (1946–)
Seated Nude Figure (1981)
Oil on paper. 20 × 16 in.
Courtesy of the artist

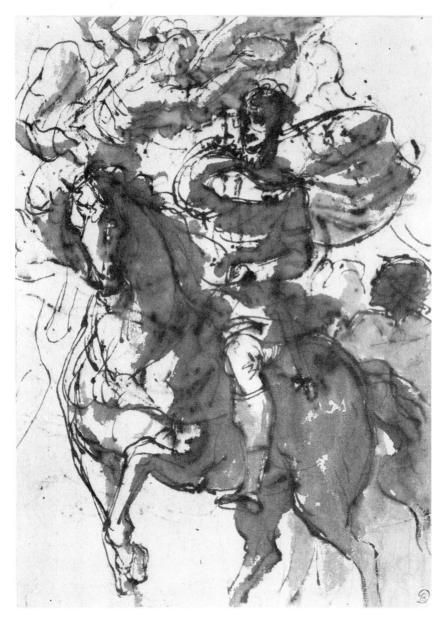

Figure 4.2
Italian, 17th Century, Venetian School
Triumphant General Crowned by a Flying Figure
Pen and brown wash on white paper. 10¾ × 7¾ in.
Courtesy of Fogg Art Museum, Harvard University,
Cambridge, Mass.
Bequests of Meta and Paul J. Sachs

beginners are uneasy about drawing large or dark tones. They are afraid that such areas will be hard to manage—or to remove—that they will surely "mess up" the drawing. These are understandable concerns. But once value's functions are understood, it is often quickly adopted and soon controlled. How soon and how well depends on how soon and how well they understand the several functions of and approaches to value. Drawing with line alone—freely selected as a mode of graphic expression—is excellent, but when drawings are restricted to line because of innocence or fear, it is a regrettable limitation. Value provides the only means to convey a broad range of responses which must otherwise remain unstated.

THE DISGUISES OF VALUE

Our world is a collection of colored forms in space. A lake is seen as blue, not as a value of 50 or 60 degrees; grass is green—its value not usually a conscious consideration. Beginners, if they are painting a lemon and a plum, are generally more aware of their color than of their inherent local tone. They may paint the lemon yellow and the plum purple, but their color choices may be lighter or darker *in value* than those of the fruits. If they are making a tonal drawing with, say, charcoal or pencil, they will of course disregard the subject's colors. But often they will also disregard the values inherent in the colors, neglecting to extract their local tone. Instead, they may draw the differing values or *value variations* resulting from light striking the subject, as if the lemon and plum were actually white. If they do try to show their local tone, it will often be at the cost of the value variations. Establishing a subject's value variations in the context of its local tones is not likely before students see the difference between these two aspects of the subject's value-state. For them, color disguises local tone. Or, seeing it, color adds to their confusion in attempting to sort out a form's inherent values and those produced by light.

The basic skill of tonal drawing is the transposing of colored forms and the light upon them into values. However, unlike the camera, which records the values of illuminated, colored forms, the student can and must make selections from, and changes in, the observed values, for light can *distort* as well as explain both local tone and value variations.

Texture can also disguise both given and light-induced values. What we mean here by texture is the character of depicted surfaces and of the media used to draw them. When a surface has a pronounced, all-over tactile quality, such as a tree trunk or silk, when it has qualities inherent in its physical composition, such as a calm or stormy sea, or when a surface results from the proximity of many small forms, such as leaves or the threads of a lace collar—the visual activity thus generated can be regarded as texture.

Texture also defines value and color changes of either a patterned or random nature in a form's surface. A plaid shirt, a tiger's stripes, and the markings of a marble slab are examples of nontactile textures. The term also includes groups of forms when they activate a large area such as a table top or a field. A display of dishes, a herd of

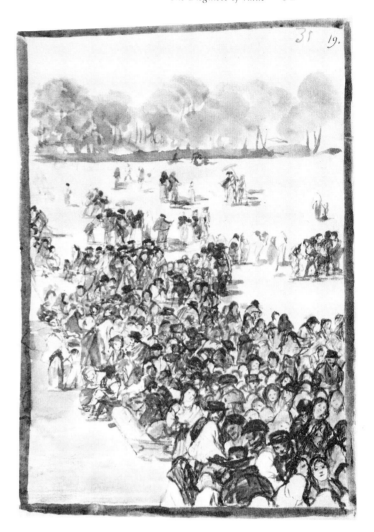

Figure 4.3
FRANCISCO DE GOYA (1746–1828)
Crowd in a Park
Brush and brown wash. 8⅛ × 5⅝ in.
The Metropolitan Museum of Art
Harris Brisbane Dick Fund, 1935

cattle, a crowd at a rally as in Goya's drawing *Crowd in a Park* (Figure 4.3)—all these can be seen as textures.

Additionally, all drawings show the texture inherent in the medium used and in the way it is used. For example, the given texture of chalk markings is grainy and rough; but the stippling, hatching, or smudging uses of chalk, while never losing their grainy character, can suggest many other textures. In Figure 4.4 the rough grain of chalk does not intrude on the delicate texture of the water's surface or the various textures of the surrounding foliage. Even the grain

Figure 4.4 (*student drawing*)
Janet Kahn, private study
Charcoal. 18 × 24 in.

or *tooth* of the surface drawn on reveals its texture by the way a medium acts upon it. As an example, compare the texture of the chalk's behavior on the smooth paper used for Figure 2.15 with the texture of the chalk in Figure 4.4, or in Seurat's *Sleeping Man* (Figure 4.5).

The texture of some subjects, like a tree with a deeply rutted trunk, or a shrub with its countless leaves catching the light from many angles, produces such an array of values that it is difficult to judge either the subject's local tone or the behavior of the light striking it. Other subjects are so boldly textured that they cannot be reduced to a single local tone. A chessboard, a zebra, a boldly patterned wallpaper or flag—or anything else that has striking and frequent contrasts in color or texture—inherently possesses two or more local tones.

But if an intense light illuminates part of such a surface, leaving the remainder in a pronounced shadow, the surface's tonal differences are made subordinate to the strong contrast of light and shadow upon it. In Figure 4.6A a strong light strikes half a chessboard, unifying the alter-nating light and dark squares of the illuminated part into a pair of values lighter in contrast to the light and dark values of the unlit part. Here the intense light unifies the two local tones of the board by showing their differences to be less great than the contrast between the lit and unlit halves of the board. But this is achieved at the cost of seeing the chessboard as split into two halves. In Figure 4.6B, the contrast occurs less abruptly than in 4.6A, resulting in a more unified image, without losing the impression of a strongly lighted board.

The textures that result from a covering of smaller forms or effects upon an unchanging background tone, such as cattle in a field, markings on a marble slab, or polka dots on a scarf, often make it difficult to judge the tone of the background. This is easier to do if we temporarily disregard the smaller "interruptions" to concentrate on estimating the background's tone. Once the ground tone is established, the values of the smaller, figure units can be better judged in relation to it.

Before such demanding differentiations can

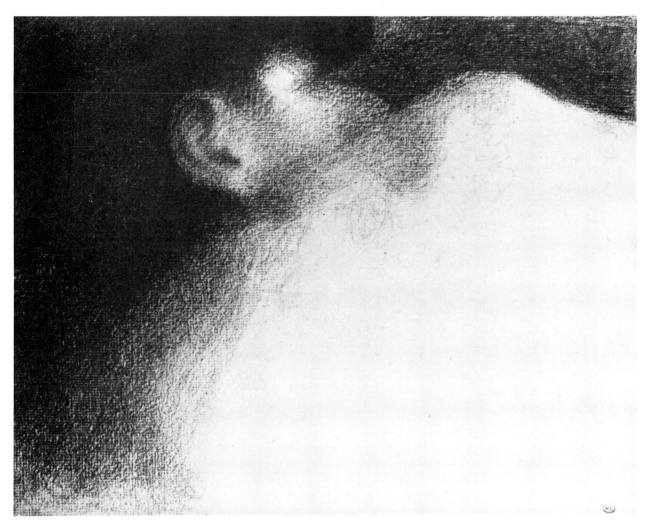

Figure 4.5
GEORGES SEURAT (1859–1891)
Sleeping Man
Black chalk. 24 × 30.8 cm.
The Louvre Museum

A

B

Figure 4.6

be made, we must experience the controlling of values as they relate to each other in some ordered scale. Being able to see and to govern such value relationships as discussed above is fundamental to responsive drawing. Exercise 4A suggests how this skill may be practiced and developed.

exercise 4A

MATERIALS: A good grade of bond paper, a ruler, and three pencils: a 2H, which makes a rather light gray tone; a 2B, which makes a moderately soft, deeper tone; and a 6B, which makes a deep, velvety gray-black tone.

SUBJECT: Value charts.

PROCEDURE: Using the 2H pencil, rule a horizontal rectangle one inch high and eight inches wide. Divide the rectangle into eight squares by drawing lines at one-inch intervals.

Make eight values progress in even "jumps" from white to black (or as near to black as the 6B pencil permits). The first square on the left will be the white of the paper. Fill the second square with an *even*, light tone. Use the 2H pencil for the first few squares, darkening them as needed with the 2B pencil. For the next few squares, the 2B pencil, used with increasing pressure, will be needed. Where necessary, combine it with the 6B pencil to establish darker tones. The last squares may require the softest pencil only, but use all three in any way that helps you achieve evenly darkening tones.

In choosing the first light tone to put beside the white square on the far left, remember that you need to make five more value jumps before you reach the nearly black square on the right. All eight squares must show *the same degree of difference between values*. If you make the first tone too light, the small difference in tone between it and the white square to its left sets the degree of value difference between all the values to come. Because the goal here is to have the eight values progress evenly on the value scale—with white zero and black 100—starting at the left, each square must be just over 12 degrees darker than the one on its left. In Figure 4.7 there are intentional errors in the eight values shown. These cause some squares to be too greatly separated in value from neighboring squares, while others are too close in value. Avoid such blending as occurs between squares 3 and 4, and such splits as occur between squares 4 and 5. Draw each tone evenly, permitting no value changes *within* a square. By placing lines close together in one direction, or by crosshatching and varying the pressure on your pencil, you can produce a uniform value of any degree.

When completed, this chart should be studied from a distance of nine or ten feet. Are there any sudden breaks in the value changes? Are any values so similar that they seem to blend at this distance? Do the values on the left side seem grouped together and split off from the values on the right? Are the values from left to right so light that they seem to drop off to black too suddenly? Check to see if any of the tones, *including white and black,* break the even progression of the values. In making any adjustments in these tones, you may find that changing one often requires changing one or more of the others.

In deciding whether or not your exercise is successful, you will be making judgments about its tonal organization, its *tonal order.* Evaluating the tonal order here—weighing the differences between degrees of value—is similar to the way values in an observed subject are assessed. Then, too, we want to see the range and relationships of the values. If our goal is to reproduce the tonal order of a subject, we must study our drawing to search for false notes—for faulty tonal judgments.

Try some variations of this chart. Here are a few suggestions:

1. Draw a ten-square value chart. Here the value changes will be subtler, their differences more critical.

2. Draw a ten-square chart using pen and ink. The true black now possible makes it somewhat easier to show ten different values, but the inability to lighten any tone makes establishing an even pace of tones more difficult. Producing unvaried squares of tone in pen and ink is likewise more difficult than in pencil, especially in the lighter values, where dots will have to replace lines.

3. Make another one-inch by eight-inch rectangle, but do not divide it into squares. Using your three pencils, make a *gradual and unbroken* progression from white to black. Here, the tone continuously grows

Figure 4.7

darker as it moves to the right. On the rectangle's far left, some white paper should remain to establish the scale's zero. Placed at a ten-foot distance, the values should flow evenly from white to black.

4. Mix eight to ten gray tones using any opaque, water-based paint, then reproduce these tones in pencil. The painted tones need not be lined up in any progression but can be used to create a small two-dimensional painting of clearly defined shapes. In this way, along with the challenge of perceiving the values of another medium, you can, in your pencil version, practice seeing shape actualities.

5. Cut out of magazines, construction paper, and the like ten or twelve evenly colored one-inch squares. Past them down in a row according to their *value*, with the darkest color on the far right. Seeing the difference between a light blue and a bright orange is a demanding test of your ability to disregard a color's hue and extract its value. When this chart is completed, draw another row of one-inch squares directly below it and, using pencils, match the value of each color in the square below it.

In Chapter 2 we saw that sorting a subject's values into two-, three-, or four-value divisions enables us to see the general distribution of a drawing's values in its early stages. Establishing these major value groupings *before* we draw the smaller, specific ones that constitute them will reduce the possibility of destroying the tonal character of an area—whether that character is the result mainly of local tones or of illumination. For example, in a drawing of a sunlit interior, a white cat lying in a shadowed, far corner of the room, seen in its value *context*, would be understood to be—not white—but gray. The darker the corner of the room, the darker the value of the cat. It is easier to see the white cat as actually gray if we first search for the major value divisions created by both local tone and light source.

Drawing values sequentially, and with no regard to the tonal order they contribute to, increases the likelihood that prior knowledge (the cat is white) may replace objective visual information.

Color, texture, sequential drawing, and prior knowledge all camouflage value. In order to extract a subject's tonal actualities from the visual factors obscuring them and to avoid attitudes that intrude on such perceptions, we must be able to distinguish between a subject's given and incidental values and to recognize the importance of objective analysis by noting the actual value relationships before us.

THE EFFECTS OF LIGHT ON VOLUME

Just as color and texture can obscure value, so value—as light is distributed upon a form—can obscure our reading of a form's structure. Light can in fact explain, distort, divide, or unite forms. The way light's indifferent behavior is understood determines whether its effects are merely copied or controlled for responsive purposes. A drawing that duplicates the values in a subject will reveal no more than the accidental light does about volume and space. But if light's behavior is understood, the values can be "edited"—selected and altered to more fully disclose the subject's structure and spatial environment. Where the light's behavior explains a form's structure, it can be used; where light confuses or denies structure, it can be changed. In responsive drawing the artist, and not the accidental effects of light, determines what the clarity of the volume will be.

Forms often appear fragmented, are seen as divided into tonal shapes when an intense light casts harsh, dark shadows across their bodies, as we saw in Figure 4.6A. Such shadows can sometimes give us a distorted idea of a form's structure or obscure important structural passages. But a moderate, well-placed light can help reveal and unify complex subject matter. A tree need not be drawn leaf by leaf. Grapes, pebbles, hair, a stadium crowd, or any other subject comprised of small forms can be expressed in a unified way by values that explain the over-all volume to which these small forms contribute.

Until the Renaissance, the manner usually employed for representing small forms was an additive one. Each leaf, grape, or pebble was delineated with roughly equal attention. A clump of leaves, a bunch of grapes, *resulted from* this patient and deliberate accumulation of virtually every member, as in the anonymous Lombard drawing (Figure 4.8), in which each leaf has been carefully drawn in each tree. Here the artist has drawn his conception, rather than his perception, of a tree. As drawing moved toward more objective analysis of the thing observed, sensitivity to the ways volume could be summarized and conveyed also grew. The drawing by Cesare da Sesto (Figure 4.9) goes far beyond the collecting of particulars in suggesting complex masses, and does so by more than line, as in Figure 4.8. Da Sesto, although still giving much individual

Figure 4.8
Anonymous Medieval Drawing
Page from a Lombard Sketchbook
Pen, brush, and ink. 23.9 × 17.1 cm.
The Pierpont Morgan Library, New York

Figure 4.9
CESARE DA SESTO (1480–1521)
Study for a Tree
Pen and ink. 15 × 10⅛ in.
Royal Collection, Windsor Castle

Figure 4.10
NICOLAS POUSSIN (1594–1665)
Trees in a Meadow
Pen and brown ink, brown wash, over black chalk.
24 × 18.1 cm.
The Louvre Museum

attention to particulars, subordinates his attention—especially on the drawing's right side—to individual leaves to show the masses they collectively form. This is achieved by making use of values to suggest light falling on the tree from above and to its right side. The shading of the left side of each branch and of the trunk unify and lend substance to these parts.

Nicolas Poussin's response to trees (Figure 4.10) utilizes the impression of light to emphasize their gesture and mass. Here, individual leaves are only broadly suggested, the emphasis being on their collective texture and mass. In an even broader, more painterly manner, Lorrain's *Landscape with Tree and Figures* (Figure 4.11) uses values to carve the broad planes that the leaves, in their thousands, comprise, and does so by employing a strong light source. Note that in these last four drawings the impression of light and atmosphere increases as values "take over" from line.

Treating whole trees as particulars of a general panorama—a forest—Rothbein (Figure 4.12) orchestrates light to unify the forest's "small" forms, its textures, and even the larger

forms of the hills and valleys. She creates a pulsating light that seems to move across the landscape "pulling together" many small forms and explaining the greater masses they are part of. Here, light is more than the means by which the subject is explained—its pulsations and its mood are as much a part of the subject as the mountain forest it defines.

Also responding to light as both means and subject, Dickinson, in his drawing *Cottage Window* (Figure 4.13), creates a silent, enigmatic scene in which the shadows of part of a house and porch are projected on the wall and window of a cottage, making these "ghosts" of structures that are "off stage" part of the drawing. Likewise, some trees across a broad meadow are seen not directly, but as reflections in the windowpanes. The light casts shadows that ride upon the wall, shutters, window frame, and panes, explaining their volume. In doing this, they create unusual tonal shapes that call attention to the drawing's two-dimensional design. Again in Figure 4.14 we see that such a tonal approach can be an informing and effective means of student inquiry.

Figure 4.11
CLAUDE LORRAIN (1600–1682)
Landscape with Tree and Figures
Pen and bistre wash. 28.5 × 21 cm.
Albertina Museum, Vienna

Figure 4.12
RENEE ROTHBEIN (19–)
Mountain Landscape
Pen and ink. 18 × 27½ in.
Courtesy of the artist

Figure 4.13
EDWIN DICKINSON (1891–1978)
Cottage Window
Charcoal. 10⅞ × 12⅞ in.
Atlanta University, Gift of Mr. and Mrs. Chauncey Waddell

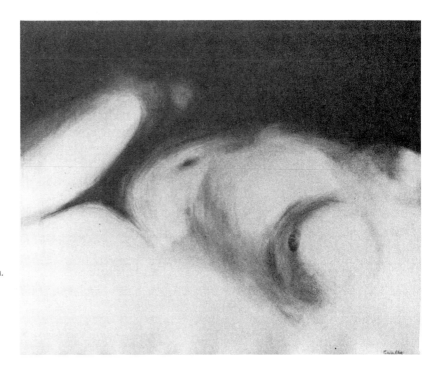

Figure 4.14 (*student drawing*)
Rochelle Allen, Utah State University
Charcoal and conté crayon. 26 × 40 in.

Figure 4.15
REMBRANDT VAN RIJN (1606–1679)
Cottage before a Storm
Pen, brush and ink.
Albertina Museum, Vienna

As the preceding several drawings imply, works in which light is the dominant graphic idea imply a view of our world as existing in darkness—darkness is the norm and light the transitory, revealing exception.

Light, then, not only can be made to explain and unify forms, it can provide important visual and expressive meanings. Rembrandt's *Cottage before a Storm* (Figure 4.15) is a striking example of the power that the impression of light can bestow. What might otherwise have been a pleasant, if ordinary, rural scene is transformed by an extraordinary control of light into a dramatic, even spiritual event. And note how space- and volume-informing are the tones that create this transcendental light.

THE ELEMENTS OF LIGHT

In drawings where values represent light, the value contrasts can denote the forms, the spaces surrounding them, and the shadows they cast.

These contrasts conform to six discernible divisions, regarded here as the *elements of light*. As seen in Figure 4.16, they are:

1. The lightest value on a form, or *highlight*.

2. The next lightest value, or the *light-tone*.

3. The third lightest value, often found on surfaces that parallel the direction of the light rays, or *half-tone*.

4. The darkest value, or *base-tone*.

5. The usually weak light cast upon the side of a form turned away from the light source, *reflected light* results from deflected light rays.

6. The dark tones resulting from the blocking of light rays by solid bodies, or *cast shadows*.

In Figure 4.16 we see that the cast shadow is the one element that does not exist on the sphere. Because of its special projecting nature, a cast shadow behaves uniquely. Often troublesome, the cast shadow *can* effectively reveal the distance between forms and explain the terrain of the form upon which it is cast. It can suggest the location of the light source and the time of

90

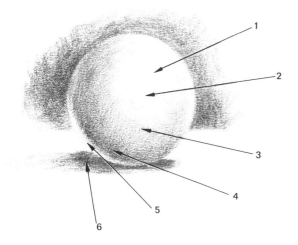

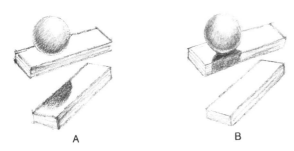

Figure 4.16

Figure 4.17

A B

placement and size of the cast shadow suggest the position of the sphere in its relation to the other two forms. The two drawings are identical, but changing the cast shadow's location and size in each changes the spatial relationship of all three objects.

Cast shadows (as we shall see in Chapter 5) are projected in accordance with the laws of perspective. Their value, scale, and shape tell us the direction and height of the light source, how close it is to the objects casting the shadows, and the nature of the terrain upon which they are cast.

In Figure 4.18 the card in A and B is the same short distance from the wall, but, because the light source is farther from the card in 4.18A, its cast shadow is smaller and darker than the cast shadow in 4.18B. In each illustration we see that the radiating light rays not stopped by the card continue to diverge, leaving unlit shapes on the wall. The cast shadow in 4.18B is larger because the closer the light source is to the object receiving the light, the greater is the degree of divergence of the light rays.

Maintaining the same distance between the light source and the card but placing the card farther from the wall also increases the size of its cast shadow, in relation to the ever-widening cone of light, as in 4.18C. Here, too, the greater distance separating the card from the wall allows more deflected light to illuminate the area of the cast shadow, lightening its value and softening its edges. Tilting the card forward, as in 4.18D causes the cast shadow to tilt backward. There are two reasons for this. First, cast shadows increase in scale as the distance between an illuminated object and the surface receiving such shadows increases, and second, the degree of

day, and it can perform compositional and expressive functions.

Cast shadows help explain spatial relationships. In Figure 4.17A the sphere hovers above the lower of the two boxes. In Figure 4.17B it seems to be located further back in space, resting on the higher box. In both illustrations the

Figure 4.18

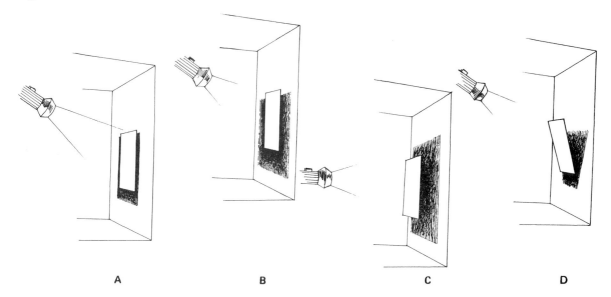

A B C D

divergence of the light rays increases as an object (here, the upper part of the card) approaches the light source.

As these illustrations show, cast shadows always retreat in the direction opposite that of the light source. If we see a form's cast shadow below it, as in 4.18A, B, and D, we know the light falls from above. When the cast shadow falls above the form, we understand the light to come from below. Additionally, should a form's shadow be cast upon an uneven surface, it will "ride" upon and thus explain that surface's topography (Figure 4.19).

Courbet uses cast shadows (Figure 4.20) to help explain the structure of the head, by projecting shadows from one part, such as the nose, upon other parts. Notice how the shadow of the hat reveals the terrain of the right side of the head, and shadows cast by parts of the clothing explain other parts of it.

We see in the strongly contrasted values of Courbet's drawing, in the areas of subtle value variations and in the sense of the subject as existing in an atmosphere of light and space, a presentation of the elements of light used in a manner sometimes called *chiaroscuro* (an Italian term meaning clear and obscure and used in the sense of light and shade). In Leonardo da Vinci's study of drapery (Figure 4.21), the strong but softly graded value contrasts demonstrate chiaroscuro's volume-revealing possibilities. Notice, in this closely observed study, da Vinci's loose, broad manner, used in the earlier stages of the drawing and visible in the upper part of the figure. Also observe that this brush drawing, heightened with white, consists mainly of hatchings that effectively produce subtly graduated value changes. These changes, like those in the Courbet drawing, demonstrate a use of all the elements of light.

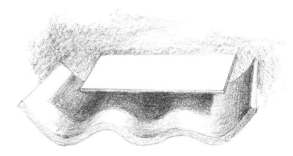

Figure 4.19

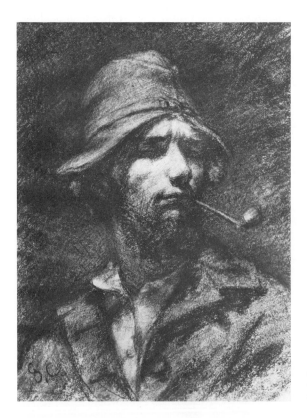

Figure 4.20
GUSTAVE COURBET (1819–1877)
Self-Portrait
Charcoal. 27.7 × 20.3 cm.
Courtesy, Wadsworth Atheneum, Hartford

Figure 4.21
LEONARDO DA VINCI (1452–1519)
Study of Drapery for a Kneeling Figure
Brush and lampblack, heightened with white, on bluish
paper. 21.3 × 15.9 cm.
Royal Collection, Windsor Castle

When an object such as glass or metal reflects light, or has a polished or reflective surface, as when an object is wet, the highlights upon it produce a mirror image of the light source. Highlights on objects with a matte surface denote the small areas where the greatest concentration of light rays strike a form directly. A subject's surface may vary in reflectivity, thus offering both kinds of highlights. This makes it difficult to be sure when a highlight is a reflection of a light source and when it is an intense concentration of nonreflecting light. In the first instance—if volume through value is a goal—it can be omitted, for it is relevant not to volume but rather to surface effects. When a highlight is nonreflective, it should be understood as part of the form's terrain and not as an isolated, bright speck of light. Seeing it as a self-contained, little shape often makes the student treat it as something separate from the form's surface, with the result that it appears to occupy a position in space *in front of* the form's surface. The intrusive nature of reflecting highlights usually warrants their exclusion. And direct highlights are relatively unimportant because they describe only a small area of a form, contributing little. We understand a subject's volume mainly through its major structural character. If the essential structural facts are not clear, highlights cannot contribute enough to make us understand the subject's volume.

We can distinguish whether a highlight is reflected or direct by deciding if it seems to promote a form's surface texture or its structure. To take an extreme example, imagine drawing a large, shining, steel ball bearing. Its mirroring of the light source (actual images of windows, light bulbs, etc.) and the sudden, drastic changes of value inherent in any curved and polished surface, "blind" us to visual cues about its volume. But coat the ball bearing with a matte paint, and the value variations that reveal its volume become visible. If both the volume and surface character of such a form are desired, placing the emphasis on volume first and surface effects second communicates far more of the form's total character than the reverse. In three-dimensional drawing the clarity of a form's volume should precede any facts about its surface characteristics.

Reducing the intensity and clarity of any highlight makes it appear to belong to the form's surface instead of floating above the drawing like

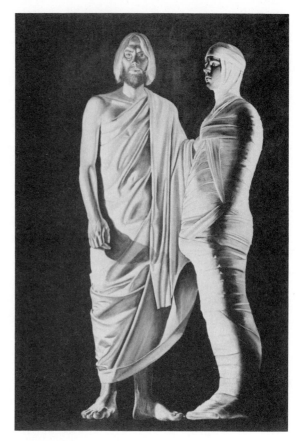

Figure 4.22
ALFRED LESLIE
The Raising of Lazarus (1975)
Oil on canvas. 108 × 72 in.
Bayly Art Museum at the University of Virginia
Photo by Edwin S. Roseberry

a bit of confetti. In general, the attitude to highlights should be: the fewer the better, and the subtler the better.

On rounded forms, the light-tone, half-tone, base-tone, and reflected light will fuse into each other gradually, as in Figure 4.22. On forms composed of flat planes, they may each occupy one or more of the form's planes, as in Figure 4.23. The light-tones are usually found on all planes in positions facing the path of the light rays. Those placed at a right angle to the light's direction will be most intensely illuminated; those turned slightly away, somewhat less so. Light-tone involves the *several* light values of planes located anywhere from a right angle to the light's position just short of one running parallel to the light ray's path. Light-tone, then, is a

term that denotes a small range of values seen as having a general lightness in relation to the half-tone, base-tone, and reflected light. These terms also denote, not a single value, but a small range of values that set them apart as a discernible tonal unit in relation to other tonal units.

The several darker values that constitute the half-tone are, as was mentioned earlier, generally found on planes roughly parallel to the direction of the light rays. Half-tones may sometimes be seen in areas where weak cast shadows reach the lightness of the half-tone range, or in reflected light areas, as in areas A, B, and C of Figure 4.24.

A form's darkest values are located on those planes turned farthest from the path of the light rays or wherever shadows cast by other forms block the light. On a form constructed of flat planes the darkest values are on planes facing in, or closest to the direction opposite the

source of light, as in Figure 4.23. On rounded forms the values of the base-tone are not always found at the edge farthest from the light source but are often located well inside a form's limits (Figures 4.22 and 4.25). This results when light rays, striking nearby surfaces, reflect back to illuminate areas of a form turned away from the direction of the light, or when weak, secondary light sources illuminate those surfaces turned away from the primary light source. The tone of an area illuminated by reflected light is determined by the intensity of the light source, the local tone of the nearby, reflecting surfaces, and the local tone and texture of the form itself; but is almost always darker than the light-tones and usually darker than the half-tones. The weak reflectivity of most surfaces greatly reduces the original light ray's intensity. Often, the reflected light is barely perceptible. A form on a black drape will produce a far weaker reflected light

Figure 4.23

Figure 4.24

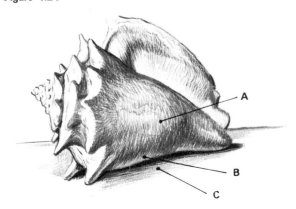

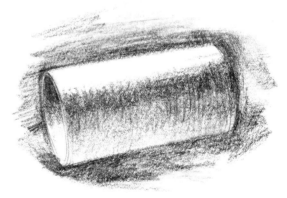

Figure 4.25

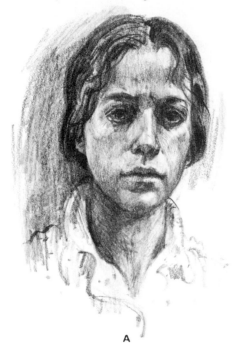

A

B

Figure 4.26

than the same form upon a white drape, and a weaker one still if the form itself is a dark one, if it has a matte rather than a shiny surface, or if the surrounding forms reflecting the light are located some distance away.

Reflected lights, like highlights, are generally more convincingly shown when only subtly suggested. Overstating reflected lights sometimes produces gaudy effects. At its most extreme, reflected light (or a second, opposing light source) is heightened to the value of the light-tones, leaving a band of base-tone to run along a form's long axis or along any pronounced ridge formed by planes abutting at strong angles.

Often, a form's base-tone is not quite as dark as a shadow cast upon it by some nearby form. This difference in tone is due to the reflecting light rays being more easily able to strike those surfaces of a form turned away from the light than the more sheltered area of the cast shadow.

These six elements of light can reinforce, but not replace, visual comprehension of a subject's structure. Analysis and intent, not an automatic dependence on a fixed system, should determine how these elements are used. The way values change in a drawing determines how we

see the subject's structure. As we saw in Figure 4.23, abrupt changes in value suggest angular terrain; gradual changes, rounded terrain. But the form of some subjects permits us to interpret their structure as reducible to either flat or curved planar units. In Figure 4.26A, the modeling of the woman's head relies mainly on curved planes; in Figure 4.26B, on flat ones. The gradual fusing of tones in Figure 4.26A enhances the sense of volume more than do the abrupt value changes in Figure 4.26B, for two reasons. First, we are conditioned to expect gradual tonal changes on rounded forms. Second, because we are less conscious of the shape-state of gradual tones, we tend to be less aware of their picture-plane existence—of their two-dimensional life. But in Figure 4.26B we are at least obliquely aware of the shape-state of the black and white divisions.

Where intentional emphasis on the shapes of tones is desired, avoiding gradual transitions of tone helps to convey both two- and three-dimensional impressions. In the vigorous drawing by Matisse (Figure 4.27), this strategy helps to manifest both a woman and a powerful dynamic event—these interdependent states together are the subject.

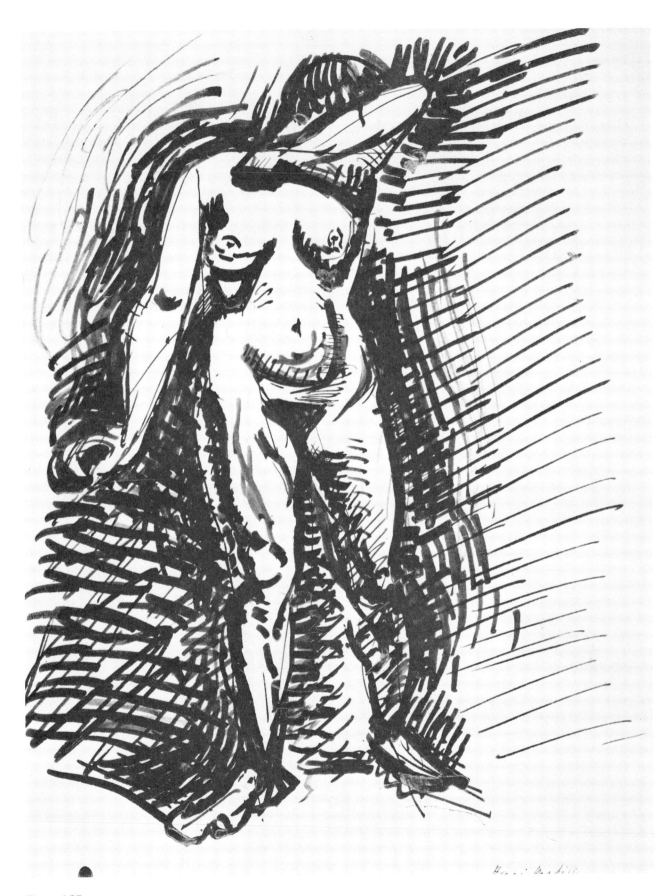

Figure 4.27
HENRI MATISSE (1869–1954)
Figure Study (c. 1907)
Brush and ink. 10⅜ × 8 in.
Collection, The Museum of Modern Art, New York. Gift of
Edward Steichen

97

"LOST AND FOUND"

In some drawings, such as Figures 4.13 and 4.20, some forms are intentionally left vague or largely hidden in shadow or dark tones that swallow up details. These devices are used in Seurat's drawing *Seated Woman* (Figure 4.28) to create a stately and timeless image. Forms emerge from and dissolve into values, their essential masses never altogether hidden by the drawing's "foggy" tonalities. Seurat shows little of the traditional chiaroscuro devices within a volume. His interest is in forming an image bathed in a vaporous atmosphere. A gentle haze envelops the figure, unifying it. Forms lose themselves in each other in the same way as the figure begins to dissolve into the surroundings. Yet the figure appears to be almost monumental. Had Seurat

Figure 4.28
GEORGES SEURAT (1859–1891)
Seated Woman (1884–85)
Conté crayon. 18⅞ × 12⅜ in.
Collection, The Museum of Modern Art, New York
Abby Aldrich Rockefeller Bequest

clearly focused the figure's edges, it would have looked silhouetted and flat. As he drew it, it exists in space, has volume and weight, and even seems to be illuminated. But note the sharply focused edge of the woman's back and the pronounced value contrast between it and the background. The visual "relief" provided by these departures from the drawing's "softer" handling provides strength and stability, keeping the drawing from seeming merely weak and unfocused. The impression of the torso rising like a pillar is made stronger *because* other edges and value contrasts are less forceful. This visual "crescendo"—the figure's granduer and strength— depends on the state of edges and values *throughout* the drawing. It is like the crescendos of sound in symphonies, which are created partly by the quieter passages that surround them.

Katzman, in his *Portrait of John Bageris* (Figure 4.29), loses edges and form clarity in the figure's lower portion in order to amplify the dramatic potency of the figure's stance and the assertive character of the head. Note how engagingly Katzman simplifies these forms. He finds strong shapes of tone that interact at the dynamic level with the same vitality that he intends for the figure. As the drawing's thrust moves upward and structural clues emerge from the shapes, the form complexities of the hands, the left arm, and the upper body are engagingly simplified into a few, telling planes.

In Figure 4.30, an unseen light source provides the motive for lost and found edges that adds to the drawing's dramatic quality. Notice that this richly tonal work is conceived by four main values, as described in Exercise 2C.

The use of values to suggest forms modeled by light and the tactic of losing and finding edges and forms provide versatile graphic devices. The following exercise suggests some general modes of approach to these uses of value.

Figure 4.29
HERBERT KATZMAN (1923–)
Portrait of John Bageris (1974)
Sepia chalk. 96 × 42 in.
University Gallery, University of Minnesota, Minneapolis, gift of The American Academy of Arts and Letters, 1976

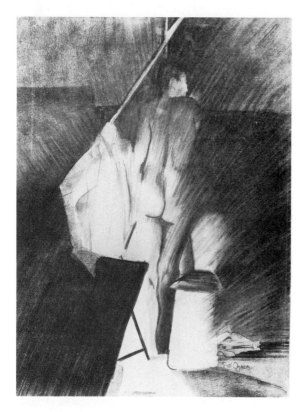

Figure 4.30 (*student drawing*)
Scott Ogden, Denver University
Compressed charcoal. 18 × 24 in.

exercise 4B

This exercise consists of three drawings. Because it is important to go as far as you can in developing the impression of illuminated volumes, none of these drawings has a time limit.

MATERIALS: Soft, medium, and hard vine-charcoal sticks or charcoal pencils, and a white charcoal or pastel paper of good quality; kneaded eraser and paper blending stump.

SUBJECT: Arrange a simple still life, illuminated by a single light source, preferably a north light. Use no more than four or five objects on a table top. Avoid large, complicated objects or those made of highly reflective materials. Select simple, bulky objects. Unglazed pottery and objects made of wood or paper, such as salad bowls or books, are usable. Shoes, mittens, hats, and handbags make interesting subjects—even the boxes they are stored in are usable (unless their surfaces are decoratively "busy," or covered with lettering or illustrations). Fruits and vegetables provide a variety of simple forms useful for the first drawing.

PROCEDURE: For all three drawings use the media listed above in any combination. As you draw, try to keep erasures to a minimum. Ideally, all the tones in the first drawing should be made of variously hatched lines. Where a particular tone or texture cannot be produced this way, some moderate adjusting of these hatchings by a kneaded eraser or a paper blending stump, called a tortillon, may be used. But blend and erase only as a last resort; both tend to weaken a drawing's freshness and promote a concern with unimportant details. In the second and third drawings, erasing and blending will be necessary at times to produce the impression of light. Then, they will be given a useful graphic role.

Draw as close to actual size as your still-life objects will permit. It is not necessary here to include all parts of each of the objects or the surface they are on. They can be allowed to run off the paper on any or all four sides.

drawing 1 Concentrate on the single experience of modeling the form by the value variations upon it, and by values you select when the light does not adequately explain the terrain. Here, disregard all local tones—assume everything in the still life to be *white.* With this in mind, begin with a lightly drawn search for gesture and for the shape, scale, direction, and location of the subject's parts. Once you have established a light, rough drawing (much of it may be linear, but avoid emphasizing edges), place the several values of the light-tone in every part of the drawing where planes face the direction of the light source. Avoid the "coloring book syndrome"—do not make an outline drawing of each part of the subject to fill in with tones. Line's temporary appearance at the outset (almost all the line will be absorbed into the drawing's various tones) quickly and economically establishes some basic structural relationships that assist the realization of volume as it is revealed by light. It should not be relied on to do more than help you get the drawing underway.

As you draw in the light-tone, also place it in *all* other areas of the drawing where your observations of the still life show darker tones to be (Figure 4.31). Except for any small areas intended to represent highlights, this will mean covering the entire drawing with light-tone.

Figure 4.31

Continue by placing the half-tones in *their* observed locations. Again, also place *it* in all areas judged to be darker than the actual half-tone areas. Next, place the base-tones in *their* observed locations only. Now place any darker values as might occur in some cast shadows or in small crevices between forms. Because you have been drawing tones on all but the highlight areas (if any), the reflected light areas (if any) are now toned. Adjust any reflected lights to their correct relationship with the other values of the drawing.

Remember that the entire subject is being regarded as white in local tone, so a half-tone of say, an egg, will have the same value as say, a black shoe. This absence of local tones will require you to make tonal judgments based on the position of planes in relation to the direction of light. Do not merely follow the subject's value actualities. Here, the information that light provides is of interest to us for structural reasons.

When the still life has been drawn as a system of more or less flat value shapes, begin to "carve" at the borders between values where transitional tones are needed to "turn" the forms. Stress the nature of the gradual or sudden turning that occurs between the planes these shapes represent, by modeling with groups of structural lines that sculpt the forms at these planar junctions.

As you model the form, the sense of value shapes will recede and the impression of planes forming volumes in space will emerge. Try to feel the weight and mass of each form you draw.

Make any changes in value that help explain a form's volume when the light fails to reveal the planar activity you know is there. Sometimes the light strikes a surface from an angle that does not distinguish its planar differences. Such changes in the terrain may actually be difficult to see because of the sameness of the light. Coming nearer to the subject or seeing it from another angle will help you see the planar state of poorly illuminated parts. To clarify the topography of such passages, you will need to expand the tonal range. The value differences needed to show the terrain in these "blank" areas must then be strong enough to perform their modeling function and subtle enough to stay within the value range of the passage in question. If, for example, you wish to explain the planar construction in an area of say, half-tone light, imagine a weak, secondary light raking across the planes in the blank area. Direct this second light from whichever angle would best reveal the various tilts and turnings of the planes.

The background can be handled more independently. Its main function here is to provide tonal contrasts for the objects in the still life. In places it can freely but subtly change value to be lighter than a form against its dark side and darker than the form on its light side, as in Figure 4.32.

Because you have been using light *and* structural analysis to explain volume, the completed drawing

Figure 4.32

should convey the impression of light revealing convincingly constructed masses.

drawing 2 Begin by using the same still-life objects in some rearranged order, but now the values you draw should first record each object's local tone. Where an object cannot be reduced to a single local tone, draw the two or more necessary to establish its inherent tonal character.

Draw the local tones as flat areas whose limits determine the various shapes of your subject. These local tones are not volume-producing values—they merely state the object's particular lightness or darkness independent of the light conditions. They can be drawn in any broad, simple way. Here, blending or working with the kneaded eraser may help produce just the degree of value you want. Except for the few, brief notations in line to get your drawing underway, line, in the sense of contour or calligraphic handling, is not needed in this drawing. But structural line groups functioning as values will be extensively used to model the forms. The boundaries of volumes should be conveyed by the values that form the volumes. Surrounding tonally expressed forms with an outline is visually redundant—it suggests a mistrust of value's ability to establish form or edges.

Keep relating the local tone of all the subject's parts. As you draw one local tone, judge its value in relation to others far from it in the still life, as well as those nearby. If your still life contains similar objects, such as two apples, see if any value differences exist between their local tones. Such differences, however slight, should be stated. It is often helpful to establish the subject's lightest and darkest local tones early in the drawing. They serve as tonal "brackets"—all other local tones are then more easily judged against these two extremes.

Be sure what you draw *is* the local tone of an object, and not the effects of light and shade upon it. If an object possessing a light local tone is observed in deep shadow, its local tone should be drawn, not its darkened state—not yet. Once you have drawn all the subject's local tones in relation to each other, you can turn your attention to the modifications of the local tones that light striking volume produces.

Two kinds of tonal change should now occur: those that convey the impression of light coming from a specific direction to strike various surfaces and those that convey volumetric information about parts of an object when the light fails to do so. Both types of change may require you to lighten as well as darken parts (or all) of every local tone. Making charcoal lines or tones lighter is best accomplished with a kneaded eraser, which can be shaped to make fine points that enable you to make a kind of "negative" hatching— white or gray lines in areas of dark tone.

The first of these changes, in which light rays explain volume, may require that some local tones be darkened entirely. If a light-toned form is located entirely inside an area of diminished light that results from a cast shadow, all its surfaces will obviously be much darker than its local tone. But to have drawn this darker tone earlier would have complicated the search for local tones by including responses to the effects of light on form. Here you want to experience value's several roles in a more isolated way. However, many artists do in fact omit the study of the local tones of objects, drawing the observed tonalities of the objects *and* the areas around them instead. That is, they respond to the tonal order of their subject at the outset.

With the local tones established, you should adjust the value of your drawing to set up their tonal order. As you do, another advantage of developing the local tones first becomes evident. It is much easier to see that a local tone is too light or too dark by a particular degree for its counterpart in the subject, and adjust it, than it is to state exactly the right tone upon the white of the page from the start.

At this stage begin, as in the previous drawing, to search for the six elements of light. Again, draw these value divisions with a view to their shape before you begin to model the forms with transitional values.

The major difference between this drawing and the previous one is that each form is now modeled in its own value range—the result of its local tone *and* its position in relation to the light source, as in Figure 4.33. Now, an egg may be light; a black glove, dark. Now, a half-tone in one part of the still life may differ greatly from a half-tone in another. Several dark objects grouped together, or in shadow, may merge their edges. Indeed, you should try to "lose" some edges and forms, and have others stand out in dramatic contrast. You may be surprised at the continuing readability of forms whose clarity you have subdued, and at the sense of atmosphere such tactics promote.

Figure 4.33 (*student drawing*)
Nancy Nabaum, University of Utah
Charcoal. 18 × 24 in.

drawing 3 Coat your paper with a layer of soft or medium vine charcoal. The value of this tone is not critical, but it should not be lighter than a 30-degree, or darker than a 60-degree tone. Extend the tone to the edges of your paper.

Begin this drawing as you did the other two, working from yet another arrangement of the still life. Now, values can be "subtracted" as well as added. With the kneaded eraser, values can be easily removed from the toned surface to give the impression of light striking planes. This removal of tone, of revealing volume the same way light does—by illuminating most those planes turned nearest to the path of the light rays—was not possible in the first drawing, and it had only limited use in the second one. Here, you actually draw the light, as well as the absence of it.

Drawing on a toned and erasable base encourages a fuller involvement with value and often results in more convincing volumes and richer tonal activity. Often, the impression of light striking forms is stronger. Generally, tonal drawings are begun on a white sheet of paper with the move toward tonality always down the value scale. Some students, in this downward progression, never reach the "lower register" of

the value scale. They feel the lighter range of values to be "safer" or more manageable. This hesitancy to use darker values is abetted by the intimidating nature of the page's whiteness. As you start a tonal drawing, any tone, no matter how light, *does* seem to intrude on the purity of the white page. When this feeling restrains the student's progress toward a subject's darker tones, the result is usually similar to a photograph removed too soon from the developing tray—a weak and incomplete suggestion of illuminated volume.

In this drawing, you begin with an overall tone somewhere near the middle of the value scale, with the extremes of black and white roughly equidistant from it. For once, white is not a given condition of the drawing but must be produced by removing tone. When this is the case, you are more likely to recognize that white in most subjects is present only in small amounts, if at all.

Beginning with a toned surface also helps to establish a subject's local tones and the elements of light that model the form. If you begin with an all-over tone that is close to many of the tones in the subject, it is easier to match these by making the minor adjustments required than to reproduce the precise value on the white page.

Once the search for the value shapes has begun, the tone of the page can be altered depending upon the developing still life's tonal order. Advance the entire drawing together. As you study the way the forms affect, and are affected by, the light rays, notice that you can better grasp the behavior of both by viewing your subject both ways. When you concentrate on a form's volumetric character, the light rays can be seen to be interrupted by it; when you fix on the light's path, it can be seen as illuminating planes according to their position in space. In the first instance you identify with the form; in the second, with the light. Doing both gives you a fuller understanding of the nature of the light *and* the volume. Each helps explain the other.

When completed, this drawing may look rather like the second one—the goals in both were the same. But because the common tendency to draw tones too lightly was here circumvented by the tone of the page, your drawing may more clearly approximate the still life's actual tonal order.

Drawings in which light reveals volume should be done at frequent intervals. The demands they make on your perceptual skills increase your ability to see shape, value, scale, direction, and texture, and develop your general sensitivity to structural considerations. Even the ability to make volume-informing "pure" line drawings is improved through tonal drawing. When values are made to carve forms into being, the deeper understanding gained of the ways edges and planes contribute to the impression of volume increases the empathy, economy, and eloquence of lines that delineate.

The drawings in this exercise may suggest other approaches to the study of tonal drawing. The following variations are helpful and may, in turn, suggest others.

variation 1 Draw on a sheet of colored pastel paper, in black and white conté crayons or chalks. Here, forms emerge from the page's *fixed* tone. By varying the pressure on your chalks, you can produce a wide range of tones, the results of optical mixtures with the fixed gray tone. The only "rule" is never to mix the black and white chalks to produce grays. Every value from black to white can be made without doing this. Black and white may appear side by side in the drawing. But all grays should result from black or white being "mixed" with the gray of the page (preferably by hatchings)—not with each other. When a gray identical with the page's tone is required, let the page provide the value, as in Figure 4.34.

variation 2 Start a tonal drawing on a stiff, white support, such as illustration board, using black and white gouache, casein, or acrylic paint. Use the paint thinly to establish the local tones, and continue to develop the forms using black and white conté crayon or chalks. Here, the black and white paint may be mixed together to produce various grays, but the chalks should be used separately, their tones "mixing" with the underpainting to make all the value variations that volume-building requires.

variation 3 Using India-ink washes of varying tints to develop the local tones, continue to establish the illuminated volume with pen and black and white ink. The black and white inks may interweave in various hatchings to produce the required grays and textures.

Figure 4.34

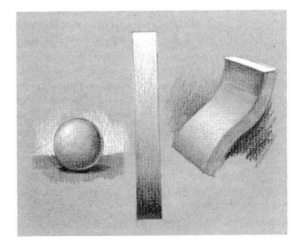

VALUE AS AN EXPRESSIVE FORCE

Values can do more than establish local tones, build forms, and suggest light. They can help artists convey their emotional reactions to their subject. The nature of their conscious and intuitive feelings about the subject are revealed by *what* artists select, omit, and emphasize, and by *how* they organize and draw—give expression to—the image. Value plays a potent role in drawings that excite, calm, amuse, sadden, or otherwise affect the viewer.

Returning to Matisse's *Figure Study* (Figure 4.27), we find the values of the background and figure express powerful moving vibrations. Although we see most of these values as composed of thick lines, and even react to their furious action, the *dominant* impression of their collective behavior is more one of value than of line. These values not only convey form and, to some extent, light, they pulsate with vigorous rhythms, reinforcing the figure's action. The fury with which Matisse attacks the page is necessary

to his expressive idea—the figure's strong forms and bold stance, and the background's envelopment of its forms. Matisse invents value shapes that animate and clash with great force. In the lower part of the drawing the values seem to "invade" the figure; above, the stark white of the torso and arms "break free" of the background to give the upper body dramatic strength. In this drawing, Matisse's values are expressively descriptive *and* abstract—they inform and they evoke.

Whether Matisse's disposition to such energetic drawing had found a "cause" in the subject's potentialities or was triggered by them, energy and idea are fused here in an image of explosive force.

In contrast with the Matisse drawing, Kuo Hsi, an eleventh-century Chinese artist (Figure 4.35), uses values to express a majestic serenity in this section of a handscroll. Tonalities range from nearly invisible nuances that describe distant peaks to emphatic contrasts in the mountainside on the right. The values suggest space,

Figure 4.35
Attributed to KUO HSI (11th Century)
Clearing Autumn Skies over Mountains and Valley
(detail)
Ink and tint on silk. 81⅛ × 10¼ in.
Freer Gallery of Art, Washington, D.C.

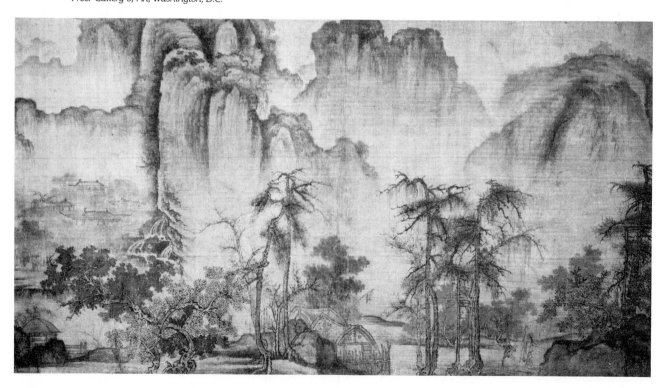

Figure 4.36
HYMAN BLOOM (1913–)
Fish Skeletons
White ink on maroon paper. 16¾ × 22¾ in.
Collection, Mr.a nd Mrs. Ralph Werman

atmosphere, texture, and volume and do so with a delicacy that expresses a stately stillness. Kuo Hsi's rhythmic design, the undulations of shapes, tones, and directions, and the gentle character of his handling—the sensitive care in making the lines and tones themselves—is as delicate as the mood they convey.

Fish Skeletons by Hyman Bloom (Figure 4.36) offers an approach to value that reverses the usual role of white or light paper and black or dark drawing materials. Here Bloom draws in white ink on a maroon surface. Depending on the subject and the expressive intent, this can be both figuratively and dynamically logical. In this instance, the reversal of light tones upon a dark surface helps convey the feeling of underwater depths—its mystery and darkness. The spikey fish skeletons are drawn light in value—which they are. Note the flowing quality of the forms, and how the artist causes them to "flash" into bright light and then fade into the deeper background.

In his drawing *Reclining Figure* (Figure 4.37), Lebrun draws the figure's head obscured by the shadow of the hoodlike drape, as contrasting with the lines and light tones of the rest of the

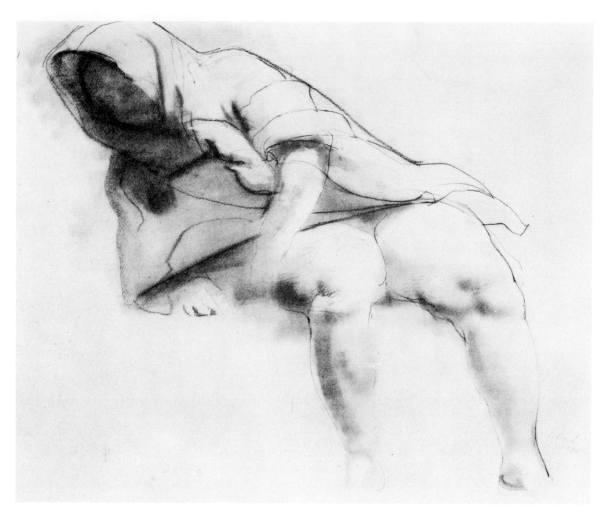

Figure 4.37
RICO LEBRUN (1900–1954)
Reclining Figure
Graphite, ink, and chalk on cream paper. 19 × 25 in.
Courtesy of Fogg Art Museum, Harvard University,
Cambridge, Mass. Gift of Arthur Sachs, Esq.

drawing. The shaded head becomes the visual and expressive center of emphasis—the focal point of the drawing's representational *and* abstract theme. Note that Lebrun "loses" other parts of the figure, making the tonal "crescendo" at the head even more expressively powerful.

Like Lebrun, many artists prefer to integrate line and value, because doing so provides an image richly varied in visual tactics and expressive effects. But sometimes the use of value shapes alone can be very effective, even though these shapes may be comprised of hatched lines, as in Picasso's *Visage* (Figure 4.38). On occasion, however, values are applied in such a way that

no evidence of line remains, as in Perella's drawing of a seated figure (Figure 4.39). Notice that despite Picasso's use of only a few tones and Perella's use of many, the forms in each work owe their clarity as mass in space to an accurate judging of just the right shape and tone in just the right place. Note too that both drawings suggest a light source and that in Figure 4.39, we can easily understand that the pronounced bands of light and dark tones are the result of light shining through a Venetian blind.

As the preceding drawings show, the degree to which and manner in which value is used are determined by felt perceptions of a subject

Figure 4.38
PABLO PICASSO (1881–1973)
Visage (1928)
Lithograph. 8 × 8⅝ in.
Collection of Lois B. Torf

Figure 4.39 (*student drawing*)
Rani Perella, School of Art, Arizona State University
Graphite and ink. 22 × 15 in.

107

that modify the observed actualities. For responsive artists, a drawing's emotive character and abstract activity—its dynamic condition—must communicate their *total* realization of the subject.

For many artists, such as Lebrun and Katzman, the expressive intent of a particular drawing is triggered largely by their subject. Although such artists *do* bring attitudes, feelings, and ideas—their unique psychological and temperamental tone—to a confrontation with a subject, their expressive responses are stimulated mainly by their perceptions. Thus, their use of value (and all other visual elements) is heavily dependent on what expressive potentialities they find in the subject.

Figure 4.40
NATHAN GOLDSTEIN (1927–)
Ellie
Pen, brush and ink. 18 × 22 in.
Collection of Martin Robbins, Boston

Other artists, such as Dickinson and Bloom, experience a deeply felt "presence"; more than an idea, less than a vision, they seek forms that will make their meanings clear. They can be said to intend *before* they see. Neither kind of artist functions as he or she does exclusive of the other's means of approach. The perceptually stimulated artist brings certain concepts and emotions to the encounter with a subject; the conceptually stimulated artist responds to the measurable and dynamic provocations of the subject. Both require value to do more than describe.

VALUE AS AN AGENT OF COMPOSITION

Value's uses in pictorial issues such as direction, balance, emphasis, diversity, and unity will be examined in Chapter 9. Here, it is necessary to mention, in general terms, the various ways in which value can participate in these design considerations.

Like line, value is capable of a vigorous abstract existence that can animate as well as define. For example, in Figure 4.40, the dark tones of the dress and the light ones of the background serve to intensify the sense of forceful vertical movement that enlivens the figure's inactive stance.

Value can relate dissimilar shapes, forms, textures, and spatial areas. In drawings where these visual phenomena appear isolated, confused, or in conflict, value can enforce visual affinities that cause groupings, emphasis, and directions to emerge, as in Figure 4.41, where three differently relating arrangements occur through change in the values of the same design of shapes. Note that while 4.41 seems balanced and unified, 4.41B appears to be too heavy on the right side. Additionally, the vertical alignment of the black shapes is somewhat overpowering. In 4.41C, the division of the light and dark values "breaks" the design into isolated halves and weights the image too much on the left.

Charles Sheeler's *Interior with Stove* (Figure 4.42) directs our attention to the play of vertical and horizontal movements in a room's interior. Throughout the drawing, values merge and contrast in a tonal pattern that activates, balances, and unites the scene into units which emphasize the strong directional force of the shapes and

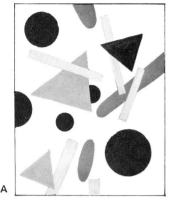

Figure 4.41

Figure 4.42
CHARLES SHEELER (1883–1965)
Interior with Stove (1932)
Conté crayon. 28⅝ × 20¾ in.
Collection of Joanna T. Steichen, New York
Photo courtesy of The Museum of Modern Art, New York

forms. Note how the dark tone of the stove, seen against the surrounding light tones, fixes our attention upon the stove's powerful verticality as well as its "mystery." Through value, Sheeler makes us aware of both shape and volume, guiding us to both the two- and three-dimensional design of the image. Here, values simultaneously serve descriptive, expressive, and organizational matters.

As was observed in Chapter 2, shape is a basic, given quality. It is important to recall that value always has shape. Whether it is as clearly defined as the shapes in Sheeler's drawing or as diffuse as a puff of smoke, the termination of a value within the boundaries of a drawing establishes its shape. Although the value shapes in Seurat's drawings (Figure 4.5 and 4.28) are vaguely defined, he balances them with all the care that Sheeler gives to his more focused ones. Thus, in tonal drawings of whatever style or degree of subjective interpretation, the artist must visually weigh the effects of value on shape, and vice versa.

Value can help locate the position in space of similar volumes when other graphic clues, such as linear perspective, fail to do so. Because of the weak value contrast, we read the hill on the right in Figure 4.43 as farther off than the similar one on the left. Likewise, the spheres and cubes occupy different positions in space because of their value differences, despite their sameness in shape and scale. In this illustration the impression of distance given through value is assisted by our recognition of the phenomenon of aerial perspective (see Chapter 5), which

causes distant objects to appear lighter in value. The position of forms in a shallow spatial field such as a still life can also be clarified by value. Then, the value of the forms relative to the value of the background determines their position in space. An object possessing a light overall tone, seen against a similarly toned background, will appear father back than a similar but dark-toned object located alongside it.

Value can also exist free of mass. As was mentioned earlier, light can envelop several forms or segment them. In Figure 4.44, a shape of light envelops a wall, dancer, and floor. When objects stand in the path of a light source, cast shadow can, as here, take on important compositional meaning. Sometimes, as in Figure 4.13, although the objects in the path of the light are "off stage," their participation in the design can be considerable.

We have seen that value is a potent graphic force. Sometimes value's powers of illumination, design, and expression are so subtly interlaced as to defy analysis, as in Kuniyoshi's enigmatic *Juggler* (Figure 4.45). Its uses in drawing are limited only by our perceptual understanding and inventive wit. Its relevance to responsive painting, which, like responsive drawing, attempts to shape a subject's actual and potential qualities into some system of expressive order, is clear, though sometimes overlooked by the student. Many responsive painting problems are really drawing problems, and those involving a subject's tonalities are among the most vexing to the beginning artist. These are more easily recog-

Figure 4.43

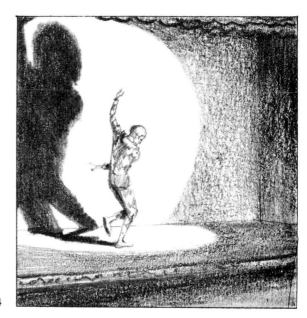

Figure 4.44

Figure 4.45
YASUO KUNIYOSHI (1889–1953)
Juggler (1952)
Ink on cardboard. 22 × 28 in.
Collection of Whitney Museum of American Art, New York

nized and solved in tonal drawing than in painting, where value, like hue and intensity, is a property of color and harder to isolate for consideration.

It is no coincidence that Rembrandt was not only a great painter but also a prolific and brilliant draftsman from his earliest days as a young aspiring artist until the end of his life. Rembrandt's mastery of value (Figure 4.46) enabled him to convey more inventively profound visual and expressive meanings through light and vol-

ume with an economy, power, and eloquence rarely equalled. His penetrating grasp of the dynamic potentials of value is amply evident in his paintings (Figure 4.47).

The development of graphic freedom—the ability to pursue your drawing interests in *any* direction for *any* purpose—depends on the comprehension and control of value's several roles in drawing. Whatever uses value will hold for you later on, its study now is essential to your development as a responsive artist.

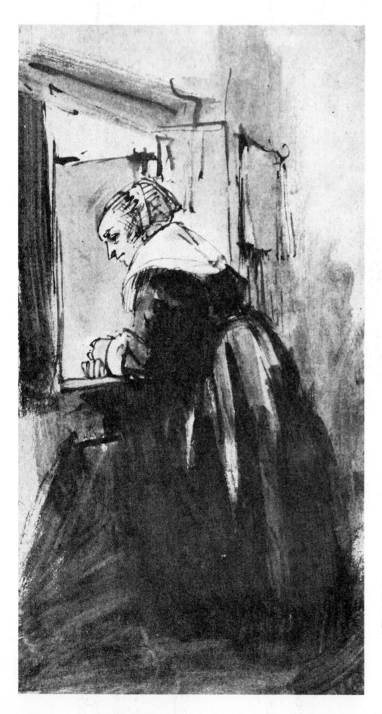

Figure 4.46
REMBRANDT VAN RIJN (1606–1669)
Woman Looking through Window
Pen, brush and ink. 29.3 × 16.4 cm.
The Louvre Museum

Figure 4.47
REMBRANDT VAN RIJN (1606–1669)
Lady with a Pink
Oil on canvas. 36¼ × 29⅜ in.
The Metropolitan Museum of Art
Bequest of Benjamin Altman, 1913

5

PERSPECTIVE

the foreshortened view

A DEFINITION

For responsive artists, the term *perspective* applies to a number of important visual facts concerning the arrangement of volumes in space. It is an implicit condition of any volume's scale, location, and direction in a spatial field. Using this broader meaning of perspective, we discover its presence in all drawings that convey a convincing impression of masses arranged in some logical spatial order. Even some primitive works show a rudimentary employment of perspective, as in Figure 5.1, where the smaller figures on the left, because of their smaller scale and higher position in the format, appear located farther back in the spatial field.

The broader interpretation of the term *perspective*, namely as clues to the appearances of volumes in space, may reassure the student who feels confronted with a complex and rather dry system. Actually, for most artists the exact (and

exacting) complexities that stem from the basics of perspective hold little interest. Moreover, a preoccupation with perspective generally restricts inventive freedom. Because perspective deals with appearances, students know more about the subject than they realize. In fact, they have been using many of the basic principles, and probably sensing others. What they need to do is to clarify and expand their understanding of these principles to benefit from the specific information and control they provide.

A knowledge of perspective is helpful in three ways. First, it serves as a "checklist" for uncovering unintended distortions of the subject's actualities. Second, it encourages the drawing of more complex and/or interesting subjects, which the student might otherwise avoid. Third, it enables us to regard space and volume clues that we might otherwise not consider.

A number of perspective methods have been devised in the past. Ancient Egyptian, Persian, and Oriental artists developed visually lucid and esthetically pleasing systems. There have been others. The system normally used in the Western world is called *linear perspective*. Like all other systems, it is not completely successful in projecting real volumes in real space onto a flat surface, without some distortion. It differs from all other methods in being based upon what forms in space really look like when observed from a fixed position with one eye closed.

Along with linear perspective are some observable phenomena (the results of atmospheric conditions and particles of matter suspended in the air) called *aerial perspective*. These affect the clarity, texture, and values of subjects seen at a distance.

Together, these concepts have helped Western artists convey much observed visual fact with little intrusive distortion (Figure 5.2). But most artists have wisely regarded perspective as a tool, and one with definite limits.

It must be remembered that in responsive drawing, results emerge from the interactions—the negotiations—between perception, intuition, and intent. The information provided by linear and aerial perspective, like all other visual information, is subject to this interpretive process. Perspective, then, is useful as a means but can have restraining tendencies as an end. It is especially useful in the matter of foreshortening.

The foreshortening of forms in space is inherent in three-dimensional drawing. In fact, much of linear perspective concerns the visual nature of things moving toward or away from us at various angles. Look around you and notice how seldom you see an object centered vertically and horizontally on your line of sight. Most of what you see is positioned at various angles, "aiming" in different directions. Even if you confront a row of books or trees, except for the ones directly in front of you, all are seen in some degree of foreshortening. This being so, we seldom see a form from a view that offers only one plane. Indeed, it's rare to see only one plane of even so geometrically severe a form as a cube. The seasoned artist usually avoids such totally foreshortened views of objects because they hide too much of the object's mass. A line drawing of a circle, representing an end plane of a cylinder, tells us nothing of the cylinder's length. Unless we are told the circle represents one end of a cylinder, we would have no way of deducing this from the circle itself. It could represent the base of a cone, or half a sphere, or any other form that resolves itself to a circular plane at its base.

An understanding of linear perspective helps us to clarify and control the impression of foreshortening in unobtrusive ways, as in Vermeer's drawing *View of Town with Tower and Windmill* (Figure 5.3). This complex arrangement of forms in space is not overbearingly aligned and rigid, but presented with the subtlety and ease

Figure 5.1

Bushman Rock Painting of a Dance
South African Museum, Capetown

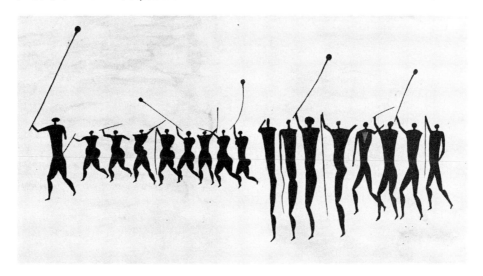

Figure 5.2
RICHARD ESTES
Ansonia (1977)
Oil on canvas. 48 × 60 in.
Collection of Whitney Museum of American Art. Purchase,
with funds from Frances and Sydney Lewis

Figure 5.3
JAN VERMEER DE DELFT (1632–1675)
View of Town with Tower and Windmill
Pen, ink, and washes of tone. 16 × 20 in.
Albertina Museum, Vienna

that a sound grasp of perspective in the service of an interpretive intent makes possible. In fact, Vermeer has not unselectively followed the dictates of perspective. We will return later to note how he has "broken" a rule of perspective in order to strengthen a dynamic theme.

Readers interested in examining some of the more complex applications of linear perspective should refer to the bibliography. Here we will concentrate on the basic principles, to establish their function as general guides to perception and to show how they assist foreshortening in particular. To paraphrase Eugène Delacroix's observation on the study of anatomy, perspective should be learned—and forgotten. The residue—a sensitivity to perspective—helps perception, varying with each individual and determined by his or her responsive needs.

THE PRINCIPLES OF LINEAR AND AERIAL PERSPECTIVE

Linear perspective is based on six principles. Each of these provides space- and volume-revealing clues, some of which have already been touched on in earlier chapters.

1. Relative scale. When forms known to be the same or a similar size differ in their scale, they indicate differences in their position in a spatial field. Thus, the decreasing scale of houses, trees, or fence posts suggests near and far forms in space.

2. Overlapping or blocking. When a form's position interrupts the contours of one or more other forms, partly hiding them, we perceive the overlapping form to be nearer than the overlapped one. Thus, seeing less than the entire form of an object suggests that its position is farther back in the spatial field.

3. Relative distance and position. When forms that are not overlapping and are known to be the same or a similar distance apart show a decreasing distance between them, we perceive them to be receding in space. Thus, the decreasing distance between fence posts or railroad ties suggests forms in space. Except when such forms are seen high above our eye level, the higher a form is in our field of vision, the farther back in space it appears.

4. Convergence. Perspective's main principle holds that when lines (or edges) known to be parallel appear to aim toward each other, or converge, they give the impression of going back in space. Thus corridors, houses, railroad tracks, or anything possessing parallel boundaries in any direction appear to recede in space if these boundaries are seen as inclined toward each other.

5. Cross-section or cage lines. When forms naturally possess or are, in a drawing, given a linear-textured surface, as in the use of structural hatchings, the relative distance and changes of direction between such lines suggest volume in space. Thus, objects as different as seashells, driftwood, cornfields, or barber poles, by their textured surface-state, suggest forms in space.

6. Light and shade. When one form casts a shadow on another, the shadow's length, location, shape, and especially its scale and value suggest the distance separating the two forms, the shape of the form casting the shadow, and the planar surface-state of the form in the area receiving the shadow.

The common denominator in these six principles is the diminution of scale. If all or most of these principles are invoked, forms—when uninterrupted by other forms—will appear to diminish in scale and finally disappear.

Aerial perspective is based on three principles. These apply mainly to forms in deeper space, such as distant houses and hills, but are sometimes employed in drawings of forms in shallow space.

1. Clarity. When forms appear less distinct in edge, detail, and general focus, we assume they are farther away than more incisively focused forms. Thus, a mountain seen at a distance appears vague and formless when compared with a nearby boulder.

2. Value range. When the value contrasts between forms diminish, often becoming lighter, but always more closely related, we assume these forms to be in deep space.

3. Relative texture. When forms diminish in textural clarity relative to other forms known to be the same or similar in physical characteristics, we perceive the less texturally active ones to be farther away. Thus, nearby grassy areas are seen as texturally active, those in the distance, far less so.

Figure 5.4
ALBERT ALCALAY (1917–)
Times Square (1959)
Pen, ink,and wash. 16 × 20 in.
DeCordova Museum, Lincoln, Mass.

The common denominator in these three principles is that as distance increases, definition (clarity of focus, value contrasts, textural differences) decreases. Used together with linear perspective, aerial perspective will cause forms to seem more accurately located in space.

Perspective can also help artists *subdue* volume and space. Knowing what clues convey these impressions, they have greater control over involving the beholder with a drawing's picture-plane activity. Alcalay, in his drawing *Times Square* (Figure 5.4), achieves an interesting fusion of two- and three-dimensional space by stressing some perspective conditions and subduing others. Despite the severe convergence of the lines of the streets and buildings, the overall configuration provides an engaging two-dimensional design.

THE HORIZON LINE

A fundamental concept in linear perspective is the horizon line. This is determined by, *and is equivalent to,* the observer's eye level. Whether visible or not, the horizon line is imagined as describing a horizontal line at the observer's eye level, parallel with the ground plane and 360 degrees around him. Being equivalent to the observer's eye level, the horizon line is as high or low as his position is above or on the ground. To someone standing on a mountain peak, the horizon line is very high in her field of vision; for someone lying on the ground, very low (Figure 5.5).

Normally, obstacles such as hills, houses, walls, or foliage block our view of actual horizon

Figure 5.5

lines. But visible or not, linear perspective requires that the horizon (eye-level) line be established in the artist's mind. This can be actually drawn or simply understood as located on a particular horizontal level in the drawing. Knowing its location helps determine quickly the general position of forms in relation to the artist. She sees anything above the horizon line as above eye level, anything below it as below eye level. We look at the undersides of forms located above the horizon line, and down on the tops of forms beneath it.

To better understand the horizon line as equivalent to eye level, take the example of a room with three transparent walls, through which we see the horizon of a lake (Figure 5.6A). Our eye level is centered between floor and ceiling, equidistant from both side walls. Through an opening in the middle wall, the horizon of the lake can be seen *directly.* If we now assume the walls are not transparent but opaque and solid, the only part of the horizon visible is the small segment seen through the window-line opening. The rest of the line that formerly represented the horizon can now be seen as a painted line on each of the three walls, exactly at eye level. Were such lines drawn on each wall near the floor, they would not form a straight line but would incline upward toward the horizon line on the two side walls. If they were drawn close to the ceiling on each of the three walls, the lines on the side walls would incline downward toward the horizon line. The horizon, or eye-level line, is that horizontal level where lines that we know to change direction appear to flatten into a straight line. In

Figure 5.6B the same room is shown with several lines on the three walls. Note that extending any pair (one from each of the side walls) causes them to meet at a point on the horizon line. That point on the horizon line (your eye level) where converging lines meet is called the *vanishing point.*

Recalling the principle of convergence, we know that lines appear to recede in space when they incline toward each other. When such lines are seen to lie upon the ground-plane, or parallel to it, they will always meet at a vanishing point on the horizon line. This can be seen by extending the lines on any of the side walls in Figure 5.6.

In Figure 5.6C, the same room is viewed with the observer's eye level near the floor. Now, the next-to-the-lowest lines on the three walls are the horizon line and appear as a straight line. This being the case, we no longer see the lake through the window in the center wall. Looking at 5.6B and 5.6C, we sense the difference in the level at which we view the two rooms. Through perspective the artist not only can set the stage but can control the level and, as we shall see, the angle from which we view it.

The horizon line need not appear within the limits of the drawing. Sometimes, as in Mantegna's *Man Lying on a Stone Slab* (Figure 5.7), the horizon line is assumed to lie above the page, because the degree of inclination of the lines representing the slab's left and right sides would make it impossible for them to meet until they had traversed several inches beyond the upper boundary of the drawing. Less frequently, the horizon line may be known to lie below the page (Figure 5.8).

Figure 5.6

A B C

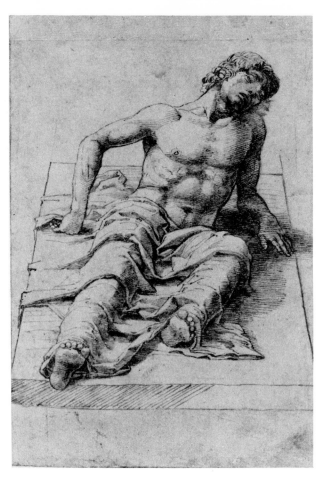

Figure 5.7
ANDREA MANTEGNA (1431–1506)
Man Lying on a Stone Slab
Pen and ink. 16.3 × 11.4 cm.
*Reproduced by courtesy of the Trustees of The British
Museum, London*

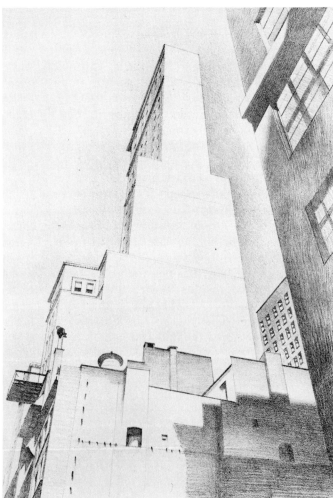

Figure 5.8
CHARLES SHEELER (1883–1965)
Delmonico Building
Lithograph. 10½ × 8½ in.
*Courtesy of Fogg Art Museum, Harvard University,
Cambridge, Mass.
Gift of Meta and Paul J. Sachs*

120

ONE- TWO- AND THREE-POINT PERSPECTIVE

Artists can view their subject in one of three ways. They can center themselves before its horizontal limits, as Mantegna does before the stone slab in his drawing (one-point perspective); they can stand to one side of their subject, as Mantegna does before the figure of the man (two-point perspective); or they can view their subject from a point very much above or below it, as Sheeler does in Figure 5.8 (three-point perspective). Whatever the view, an artist gains helpful information by regarding the converging behavior of lines known to be parallel (in discussing perspective, the term *line* often replaces *edge*, for purposes of clarity).

When artists are centered and parallel to their subject, those lines they see as *actually* horizontal or vertical do not meet at any vanishing point, for there is no convergence. Such lines, then, will appear as verticals and horizontals in their drawing. Only those lines they see as *diagonals*, as moving away from them, incline toward each other and meet at a vanishing point on the horizon line, as in Mantegna's drawing. Note that the horizontal lines of the slab, being *parallel* to the page, do not converge.

Drawings in which the artist is centered on his subject are called *one*-point perspective drawings because all the converging lines meet at the same vanishing point, as in Vermeer's *View of Town* (Figure 5.3), where the converging lines of the houses and lane in the foreground appear to meet below and to the left of the windmill. But note that the church and windmill, because they are positioned more parallel to the picture-plane, show little convergence of lines. Again, in Saenredam's drawing (Figure 5.9) we see that the converging lines of the pillars, walls, and floor lead us to a point on an unseen horizon line near the top of the far, arched wall, aligned parallel with the picture-plane. But that far wall and all of the other forms and planes in the drawing

Figure 5.9
P. J. SAENREDAM (1597–1665)
St. Cunera Church, Rhenen
Pen and ink. 38.2 × 53.5 cm.
Rijksmuseum, Amsterdam

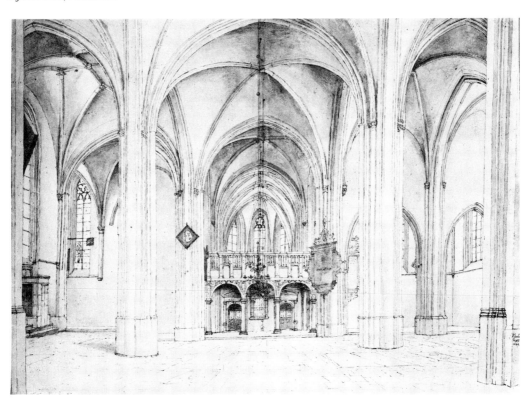

that are parallel with the picture-plane do not converge.

The meeting of converging lines will occur whether the forms are above, on, or below the horizon line, so long as the lines are parallel to each other, as in Figure 5.10A. Note that the middle box, observed at eye level, shows only one plane. This is the one parallel to our field of vision (or at a right angle to our line of sight), and it is comprised of four right angles. The other boxes show the same plane, but because these boxes are above and below the horizon line, we see the underside of the one above and the top of the one below.

But one-point perspective has an immediate limitation. If we wish now to surround the central box with two others—one far to the left and one far to the right and parallel with it—a dilemma arises. There is only *one* position that will show a plane with four right angles: the eye-level position of one-point perspective. This is also the only position that will not show any of the sides of the boxes. But seeing the sides of the two new boxes in Figure 5.10B, we recognize that the observer is no longer directly in front of them but views them from oblique angles. But if the new boxes are turned enough to show a foreshortened view of their side plane, their front planes should no longer be seen straight on. The new boxes cannot show a three-quarter view of their *side* planes without similarly changing their *front* planes. If, then, the front planes of these

two boxes are centered on the observer, they must conform to the principle of convergence and show the horizontal lines of their front planes to incline toward vanishing points on the horizon line.

This "correction" has been made in Figure 5.10C, and the boxes on either side of the center one are no longer distorted. They are now "in perspective" but their alignment with the center box has been destroyed. In Figure 5.10B the three boxes line up in a row parallel to the observer, but at the cost of distorting the side boxes. Here the limits of projecting real volume and space onto a flat surface become apparent.

Because Vermeer's design theme (Figure 5.3) depends on the bold convergence of the lines of the houses and lane, especially on the right side, he chooses, on the far left, to contrast this thrust by treating the planes of the houses more nearly facing us as being parallel with the picture-plane. Thus, in selecting the "option" shown in Figure 5.10B over that of Figure 5.10C, he forsakes a degree of measurable fact in one place in order to amplify a dramatic spatial event in another.

Looking again at Figure 5.10C, we note that each side box, no longer centered on the observer, possesses *two* sets of converging lines that meet at two widely separated vanishing points. These boxes, unlike the center one or their counterparts in Figure 5.10B, are drawn in *two*-point perspective.

Whenever forms are parallel to the ground-plane but not to the observer, as, for example, when we stand facing an inside or outside corner rather than a side of a building, the lines of its two visible planes will appear to meet at two vanishing points on the horizon, as in Mazur's *View into Broadway* (Figure 5.11). Any number of forms, when parallel to the ground-plane but differing in their alignment to each other, as, for example, a floor strewn with boxes all upright but at various angles to each other, will each have its own two vanishing points on the horizon. Though an object like the folding screen in Figure 5.12 may have many parallel lines converging on many vanishing points, it is still regarded as being drawn in two-point perspective.

When forms are positioned at an angle to the ground-plane, their vanishing points will be above or below the horizon, as occurs in several instances in Figure 5.12. Note that the lines of the folding screen and the boxes denoting their ver-

Figure 5.10

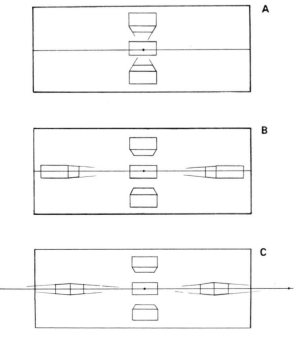

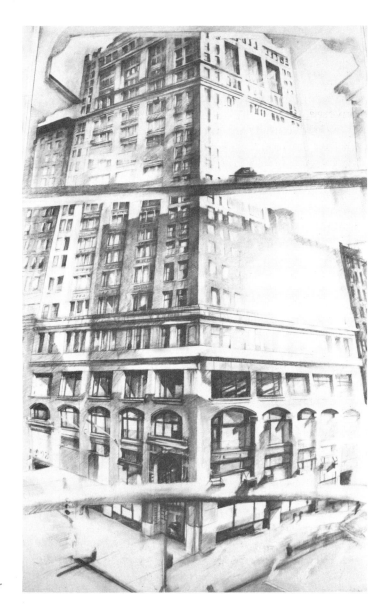

Figure 5.11
MICHAEL MAZUR (1935–)
View into Broadway (1971)
Pencil. 40½ × 26½ in.
Collection of Mr. and Mrs. William Marsteller

Figure 5.12

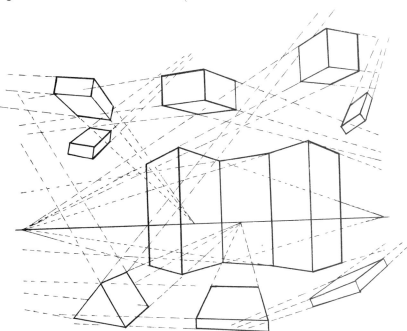

ticality, whether or not they are actually at a right angle to the ground-plane, do not converge. In one- and two-point perspective, lines parallel to our field of vision (and hence, parallel to the picture-plane), as was noted earlier, are drawn as true parallels.

But this is not the case when the vertical lines are very long, or when we look down upon a subject from a great height or look up from a low observation point to see a towering form such as a skyscraper. Then, the subject's *vertical* lines will appear to converge toward a vanishing point. When this is observed, a *three*-point perspective situation exists, as in Figures 5.8 and 5.11. Thus, three-point perspective occurs when the long axis of a form aims well above or below our eye level. But note, in Figure 5.12, that one set of converging lines of the block in the upper left corner goes to the horizon line while the other set aims upward toward a vanishing point in the sky. This is the result of the block's particular angle in relation to the ground-plane. But because the vertical lines that define the block's side planes are not seen as converging, the block is regarded as drawn in two-point, not three-point perspective.

In both two- and three-point perspective the vanishing points should not be placed too close together. Crowding them produces forced and distorted forms, such as those in Figure 5.13. Because of the unavoidable distortions in transposing real volume and space to a flat surface, most artists make subtle adjustments between conflicting perspective conditions such as exist between Figure 5.10B and 5.10C, thereby reducing and obscuring the evidence of distortion, as

in Meryon's preparatory sketch (Figure 5.14). Here, neither the lines indicating rows of bricks on the arch nor those which we can extend from the tower and the buildings below come to common vanishing points. Many artists intentionally reduce the convergence effect, to reduce the camera-like distortions that a strict adherence to perspective can sometimes cause. They purposely place a form's vanishing points extremely far apart, giving it a broad "frontality" that emphasizes its picture-plane condition (Figure 5.15).

In the following exercise, try to select views that will test your understanding of one-, two-, and three-point perspective.

exercise 5A

MATERIALS: Pencil on any suitable paper, 18 × 24 inches. Use a ruler and eraser freely on all but the last of the three drawings you will make.

SUBJECT: Observed and imagined simple forms in one-, two-, and three-point perspective.

PROCEDURE:

drawing 1 Use two simple block forms as models. Gift boxes, cartons, or children's large pasteboard building blocks are excellent, but any block-like objects will serve. These need not be cubes, but do avoid very long block forms. If possible, one or both of the forms should be open at one or both ends, permitting you to see inside. You will be drawing both forms as if they were semi-transparent. It is important to consider the angles of inside as well as outside lines.

Plan to cover a sheet of 18 × 24 inch paper with as many views of these two blocks together, in varying

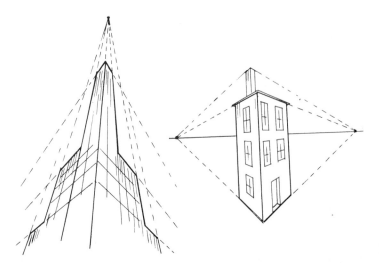

Figure 5.13

Figure 5.14
CHARLES MERYON (1821–1868)
Study for Etching "La Pompe Notre Dame"
Pencil. 11⅝ × 13⅞ in.
Courtesy, Museum of Fine Arts, Boston
Gift of the Members of the Visiting Committee

Figure 5.15
DOMENICO CAMPAGNOLA (c. 1500–1552)
Buildings in a Rocky Landscape
Pen and ink. 6¹/₁₆ × 7¾ in.
The Pierpont Morgan Library, New York

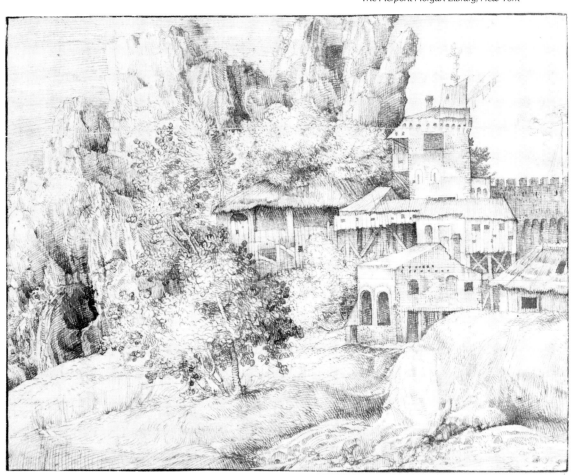

positions, as will conveniently fit on the page. Draw these considerably smaller than actual size, but avoid tiny drawings.

Arrange forms in any way that offers a new combination for each sketch. You can place them next to each other at different angles, place one atop the other, or lean them against a support, balancing them on their corners. Draw them as they appear above, at, and below your eye level.

Begin your drawing of each view in a free manner. Note first, where each form is in relation to the other and to your eye level. Search for the actual shape of each plane. In doing so, you will see planes more objectively and be more aware of the direction of their lines. When your drawing has some rough relationship to the shape, scale, and location of the two forms, use a ruler, if necessary, to establish the right relationship of inclination between the lines. Should you wish to strengthen further the sense of lines moving toward common vanishing points, you can slightly increase the degree of convergence between them. Allow the lines to extend beyond the point of intersection with other lines when you see them as converging toward a vanishing point. Since there are no visible horizon lines to be drawn on this page, extend such lines only slightly beyond the form itself. These extensions help you to see their inclination better, as in Figure 5.16. Notice that some of the lines of the lower block are visible through the upper one. Assume the forms to be semi-transparent, allowing you to draw most of the unseen lines. Should a profusion of lines become confusing, draw those you do not actually see only lightly, occasionally allowing some of these lines to disappear for a little distance along their paths.

In Figure 5.16 the two forms each show three groups of lines. Those marked p are parallel to the observer, despite the tilt to the left of those in the up-

per block. Lines a and b of the lower block and lines c and d of the upper one are not parallel to the observer and are therefore drawn in two-point perspective. There is no time limit for the various views you will draw on this page. When you have filled the entire page, go over each sketch to see if any of the forms seem distorted because the inclination of the lines is too extreme, or because they have gone awry. Look at these drawings again in a few days to see if you can locate the observer's position for each sketch and if they "feel right."

drawing 2 This drawing is to be completely imaginative. Again, draw in pencil on a sheet of 18 × 24 inch paper. Turning the sheet vertically, divide it into three even sections. Starting with the topmost section, draw a horizontal line 4 inches from its base, dividing it in half. In the second section, draw a similar line 2 inches from its top. In the third section, draw a horizontal line 2 inches from its base. These three lines will represent, in each drawing, the horizon-eye-level line.

Starting with the *middle* section, draw three block-like forms that appear to "sit" on the ground-plane. Each should be drawn in two-point perspective at an angle differing from the other two. This will result in six different vanishing points. We saw in Figure 5.12 that forms parallel to the ground-plane but not to each other have their own vanishing points on the horizon line.

Again, assume the forms are semi-transparent and let the converging lines extend beyond the forms, this time all the way to their various vanishing points. You may find that a block's placement results in one or both of its vanishing points being located beyond the limits of the page. When this is the case, temporarily place a sheet of paper alongside your drawing, extend

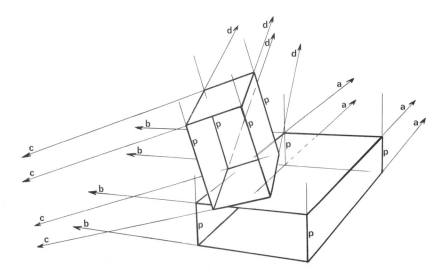

Figure 5.16

the horizon line, and, using a ruler, draw the converging lines onto this sheet of paper to their vanishing points.

There is a second way by which you can establish the three blocks. Instead of drawing the forms and adjusting their lines until they meet at their appropriate points on the horizon, you can begin by selecting a block's two vanishing points and drawing two *diverging* lines from each in the general direction of your desired location for the block. The shape resulting from the intersecting of the four lines establishes the block's bottom plane. Elevating a vertical line at each point of intersection raises the four sides of the block. To locate the top plane of the block, again draw diverging lines from both vanishing points until they intersect the four verticals at the desired height.

Whichever way you draw the three blocks, place them well away from the horizon line. They may, however, vary in their nearness to the viewer. These blocks, when completed, will be your "models" for the two remaining sections.

Using a ruler held vertically, locate the six vanishing points on the horizon lines of the first and third sections. In both sections, draw the three forms in the same relationship to the ground-plane (and to each other) as established in the middle section.

The differences in the location of the horizon line will make the blocks appear farther below the observer's position in the first section than in the third section. Depending on their height and position on the ground-plane, the upper portions of the blocks in the third section may rise above the horizon line.

When you have completed drawing the first and third sections, return to the center section and continue to develop it as if the blocks represented the geometrically "pure" state of houses. Add windows, doors, and anything else that would convert the original forms into houses. Place a simple landscape setting about them that may include streets, lamp posts, trees, and fences. Keep these additions quite simple. Use converging lines to align windows, streets, and so on. Then try to show how this landscape would look from different elevations by drawing the same objects in the same positions in the first and third sections. When completed, the three sections should show three different elevations of the houses and their environment.

You may find yourself faced with perspective matters not yet discussed. If so, return to this drawing at the completion of the chapter to see what new information you can apply to complete the three views of this imaginary scene.

drawing 3 Sit about two feet away from a small table upon which you have arranged eight or nine books of various shapes and sizes. Several should be stacked on their sides at different angles, one or two can lean against the stacked books, while others can be placed at various angles on the table top and may overhang it.

Study the subject to determine your horizon-eye-level line and lightly indicate this on a sheet of 18 × 24 inch paper, held horizontally. Do not use a ruler for this drawing, and keep erasures to a minimum. Your attitude here is to use perspective as an aid to inquiries intended at uncovering gestural, structural, and tonal facts about the subject.

Begin gesturally and develop the drawing tonally. Search for positive and negative shapes, scale differences, and the relative location of the components to each other (you do not need to include all of the table). At every stage of the drawing refer to the eye-level line to help you align planes and forms. Note the angles of convergence of the edges of your subject's parts and, where books seem to "float," check on their diagonal lines to see if they terminate at the horizon line. Use, but do not merely rely on, perspective to assist your understanding of the arrangement of these forms in space. Now your goal is a drawing responsive to your subject's dynamic as well as structural condition.

PERSPECTIVE AND EXACT LOCATION

Occasionally, it is necessary to locate the middle of a square or rectangular plane turned away in some direction from the observer's line of sight. In Figure 5.17A, a square and rectangle are shown parallel to the observer. When diagonal lines are drawn from corner to corner in each, they intersect in the exact center, thus establishing the central location of the window in each shape. Drawing diagonal lines from corner to corner on foreshortened planes gives us their exact *perspective* center, enabling us to accurately locate the windows on them, as in Figure 5.17B.

Figure 5.17

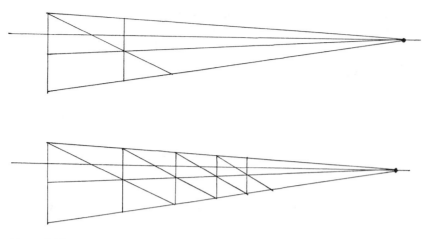

Figure 5.18

Perspective provides a simple system for locating the position of evenly spaced forms such as trees or posts. To locate them, you draw the first member of a row of forms and, extending lines from its tip and base, incline these lines to meet at the desired vanishing point. On the basis of these lines, you draw the second member at the desired distance from the first. This first space interval establishes the size of all the spaces between the rest of the forms. Recall that the principle of relative distance demands that spaces between evenly spaced forms must diminish as they recede toward the horizon line. To locate the placement of the third member, first you draw a line from the vanishing point to the center of the first member, dividing it in half. Then you draw a diagonal line from the top of the first member through the point of intersection between the second member and the dividing line, continuing until it strikes the base line, as in Figure 5.18A. The third member is drawn at the point at which the diagonal line strikes the base line. This procedure is repeated to locate all subsequent members, as in Figure 5.18B.

THE CIRCLE IN PERSPECTIVE

To see a circular shape, the observer must be parallel to its surface and centered on its limits. When totally foreshortened, the circular shape (or any other shape) will of course be reduced to a straight line, as in Figure 5.19. Viewed from any other angle, it appears as an ellipse-like shape, growing narrower as it approaches total foreshortening.

If we bisect a true ellipse along its longer axis, it produces two equal halves. Bisecting a circle seen in perspective in this way produces a slightly fuller curve in the half nearest the observer (Figure 5.19). In drawing foreshortened circular forms, it is important to remember that they are not seen as true ellipses—though sometimes referred to as such in this chapter.

The angle of any foreshortened circle is determined by its long axis. When such an elliptical shape is upright, its long axis will be vertical. When it is parallel with the ground-plane and centered on the observer, it is horizontal. All other positions will show the long axis as inclined to some degree.

Figure 5.19

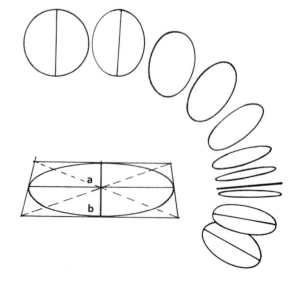

In Figure 5.20 the long axis in each of the four ellipses is different. In A it is horizontal because, unlike in B, it is centered on the observer. But both are parallel with the ground-plane. In C, it tilts away from a vertical position, matching the tilt of its box-like container. Many artists find it easier to place an ellipse (or any other curvilinear form) at the desired angle by first drawing such containers in the required position. Note that the vanishing points for C are above the horizon line, and for D, below it. Note, too, that the long and short axes of each of the four ellipses always form a right angle. This can be seen in E, where the line running through the curving cylinder represents the short axis of the ellipses shown.

To help establish the desired angle of an ellipse at one end of a cylinder form, such as a wheel or column, begin by drawing the box-like container, as shown in Figure 5.21. Running a line through its center parallel with its tilt in space establishes the long axis of the container shown but the *short* axis of the ellipse. Drawing a line at a right angle (90 degrees) to the short axis establishes the oval's long axis. Circles in perspective offer no view from which sharp corners are visible, as in the wrongly drawn cylinder in Figure 5.21.

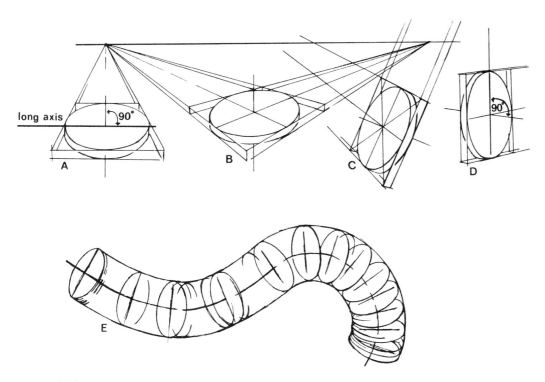

Figure 5.20

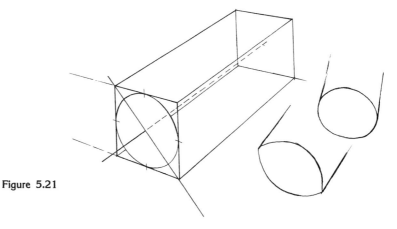

Figure 5.21

CAST SHADOWS

Linear perspective affects the shape and scale of cast shadows. When forms are illuminated by a nearby source of light such as a candle (Figure 5.22), their cast shadows will radiate from a point at the base of the light source. To establish the length of a shadow cast under these conditions, you draw lines from the top of the light source, touching the top of the form and ending where these lines meet with lines drawn from the base of the light source, as in Figure 5.22. The lines emerging from the base of the light source represent the shape of the cast shadow. Here, the base of the light source acts like a vanishing point toward which the lines of the cast shadow converge.

When forms are illuminated by sunlight, the radiating effect of the light rays is far less evident because of the great distance separating them from the light source. To establish the shape of a shadow cast by a vertical plane in sunlight, drop a vertical line from the position of the sun to the horizon line. This creates the vanishing point for the lines of the shadow (Figure 5.23). Two lines, drawn from the sun at an angle that touches the top corners of the plane and continues farther to intersect the radiating lines of the cast shadow, establish the shape, scale, and direction of the cast shadow. Using the plane's vanishing point to draw a line the touches both of these intersections "proves" the angle of the leading edge of the cast shadow.

To establish the shape of a shadow cast by a three-dimensional solid such as a block, follow the same general procedure. However, as is shown in Figure 5.24, there are now *three* vanishing points that affect the cast shadow. The vanishing point of the shadow's lines dictates the direction of the block's shadow; the other two vanishing points and the sun's height determine the shadow's shape and scale. The irregular shape of the cast shadow in this illustration results from the block's height and position in relation to the sun.

Another Mazur drawing, *Ladder* (Figure 5.25), shows cast shadows resulting from a light source located high up and to our right. Note that Mazur does not overload these shadows with dark tones, nor does he call undue attention to them by sharply focused edges. To do either would risk a confusion between shadow and substance. This drawing serves as a good exam-

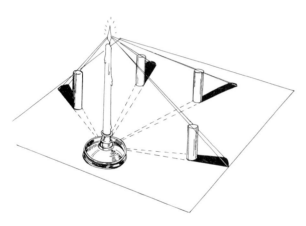

Figure 5.22

Figure 5.23

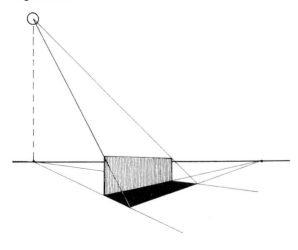

Figure 5.24

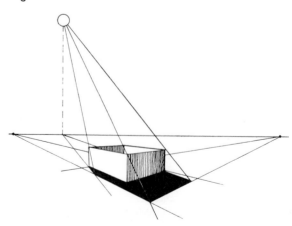

Figure 5.25
MICHAEL MAZUR (1935–)
Ladder (1971)
Pencil. 40 × 26 in.
Courtesy, Terry Dintenfass Gallery, New York

ple of one way in which perspective can serve creative instincts. Mazur faithfully records the two-point perspective condition of the ladder and even tells us that he drew it from a position below the lowest step. But instead of emphasizing the subject's perspective state as the goal, or merely allowing the rules of perspective to determine the image, he uses perspective selectively, omitting an occasional segment of cast shadow, widening or thinning down the shapes of shadows and ladder parts, and adjusting the location and clarity of some edges, thus creating an engaging abstract play of shapes, tones, and directions.

FORESHORTENING

The real theme of this chapter is *foreshortening*. We have been discussing it all along. As was noted earlier, foreshortening is a given condition of three-dimensional drawing; it is never absent in drawings of masses in space.

Those parts of a three-dimensional form that recede into space at angles that permit us to see them always undergo two major changes. Their *length* and *width* are both diminished to some degree, but usually, *they do not diminish at the same rate.* As a form approaches total foreshortening, its length diminishes at a faster rate than its width—its overall girth. Only with severely foreshortened views of subjects that possess enormous length does the reduction in width keep pace with that of length. This differing rate of reduction is important. As an example, if we draw a foreshortened view of a leg (Figure 5.26), it is necessary to distinguish between the rapid "telescoping" of its length and the relatively minor reduction of its width, as in Figure 5.26A. Many beginners, perhaps subconsciously influenced by the severe reduction of a form's length, reduce its width far too much, as in Figure 5.26B. When confronted by a foreshortening situation, they will often substitute remembered notions of the subject's forms for what they actually see. They may *see* a foreshortened leg, but they will draw it as if it were fully extended. Or, if they attempt to show its foreshortened state, they may diminish the leg's width rather than its length, because they are more likely to note the

Figure 5.26

reduction of the overall scale of the form than its foreshortened shape-state. Then, too, it is somehow easier for the beginner to accept a reduced scale for the leg than to alter its familiar outlines. Naturally, this tendency toward unintended frontality subsides as the student begins to shift from preconceived notions to more objective perceptual comprehension.

Perspective conditions are more easily seen in geometric solids. Applying its principles to a house or fence seems logical and manageable. Its presence in organic forms such as trees or the human figure is less evident and too often overlooked. But doing so risks losing the sense of the artist's fixed position in relation to the subject and increases the likelihood of perceptual errors going undetected. For example, it is helpful to know that if we are seated before a standing figure, we look *down* upon the tops of the feet but *up* at the underside of the chin and nose. Knowing that our eye level falls approximately at the figure's hips alerts us to an important relationship that exists between each part and our own position.

Perspective, then, helps organize complex organic subjects by providing us with a set of conditions to look for in even the most fluid and ornate subjects. Bernini, in his drawing *Sunrise* (Figure 5.27), although he shows few diagonals to suggest convergence, and treats his subject in a broad, painterly manner, convinces us of the

perspective rightness of the clouds, water, and rock formations. His sound grasp of perspective enables him to incline the clouds, keep the surface of the sea level, and raise the rocks from it with only the subtlest of visual clues. Knowing that the most fanciful cloud or tree can be conceived of as temporarily reduced to its most suitably simple container permits us to better locate and understand its essential mass. Once the geometrically simple "stand in" has taken its position, and its scale, shape, and converging edges have been established, the development of its unique form particularities can be more easily stated.

Similarly, in Figure 5.28, although a flower would seem to offer few geometrical simplifications, it is at once apparent that the artist conceived the basic ellipses that enabled her to feel the form "in the round." Note, too, the foreshortening in the variously turned leaves.

In Rubens' drawing of arms and legs (Figure 5.29), the limbs have been drawn in a way that echoes their geometric core. Rubens favors cylindrical and ovoid form summaries, as is especially evident in the drawing of the foreshortened right lower leg. Notice how well Rubens clarifies many of the smaller forms that comprise these limbs. In the drawing of the arms in the lower left corner he even distinguishes between the direction of the upper and lower segments of the man's left forearm.

Figure 5.27
GIOVANNI LORENZO BERNINI (1598–1680)
Sunrise
Pen and wash. 29.5 × 27.3 cm.
Kupferstichkabinett, Berlin (KdZ 15200)

Figure 5.28 (*student drawing*)
Joyce Goldstein, private study
Charcoal. 14 × 17 in.

Figure 5.29
PETER PAUL RUBENS (1577–1640)
Studies of Arms and Legs
Black chalk, touches of white chalk. 35 × 24 cm.
Museum Boymans-van Beuningen, Rotterdam, The Netherlands

The overlapping of one part by another often plays an important role in conveying the foreshortened state of one or more forms. In Figure 5.29 the clear overlap of the lower left leg by the foot, and in turn, the lower leg's overlap of the upper leg leave no room for a misreading of the alignment of these parts. Again in the right foot, the overlap of the bones at the ankle by the protuberance of the heel, and *their* overlap of the forward part of the foot help us to understand the order of these parts in space.

When forms overlap, the nearer, or dominant one sometimes casts a weak shadow or causes a lessening of light upon the farther, or subordinate one, on that segment nearest to the dominant form, as in Figure 5.30A. The impres-

Figure 5.30

sion of volume is increased when values "underscore" the blocking of one form by another in this way. When forms are positioned side by side in a way that makes it difficult to know which one is dominant, using values to darken the subordinate form near its neighbor helps to clarify their placement (Figure 5.30B). As with any device, unselective usage can make this tactic quickly degenerate into gimmickry. But it is a helpful step when other clues cannot sort out the dominant from the subordinate forms, or when we wish to emphasize a part.

The use of structural cross-section or cage lines or of other kinds of hatching is another means of providing clues about foreshortened forms. In Figure 5.31 the undulations of the lines convey the surface-state, their increasing closeness or delicacy, the sense of receding in space.

Even aerial perspective, generally reserved for subjects in deep space, can help to show the spatial location of nearby forms, when used with great subtlety. Leonardo da Vinci, in his *Five Grotesque Heads* (see Figure 3.5), discreetly draws the second head from the right in a less defined way. Relative to the other figures the value range of this head is lessened, and there is less textural activity. Likewise Katzman's drawing (see Figure 4.29), although drawn in a very different manner,

Figure 5.31

relies on aerial perspective devices to make the figure's far leg go back in space.

Relative distance and position can also locate forms in space. The decreasing space between trees, flowers, or figures arranged in some orderly patterns suggests space, as in Figure 5.32. The farther back in space such separations occur, the more critical their position and scale become. In a drawing showing a foreshortened view of a row of trees intended as equidistant, enlarging or even only failing to reduce the distance between the last two trees would show the last one to be huge and a city block away from its neighbor, when only a fraction of that distance was intended.

Thus, all nine principles of perspective can be present in the foreshortening of some forms, although *the factors of convergence and overlap will always be dominant considerations.* The more complex the form or the more severe the foreshortening, the more necessary these factors become in clarifying direction, scale, and location.

Because volume and space are inseparable qualities, the drawing of a foreshortened form must be made as though we believed that the flat surface of the page does not exist and that, like Alice going through the looking glass, we can reach in and touch, with our drawing instrument, a form located far away in space.

In the following exercise, you will draw some foreshortened forms. As you go from simple to more complex ones, remember the nine ways in which perspective can help locate and construct both form *and* space.

exercise 5B

MATERIALS: Use any medium or combination of media, and work in any scale you wish. However, avoid extremely small or large drawings. Do not use a ruler for the first five drawings.

SUBJECT: Invented and observed forms in space.

PROCEDURE: There are no time limits on any of the six parts in this exercise. The first part consists of invented forms, the remaining five will be drawn from observed subjects. The landscape drawings should be done from a locale that provides some forms in the far distance, but it need not be a complex panoramic view. For the rest, use the human figure, either draped or nude, as your subject. If no model is available, make a still-life arrangement consisting of some of the following: pillows, purses, hats, boots, dolls, and house plants. Here, the idea is to simulate some of the characteristics and forms of organic subjects. Any other objects that you feel would be consistent with this theme may, of course, be used. The still life should be fairly

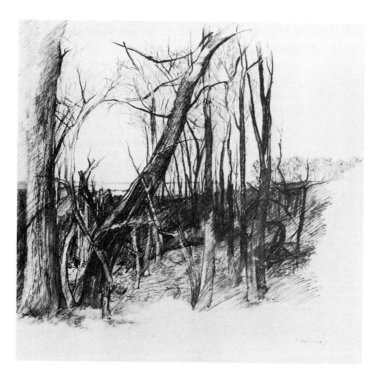

Figure 5.32 (*student drawing*)
University of Illinois at Urbana-Champaign
Charcoal. 18 × 24 in.

A B

Figure 5.33

simple and should avoid more than a few angular or mechanical objects.

drawing 1 Fill one half of the page with some seven to ten simple geometric forms such as cylinders, cones, half-spheres, and any other variations of such basically rounded forms. A few may, as in Figure 5.33, show straight or angular passages. Use your imagination freely, but avoid complex forms. The cylinders may bend, interlock, or develop variations in their thickness. However, their elliptical end planes must be shown at right angles to their bodies. Other forms may consist of several joined volumes, as in Figure 5.33.

Begin by "encasing" each invented form in a container, as in Figure 5.34, to help you control its direction and degree of foreshortening. Once you have roughed in a form's essential structure, erase its encasing lines and develop it in structural lines whose hatchings further explain the form.

When you have completed the half-page, as in Figure 5.33A, draw each of the objects again on the other half of the page—as if you have moved a few feet to your right. Imagine how each of these would look if you changed your position in this way, and draw their new view. Although each form is now "seen" from this new angle, avoid any blocking of independent forms that would occur in such a shift of position. Therefore, draw each one independent of its position in relation to other forms—as floating free of the rest (Figure 5.33B).

drawing 2 Make two drawings of the same view of an observed landscape (or cityscape). In the first, try to create a sense of deep space by aerial as well

Figure 5.34

as linear perspective devices. Using Vermeer's drawing (Figure 5.3) as a rough guide, permit structures and space farther back in the spatial field to become less focused, less tonally contrasting, and less detailed. In the second drawing, and using Figure 5.35 as a rough guide, try to handle the same view in a more linear way, omitting aerial perspective devices. This will make the dynamic activities of the picture-plane more evident, as it does in Lapp's drawing (Figure 5.35).

drawing 3 The model or still life used for this drawing will also be the subject for drawings 4 and 5. The subject should be placed atop a tall stool, desk, or other support higher than a household chair. If the figure is used, the pose should include crossed arms or legs, or otherwise show a variety of directions of the

Figure 5.35
MAURICE LAPP
Stowington, Maine
Pen and ink. 10 × 14 in.
Courtesy of the artist

limbs. If you are drawing from the still life, arrange the components to offer a similar variety of directions. For this drawing, stand at an easel or any comparable support.

Study the subject until you understand the various directions of its major parts. Begin by lightly indicating the horizon-eye-level line. Freely draw the forms of your subject *as if they were simple geometric solids,* as in Cambiaso's drawing (Figure 5.36). The resulting drawing will, of course, look manikin-like, or, in the case of the still life, machine-tooled. But it should clearly show forms turned at various angles in space. As in Cambiaso's drawing, use some tones to help create more solid forms and clearly established spatial cavities. Where possible, indicate the stool or other support, and perhaps some corner of the room.

drawing 4 With your subject in the same position, you are to work this time seated, in a chair, on a low stool, or even on the floor. Begin as you did the previous drawing, by noting the horizon-eye-level line. Though the pose has not changed, your lowered position will have altered all the relationships between the subject's parts. Noting these differences, again draw each form as reduced to a simple geometric state, but this time do so lightly, using as few lines as possible. Once you have established the direction, scale, and overlapping of these forms (which are best thought of now as transparent), continue by drawing upon them what you *do* see of the subject's surface actualities. That is, using the geometric forms as "armatures" that show each part's essential mass and direction, go on to develop the surface forms of your subject. Normally, it is not necessary to use such severely summarized masses as a basis for drawings in which structural solids are to be stressed (we examine that in Chapter 6), but here it helps to control more easily the subject's perspective condition.

As you develop the simplified forms, do not bury them under small details, but keep a strong undercurrent of the geometric "parent" evident in all the final forms, as in Figures 5.29 and 5.37. The rule here can be: "When in doubt, leave it out."

Your goal here is to produce a drawing modeled mainly by structural lines that show convincing volumes in various positions in space as you saw them from your fixed position.

Figure 5.36
LUCA CAMBIASO (1527–1585)
The Martyrdom of St. Lawrence
Pen and brown wash. 9⅜ × 12½ in.
National Gallery of Canada, Ottawa

Figure 5.37
SIDNEY GOODMAN (1936–)
Eileen on Beach Chair
Pencil. 15 × 10½ in.
Courtesy, Terry Dintenfass Gallery, New York

drawing 5 Rearrange the model or still life to create a strong foreshortening among many of the forms, as in Goodman's *Eileen on Beach Chair* (Figure 5.37). Locate yourself so that the subject is just a little below your eye level in order to increase the telescoping of forms. Proceed to develop the forms as in the previous drawing, but here, as in Goodman's drawing, emphasize the shape-state of the parts. This last drawing can be regarded as a kind of summary of the topics covered in the previous chapters, as well as in this chapter. This being the case, consider gesture, shape, line, and value to be as important as perspective. Here, then, perspective no longer dominates but takes its place as one more set of considerations in helping you to "essay" your subject's inherent and potential qualities.

Should you find that any of these exercises is beyond your present level of control, work out the subject's perspective state in a preparatory sketch, and, using it as a guide, begin your exercise on another sheet of paper. You will find the preparatory analysis helps you to place and construct the forms better.

drawing 6 Select a newspaper or magazine photograph of several forms (they may range from boxes to buildings) arranged at different angles on a flat plane. Overlay the photo with tracing paper and, using a ruler, establish the horizon line and the major lines running from the forms to the several vanishing points. When vanishing points lie beyond the boundaries of the photo, locate them by lines drawn onto sheets of paper affixed to either side of the photograph. Look for converging lines that lead to vanishing points above and below the horizon line, as in Figure 5.12.

PERSPECTIVE AS AN AGENT OF EXPRESSION

Perspective can contribute to expressive meanings by enabling the artist to draw a subject from the angle most evocative of its actions and character, and most compatible with the artist's feelings and intent. The view given in Sheeler's drawing (Figure 5.8) stimulates emotions about the scale and character of his subject. His use of three-point perspective helps us feel the building's towering elegance. Piranesi's turbulent drawing *Interior of a Prison* (Figure 5.38) shows a view that amplifies the artist's fascination and

Figure 5.38
GIOVANNI BATTISTA PIRANESI (1720–1778)
Interior of a Prison
Pen and wash over pencil. 25.6 × 18.9 cm.
Kunsthalle Hamburg

Figure 5.39
JACOPO TINTORETTO (1518–1594)
Study of the Head from Michelangelo's "Giuliano de Medici"
Black and white chalk on toned paper (detail)
Rijksmuseum, Amsterdam

dread of his subject. Here, as in Figure 3.24, Piranesi proves that perspective can be a tool of exciting expressive possibilities. In a very different mood, Saenredam's drawing (Figure 5.9) shows a hushed and serene interior. Although both drawings owe much of their expressive force to their handling—Piranesi's furious attack contrasting sharply with Saenredam's delicacy— Saenredam's view is as necessary to his expressive theme as Piranesi's more oblique view is to his theme. Likewise, the expressive mood of Tintoretto's drawing (Figure 5.39) is due in part to the bold foreshortening of the forms of the head. Perspective, then, as these drawings amply demonstrate, need not be thought of as the dry logic of structure and space, but as a fertile source of graphic invention which may influence even nonobjective imagery, as in Figure 5.40.

We have seen that perspective is a given condition of three-dimensional drawing. It helps provide important information about masses in space, and it furnishes the means by which masses can be composed, clarified, and emphasized. Although sensitive visual perception would seem to make the study of perspective almost unnecessary, a firm grasp of its principles endows a drawing with that extra measure of authority and economy that the sensitive beholder recognizes as issuing from knowledge rather than bravado or whimsey (Figure 5.41). Further, because responsive drawing may, for some artists, require considerable changes in what is observed, when such changes concern the relocation of volumes, perspective is immediately involved. While perspective has its limits, it has important virtues, especially in helping us understand the condition of foreshortened forms. Its general influence promotes a sensitivity to the nature and behavior of forms in space—and the freedom to follow our responsive interests.

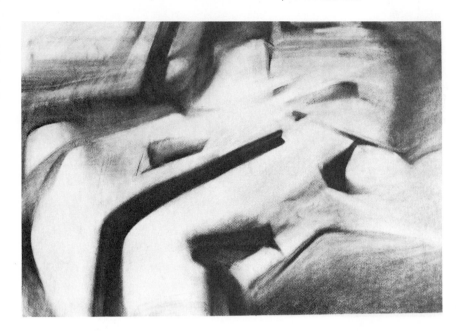

Figure 5.40 (*student drawing*)
Linda Wheadon, University of Utah
Charcoal. 22 × 31½ in.

Figure 5.41
WILFRED LORING (1952–)
Glass Roof (1981)
Aquatint. 28 × 19 in.
Courtesy of the artist

6

VOLUME

the sculptural sense

A DEFINITION

An important consideration in each of the previous chapters was the physical and behavioral nature of volume in space. This is not to suggest that responsive artists are concerned primarily with the depiction of solid masses in some kind of spatial field; our own creative purposes decide what role such matters will play in our work. It is the crippling restrictions on our creative freedom resulting from the inability to create convincing volumes in space that make it necessary to develop the skills that convey such impressions. Then, too, in failing to comprehend a subject's structural condition, we fail to uncover a rich source of dynamic activities. For, as we shall see, important organizational and expressive tactics are revealed by the structure and arrangement of the forms we draw.

In this chapter we will explore, and occasionally review, the various factors that partici-

pate in creating volume and space—not the mere outlining of volumes, not their surface effects, not vague suggestions of volumes, but the convincing impression of solid masses that occupy convincing space, show their various structural conditions and suggest their differing weights and surface characteristics.

Volumes can be represented in two ways. A drawing can describe a subject's outsides, its tonal and textural surface-state, or it can explain its structural nature, the way its parts are constructed, interjoined, and arranged in space. These are not mutually exclusive concerns, and many old and contemporary drawings exhibit forms whose inner and outer conditions are well understood and integrated. Some artists are almost exclusively preoccupied with structural matters (Figures 3.2 and 6.1), some concentrate on surface conditions (Figures 4.29 and 6.2),

while others more evenly address both matters (Figures 5.37 and 6.3). But no artists of serious inventive worth concentrate *wholly* on surface matters. This is hardly surprising, for no visually commendable results are possible without an understanding of a subject's structural and dynamic essentials, and these cannot be replaced by a concentration on surface detail.

In drawings that do concentrate exclusively on the effects of light, texture, and atmosphere, a sense of volume similar to that in an ordinary snapshot of the subject can result. Such an overemphasis on surface characteristics tends to limit the impression of volume in the same way the photograph does. In both, the results are confined to the nature of the light's accidental behavior and the subject's superficial and occasionally volume-denying details. But when the light source is controlled in a way that reveals the subject's volumetric character, and care is given to the arrangement of the subject's parts, striking results are possible in this mode (Figure 6.4). In this chapter we will concentrate on drawings that more plainly reveal a subject's constructional nature, the tensions and energies within and among its parts, and its relationships of direction, shape, location, and scale. These are the visual issues we see at work in both old and contemporary master drawings, as the examples already given illustrate. And it is the mastery of these issues that leads us by the most direct route to our own eventual mode of visual expression.

THREE BASIC APPROACHES TO STRUCTURED VOLUME

The surfaces of all volumes, as we saw in Chapter 2, can be restated as made up of flat or curved planes. Some objects—jagged rocks, bureaus, books, or bananas—clearly disclose their planar construction. Whether simple or complex, their surfaces can be resolved into planar divisions that give such objects great structural clarity. Other forms—flowers, apples, boulders, or animal and human forms—being less angular, show less clearly defined surface facets. The more smoothly rounded a subject's surfaces, the more arbitrarily intrusive it seems to translate them into planar divisions. The sphere, for example, would seem to defy planar analysis. But in drawings showing volume with emphatic clar-

ity, evenly rounded forms are often shown as less smoothly rounded by flat or curved planes that abut at subtle angles, as in de Gheyn's *Three Gypsies* (Figure 6.1). As this drawing shows, such an approach, even when tonalities play a considerable role, often relies on the use of structural line-groupings.

A second approach to structured volume relies less on clearly defined abutments. Instead, the planar-state of forms, especially organic and curvasive ones, is shown by sensitive graduations of value, as in Figures 6.2 and 6.3. Here the planes are more discreetly defined, their clarity conveyed more by tonal than by linear modeling.

A third approach, and one often showing strong calligraphic qualities, combines both tonal and linear drawing, as in Rembrandt's *Standing Male Nude* (Figure 6.4), Bishop's *Two Girls* (Figure 6.5), and Carpeaux's *Study for Ugolino* (Figure 6.7).

De Gheyn in Figure 6.1 constructs the folds of the robes by long convex or concave planes that abut each other somewhat abruptly, thereby clearly suggesting changes in their direction. Despite these sudden and sometimes angular abutments, the forms are not stiff or mechanical but move in a decidedly rhythmic way. Note that de Gheyn models the forms by hatchings that partially encircle the terrain of convex and concave parts *on their darker sides*, thus suggesting a common light source falling from the left.

In da Empoli's drawing, gradual transitions of value explain the fusing of planes to create gently undulating, "caressed" surfaces. But unlike de Gheyn, who permits unexplained (but implied) planes to be represented by the white of the paper, da Empoli insists on value variations that show every nuance of change in the figure's surface-state. However, in the man's drape, the values are less blended, producing a bolder planar construction. This change in tactics from subtle graduations of tone to a more linear and planar treatment helps the artist to reinforce the textural differences of these two areas.

A drawing by Legros (Figure 6.6) is of interest here because it shows several stages of its development. In the left leg and right arm we can still track something of the initial gesture drawing. Much of the drawing shows the structure-line hatchings by which the planes and values of the forms are first established. This treatment is not unlike DeGheyn's manner of "riding the waves" of a subject's changing surfaces, al-

Figure 6.1
JACQUES DE GHEYN (1565–1629)
Three Gypsies (c. 1605)
Pen and brown ink on buff laid paper. 22.5 × 25.7 cm.
Courtesy of The Art Institute of Chicago. Margaret Day Blake
Collection. Photograph © 1990, The Art Institute of Chicago.
All Rights Reserved

though Legros' lines (and the lines in da Empoli's drawing of the man's drape) are drawn faster and straighter than the more sensual turnings in the DeGheyn. On the more fully developed left side of the figure in the Legros drawing, the more tonal approach of da Empoli can be seen. Although all three artists suggest an illuminating source, none permits any part of the subject to be lost in shadow. Even though da Empoli's and Legros' drawings suggest that the back of each figure is in shadow, every form unit is volumetrically clear. Likewise, the planar surfaces

of the center figure in de Gheyn's drawing are visible even when they are shaded by the robe and arm.

Notice how these three artists create spatial depth. Da Empoli uses a series of faint, curved lines to imply an area of space behind the figure. When we look at the figure, we are not immediately aware that the background is comprised of lines, but we do sense space around the figure.

De Gheyn's solution for establishing spatial depth is simply to draw small, vague cast shadows at the base of the figures, the obliquity of the

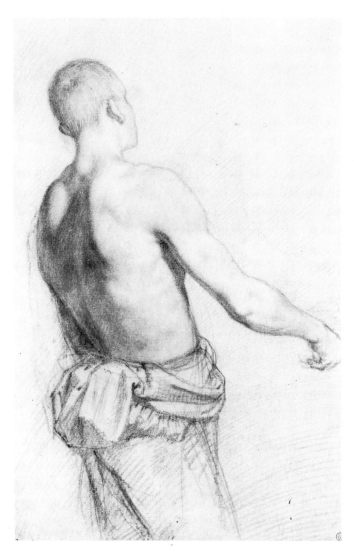

Figure 6.2
JACOBO DA EMPOLI (1551–1640)
Young Man, Seen from the Back
Red chalk. 16 × 10⅝ in.
The Pierpont Morgan Library, New York

Figure 6.3
MEL ROSAS (1950–)
Porch Display (1978)
Charcoal on paper. 28½ × 40 in.
The Arkansas Arts Center, Little Rock Foundation
Collection: The Museum Purchase Plan of the NEA and the
Tabriz Fund, 1980

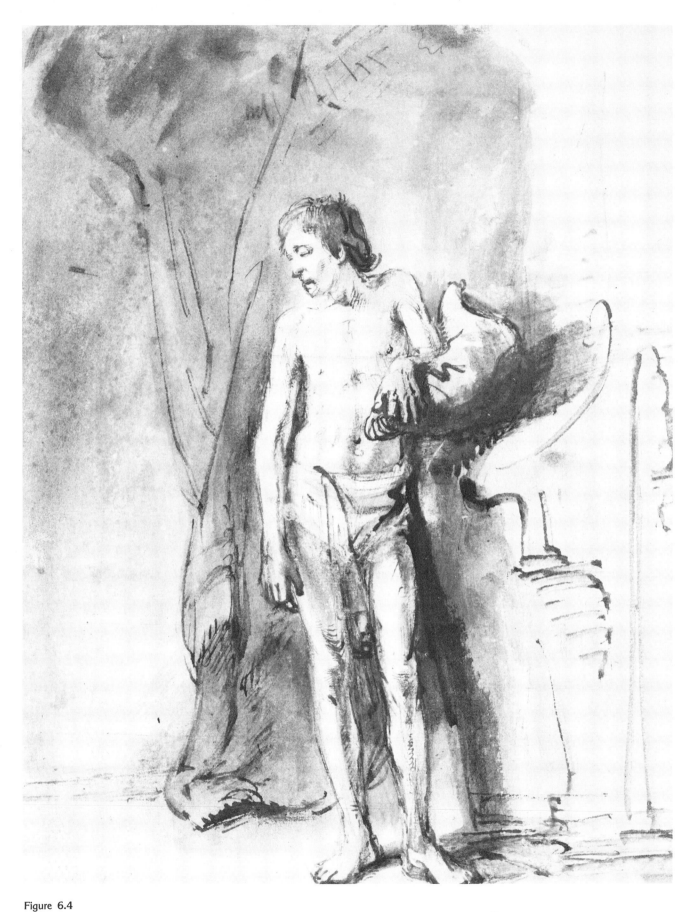

Figure 6.4
REMBRANDT VAN RIJN (1606–1669)
Standing Male Nude
Pen and brown wash, heightened with white.
25.2 × 19.3 cm.
Reproduced by courtesy of the Trustees of The British Museum, London

147

Figure 6.5
ISABEL BISHOP
Two Girls (c. 1935)
Mixed media. 17 × 23 in.
The Butler Institute of American Art, Youngstown, Ohio

shadows suggesting a ground-plane that extends behind the group. Legros, on the other hand, suggests space by the tone separating the torso from the arm on the right side, and by the rough suggestion of the form on which the figure is seated.

Rembrandt, as was mentioned earlier, uses both line and value to explore and explain structural character. In the broad and vigorous handling of the background, he relies mainly on line to establish the boundaries of planes, and to suggest some folds in the drape behind the figure's right side. A light tone that envelops over two-thirds of the background serves to push the figure forward, as in da Empoli's drawing, and, in its several variations, creates the spatial cavity occupied by the figure. On the drawing's right side, bold cast shadows help explain the masses of the supporting pillow and the surface against which the figure stands. As the cast shadow descends, it "measures" the increasing divergence and ad-

vance of the figure's left leg from the nearby wall. In drawing the forms that make up the young man's figure, Rembrandt more evenly divides the roles of line and value to develop the volumes. Usually, short, structural hatchings define sudden changes in direction between planes, and washes of tone explain the more rounded forms or serve to push back large segments, such as the upper part of the supporting leg. Here, as in the de Gheyn and da Empoli drawings, illumination helps to explain, not obscure, the subject's structural character. Note that Rembrandt considers the tonal order and shape-state of the dark as well as the light areas. The dark areas are not merely "left" as a result of a concentration on forms in the light. Thus, a two-dimensional pattern of light and dark tones, and a concern for the structural conditions of forms in shadow, as well as in light, reveals two deliberately conceived systems of design and structure that interwork to activate the forms they describe.

148

Rembrandt often relies on broad planes to stand as summaries of several smaller ones, gaining the structural clarity and strength that such a succinct analysis provides. For example, a single faint tone describes a broad plane at the side of the head, bounded at the top and left side by the ridge of the cheekbone. Such incisive carving reveals a grasp of structural issues too often obscured in more detailed approaches. In Bishop's drawing, too (Figure 6.5), there is an assured and vigorous use of line and tone, and a sensitive simplification of planes (especially in the two heads) that helps us find our way upon the forms. Note the animated calligraphy of the hatchings—a fine example of the fact that structural modeling needn't be either mechanical or mannered.

Carpeaux's drawing (Figure 6.7), a study for a sculptural work, also combines tonal washes of grays and grays formed by line groups, to more fully explore volume. Here there is the need to examine each part's structural essentials and the overall structural behavior of five interwoven figures. Carpeaux's study aims at understanding the major planes that form the parts of each figure; the spaces, or negative "masses" that result from the placement of the figures; the compositional and dynamic character of the group; and the way light plays across the forms from this view. By drawing on a toned surface and adding both light and dark tones, Carpeaux gains a further measure of control in modeling the forms. The results of such analytical approaches to volume as Rembrandt and Carpeaux utilize enable them to indicate structural and spatial qualities that would otherwise be lost.

To disregard the interlocking, directional behavior of a subject's planes weakens the impression of volume. Trying to convey the weighty substantiality of solids in space by copying their externals only *re-presents* the subject's superficial and random properties—some of which actually obscure the essential nature of the volumes.

As we have seen, there are a number of factors that participate in creating the convincing impression of structured volume. Whether it is general information about masses in space that result from the search for their gestural behavior, for shape, line, or value, or for the more specific information provided by the principles of perspective, or any of the other volume-revealing considerations already discussed, the sense of

Figure 6.6
ALPHONSE LEGROS (1837–1911)
Study of a Figure
Red chalk
The Metropolitan Museum of Art
Gift of the artist, 1892. All rights reserved, The Metropolitan Museum of Art

solid masses results from the *choices* and *changes* such perceptions make possible. To establish volume, it is always necessary to analyze and extract the measurable and dynamic qualities that define it.

In the energetic drawing by Delacroix, *Studies after Rubens' "Crucifixion"* (Figure 6.8), there are some extreme examples of just such extracts from some forms in a Rubens painting. We see these forms as both weighty and animated be-

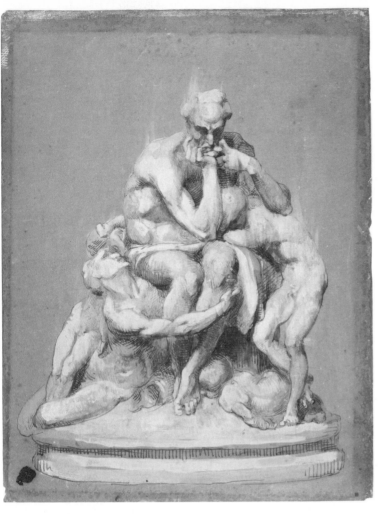

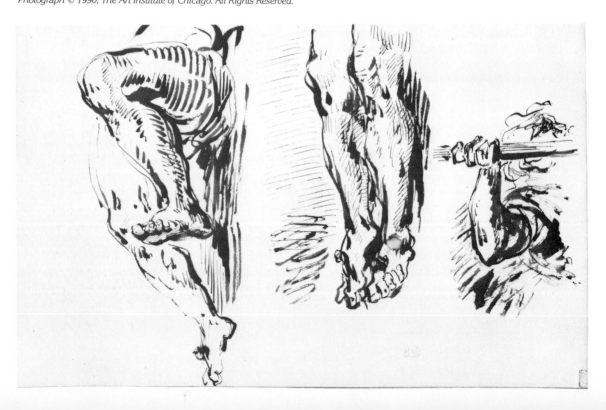

cause Delacroix stresses these qualities. In making this sketch he knew what his interests and intentions were and, consequently, so do we.

This drawing, made not from nature but from a work of art in which the volumes of the original subject have already been interpreted and translated into visual terms, is a kind of double extraction. Perhaps that is what makes Delacroix's brief sketch appear to seize the very essence of the structural character of these human forms. Although Delacroix's spirited approach to drawing is quite different from Rubens' more sensuous one (Figure 6.9, and see also Figure 2.26), each in its own way builds powerful volumes from an excited involvement with the processes and concepts of structural *and* dynamic inquiry. For, just as gestural drawing includes (or develops into) a search for the subject's structural generalities, so must the structural analysis embrace considerations of the subject's actions

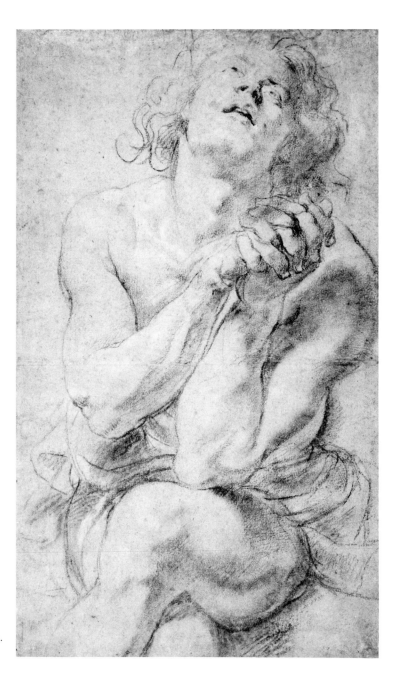

Figure 6.9
PETER PAUL RUBENS (1577–1640)
Study for "Daniel in the Lion's Den"
Black chalk, heightened with white. 50.3 × 30 cm.
The Pierpont Morgan Library, New York

and energies. To do otherwise too often results in drawings that are rather dry inventories of planar facts, unfertilized by feeling.

DIRECTION AND
GEOMETRIC SUMMARY

The impression of structured volume, like most other goals in responsive drawing, is usually arrived at by working from generalities to specifics. The artist, like the sculptor, generally states the broader planes of his subject before the smaller ones. Indeed, neither one can know with any certainty just where smaller planes are to be located until the broad "parent" plane is established, because the smaller ones are always variations on the direction of the parent plane and depend on *its* position for their own.

This is especially evident when we are drawing forms that are naturally almost pure geometric volumes. But in complex forms the superficial details of surface and texture can easily divert a student from perceiving the direction of major planes or of entire masses. For example, few students are likely to overlook the basic planes and directions of an old stucco wall by any minor variations in its surface-state due to aging or an uneven application of stucco (Figure 6.10A). However, as such variations increase in scale and frequency, the likelihood of disregarding the wall's position in space, as well as the major planes of which it is constructed, increases (Figure 6.10B). When we consider the many volumetric complexities of subjects such as human figures or cityscapes, the need to understand each part's direction and those of its major planes becomes apparent.

There are, generally, two unfortunate results when a concern for details overrules the early establishment of a subject's position in space and the location of its major planes. First, because what is not perceived is only accidentally (and rarely) drawn in accordance with the subject's actualities, the probability of error in any part's direction, location, or proportions is very high. Second, beginning with details and permitting them to determine the whole, is, as we saw in Chapter 1, a sequential, piecemeal process in which little particulars fail to unify into an organized whole. It is the tail wagging the dog.

It thus violates the way we see forms in nature. A form's volumetric character is not perceived by adding up its details. Rather, the details are seen secondarily as particular facts belonging to a volume whose general structure is understood. If, for example, we are asked to identify, say, a human head flashed on a screen for one-tenth of a second, we may recognize it by its general shape and structure, but we are not likely to have seen details of its surface structure, texture, or illumination.

In drawings that include a considerable amount of volumetric or other detail, the major planes and masses must maintain their dominance over smaller ones. When their influence as basic planes and masses is buried under minor embellishments, both the structure and the unity of the forms are seriously weakened.

The persistent influence of major planes and masses seen "through" the details is readily sensed in Michelangelo's imposing study (Figure 6.11), and in an early Degas drawing (Figure 6.12). In these drawings, otherwise so different in mood and manner of execution, there are

Figure 6.10

Figure 6.11
MICHELANGELO BUONARROTI (1475–1564)
Seated Nude and Head Study
Black chalk. 24.3 × 18.3 cm.
Teylers Museum, Haarlem, The Netherlands

many similarities. But in neither do the parts merely "add up" to become the figure. Nor, in either drawing, do the parts of the figure result from an accumulation of details. Instead, the details are seen as subtle planar and tonal variations on the basic geometrical, directional, and tonal condition of these forms. They well up from the forms and "belong" to them.

Likewise, the position in space of the figures themselves does not result from their parts

having been drawn separately. Seeing the figure's overall direction in space (note the search for the entire figure's direction in the beginning few lines of a second nude in the Degas drawing), each artist was better able to locate the direction of arms, legs, and other parts to it, and relate these parts to each other. In both drawings, the parts are subordinate to the whole. In both drawings we even sense the basic geometric core that underlies each of the smaller form-units

Figure 6.12
EDGAR DEGAS (1834–1917)
Standing Nude
Pencil. 11½ × 8⁹/₁₆ in.
Sterling and Francine Clark Art Institute, Williamstown, Mass.

which make up the figure's forms. And each of *these* is a convincing structural form with its own hierarchy of essentials and details, that has weight and occupies a specific direction in space. Note that neither artist relies much on smudges of tone to model the forms, but rather establishes the masses by subtle hatchings. These are more involved with a tactile experiencing of the sub-

ject's terrain than with the effects of illumination. In these drawings, light's ability to reveal form is integrated with, but subordinate to, modeling based on the structural clarity of major planes and masses.

When a subject *is* comprised of many independent volumes, the danger of disregarding its overall mass is increased. If in the earlier exam-

Figure 6.13

ple the wall were made of casually heaped fieldstone instead of stucco, a greater analytical effort would be required to see its overall mass as reducible to a basic mass. The more the independent volumes that form a greater mass are scattered, the more difficult it is to see their collective form. The direction and basic mass of the tightly constructed wall (A) in Figure 6.13 is easier to see than in the wall formed by loosely piled stones (B).

Unlike the walls in Figure 6.10, which are both reducible to slender, vertical slabs inclined toward the horizon to the observer's right, only the tightly constructed wall in Figure 6.13 approximates a similar volume-summary. Although both walls in Figure 6.13 go in the same direction as those of Figure 6.10, the loosely constructed wall (B) is more accurately analyzed as a half-cylinder. Discerning a form's volume-summary is essential to its more specific development. Leonardo da Vinci's drawing of stratified rocks (Figure 6.14) clearly shows his grasp of the basic masses that unite the subject's many independent volumes. Indeed, it seems that discovering such summaries is part of this striking drawing's visual and expressive theme.

In analyzing structure, then, the two basic perceptions of a subject's masses are its main directions and volume-summaries. Both require an effort to temporarily bypass smaller planes and volumes to be seen—and much depends on

their being seen. The more complex a subject's forms are, the greater the need to see such generalities first. There are three basic ways of approaching these simplifications.

Some artists begin by actually drawing the subject's basic masses in a manner similar to those described in Exercise 5B. However, such severe reductions are often felt to be too mechanical or too removed from the character of most subjects. Therefore, many artists who begin by showing a subject's volume-summaries arrive at simple geometric masses that are less extreme. They search for simplifications that clarify perspective but still retain the major, and even some of the secondary, structural features, as in Cambiaso's drawing (Figure 5.36). Although the Cambiaso is a completed study, it is sometimes useful to establish such a stage of form simplification even when the volumes are to be developed further. Unencumbered by many small planar changes, by texture or by the effects of illumination, perceptions concerning direction, scale, shape, or location can be more easily established. Making adjustments in such perceptions before the forms are developed further avoids the later, more difficult changes that are so injurious to a drawing's spontaneity.

Other artists, such as Cézanne (Figure 6.15), start by drawing only a few abbreviated hints about a subject's volumes in space, again somewhat simplified for the sake of clarity. This second

Figure 6.14
LEONARDO DA VINCI (1452–1519)
Outcrop of Stratified Rock
Pen over chalk. 18.5 × 26.8 cm.
Royal Collection, Windsor Castle

Figure 6.15
PAUL CÉZANNE (1839–1906)
Quais avec pont et barque (c. 1880–83)
Pencil. 17¾ × 21¾ in.
The Arkansas Arts Center, Little Rock
Collection: The Fred W. Allsopp Memorial Acquisition
Fund, 1983

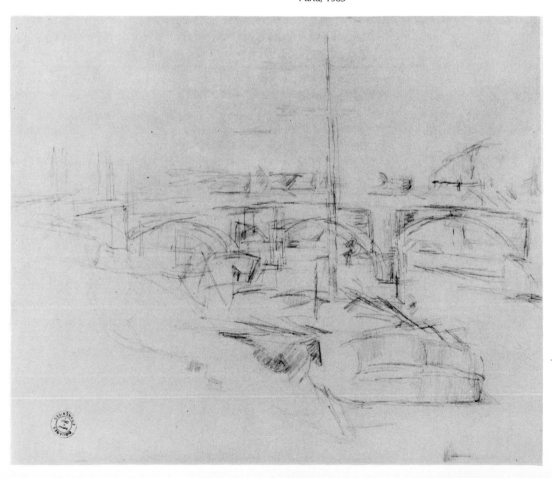

Figure 6.16 (*student drawing*)
Marsha Warren, Art Institute of Boston
Reed pen and ink. 14 × 17 in.

approach is preferred by those who feel it is too restricting to divide the act of drawing into separate stages. Once established, these more briefly stated forms can be integrated, as they are developed, with other, nonstructural considerations. Sometimes such condensed structural statements, reduced to the barest of visual clues, are intended as a drawing's final state, as in Figures 1.16, 3.8, and 6.14.

This second approach is also useful where the nature of some drawing media, as, for example, pen and ink or wax-based crayon, make any extensive underdrawing impractical, as in Figure 6.16. Finally, this approach is practical where an artist's intention is toward simple and spontaneous images that exhibit structural conditions clearly (Figure 6.17). Because this approach places a higher priority on the economy of means, many of the volume-summaries must be conceived in the mind's eye rather than worked out on the page, as is possible in the first approach.

Still other artists begin a drawing in the charged spirit of a direct attack—intending each

line and tone as final. Although some changes and developments in the initial drawing usually take place, the intention, at least, is to state the total interpretation of their subject in one spontaneous encounter, responding to all of the visual and expressive stimuli simultaneously. Here again, the volume-summary of parts must be understood not by feeling one's way to a solution while drawing, but before the part is drawn. Held in the mind's eye, it serves as a guide, as a kind of invisible scaffold upon which the form is built. Of course, envisioning the simple form-summary of an observed part while you draw its *final* form "over it" requires an ability to reason in visual terms. It is the ability to sort out its important (usually largest or visually dominating) directions, shapes, and planes from lesser ones to "see" what simple mass can be fairly claimed to underlie it.

Millet's direct drawing (Figure 6.18) reveals his envisioned form-summaries. We can name the geometric mass underlying virtually every part, from the truncated cones of the cooking

Figure 6.17
RENE MAGRITTE (1898–1967)
Untitled (c. 1963)
Ink on paper. 9 × 6¼ in.
The Arkansas Arts Center, Little Rock, Foundation Collection:
The Memorial Acquisition Fund, 1964

Figure 6.18
JEAN-FRANCOIS MILLET (1814–1875)
Young Mother Preparing the Evening Meal
Pen and brown ink. 8³⁄₁₆ × 6¹¹⁄₁₆ in.
National Gallery of Canada, Ottawa

vessel to the cylinders, wedges, and blocks of the figures. Some form-units, while they do not conform to namable geometric solids, are clearly legible, as in the woman's skirt, where large interlocking forms are simple variants of spheres, cones, and cylinders. And, as in all master drawings, Millet's certainty about the rightness of his form judgments is reflected in the conviction with which the parts are drawn.

PLANAR ANALYSIS

All three approaches we have been discussing utilize an important process in the analysis of a form's structure, which holds that planes are the basic structural unit of volume building. And, while planes, in drawing as in painting, can be stated by value, line is the most frequently used element, its presence sensed even in the boundaries of toned shapes.

The process, therefore, uses line diagrammatically to run between *key structural points,* measuring the distances that separate them.

These reference points occur on *and within* a form's boundaries. We find them at the junction between planes as occurs on outer edges where the changing direction of an edge indicates the differing lengths of totally foreshortened planes, as in Figure 6.19A; or at the junction of inner edges that establish a plane's particular shape, as in Figure 6.19B. Here, schematic lines not only measure the distance between points along edges, but estimate distances between points on widely separated parts. For example, the lines running from the hat's brim to the cheek, and from the nose to the shoulder, measure the relative distances between these parts. Additionally, some lines establish true verticals and horizontals to serve as references for the various angles of other lines and form-units, while other lines reduce observed curved boundaries to several straight line-segments (Figure 6.19C). Naturally enough, such a search for the relative length of planes and edge segments and their differing directions provides an important means for determining the location, shape, and scale of whole parts.

Figure 6.19

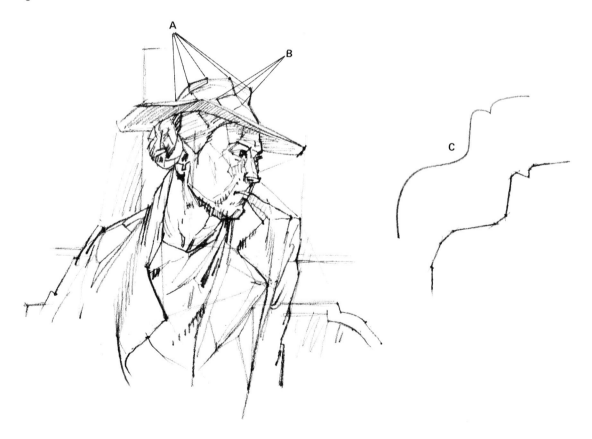

As in the case of volume-summaries (which this process so importantly assists), often such key structural points are not drawn but are held in mind as important places where some change in the direction of an inner or outer edge marks a visually logical stop—and a structurally significant fact. As such points are found and the lines that connect them are drawn, planes emerge.

As was noted in Chapter 3, such an analytical underdrawing intellectually responds to the *principles* of the subject's structure rather than to perceptions of textured, illuminated, or inherently toned surfaces. Often drawings developed in this way, at least in their early stages, show forms as if they were transparent—the results of measurements that search out the width, depth, and axes of parts as well as their lengths. Thus, as in Figure 6.19, a kind of skeletal framework of points and lines emerges that, in noting mainly the straight or simple C-curved paths between key points, creates simplified planes that cut through the surface complexities of a form (especially intricate organic ones). This helps the artist to establish the volume-summaries that organize even the most involved complex of forms. And, as we shall see later in this chapter (and in Chapter 9), such a structural armature is important not only as a means of understanding a subject's architectural system, but as a helpful tool in discovering dynamic relationships as well. Of course, some artists find in this process a basis for their creative activity. In Figure 6.20, the exploration and eventual fusion of the subject's volumes and "volumes" of space are Giacometti's main theme.

However, this important means for relating measurable matters, developed in the Renaissance and utilized at least to *some* degree (often subconsciously) by all artists, can, if too exclusively pursued, overrule those dynamic responses that make drawings come alive. For, as in Giacometti's engaging work, the best drawings always disclose a fusion of facts and feelings, and to displace intuition and empathy with a dry intellectual examination of a subject's structural condition upsets the necessary and delicate balance between discipline and indulgence that gives master drawings their individual character and spirit.

Although some artists, like da Empoli, sometimes prefer to lessen attention to a subject's structural condition and to concentrate instead on a fuller exploration of light, local-tone, and texture, others, like Delacroix (Figure 6.21) and Jacques Villon (Figure 6.22) emphasize a planar simplification of volume, achieving a sculptural quality. In such drawing, volume-summaries, with few modifications, become final structural statements. The sculptural nature of this kind of bold modeling is especially evident in Villon's etching, which is in fact a work based on a sculpture by his brother, Raymond Duchamp Villon. Here, the chin, a block-like form jutting out at almost a right angle to the thin, clearly defined plane under the lower lip, is typical of the incisive carving of the rest of the head. Note how the planar clarity of the nose, ear, forehead, and cheek rule out any misreading of these form-units.

Figure 6.22 illustrates another helpful device for conveying volumes in space: "stacking" volumes one upon the other to emphasize their

Figure 6.20
ALBERTO GIACOMETTI (1901–1966)
Chambre d'hotel IV (1963)
Pencil. 50 × 33 cm.
Kunsthaus Zurich, Alberto Giacometti Foundation

great clarity, but his more sensual approach to volume sharply contrasts with Villon's more intellectual one.

A brief summary of the perceptions necessary in analyzing a subject's structural nature would be helpful here. We have already seen the importance of an early noting of the subject's gestural character, shape-state, tonalities, and its perspective conditions, and we have examined some ways of establishing these underlying, basic states.

Figure 6.21
EUGENE DELACROIX (1798–1863)
Nude Woman
Pen and brown ink, 6¹¹⁄₁₆ × 4⅛ in.
Sterling and Francine Clark Art Institute, Williamstown, Mass.

Figure 6.22
JACQUES VILLON (1875–1963)
Portrait of Baudelaire
Etching. 24⁷⁄₁₆ × 17⅝ in.
Collection, The Museum of Modern Art, New York
Gift of Victor S. Riesenfeld

relative locations in space. By drawing the head set upon a pedestal, which in turn is placed upon a flat surface, Villon provides clear, planar guides that help us understand the head's location to be well back of the picture-plane and at our eye level. Here, as in the da Empoli drawing, the lines of the background tone pass behind the head, adding to the impression of its existence in a spatial field.

Delacroix, using more curved than flat planes, draws the figure's forms as simplified masses that occupy clearly readable positions in space. For example, note the subtle difference in elevation between the left and right legs, and the differing axes of the upper arms. Like Villon, Delacroix explains the form's structural nature with

Without a grasp of the subject's physical and dynamic gestures—of what it is *doing* at both the representational and abstract levels—we miss the necessary understanding of the subject's overall actions and patterns. And, as was noted earlier, such a perceptual omission not only risks stilted drawings that seem made up of isolated units, it also results in missed insights concerning the subject's volume generalities, its important axes, shapes, and scale differences.

Without a deliberate examination of negative as well as positive shapes, countless misjudgments accumulate, each one causing the drawing to drift farther away from the actualities. And, because planes must be simultaneously understood as shapes, no useful understanding of structural conditions is possible without a search for shapes.

Without a study of the subject's tonalities, important structural clues are missed. Disregarding the subject's tonal facts also bypasses important representational and dynamic truths which both serve and stimulate structural understanding.

And without a sense of the perspective principles at work from our view of a subject, broad structural and spatial essentials are missed.

As these basic perceptions are made, a general and *tentative* armature emerges that both holds and guides further structural (and dynamic) observations and ideas. This armature is regarded as tentative not only because further perceptions will be drawn over it, but because some of these perceptions may uncover ways in which the armature must be adjusted. Therefore, it is best to regard these first estimates and insights as exploratory and to state them economically in a light and fluid manner. Being approximations, they are almost always right in noting essentials but frequently somewhat "off" in exact measurements of shape, scale, location, or direction. Yet without these preliminary probes—"near misses" and all—our subsequent estimates and judgments about the subject's structure *and spirit* are almost impossible to establish.

Such scaffolds prepare the way for further structural development in two important ways. First, any greater form, if it is to retain a sense of its basic volume character and unity, requires its component parts, large and small, to be subordinate to it. Many otherwise admirable student drawings have suffered because a part "broke away" from its major form, as in, say, a figure drawing when a muscle is shown as a self-contained unit, isolated, and as visually attracting as its parent form. Or, when a few folds of a coat sleeve appear more important than, and compete with, the arm inside. Establishing the greater form first increases its influence in the drawing's final state and helps to govern the visual power of its components.

Second, locating the directions of the greater planes and masses guides us in locating all smaller ones. If the subject is, for example, a hand, its mitten-like mass should be known before the structural nature of its major subdivisions is considered. Seeing these should, in turn, precede the drawing of specifics—fingernails and skin folds (Figure 6.23). As was noted earlier, reversing the visual order of showing smaller parts as belonging to larger ones isolates the specifics as ends in themselves, obscures the character of the greater volume, and destroys the unity of the drawing.

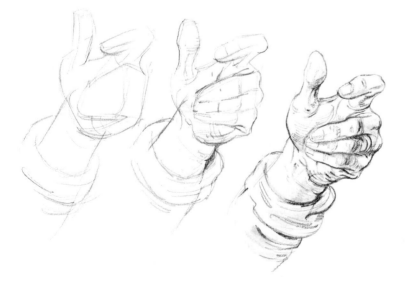

Figure 6.23

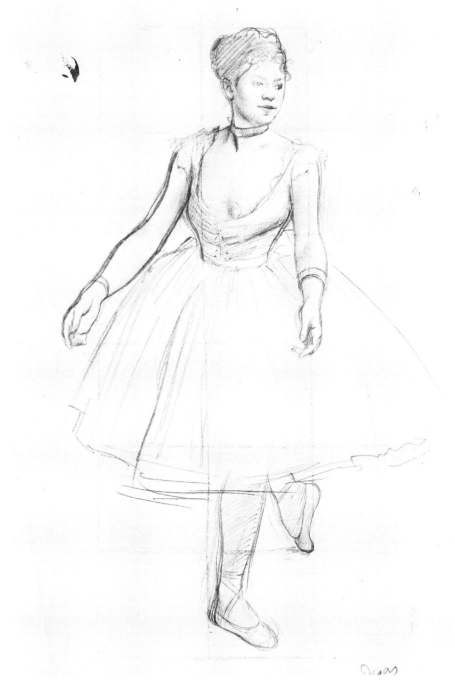

Figure 6.24
EDGAR DEGAS (1834–1917)
*Ballet Dancer in Position Facing Three-Quarters
Front* (1872)
Black graphite and crayon, heightened with white chalk
on pink paper. 16⅛ × 11¼ in.
*Courtesy of Fogg Art Museum, Harvard University,
Cambridge, Mass. Bequest of Meta and Paul J. Sachs*

In forming such tentative frameworks, it is best to rely on diagrammatic and structural uses of line, as in the Degas study of a dancer (Figure 6.24), for our interest here is in developing an efficient and economical means of stating the measurements necessary to establishing a subject's structural condition. While calligraphic and expressive line activities are intrinsic to responsive drawing, they are not, strictly speaking, *directly* involved with measurement. Rather,

they reflect our feelings about a subject's structure and spirit. Therefore, even when the only line describing, say, a shore's curving edge is richly calligraphic, its length, direction, and position in the drawing are essentially diagrammatic properties of that line. Thus, whatever our temperamental disposition to line may be, in the early analysis of structural matters we must recognize its primary function to be investigatory.

THE JOINING OF PLANES AND VOLUMES

Any ambiguity in the direction of planes, or in the way they join to produce volumes, interrupts the continuity of the structural and spatial clarity of volumetric drawings. Although some structurally unexplained passages are often found in master drawings (Figures 6.1, 6.8, 6.11, 6.21), they are never the results of indecision or innocence. Sometimes such drawings are preparatory studies for works in other media, and the artist develops only those areas of the subject that he or she wishes to study more fully. Often undeveloped passages serve compositional or expressive interests.

In master drawings that stress volumes in space, undeveloped areas often serve as passive foils for other areas that stand out as crescendos of structural emphasis. In this way, the weight and sculptural strength of emphasized parts take on greater visual and expressive meaning. In such master drawings, unexplained passages, when consciously left, are intended; when subconsciously left, they are necessary. But they are never perceptual failings or oversights.

Nor are such unexplained areas *wholly* without volumetric clues. In Figure 6.8, Millet provides strong hints about the surface-state of the woman's arms, back, and skirt by the shapes of the planes and the nature of the contours surrounding these "empty" passages. In Delacroix's drawing (Figure 6.21), the differing directions between the figure's right thigh and hip are clear, though no line or tone marks the end of one part and the beginning of the other. Some of the appeal of these two drawings comes from our realization that so much is established by so little. Both are good examples of how much economy is possible in structural drawing. Note that, although both are pen-and-ink drawings, we can find, especially in the Millet, lighter, schematic lines along inner and outer contours and at junc-

tions between planes—evidence of the preliminary framework.

But for the student the sculptural attitude toward forms should be tested through the experience of working from a subject's broader planes and masses to those smaller ones that clarify specific volume characteristics of its parts. In doing so, care must be taken to select only those small planar surface changes that are most informing of a part's smaller form-units. Just as in drawing major planes and masses, small ones are clarified by seeing *their* direction, shape, and location, summarizing *their* volumetric character, and explaining, by lines and tones, the way *they* join with other parts. The scale of a part or plane, then, should not affect the way it is perceived or developed. The planes of a pebble, blossom, or eyelid are as deserving of structural analysis as are those of a mountain, tree, or person.

It is helpful to think of every joining of planes or volumes, large or small, as interlocking, clasping, impacting, or fusing. The clarity and conviction with which unions are drawn require more than sensitive perceptual skill. They demand *felt* responses to the ways they join. Although the drawings reproduced in this chapter are highly individual in temperament and intent, they all reveal the artist's feelings about the nature of the unions between planes and masses. Hence, seeing the relative scale, location, direction, and essential shape-state or mass of every plane or form is necessary to the clarity of their various joinings, but feeling the gentle or driving energy behind such joinings invests a drawing with the expressive nature of the subject's structure.

The gestural characteristics of such unions are limitless. They may suggest slow, subtle movements, as in the way the column of the young man's neck in da Empoli's drawing (Figure 6.2) seems to lift gracefully from deep between the shoulder masses that appear to part and allow its rise. Or they may seem fast and forceful, as in the interlaced race of folds around the young man's waist. They may be given to variously gradual fusions, as in Degas' figure drawing (Figure 6.12), or to sudden abutments of planes and wedge-like interlockings of form-units, as in Carpeaux's drawing (Figure 6.7) and Villon's etching (Figure 6.22). They may be frenzied couplings, as in Delacroix's drawing (Figure 6.8), or rhythmic, as in Leonardo da Vinci's (Figure 6.14). Often the nature of form-joinings eludes any verbal description.

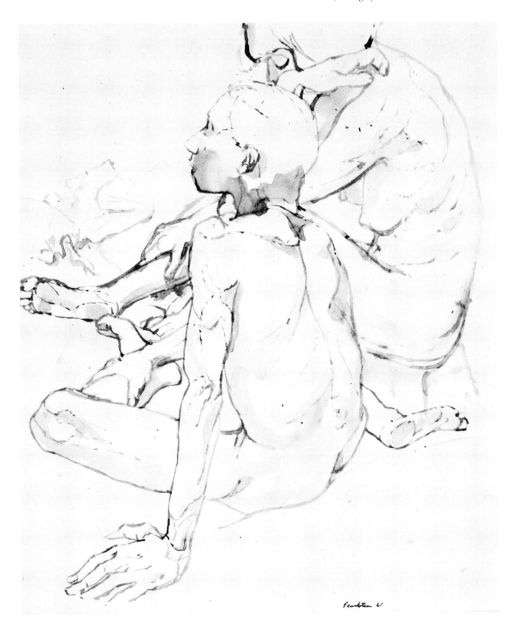

Figure 6.25
PHILIP PEARLSTEIN (1924–)
Two Seated Nudes
Wash drawing. 22 × 30 in.
Courtesy, Allan Frumkin Gallery, New York

Pearlstein, in his drawing of two nudes (Figure 6.25), emphasizes the boundaries and unions between form-units by dotted lines, solid lines, and washes of tone. Note the artist's sensitivity to subtle joinings, such as occur in both torsos.

Another aspect of structure to be considered concerns inner or hidden supports. Some subjects such as human or other living forms, buildings, furniture, or even a log pile are constructed of parts which support and other parts which are supported. These form-arrangements create tensions and pressures between the parts of such subjects. Some of these forces are actual, some are implied. When a subject's forms are supported by, suspended from, or attached to an

inner skeletal framework such as a human or other skeleton, or when naturally limp materials like cloth or leather are supported by solid masses beneath them, there are real tension and pressure between the visibly "held" and the inner "holder."

In such constructions, the supporting structure, whether skeletal or solid, is sometimes stable, as when a cube supports a cloth draped over it. Removing the cloth does not affect the cube's construction or behavior. Other constructions depend on mutual support among the parts. Two poles holding up a pup tent are themselves held in place by the balanced weight and tensions of its canvas cover, stretched taut when stakes are driven into the ground at each of its four corners. The human figure's construction is of the latter kind. Its inner supports and outer suspensions assist and restrain each other.

In such subjects the forces of weight and tension—the burdens of support and containment—create folds, bulges, and sags that disclose the strain, resistance, and pressure between the holder and the held. To infuse a drawing with the power to convey the *feel* as well as the *look* of such force and counterforce, the artist must empathize with the struggle between the inner and outer parts of his or her subject, must feel the weight and strivings of the parts. The force of gravity is an important participant in the struggle between the parts. Supporting frameworks, in addition to the tensions and pressures between themselves and the material they support, also resist the force of gravity upon themselves and the supported material.

The pressure upon the right shoulder of the figure in Michelangelo's drawing (Figure 6.11), the straining of the bones and muscles of the shoulder and the chest against the thin container of skin, the pressure of the heavy upper body upon the midsection—these are more than accurately noted observations. They are deeply felt responses to the actualities of the figure's structural character—intensified to express the artist's feelings about the drama of the powerful struggle of physical forces within and upon the figure. Likewise, in Delacroix's sketches from a Rubens painting, bone, muscle, and skin all strain, press, and resist each other to achieve a balance of forces. The knee bone of the figure's raised left leg, at the far left of the drawing, is barely constrained by the taut skin covering it. The lower leg drives up hard against the upper,

which swells with bulging muscles that tell of the pressure upon them. At the drawing's far right, the bone at the elbow shows the strain of the arm's burden—of its being forced down while it strains to support its load. These actions strike us as highly charged because Delacroix (and Rubens) felt their force, and intensified it.

Empathic responses to the ways in which planes and masses join, and to those generated by a subject's inner and outer structure and weight, help endow a drawing with a "life" that is the graphic equivalent to those qualities seen and felt in living subjects. But such responses are not restricted to organic forms only. All forms generate movement energies and tensions, and whether the energies are actual or inferred, the artist must feel the force of their structural activities as "meant" or necessary—as inevitable actions inherent in the subject's construction. To the extent that we can identify with these actions, our expressive involvement deepens, urging more incisive drawing solutions (Figure 6.26).

That such energies can come alive in inanimate objects can be seen in Goodman's *Wrapped Still Life* (Figure 6.27). The force with which the table's edges seem to push against the drape, and the drape's own harsh, planar facets create tensions and rhythms that activate what might otherwise be a dull subject. Indeed, the artist, in emphasizing the structure of the forms and the strong light falling upon them, creates a sense of expectancy and dread.

Pontormo's drawing *Striding Nude* (Figure 6.28) suggests the energies that drive planes and volumes into strong unions, and those issuing from pressures and stresses between inner and outer parts. Note how the volumes around the shoulders, knees, and ankles insert and clasp each other with hard intent. The planes abut with vigorous certainty, enacting the forceful energy of the interlockings among the form-units they produce. The skeletal framework emerges from deep within the figure to press against the containing surfaces at the ankles, knees, elbows, and at several places on the torso, creating firm anchors against which the muscles strain. The entire figure seems to vibrate with the activity of forms pressing, straining, and resisting.

Pontormo's interest in such energies is apparent in the way he suggests animated "ripples" of motion that course through the figure, and lesser ones that move between the parts.

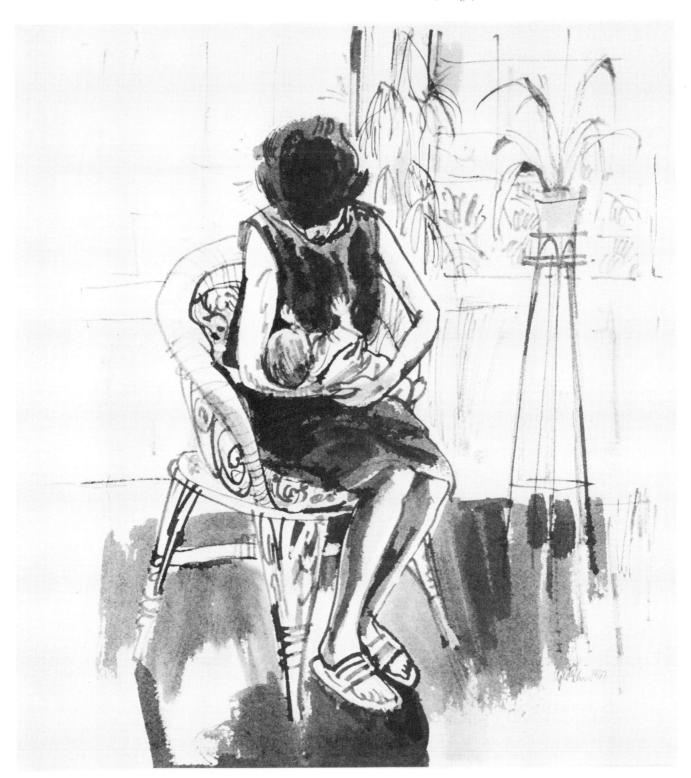

Figure 6.26
NATHAN GOLDSTEIN (1927–)
Mother and Child
Pen, brush and sepia ink. 15 × 16 in.
Collection of Drs. Arje and Elizabeth Latz, Kiryat Ono, Israel

Figure 6.27
SIDNEY GOODMAN (1936–)
Wrapped Still Life (1970)
Charcoal. 29¾ × 36½ in.
Courtesy, Terry Dintenfass Gallery, New York

These actions are further strengthened by his showing some volumes as elongated—as if they were being stretched between fixed points. Such distortions serve to exaggerate the graceful flow of the forms. Just as Pontormo causes small form-units to rise from, swell, and subside into larger forms, so major volumes, like the torso, right arm, and right leg, suggest a pattern of moving, changing masses. In the right leg, for example, the volume begins at the ankle, swells at the calf and, beginning to subside, is overtaken by the clasping tendons of the upper leg. These, in turn, expand and merge to form one swelling, tubular mass which suddenly erupts into a still greater volume by the addition of the buttock, part of the pelvic area, and some muscles of the lower torso. We see the right leg and hip as *one* volume springing up from the ankle with some velocity, swelling, subsiding, and finally implanting itself deep within the torso. Its last identifiable ripples reach as far as the figure's rib cage. Evidence that such tensions and energies can enliven students' responses to their subjects is clearly seen in Figures 1.2, 2.20, 3.37, and 6.29.

Figure 6.28
JACOPO DA PONTORMO (1494–1556)
Striding Nude
Red and black chalk, heightened with white chalk.
16 × 8⁷⁄₁₆ in.
The Pierpont Morgan Library, New York

Figure 6.29 (*student drawing*)
Kirk Rose, Art Institute of Boston
Conté crayon. 18 × 24 in.

THE DESIGN OF VOLUMES IN SPACE

Pontormo's interest in structural energy does more than make good use of a subject's clues for its gesturally expressive potentialities. By intensifying them, he clarifies another important category of response: the sense of volumes as related by a comprehensible order or plan—a system of abstract affinities. Chapter 9 will further explore the design of volumes, but here it is necessary to grasp something of the basic nature of ordered patterns among volumes, and of the necessity for such order in responsive drawing. There are a number of structural factors that can help extract this sense of order between volumes.

Similarities and contrasts of scale, direction, shape, value, texture, and manner of handling and of form joinings, as well as the distribution of parts within a spatial arena, all contribute to establishing a system of design among volumes. Especially does the distribution of masses, the various ways they overlap and interlock, provide a strong sense of order among volumes. Hence, when Pontormo stresses structural energies coursing through the figure, he also contributes to the sense of its abstract, dynamic actions and patterns.

This is so because sensitivity to a subject's structural condition is largely an awareness of relationships based on similarities and contrasts of scale, direction, location, and shape. The rhythms and affinities these relationships uncover help convey the subject's volume design. To the extent that artists wish to strengthen the sense of volumes as unified by an overall system of associations, *usually based on movement,* they will stress the visual bonds between the parts of their subject—the "alikeness" between unlike things—*and* their collective gestural behavior. For example, Pontormo's frequent use of straight lines to define passages of the contours causes these segments to "call" to each other, even when they are separated by great distances in the drawing, as are the straight lines that describe the spinal furrow and the feet. And such kinships reinforce movement energies.

Conversely, sensitivity to the rhythms and actions in a subject's forms helps discover structural facts, for, in responding to the "rush" and "resistance" of parts, our attention is drawn to the state of the planes and masses that produce such actions. Did Pontormo first see the dynamic

or the structural aspects of the right leg—or both simultaneously? It is impossible to say. What is evident in his drawing, however, is his awareness that both of these qualities *are* the leg. Measurement alone can never make forms come alive, any more than empathy can. These two considerations, the mechanics and the dynamics of volumetric structure, are interlaced considerations. Both are necessary in apprehending the potentialities for expressive order in nature.

Without the visual links and harmonies among the drawing's marks, and among the forms they produce, even representational content suffers. For whatever subject we may happen to select, it *is* a subject because we see it as having a set of related conditions separate from other forms surrounding it—as having at least a raw unity and spirit. Disregarding the abstract associations by which its unity and spirit can be extracted and enhanced results in works in which even the subject's raw order is broken down—works that are no more than collections of isolated and discordant details.

Degas, in his drawing *After the Bath* (Figure 6.30), shows a strong interest in the design of volumes. Although the model's forms must have described something like the action of the drawing's forms, it is evident that Degas extracted and strengthened the continuity of their flow. They rise from the bottom of the page as three simple shapes that become three volumes as they move upward, united in a vigorous curving action continued and intensified by the forms of the upper body. The energy generated by the figure's forms sweeping to the right seems to have an "escape" in the hair that ripples down in a way that answers their rising thrust.

Degas' responses to his subject's volumes, united in a curving motion, is conveyed by virtually every available means. He accents the similarity between the shape and scale of the left leg and two parts of the nearby towel. Note that the lighter of the two shapes of the towel strongly resembles the left leg upside down, while the other towel shape imitates the movement and direction of the leg and the contour of its right side. Degas' use of structural hatchings made of thick, bold charcoal strokes introduces a texture that further unites the volumes. He holds his darkest values in reserve while the curving action mounts, and commits them in the curve's "crescendo" in the head and hair—the two forms that, in descending, are in contrast with

Figure 6.30
EDGAR DEGAS (1834–1917)
After the Bath
Charcoal. 13⅞ × 10 in.
Sterling and Francine Clark Art Institute,
Williamstown, Mass.

the rising of the others. Thus, values also help explain the moving pattern of the forms. Degas' stressing of the figure as comprised of twin halves and his treatment of the volumes as somewhat tubular give additional unity and force to the figure's forms. Note how emphatically he overlaps the lower part of the head with the right shoulder, and how powerfully the right hand is forced into the towel.

Again, in Cretara's drawing *Reclining Woman, Reading* (Figure 6.31), a sound structural knowledge and a keen dynamic sensibility combine to create an image that is alive at both its representational and abstract levels. Here, too,

as in Figure 6.32 (see also Figure 6.34), structural insights uncover dynamic actions and vice versa.

Whether we emphasize the structure of volumes or their designed flow, both considerations must be understood as interrelated aspects of any form. Without the energies that structural conditions provide, volumes are dead bulk; without the dynamic energies that move among the marks, they are discomposed as well.

In the following exercise, a series of drawings will stress the material discussed in this chapter. As you first look at your subject, most of its perspective, planes, system of support, the forces that drive them, and the subject's overall

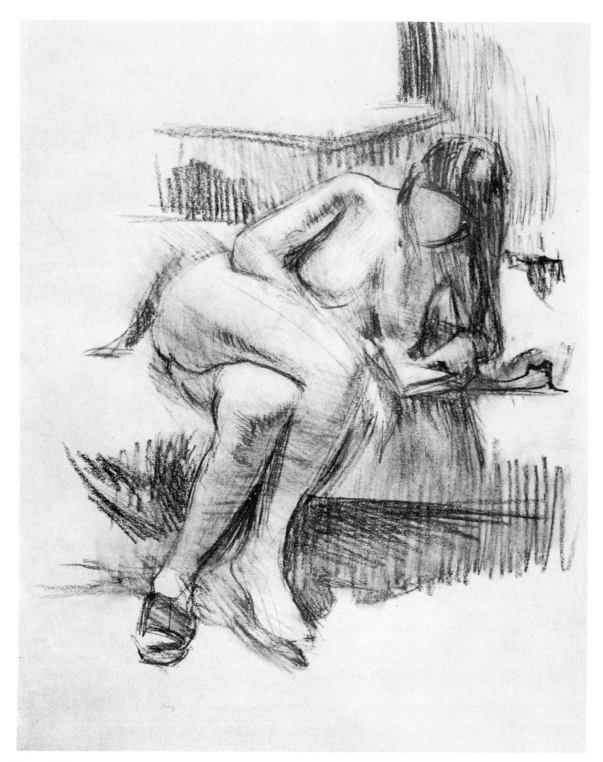

Figure 6.31
DOMENIC CRETARA (1946–)
Reclining Woman Reading
Red chalk and oil wash. 14 × 17 in.
Courtesy of the artist

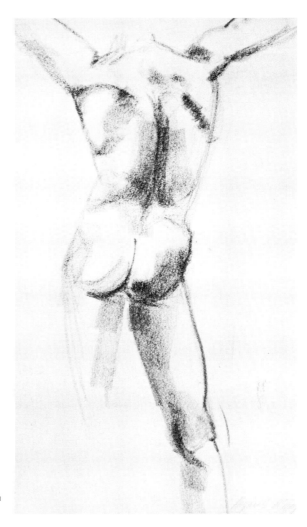

Figure 6.32 (*student drawing*)
Megan McNaught, Art Institute of Boston
Conté crayon. 18 × 24 in.

design potentialities may not be at all apparent. After all, you are looking for many things, and many of them are elusive and subtle. Their presence is better discovered by searching with an empathic as well as an analytical eye.

exercise 6A

MATERIALS: There are eight drawings in this exercise section. For the first six, use an easily erasable medium such as vine or compressed charcoal sticks or a 5B or 6B graphite pencil, on any suitable surface. For the seventh drawing, use only pen and ink. There are no restrictions on media for the last drawing.

SUBJECT: Still-life, figure, and envisioned subjects; discussed further in the context of each drawing exercise.

PROCEDURE: In the following drawings your attention must focus on the structural facts *and* forces of your subject: on its measurements and relationships of length, scale, shape, direction, location, value, and edge, and on the rhythm and movements of its masses. In fact, your involvement in discerning these qualities should be so exclusive that the resulting drawings will be something of a surprising by-product of your experience in responding to the constructional, relational, and gestural aspects of your subject. The real value of these drawings is more in the quality of the realizations and insights they provide than in their successful accomplishment on the page. In responsive drawing, as in the development of any other ability, concept and experience precede successful usage. Here then, you must, strange as it may seem, concentrate on this new kind of searching rather than on results.

drawing 1 Collect seven or eight small objects of a simple volumetric nature. Books, boxes, cups,

bowls, or anything else that is basically box-like, cylindrical, or the like are usable, but the objects need not be severely geometrical in form. Fruits and vegetables, shoes, shells, even rocks will do. Cover some of these with a thin fabric such as cotton or jersey. Some of the objects may be partially uncovered. Place the remaining objects upon the fabric, among the fully or partially hidden objects beneath it. Arrange all the objects in ways that reveal something of the forms of the hidden ones and that create strong protrusions, hollows, sagging and taut folds, and overlaps. The tensions and pressures produced will be roughly similar to those on the surfaces of subjects formed around skeletal frames. The overall arrangement should not be an extended, rambling one, but somewhat compacted, as in Figure 6.33.

This is a twenty-five–minute drawing. In the first five minutes draw in a schematic and investigatory way to establish a preliminary structural framework. That is, broaden your gestural approach to include a greater emphasis on establishing the subject's main directions, shapes, scale relationships, and volume summaries. To do this, you must disregard all surface effects of light and texture and all small details, *including minor planar conditions.* Avoid making this merely a contour drawing, but "get inside" a form's boundaries to define major planar joinings. Here you will draw edges in a simplified way, measuring the lengths between pronounced changes in direction, noting only prominent turnings and angles. This five-minute phase has the general character and goal of gesture drawing, but it attempts to measure, however broadly, the subject's major structural actualities. It is somewhat similar in concept to that of Exercise 5B in the previous chapter. There, the need to clarify and stress foreshortening, overlap, convergence, and so on led us to draw the simplest available geometric volume to which a part could be reduced without losing its basic volume character. Thus, a head became a block *or* cylinder, because a visual case exists for either as an acceptable geometric core form. Here, such extreme generality is not desirable. Although the clarity of the subject's foreshortenings, overlaps, and so forth is just as important in this drawing as in Exercise 5B, clarity now should not be gained at the expense of the general structural spirit, as well as character of the subject's parts. Grasping the essentials of the subject's action and structure in the first five minutes is important to the development of the volumes in the remaining twenty minutes.

Figure 6.34 suggests a degree of gestural and structural summary, and of a stress on directions that the arrangement in Figure 6.33 could be reduced to. Note the use of structural hatchings to suggest some

Figure 6.33

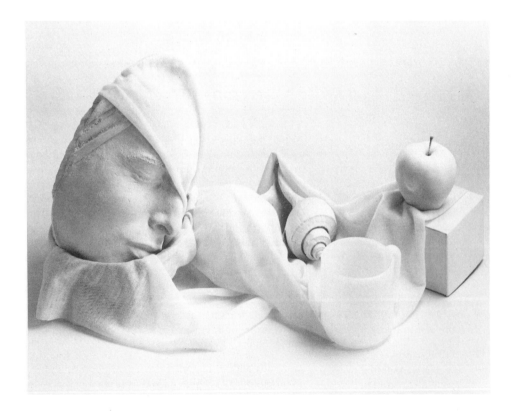

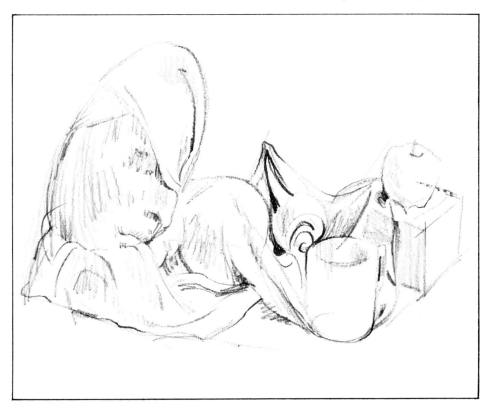

Figure 6.34

major planes, and the diagrammatic lines feeling out both solid mass and spatial areas. Note, too, the emphasis on pressures, tensions, and weight, and on the rhythms and movements between the parts.

This illustration should not influence you to emulate its particular characteristics—its handwriting. It is not intended in a how-to-do-it sense, but as an example of a serviceable degree of development of the subject's forms and forces in the five-minute phase. It *is* intended to suggest a degree of emphasis on direction, volume summary, and the energies of structural and moving forces, specific enough to establish important aspects of the subject's major masses, and general enough to be free of lesser and—for the moment—complicating ones. To summarize in a more sweeping way produces generalities too removed from measurable actualities and restricts reponses to the structural and dynamic energies. To draw the arrangement in a much less generalized way than that suggested in Figure 6.34 risks missing some basic observations having to do with direction and essential mass, as well as with relationships of scale and location, and the energies that flow between the parts.

In this five-minute phase, your goal is to extract from the arrangement the simplified nature of its various volumes and their relationship to each other, and to convey the dynamic forces that move among them.

Look for independent parts that may share a common direction, scale, or value by comparing such angles, sizes, and tones with those of parts placed far from as well as near to each other. Stress the strongest pressures and tensions, and call forward the subject's overall design theme—the rhythmic order of its parts.

This phase of the drawing is limited to five minutes for the same reason that the gestural drawings in Chapter 1 were held to even briefer limits. It encourages a search for essentials before particulars.

In the second part of this drawing, the emphasis should shift to an analysis of the shape, scale, angle, and location of smaller planes—those that explain the various surface irregularities of the subject's components and any substantial volume variations formed by their unions. Even here, however, you should distinguish between those smaller, or *secondary planes* that advance your explanation of a part's structure, and those which, because of their tiny scale—such as the hundreds of small planes in an extremely wrinkled cloth—merely crowd the drawing with unimportant, "busy" details. When a surface is comprised of such tiny planes, most artists draw only a few here and there to imply their presence throughout the object.

Beginning anywhere on the drawing, compare any generalized volume with its original in the arrangement. If the generalized volume represents a

A

B

Figure 6.35

rather geometrically simple object such as a book or cup, you may find little to add to your first notations. Instead you may want to adjust its direction, perspective, scale, or contour. If it represents a complex and irregular object such as a pillow (Figure 6.35), it will require the addition of its secondary planes to convey its unique structural and expressive character (Figure 6.35B).

In the case of a volume formed around and enclosing a space, as, for example, a cup, consider this enclosed space as a "negative" volume. Instead of having it result from observations of the cup's solid parts, study the space as one more measurable component of the cup. Seen directly, its direction, scale, and shape requirements may warrant changes in your drawing of the cup's solid parts.

Now you are more precisely clarifying the subject's physical facts, moving energies, and overall rhythmic order. Try to keep a balanced attitude to all three considerations.

Here we should consider a common error in placement. Sometimes two adjacent objects are drawn so close that an overhead view would show them to be interpenetrated. Be sure that you allow enough room for the bodies of closely placed objects. Although your drawing of any volume stops at its contours, your ability to believe in the existence of its unseen back must be strong enough to prevent the invasion of one solid by another.

As you draw, try to feel the heaviness of the objects and the "determined" resistance of the fabric-supporting solids. Thinking of the fabric as sopping wet helps us to respond to its surrender to the pull of gravity. This also helps explain the form of the objects covered by the fabric.

As the drawing develops, refer to the principles of perspective to prove or help clarify any part of the drawing that seems troublesome. In fact, perspective considerations have been an influence throughout the drawing. Now a concentrated examination of relative distance, scale, and convergence, and any other perspective consideration dealt with in Chapter 5, can help you adjust some faulty or confusing passages.

drawing 2 You have thirty-five minutes for the second drawing. This time select three or four of the objects used in the first drawing and place them inside a cloth container, such as a laundry bag or pillowcase. Tie the container at the top with a rope long enough to tie onto some overhead support such as a rafter or pipe, enabling the container to hang free. As you draw, notice the folds caused by the weight of the container pulling against its restraining rope. At the top of the container they will be extremely pronounced. Lower down, the objects inside it will press against the fabric, revealing parts of their form. Try to show this struggle between the container and its restrainer, and between the container and the objects inside.

Again, begin the drawing with a five-minute analytical–gestural search for direction, location, shape, scale, and so on. Again, establish a preliminary armature based on the subject's essential structure and action.

In the remaining thirty minutes, spread your attention over the entire subject, advancing it together. Here, be especially insistent on showing the pressures and tensions between the parts of the subject. Do not hesitate to make moderate adjustments to help intensify these forces—to exaggerate the weight of the objects and the pliancy of the container. Here, too, search for the abstract energies—the rhythms and movements—that organize the subject into a system of visually related forms, each of which participates in the structural *and* design activities.

drawing 3 Before turning here to the more demanding subject of figure drawings, try a twenty-minute cross-contour study of several still-life objects, or of the figure itself, as in Figure 6.36. Begin by broadly roughing in the gesture with the side of your chalk and,

their volume better. The objects were rather simple in their construction, and establishing their generalized volume-state was correspondingly simple. Now the subject is composed of complex organic forms, rooted in the central form of the torso—a single, extended system of inner-supported masses. Pose the model to avoid complicated overlappings of the limbs. A simple standing or seated pose is most suitable.

In such less compacted poses the forms are seen as flowing into one another. For example, there is no one place on a leg where we can see the ankle as ending and the lower leg beginning with sausage-link clarity. Instead, there is an interlaced, almost braided system of bone, tendon, and muscle, producing transitional planar passages. Sometimes these planes are subtle and fluid (Figure 6.12); sometimes they erupt from the surface forming clearly carved volume variations (Figure 6.11). Often, these transitional planar "avenues" can be traced for long distances above and below a joining of parts, adding to the flow of the forms. As your drawing continues beyond the five-minute phase, try to see the several planes and the volumes they form, that explain these transitions. Their visibility is partly due to the yielding, pliant character of the skin, which, like the fabric, will collapse unless supported by a framework. As the inner systems of bone, tendon, muscle, and fatty tissue interact, their forms, pressed against the elastic skin, like the objects in the suspended container, reveal their support function and some of their volume by the amount of pressure they exert on the figure's surfaces.

In the remaining thirty minutes, try to see and feel the subject's structural behavior as having its origins deep inside, the result of forms and forces that press against the figure's interior walls. As before, first establish the secondary planes and then consider the smaller ones. Use only those smaller planes necessary to explain the important structural characteristics of the figure's forms. Such a restriction usually reveals how much the impression of structured volume is carried by the primary and secondary planes, as in Figure 6.37. Often, only a few smaller planes are required, or, as in Delacroix's drawing *Nude Woman* (Figure 6.21), desired. Looking at this drawing we know that the artist has omitted many of the planes of the female figure, but nowhere are we left with blank flat areas. The figure's "topography" is readable everywhere. Here, the volumes owe much of their sculptural strength to Delacroix's emphasis upon those larger planes that denote important changes in the direction of a volume's surface. Such bold, selective carving of large forms by large planes itself gives volumes power and impact. It *is* impressive when so little can express so much. This is not to suggest that your drawing should stop at this degree of volume-revealing information. Delacroix did because he felt this drawing fulfilled his purpose at its present stage. His goals were realized. What *is* suggested by the example of this drawing is the inadvisability of stopping short of this

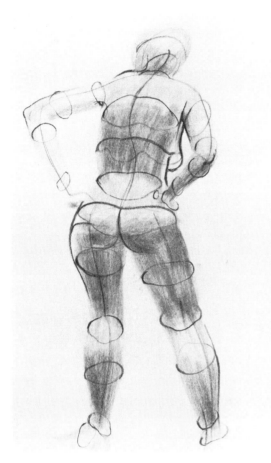

Figure 6.36 (*student drawing*)
Denise Moore, University of Denver
Charcoal. 18 × 24 in.

as in our example, any segments of edge that will help clarify the general state of the masses. Next, using the point of your chalk, or a charcoal pencil, "feel" your way upon the subject's changing terrain by a slow, deliberate line that "rides" the hills and valleys as if a bug dipped in ink were leaving a trail as it moved along. Where possible, let the line move all around the forms, as in Figure 6.35, but try drawing some lines that run in the direction of a part's long axis, as in the line that traces the changing surface of the figure's back.

drawing 4 This is a thirty-five–minute drawing. Now, the human figure, preferably nude, should be used. If it is to be a draped figure, the attire should be simple and should not cause complex folds or billowing shapes. Again, begin with a five-minute analytical-gestural drawing. The forms should be simplified enough to help you establish the foreshortening of forms with some ease.

In the first drawing of this exercise, the independent nature of the objects helped you to understand

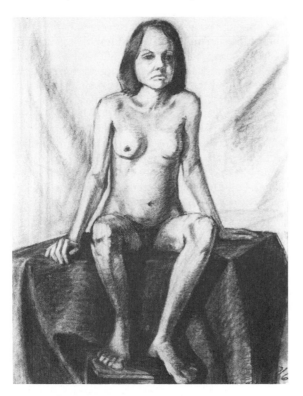

Figure 6.37 (*student drawing*)
Boston University
Vine charcoal. 18 × 24 in.

degree of volume building, to build such volumes by their larger planes, and to avoid the enticements of little details as ends in themselves.

drawing 5 This drawing will take one hour. Use only a segment of the figure for your subject. It can be an arm, leg, torso, or head, from any challenging view of the form, as in Figures 6.38 and 6.39. Draw large—a little over actual size. Again, begin with an analytical–gestural search for the volume fundamentals described earlier. This time, however, take as much time as you need to establish these generalities. Now you have about twice as much time as you had for the previous drawing in which to draw considerably less of the figure. This will permit you to include many of the smaller planar changes that would ordinarily be omitted in drawings limited to less time, or to a smaller scale. In closing in on a part of the former whole, you will find that what are small planes in drawings of the segment as part of the entire figure are elevated here to the status of primary and secondary planes.

The longer drawing time allows you to make a more probing study of quite small structural details. As you begin to include these, be sure to keep them subordinate to the larger planes and masses. Here, as in the previous drawings, look for the pressures and tensions between the holder and the held, for the way in which parts join, and for the design of the seg-

ment—the continuity among its parts. Avoid involvements with illumination where it does not help explain volume, and use direction-informing hatchings to show the various tilts of the planes, as in Figure 6.38. Notice that the hatchings in Figure 6.39 all move in the same direction. Here, surface changes are conveyed by the variations in their density and in their value. Although such line variations do explain the subject's terrain, changing the direction of lines to correspond to the direction of the planes they describe is an important aid in explaining the subject's surface-state.

Your goal here is to develop a drawing so structurally clear and convincing that a sculptor could use it as a guide for sculptural work and never be confused in understanding the subject's basic structure or the various planar changes on its surfaces.

drawing 6 This drawing is limited to fifteen minutes. Pose the model in some animated position. There is no time limit for establishing the broad volume generalities. You may, if you choose, attack directly, intending each mark as part of your final state-

Figure 6.38 (*student drawing*)
Tony Hurst, Art Institute of Boston
Black chalk, 18 × 24 in.

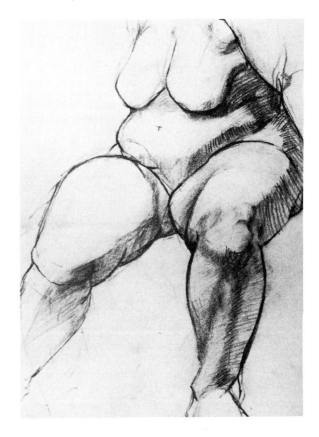

Figure 6.39
Follower of LEONARDO DA VINCI
Head of a Woman
Metalpoint on greenish prepared paper. 5⅞ × 4⅞ in.
Sterling and Francine Clark Art Institute, Williamstown, Mass.

ment. In this case, begin in a gestural way, as described in Chapter 1. Whether or not you employ an underdrawing stage, continue to emphasize the major planes and masses first.

In the previous five drawings, establishing a preliminary structural and dynamic scaffold permitted you to develop your drawings in the knowledge that all early explorations were tentative—that they would largely be absorbed and altered by later drawing. Here, should you choose to work directly, every mark must respond to the subject with feeling and decisiveness. Instead of emphasizing analysis first and "conclusions" later, in direct drawing these considerations are parts of the same percept and the same action.

You may find that the reduced time demands a more energetic and broader approach to your subject. This can assist rather than restrict your grasp of the essentials. Figures 6.28, 6.29, 6.30, and 6.31 show the kinds of energy and excitement such a spontaneous approach can reveal. This is knowledgeable simplicity, not empty flourish. Your drawing, too, should aim for volume in simple, sculptural terms. And it should convey the structural and dynamic energies that make it more than just bulk.

drawing 7 Using pen and ink (a ball-point pen will also work well here) and using Leonardo da Vinci's drawing (Figure 6.14) as a rough guide, make a drawing no smaller than 16 × 20 inches of some rock

formations. Your "models" can be any two or three interesting stones or pebbles. Arrange them in a good light and proceed to draw them large enough to fill the page. Because it takes time to draw in pen and ink to develop the structure of complex forms about which you have no preconceived notions, there is no time limit on this drawing. This being the case, you might want to make your rock formation more permanent by gluing the stones to a rigid support. As in the previous drawing, preliminary underdrawing must be held to a minimum, for erasures are not possible. Your drawing is to carry the clarification of the rock's terrain even further than da Vinci does. His drawing is an investigatory probe; yours is to be an extended realization of the subject's forms, and of the *light* and *textures* upon it. The challenge here is not only to build solid volumes using a medium that restricts underdrawing and erasures, but to construct them well enough to show the surface effects of local tone, light, and texture without being buried or flattened under such surface detail. Keeping such surface changes from obscuring the forms will demand a strong grasp of each part's structure as well as the discipline to keep surface details from overruling basic structural facts.

drawing 8 This drawing allows you a great deal of free choice. *You* set the time limit, determine how much time, if any, to use for a preparatory stage, and select both the subject and the medium. Although the figure is an excellent subject for this largely self-directed drawing, you may want to apply the concepts and procedures you have been practicing in this sec-tion to a landscape, animal form, interior, or other subject.

You will even decide whether constructing volume is to be a dominant or supporting theme of this drawing. Your goal is to regard what you now know about volume-building more as a tool (albeit an important one) of responsive drawing, and to use it here as your interests require. Whether it will be central to your drawing's theme or subdued by other visual interests should now depend on your first, generalized responses to your subject—let the subject suggest the means and even the medium. But, however subordinated the role of volume may be in this exercise, and however subjectively you state the forms, none should be ambiguously drawn or discordant in the drawing.

Creating the impression of convincing structured volume is both a demanding perceptual challenge and an emotional experience. It calls for an understanding (and interworking) of gesture, line, shape, value, perspective, and the ability to feel a subject's structural and dynamic energies, as well as to measure its actualities of scale, location, direction, and length. It is the quality of the negotiations among these considerations that determines the quality of the resulting volumes. By knowing what is involved in creating volumes, we also know what is involved in subduing them. In this way, we expand our control of the images we make.

7

COLOR

the transforming element

A DEFINITION

Historically, the use of color in drawing occurs only occasionally, and even then it is often subordinate to other considerations in the work. Nevertheless, color can be a powerful enhancing factor, strongly affecting a drawing's compositional and expressive meanings. In drawing as well as painting it is the visual element most capable of modifying the other elements, imbuing them with associations and contrasts that profoundly affect the resulting imagery. Color's transforming effects can play an important role in drawing even when its use is sparse and supportive. For example, in black and white, Cézanne's *Study of Trees* (Figure 7.1) is a subtle and well-balanced arrangement of line and tone. The darker values of some of the tree trunks and foliage help us locate near and far forms; we can find our way through this forest scene. It is a sensitive graphic statement. But when the work is seen in color (Figure 7.2), the clarity of volume

and space and the work's overall compositional and expressive meanings are plainly expanded. Mass and space are more fully explained by Cézanne's use of warm and cool colors that advance and recede in ways that the gray tones in Figure 7.1 do not; the drawing's composition now includes a play of contrasts between patches of blue, mauve, green, and pale yellow hues instead of variously toned grays; and expressively, the cool tones of the trees in relation to the warm tone of the page invites us in a more appealing way to enter the quiet, shaded forest on this warm day.

But what *is* color? Webster's dictionary defines it as "a phenomenon of light . . . or visual perception that enables one to differentiate otherwise identical objects." We do, after all, live and move among colored objects and, naturally enough, tend to regard color as an important distinguishing property of the things we see (the

181

Figure 7.1
PAUL CÉZANNE (1839–1906)
Study of Trees
Pencil and watercolor. 49.5 × 32 cm.
Victoria and Albert Museum

Figure 7.2
PAUL CÉZANNE (1839–1906)
Study of Trees
Pencil and water color. 49.5 × 32 cm.
Victoria and Albert Museum

red shoe, the blue car). This being the case, it may come as something of a surprise to learn that objects have no color of their own. Color is not an inherent substance in the things we see but is derived from light. When white light, as Sir Isaac Newton showed, passes through a prism and strikes a white surface, the rays of light are bent or *refracted* at various angles determined by their wavelengths. What we see reflected from the white surface is the familiar rainbow arrangement of intense pure hues called the *spectrum*. The colors of the spectrum are red, orange, yellow, green, blue, and blue-violet or indigo (Figure 7.3).

Liquids, gases, and solids possess no color of their own, but they do possess the ability to absorb certain rays of light and reflect others. For example, the red shoe absorbs all the rays of light except the red ones. The shoe appears red to us because it is the red rays that are reflected to our eyes. We see some objects as white because they reflect all the rays, while other objects appear black because they absorb all the rays.

Webster's definition goes on to list the three visual features of any color: "The aspect of objects . . . that may be described in terms of hue, lightness, and saturation." The term *hue* simply designates a color's common name. When we refer to one object as blue and another as green, we are stating their observable hue. *Lightness*, according to Webster, refers to a color's degree of value. All colors possess value and it is important to become familiar with the great range they show, from light to dark tones. Yellow, for example, is inherently light in value, whereas violet is very dark. The term *saturation* (or intensity) de-

fines a color's brilliance. Some colors possess a vivid brilliance and others are quite dull. Orange is an example of a high-intensity color, whereas a tint or shade of orange is a low-intensity one.

In drawing as in painting, color can perform a number of functions. One, mentioned earlier, is that of describing an object's hue: the chair is green, the blouse is dark blue. This descriptive function is color's simplest and most straightforward role. Unfortunately, color (in painting as well as drawing) is too often restricted to this single activity. But even such a narrative use of color is not always restricted to objectively observed color. A descriptive use of color has often served symbolic rather than responsive motives. In oriental, medieval, and early Renaissance art, in children's art, and in the works of those untrained adults, called *primatives*, color often describes preconceived notions, with grass always bright green, cheeks invariably rosy, and water unfailingly blue. Sometimes the results of a symbolic use of color are strikingly beautiful (Figure 7.4). It is only among objectively oriented artists with acute analytical skills that the descriptive use of color approaches the colors and values of a subject observed in a particular light (Figure 7.5).

Color can do more, however. As we saw in Figure 7.2, color can be used to create more convincing impressions of volume and space. Later in this chapter we will examine this important role of color, but here it should be pointed out that highly accurate color notations do not always produce the most convincing volumetric or spatial results.

Color can also determine patterns of con-

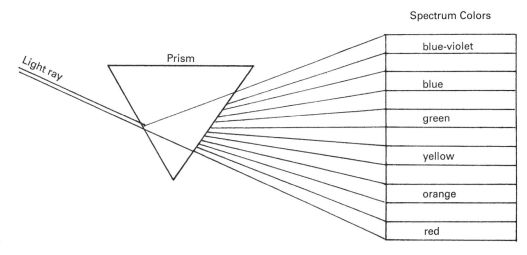

Figure 7.3

trast and association, can lend emphasis to an object or area through strong differences in hue, or can join such parts to other parts through similarities of hue. These possibilities make color a powerful compositional tool, as we can see in Figure 7.5, where the decorative stripe on the drapery relates with the apples because of their common hue, while the several yellow patches in the apples help to keep the bananas from appearing isolated.

Color is just as powerful an expressive agent, and its ability to trigger emotion is well known. Interior decorators are well aware of color's influence on mood. We associate color with mood when we say that someone is in the pink, or feeling blue, or red with rage. Colors arouse our emotions because each of us has certain personal associations—likes and dislikes—regarding particular colors and/or the ways they combine. We make such judgments every day. We may choose the red rather than the blue sweater, and the tan rather than the green notebook, even when these items are otherwise identical, because these choices please our sensibilities this day. They express our taste and our mood. In the same way, color in drawing can enhance our expressive purpose, not only by the colors we choose but through the dynamic interactions among them, and by our use of color to rivet attention to certain areas.

Finally, color in certain combinations and amounts can create sensations of a more abstract kind having less to do with composition and expression than with what we might call color "harmonics." Not unlike the harmonics in music, such colors confronting each other in a work seem to transcend their other functions to produce color chords, discords, and crescendos that impart something like the mystery and emotion we experience when listening to good music. These are sensations that only color can provide. Although the quality of these harmonics depends on our ability to sense their rightness in the context of a drawing's essential purpose, their fullest effect comes from a sound grasp of how hues, values, and intensities may be manipulated to function in all the roles of color discussed above.

THE COLOR WHEEL

First formulated in the eighteenth century, the color wheel is a useful device for showing simple divisions of basic colors which, by their position on the wheel, can be readily related for various mixing purposes. The color wheel begins with the premise that there are three *primary* hues—red, yellow, and blue—and that each is unique among all colors in being least like the other two. Or, to put it another way, red, yellow, and blue are the three most dissimilar hues we can conceive of. This fact becomes evident when we try to add a fourth hue to the group. If we include, for example, green to make four primaries, it is apparent at a glance that it is closer to yellow and blue than to red. If, instead, we add orange, we find it closer to yellow and red than to blue.

Another justification for regarding red, yellow, and blue as the three irreducible and fundamental hues is that none of them can be produced by mixing together any other colors, whereas, in theory at least, all other colors can be produced by various mixtures of the primaries, plus black and white. Adding white to any color produces a light-toned color called a *tint*, and adding black to any color produces a dark-toned color called a *shade*. For example, pink is a tint of red; brown is a shade of red. The colorplates in this book are made by overprinting layers of red, yellow, and blue inks, along with black. Depending on the density of the tiny dots of colored inks and on the particular mixture of these colors, a great range of colors can be produced.

Figure 7.6 shows the arrangement of the three primary hues of the color wheel. Note that the primaries form a triangle, with yellow at the top. If we mix roughly equal amounts of any two primary colors we produce a hue that is equally related to each "parent." Only three mixtures are possible, and the colors they produce—orange, violet, and green—are called *secondary* colors, as shown in Figure 7.6. Mixtures between any primary and either of its adjacent secondary colors produce a *tertiary* color, of which there are six possible combinations, as in Figure 7.6.

Positioned like the numerals of a clock, these twelve hues complete the color wheel. Note that with yellow, lightest in value, at the top of the triangle of the three primaries, the colors to the left are those we regard as warm ones and they grow darker in value as they descend, and that the colors to the right of yellow are those we regard as cool ones and they also become darker as they descend, with blue-violet representing the hue darkest in value.

Seeing these basic hues in this arrangement gives us a clearer overview of their differing warm–cool temperatures and values and helps

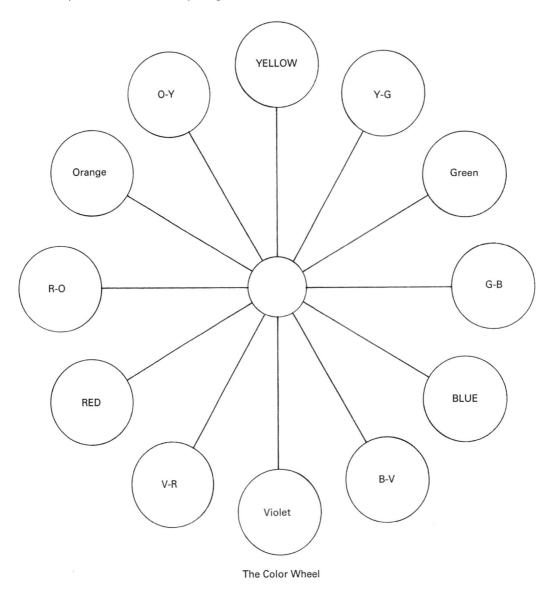

The Color Wheel

Figure 7.6

us see how various crossovers can produce still other hues. The closer together any two colors are located on the color wheel, the closer is their hue relationship. Mixtures between such near neighbors are least likely to produce grayed, neutral results. The farther apart hues are located on the wheel, the stronger is their hue contrast; mixtures between such hues are more likely to produce grayed results. Colors located directly opposite each other on the wheel provide the strongest hue contrasts. Such opposing hues are called *complementary* colors. When complementary or near-complementary colors are placed alongside each other, both colors attain their maximum intensity potential. They produce the strongest *simultaneous contrast* effects (Figure 7.7).

Mixing complementary colors together in roughly equal amounts produces very grayed colors. However, adding a very small amount of, say, orange to a large amount of blue has the effect of reducing the intensity of the blue, making it a more muted, grayed blue (Figure 7.8). Modifying a color by adding a small amount of its complementary is an established color practice of long standing. Note in the color wheel that all

Figure 7.7

BLUE GRAYED BLUE

Figure 7.8

WARM AND COOL COLOR

Color's power to advance and recede was not *fully* explored until the late 1800s, when the Impressionist painters, and especially Cézanne, turned to color as a primary means of achieving their volumetric and spatial purposes. Nevertheless, this phenomenon was known to some earlier artists. Modeling form by juxtaposing warm and cool variations of a color can be seen in the paintings of Rembrandt, Hals, and Rubens, to name a few. In drawing, mainly in landscape subjects, the use of warm and cool colors to underscore the illusion of near and far and to call attention to certain areas dates back hundreds of years (Figure 7.9). Its use to assist in creating the impression of volume and space, as in painting, also has a long history. Some evidence of this technique can be seen in Figure 7.10, where the cooler tone of the woman's neck thrusts the head forward. Note, too, the cooler color of the strokes that model the neck, left shoulder, and left arm of the sitter.

Used in this way, color is not necessarily less involved with describing a subject's perceived colors, but it does so in a more interpretive way. Such a use of color does establish a form's particular color, but goes on to include those warm and cool variants essential to giving the form convincing substance. It is possible, however, for the colors that model the form to take over its *local color*, that is, the actual color of the form quite aside from the effects of light and shade upon it. When this occurs, the resulting form is a well-explained solid but of no particular hue. Cézanne, who led the way in showing the mass- and space-making properties of color, is known to have warned young painters to "maintain the local color."

Warm and cool colors are also used, usually in conjunction with other visual devices, to produce *ambiguous* volume and space effects, that is, effects that are intentionally unclear or equivocal and so permit other kinds of visual phenomena to occur. An example of such purposeful ambiguity is seen in Figure 7.11 where, along with some Cubist devices that create broken and sometimes interpenetrating planes, color blocks certain spatial cues while creating others. For example, some of the yellow and red shapes meant to represent planes coming forward do so easily because they overlap other shapes, while other yellow and red shapes, meant to be seen as nega-

complementary combinations are between primaries and secondaries, or between tertiary hues, and that each pair is made up of one warm and one cool color. Such mixtures in unequal amounts often produce engaging grayed colors of much mystery and charm.

A familiarity with the color wheel is useful for choosing those hues, values, and intensities that will best convey your creative intentions. For the same reason, it is advisable to study other color systems such as the Munsell or Ostwald color systems. But be wary of ready-made formulas for producing sure-fire effects. None can compete with the quality of color that comes from a deep commitment to strongly held creative purposes.

One limiting condition of any color system text has to do with the sameness in size of the color squares or disks arranged for comparison and study. In the act of painting or drawing in color, artists always need to consider the factor of *quantity* in making their color judgments. Often two or more colors that seem incompatible, that seem to clash or strike visually "sour" notes, can be made to harmonize by adjusting their amounts. Josef Albers, one of the great color theorists of our time observed that "Independent of harmony rules, any color 'goes' or 'works' with any other color, presupposing that their quantities are appropriate."

Figure 7.9
PAULUS VAN VIANEN (1570–1613)
Landscape with River and Raftsman (1603)
Pen and brown ink with blue washes
Reproduced by courtesy of the Board of Directors
of the Budapest Museum of Fine Arts

Figure 7.10
EUGENE DELACROIX (1798–1863)
Portrait of a Young Woman (ca. 1826)
Watercolor.
Collection of Museum Boymans-van Beuningen, Rotterdam

tive or ground shapes, continue to advance because of their warm hues. Conversely, some cool-toned shapes, trying to recede, are thrust forward anyway because they overlap other shapes. Despite such interruptions and uncertainties about which shapes represent mass and which represent spatial depth, or where exactly certain planes are located, we can still follow a progression of planes forward from the sky-like region at the format's top, past the trees to the goats in the foreground. Such ambiguities take us on an adventurous hike in and out of the spatial field, where false starts and dead ends give our eyes and mind an enjoyable workout as we try to move among these colored shards in some logical way. Such in and out ambiguities also have the effect of returning us to the picture-plane, where the drawing's two-dimensional design takes us on another trip, this time across the surface, following various directed actions. In a very different stylistic mode, Redon's *Roger and Angelica* (Figure 7.12) also shows color participating in an intentionally ambiguous image in which warm and cool hues as much as value contrasts alternately emphasize "in and out" space and picture-plane movements.

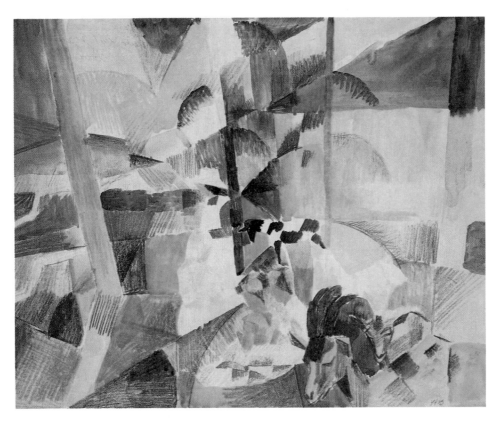

Figure 7.11
AUGUST MACKE
Children and Goats on the Bank of a Lake (1913)
Colored chalks and watercolor. 31.4 × 40.2 cm.
Oeffentliche Kunstsammlung, Kupferstichkabinett Basel

Figure 7.12
ODILON REDON (1840–1916)
Roger and Angelica (c. 1910)
Pastel on paper on canvas. 36½ × 28¾ in.
Collection, The Museum of Modern Art, New York.
Lillie P. Bliss Collection

Figure 7.13

COLOR AND COMPOSITION

Although composition is more fully discussed in Chapter 9, here it can be briefly defined as the visual integration of a drawing's elements and parts in ways that show them to be balanced and unified in the format. That color can profoundly affect composition is seen in Figure 7.13, where the same sketch shows different compositional solutions based on differences in color usage.

Such color activities result from five basic kinds of color phenomena. While these five categories do not directly explain the emotional, psychological effects of color, these effects also emerge from the same sources.

1. Hue contrasts. The most obvious way to relate and contrast parts is by color. The more nearly alike any strokes, areas, or forms are in hue, whether near or far apart in the drawing, the more strongly will they relate to each other and thereby also tend to unite differing, opposing hues. Such color associations and contrasts depend first on hue and second on the relative warm and cool characteristics of surrounding hues. For example, green and blue parts will tend to relate if encircled by orange and red areas (Figure 7.14).

2. Value contrasts. As was noted earlier, some colors are inherently light in value and others are

Figure 7.14

dark. As with contrasts in hue, the more nearly alike any strokes, areas, or forms are in value, whether located near or far apart in the drawing, the more strongly will they relate, and thereby tend to unite all other colors that contrast with them in value. This union of like values will occur even when these values "belong" to very

Figure 7.15

unlike hues, except for differing hues of vivid intensity. Figure 7.15 shows that relationships of different hues of about the same value are strongest when the common value is either light or dark, or when the various hues are somewhat grayed; intense colors in the middle range of value call more attention to their brilliant saturation than to their value.

3. Complementary contrasts. Complementary colors, being located directly opposite on the color wheel, suggest the tendency of our eyes to produce the illusion of a color opposite to one we fixate upon. If, for example, we stare at a blue shape for a minute or so and then turn to look at a white surface, the shape will seem to reappear in orange. In the same way, a strong color such as a primary or secondary one will seem to show a faint aura of its complementary.

Any color can be made to seem more brilliant by surrounding it with one or more colors that are close to being its complementary. If red and green hues, even grayed ones, appear in some proximity to one another, both colors will appear more intense (Figure 7.16). The opposite occurs when any color underlies its complementary. An intense green will appear duller if it covers an area of red in such a way as to permit some of the red to show through or between strokes. The more nearly any colors complement each other, the more they will oppose and intensify each other. However, for this to occur, color shapes must maintain a fairly large scale in the work. Small shapes of color crowded together, no matter how varied or brilliant, will cancel out all complementary action. Our eyes will see a field of small spots of pure color as a somewhat muted color area, as in Impressionist paintings.

Related to this phenomenon is the tendency of any intense color to make neighboring

Figure 7.16
MARC CHAGALL
Study for Calvary (1912)
Gouache, watercolor, and pencil on paper.
18⅝ × 23⅜ in.
Collection, The Museum of Modern Art, New York. The Joan and Lester Avnet Collection

weaker or more neutral colors take on the hue of the intense color's complementary. A red shape appearing on a neutral light gray field will give the light gray area a weak greenish cast, while a strong yellow hue on the same gray field will impart to it a pale violet overtone. Making use of this phenomenon, artists sometimes suggest rather than actually use colors to create ineffable and mysterious color effects. Rembrandt seldom used blue, but many of his paintings suggest passages of subtle blue and violet nuances—the effect of finely tuned surrounding warm colors on various cool grays.

4. Intensity contrasts. As was noted earlier, every color has its inherent brilliance. A pure color, such as those of the color wheel, can be lessened in intensity by mixing into it a small amount of a neutral gray *of the pure color's value*, as shown in Figure 7.17. Note that the more gray added to the pure hue, the weaker its hue identity and impact. Of course, when the added gray is lighter or darker than the pure color or has a pronounced warm or cool character of its own, the hue and value of the pure color are altered more. When various hues of vivid intensity appear against a backdrop of duller colors, they will contrast sharply in hue but tend to form a relationship based on their roughly equal intensities. Something of this can be seen in Figure 7.18,

Figure 7.17

where shapes of red and yellow, although they contrast as hues, join forces on the basis of their intensity to soften and stablize the fast-moving, angular network of Cubist-like lines and shapes drawn in gray and brown tones.

More typically, however, the stronger visual response will be to the contrast between differing hues than to similarities and differences based on intensity. In drawing, as in painting, a color's fullest intensity is often reserved for purposes of emphasis.

5. Quantity contrasts. In the realm of visuality, quantity attracts attention. In a drawing comprised of short lines, a long line stands out. A huge, dark-toned shape set among small, light ones, or a large red form seen against a field of smaller, cool-toned forms, such as a red barn nestled among trees and bushes, are all atten-

Figure 7.18
CHARLES DEMUTH (1883–1935)
Stairs, Provincetown (1920)
Gouache and pencil on cardboard. 23½ × 19½ in.
Collection, The Museum of Modern Art, New York. Gift of Abby Aldrich Rockefeller

Figure 7.19
JASPER JOHNS
Study for Painting with Two Balls (1960)
Charcoal on paper. 24⅜ × 18¹¹/₁₆ in.
Hirshhorn Museum and Sculpture Garden, Smithsonian
Institution, Gift of Joseph H. Hirshhorn, 1966

tion-getting features in the context of their settings. Psychologically, too, bigness carries meanings. One square inch of red in a work may be a refreshing variation; one square yard of red will stop us in our tracks. In the use of color we must be sensitive to scale and intensity. Some colors, especially those running from yellow to red on the color wheel, because their intensities are so attracting, can easily be overused and will then intrude on both a work's compositional and expressive conditions. We have only to think of the orange-yellow color of life jackets and dinghies visible from the air against the cool colors of the sea to recognize just how powerful is the factor of intensity.

As a glance at the color wheel shows, there is among colors a hierarchy of intensities. At the top is yellow, followed by orange, then red and green, then blue, and finally violet. Thus, the lessening of intensity among pure colors roughly parallels the darkening of their value. But this correlation does not hold true for tints or shades of any color or for mixtures made of exact or near complementaries. A pale pink or tan color may be light in value but cannot generate the brilliance of, say, an orange or green hue. It is a common error to confuse a color's brilliance with its value, but bright and light are not the same thing. We need always to be aware of the relative

differences in the visual impact of colors and adjust their quantities according to our compositional and expressive purposes.

Although intensity and value are not the same thing, light may in fact sometimes be used as bright. This use is demonstrated in Figure 7.19 by the pale yellow tint that represents a narrow opening in the drawing's wall-like surface. This color actually underlies the rest of the page, but because it is overlaid by variously toned deposits of charcoal, chalk, and pencil, it has a mellowing effect on these powerfully calligraphic strokes, just as the few vertical and horizontal lines and edges have a stabilizing influence. In contrast to the large area given over to these dark and energetic "rumblings" is the drawing's only focused passage, the narrow horizontal opening. This slit, being sharply defined and light in value, acts as a psychological as well as visual counterpoint to the drawing's otherwise brooding mood. Among the drawing's many contrasts—which include spontaneity versus deliberation, painterliness versus precision, and illumination versus darkness—the *quantity* of light and *degree* of intensity play a major role. Notice that the drawn marks, serving as cool notes in contrast to the warm tone of the page and the narrow opening, also play a part in establishing the drawing's intriguing spatial and psychological effects.

193

COLOR AND EXPRESSION

That color is a powerful agent of expression is at the heart of Marc Chagall's observation that "Color is love." It was earlier noted that color's expressive associations permeate our speech. Someone is "green with envy," or is "feeling blue." It is sometimes observed that certain colors trigger certain associations—and often they do. Red is universally associated with fire, blood, passion. Yet the symbolic use of color is not entirely reliable for communicating a particular meaning. Pink may suggest blossoms, candy, or parties to many of us, but not to the person who was punished or confined in a room painted pink. In some cultures, black is associated with evil and death; in other cultures, with beauty and good luck. The farmer feels one way about green, the doctor, another way. Therefore, whatever universal agreement there may be about various colors, the differences among people and cultures make misreadings of intent a certainty for many.

A far wiser plan than reaching for a particular color because it is supposed to produce a particular effect is to uncover our own unique feelings about this elusive element. This can be accomplished in several ways: (1) by noting what colors and color activities attract us in the works of old and contemporary masters; (2) by examining those color choices and functions in our own works that seem to recur and that we find visually and expressively satisfying; (3) by continually trying to learn from our use of color, what choices and uses are effective for both compositional and form-building purposes; (4) by making charts of colors on a free association basis, as described later in this chapter; and (5) by trying to analyze objectively the colors in the world around us in an ever more demanding way.

Many artists, consciously or not, gravitate to certain kinds and uses of color. They have found these colors and uses to be logical, effective, and satisfying. The colors in such works seem necessary because the artist found it unavoidable to choose them in trying to be visually and expressively *clear*. The sensitive viewer responds psychologically to such works as though the engrossed excitement of the artists were infectious. One reason we experience their works so fully is because obviously *they* did—and it shows.

In Figure 7.20, color enhances the emotive force of an image that relies mainly on value for its expressive effect. But the drawing's somber tones are punctuated by muted, even scruffy applications of red, tan, and blue colors that, in straining but failing to break out of the drawing's brooding mood, only amplify it.

The expressive role of color in drawing need not be limited to strong emotion or dramatic events. Holbein's *Portrait of Anna Meyer* (Figure 7.21) is a gently crafted image in which the choice and use of color is in harmony with the sitter's introspective mood. These light-toned warm colors, only occasionally relieved by darker, richer hues, seem to suggest a warm and sunny environment; they hint at quietude and reflection. Holbein's choice of a reddish-brown for the belt is just the right note to serve as a link between the pink tones of the young woman's face and the several yellow and brown colors seen throughout the rest of the drawing. In value, too, it serves to bracket the area between it and the top of the head, to provide a much needed variation in color and value at that place in the drawing, and to "announce" the beginning of a series of encircling bands on the figure's forms that carry us up to the head, where the richer color of the

Figure 7.20
GEORGES ROUAULT
Woman at a Table (*The Procuress*) (1906)
Watercolor and pastel on cardboard. 12⅛ × 9½ in.
Collection, The Museum of Modern Art, New York. Acquired through the Lillie P. Bliss Bequest

cascading hair helps take our eye downward to start the cycle again.

To a considerable extent, the matter of color harmonics, referred to earlier in this chapter, is present in any work in which the colors integrate in their various functions. Nor does it require the use of many colors doing many things. Holbein's drawing is a good example of color's alluding to the condition of music. These color chords are like the strumming of a lute, whereas the chords in Figure 7.20 are of a harsher, louder kind.

Even some *monochromatic* drawings, that is, drawings made with just a single color, especially when made on a toned paper of a different color, show an emotive quality and at least a rudimentary kind of color harmony that amplify the drawing's impact, as Figure 7.22 demonstrates. In Watteau's drawing at least some of the dignity and introspection of the heads can be traced to the gentle warm tone of the page, from which the forms appear to rise and subside.

Redon's theme requires different colors, and his choice of charcoal on a paper toned a deep buff suits his purposes well (Figure 7.23). Note how the artist, by applying some tone to

Figure 7.21
HANS HOLBEIN, the Younger (1497–1543)
Portrait of Anna Meyer (1525–26)
Colored chalks. 13⅞ × 10⅝ in.
Oeffentliche Kunstsammlung Kupferstichkabinett Basel

Figure 7.22
JEAN ANTOINE WATTEAU (1684–1721)
Studies of Women's Heads and a Man's Head
Black and red chalk heightened with white on buff
paper. 25.1 × 38.4 cm.
The Louvre Museum. © Photo R.M.N.

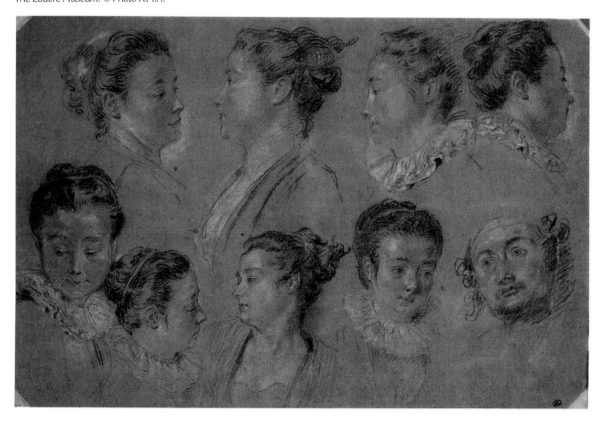

Figure 7.23
ODILON REDON (1840–1916)
The Grinning Spider
Charcoal on buff paper. 49.5 × 39 cm.
The Louvre Museum. © Photo R.M.N.

Figure 7.24
EDGAR DEGAS (1834–1917)
After the Bath (c. 1895)
Pastel. 27⅝ × 27⅝ in.
The Louvre Museum. © Photo R.M.N.

most of the page, makes the lower right side more intense and warmer in hue. This warmer tone increases the sense of color because where the gray tones overlay the buff color a slightly greenish cast is imparted.

There is no clear boundary separating the realms of drawing and painting, and any attempt to establish one is sure to end in frustration. This is so because these two disciplines overlap. Thus we have paintings in black and white (Goya and Kline, for example) and drawings in color. There are small paintings on paper and large drawings on canvas, paintings in line and drawings in value, paintings in dry media and drawings in paint, and so on. Not surprisingly, then, there are a number of works that defy being securely placed in either catagory. Some artists often work in a manner that places their imagery somewhere between drawing and painting. Degas' *After the Bath* (Figure 7.24) is a good illustration of this kind of visualization. The extent and quality of the drawing in this work seem to tilt the scale in favor of its being regarded as a drawing in color. However, the extensive use of color for clarifying volume and space and for compositional and expressive purposes, indeed, the complex color relationships and harmonies of this pastel, all suggest many characteristics of painting.

Such works make it clear that we do not stop drawing when we begin to paint. Painting envelops drawing and cannot be regarded as a separate pursuit. Drawing is the fundamental forming skill and is therefore a given condition in the process of painting, as it is in sculpture, pottery, weaving, or any other category of the visual arts. Adding the element of color to drawing introduces new challenges as well as new options and should not be seen as making the act of drawing easier. When color is judged to be necessary to our expressive purposes, its inclusion makes for an even more fascinating challenge of our responsive skills.

exercise 7A

MATERIALS: Unless otherwise noted, these drawings may be made with the medium (or mixed media) of your choice.

SUBJECT: Unless otherwise noted, these drawings may be of any subject matter you choose.

PROCEDURE: The exploration of color phenomena requires patient study and consequently no time limits are suggested for these drawings. Where no size limits are given, you may work as large or as small as you wish. Unless otherwise noted, do not make a drawing in line, to be colored in later. Such a coloring book procedure usually leads to tight and lifeless results. A better approach when drawing with color is to use it from the start—to think at the outset in terms of color. However, some of the following exercises do require that you add color to a completed line drawing.

Do not hesitate to make changes in your color choices as you proceed. In fact, it is usually not until all the colors in a work are in place that you can decide which colors need to be changed.

drawing 1 *Personal color chart.* Few students realize that they tend to favor a particular range and type of color. The chart you will make here is designed to help you explore your present color preferences and sense of color harmony. On any suitable support, rule a horizontal rectangle 1 inch high by 12 inches long and divide it into twelve 1-inch squares. The result should resemble a ruler. In the square on the far left, paint any color you *like*, using either gouache or watercolor paints. This may be a favorite color or one that happens to suit your mood at the time. In the square next to it, paint in a color that you feel is an especially harmonious partner for the first one. You are trying to produce what you will regard as the most satisfying chord of two-color "notes" you can conceive of. Continue to add colors to each square on the basis of its attractiveness and congeniality with the colors already on the chart. The only criterion here is your judgment, not the goal of making a balanced or unified row of colors. You may choose tints, shades, or mixtures of any combination of colors, as well as colors as they come from the tube. Some colors may even appear more than once. When you have filled in the entire row, continue to make any changes you feel would satisfy your color sensibility even more. You can adjust colors to be richer or duller, lighter or darker, or replace some altogether.

If you redo this exercise in a few weeks—or even in a few days or hours—you may find that your mood dictates different choices and results in a different chart. However, if you collect seven or eight of these charts painted over a period of a few months, they will usually show a basic similarity. Some students will tend to produce charts of a muted and dark kind, others will favor lighter values of perhaps warmer hues, still others will tend toward intense hues offset by a few dark colors, and so on. Each of us has some particular color preferences, and knowing what these are can have important expressive significance. They are our particular means of communicating through color because they are *our* color "alphabet." We choose them

because they reveal best how we feel about the things we draw or paint and they will therefore be used in a more or less consistent way. It is this consistency that makes it possible for the sensitive viewer to decode their meanings.

drawing 2A Warm and cool color. Working from any observed subject, use the following chalks, crayons, or colored pencils to model volume and space through the use of warmer and cooler tones as well as lighter and darker ones.

1. Black
2. Warm gray
3. Cool gray
4. Earth red

The exact hue and value of the above colors are not critical. The gray colors may be of a light or dark value, the earth red may range from burnt sienna to venetian red, and so on.

Begin by drawing lightly in a schematic manner with either of the gray colors to establish the subject's basic "armature," that is, its gestural aspects and some indications of the shapes of its parts. Continue to develop forms and space by relying mainly on warm–cool contrasts. Use cool tones to push back into space planes, parts, and whole areas; use warm tones to bring planes, parts, and whole areas forward. Black should be used sparingly and later in the drawing's development in order more emphatically to establish deep recesses, accents, and some color nuances.

drawing 2B Warm and cool color. Working from any observed subject and drawing on either a warm or cool-toned paper such as a buff or blue-gray pastel, use the following chalks, crayons, or colored pencils to model volume and space as described in drawing 2A.

1. White
2. Black
3. Earth red
4. Color of your choice

In this drawing do not begin with white. Instead use it later in the drawing's development to adjust values, establish highlights and accents, and lighten the tone of the page where desired. In using white to establish highlights, do so sparingly; less rather than more should be the rule (see Figure 7.22).

drawing 3A Color and composition. Make four identical copies of a simple nonobjective arrangement of about fifteen shapes within a 4 × 5 inch rectangle, similar to the example in Figure 7.25. These shapes should demonstrate a balanced arrangement in the format. Note that the shapes in Figure 7.25 are drawn

Figure 7.25

in a way that suggest no background but rather a harmonious pattern of shapes on the picture-plane. Copies of your original drawing may be made on a photo copier.

Using any medium and applying each color in a flat manner, make the following four drawings:

1. Select any hue on the color wheel and, using only black and white for color and value mixtures, compose a balanced and unified arrangement of monochromatic tones. Sensitive adjustments and placement of the various mixtures can suggest that more colors were used than is the case, and you should try for this effect.

2. Select any two of the three primary hues and, using only black and white for color and value mixtures, compose a balanced and unified arrangement of intense and muted colors. Again, try to suggest through various mixtures that more colors were used than was the case.

3. Using all three secondary hues on the color wheel plus black and white, compose a balanced and unified arrangement of colored shapes, each of which is the result of some kind of mixture among two or more colors, so that none of the secondaries (nor black and white) appears in a pure (unmixed) state. Here the purpose is to create an image of subtly muted colors that cannot easily be traced to their origins, that is, as having been produced by the secondaries and black and white. Therefore, the more mysterious and illusive the resulting grayed tones, the better.

4. Use full color to produce a balanced and unified arrangement in which a strong area of visual attention is achieved by building up from muted tones to an intense area of color. However, the freedom to use any colors you wish should not necessarily lead you to use many colors.

drawing 3B *Color and composition.* Using any medium and any choice of subject for four drawings of any size, develop each one by using only the colors described in each of the four sections of the previous exercise (drawing 3A). Thus, your first drawing here will use only the single hue plus black and white, as described for the first drawing of the previous project. Your second drawing will use only two of the three primaries plus black and white, as described in the second drawing above, and so on.

You may elect to draw four different views or aspects of a single subject, or may vary the choice of subject with each drawing. For example, you may wish to do a self-portrait for the first drawing, an abstract interpretation of a still life for the second one, and so on.

Now that you are modeling form and creating space, you will need to consider more fully the distribution of values as well as colors to establish balance and unity in these works.

drawing 4 *Ambiguous space.* Make an abstract drawing of something observed that uses color to help create purposely ambiguous spatial and volume effects. Refer to Figures 7.11 and 7.12 as rough guides only in regard to their use of color in this way. There are no restrictions on size, medium, or kinds of colors used.

drawing 5 *Complementary colors.* On a sheet of warm- or cool-toned paper, make a portrait drawing using five or six colored pencils that are more or less complementary with the color of the paper. For example, if you select a blue-gray sheet, use pencils in the warm family ranging from a cream-colored one to a brown-orange one. If you select a tan or pink sheet, the pencils should be chosen from among the cooler colors. Be sure to have a range of values from light to dark among your pencils, but do not use either white or black. Use the value of the paper wherever it strikes the right value note in your drawing, as in Figure 7.22, where each head shows some of the tone of the paper.

drawing 6 *Intense and grayed color.* Using any medium, select any subject and make a drawing of an objective kind, in largely muted colors, in which the composition's main emphasis is dependent mainly on color intensity. This emphasis can be further strengthened by having some of the surrounding colors more or less complementary to the area of intense color. Unlike the fourth exercise in drawing 3A, which concerned an intense "eruption" among two-dimensional configurations, the requirements of tonal modeling here will necessitate your taking into account the light source when arranging your subject.

drawing 7 *Quantity of color.* Make two identical copies of a simple nonobjective arrangement of about fifteen shapes within a 4 × 5 inch rectangle, similar to the example in Figure 7.25 (and as more fully discussed in drawing 3A).

Using any medium and applying each color in a flat manner, make the following two drawings:

1. Select any primary color and, along with modest variations of it, apply it to most of the shapes in your design. Next, select any other contrasting colors, either pure or muted ones, and arrange them in such a way as to achieve a harmonious balance of these contrasting colors in the work. For example, if you select red as the primary, apply it to some shapes and, mixing it with orange, yellow, or a cooler red, apply these various mixtures to other shapes, giving the effect of several kinds of red occupying most of the design. Contrasting colors could then be of a cooler kind and of various shades and tints.

2. Select any muted warm or cool color and, along with modest variations of it, apply it to most of the shapes in your design. Next, select any other contrasting colors, either pure or muted ones, and arrange them in such a way as to achieve a harmonious balance of these contrasting colors in the work. The dominant, muted color, can be extremely grayed and dark, or moderately intense and light.

drawing 8A *Expressive color.* Referring to Figure 7.21 as a rough guide with regard to mood, make an observed drawing of a seated or reclining figure, in any medium, showing the predominant use of one color (and some subtle variations of it). Try for a feeling of introspection and serenity.

drawing 8B *Expressive color.* Referring to Figure 7.20 as a rough guide with regard to mood, make any kind of drawing that enables you to show color and value being used to heighten a dramatic occurrence.

drawing 8C *Expressive color.* Using a toned sheet of any color and referring to Figure 7.22 or 7.23 as a rough guide in regard to mood, make a drawing using only one color (which may include the choice of black) to convey either a mood of tranquility, as in the Watteau, or a mood of unease or repulsion, as in the Redon.

drawing 9 *Toward painting.* Using Figure 7.24 as a rough guide in regard to its approach toward painting, make a work of any kind, in any medium, that seems to occupy a place somewhere between drawing and painting.

Although color is only an occasional participant in drawing, when it is successfully joined to line and value it can have profound effects. For responsive artists, color provides one more important means of understanding their subjects and sharing these encounters with others.

8

MEDIA
AND MATERIALS

the tools of drawing

A DEFINITION

The substances that produce the lines and tones of drawing—the *media*—and the papers and boards that receive them—the *surfaces* or *supports*—simultaneously carry and influence an artist's responses and thus are important considerations in the forming of his or her works.

Some order can be made of the many varieties of media if one recognizes that they are all either *abrasive media*, applied by rubbing off particles onto the grain, or *tooth*, of the surface; or *fluid media*, applied by a brush or pen holding pigment suspended in some liquid agent. This agent is usually water plus some kind of *binder*, a material designed to hold the pigment to the surface. When applied, the pigment, binder, and water are absorbed into the surface. The water evaporates, but the binder dries among the fibers of the support, holding the pigment in place.

Although every medium is distinct in its character and range of usage, the graphic possibilities of each can never be fully exhausted. There can be as many original uses of a medium as there are inventive artists for whom its nature is congenial and stimulating. Although the technical limits of a medium cannot be appealed, the scope of its behavior within these limits is bounded only by the artist's sensitivity to the medium and by his or her creative wit.

A medium's range and nature can influence the artist's tactics. We are not likely to draw a cloud formation with pen and ink in the same way we would with charcoal. Artists tend to use a medium's strengths and avoid forcing it to do what it cannot do well. Congenial media will stimulate and extend our range of responses, but they do not determine them. Thus, the medium does influence but should never dominate a drawing's imagery.

It is not uncommon for many beginners to prefer "neat" media such as the harder degrees of graphite or charcoal pencils, but you should not reject an unfamiliar medium because of its bold or permanent nature. It can help guide you away from minor niceties toward major essentials. We should realize that too often the medium has been blamed for shortcomings of perception *and* conception. A compatible medium *will* stimulate invention and enhance expression but cannot itself provide perceptions or directly contribute concepts. The medium is an integral part of the graphic message, but it is not the message itself.

Beginning with the cave artists, who discovered painting and drawing possibilities in natural chalks and clay, artists have always shown ingenuity in adapting any material that suggested potential as a medium or tool. The need to create certain textural, tonal, or color effects, or to improvise when art supplies were unavailable, has stimulated the invention of many tools and materials in use today. The first painting knife may well have been an artist's palette scraper, used when a heavy impasto was needed. For years, soft bread was used as a charcoal eraser. Crumpled paper dabbed with ink, watercolor, or opaque paint produced interesting results, and this is now a common practice. Fingers were probably man's first "brushes," and there are few artists who do not add or adjust a tone or line in this way.

In the absence of a pen or brush, an artist may apply ink or paint with a twig, a cotton swab, sponge, matchstick, or any one of a score of adaptable applicators. When the medium itself was unavailable, coffee or tea have been used, as have food coloring, iodine, and similar staining liquids. Almost any substance that can make a mark and any surface that can receive it may serve as drawing materials. Sometimes tools and media discovered in an emergency situation, or in a free experiment, have become favored media for some artists. One contemporary watercolorist of note for years regularly used Mercurochrome to produce golden reds and executed his works on common shelf paper. Too often, however, as in this case, such innovations lack permanence or adequate control.

The abrasive media in common usage can be grouped into four general divisions: the several kinds of charcoal-based media; the several kinds of chalks; the fatty-based crayons; and graphite, with clay or carbon mixtures. The fluid media include waterproof and washable inks, transparent watercolors, and the several more or less opaque water-based paints. Sometimes thinned oil paint is also used as a drawing medium—a practice of long standing.

Often dry and wet media are intermixed. In Daumier's *Connoisseurs* (Figure 8.1), graphite pencil, charcoal, and watercolor washes are used. Mixed-media drawings often result from the structural and expressive needs of the moment, with additional media being introduced as new creative possibilities emerge in the evolving work.

Sometimes an artist's strategy necessarily includes several media. Daumier's drawing seems to be one of these. Here, the soft, vague charcoal lines appear as a first, gestural underdrawing, as can be seen by the preliminary indications of a figure on the far left. Graphite lines delineate the forms more specifically, and watercolor washes convey the local tones and the broad modeling of the forms. Note the integration of the media; the drawing has no sizable segment expressed by only one medium. Each is active everywhere.

Unless media and materials are technically or chemically incompatible, they can be combined in any way that offers a solution to our desired goals. "Rules" for using the various media have often presented unnecessary barriers to creative expression. Many of these prescriptions for usage grew up around those procedures that direct the user toward a medium's most natural characteristics, or that have proven successful in the past. But the justification for the use of any medium or combination of media can be found only in the artistic worth of the work in question.

Because successful drawings always disclose a happy union of their meaning and the means used, every great drawing is a virtuoso performance of the medium used. But placing the emphasis on a display of technical facility shifts the emphasis in drawing from analysis and expression to deliberate performance. Drawings then become not the result of an artist's interpretation of nature, but a show of skill in manipulating tools. When such clever usage becomes the primary objective, then a drawing's *real* subject has become the exhibit of an artist's facility with materials—a dubious goal.

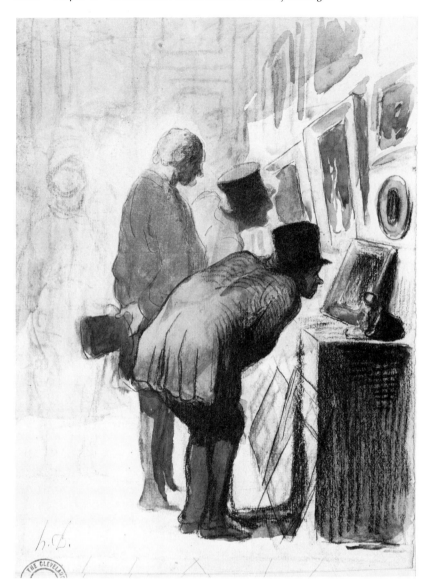

Figure 8.1
HONORÉ DAUMIER (1808–1879)
Connoisseurs
Watercolor, charcoal and pencil. 10¼ × 7⅝ in.
The Cleveland Museum of Art Purchase,
Dudley P. Allen Fund

THE ABRASIVE MEDIA

The common *stick*, or *vine charcoal* (Figure 8.2), possibly used in prehistoric times, continues to be a popular medium. Stick charcoal is simply carbonized wood, usually willow, beech, or vine branches. The longer they are allowed to carbonize in a sealed chamber, the softer the charcoal sticks become, producing darker lines and tones. Because charcoal has no holding or adhesive agent—no binder—it is an especially *friable* material; that is, it can be very easily crushed into a powder. It depends, as do most abrasive media, on a surface that has at least a moderate tooth. When charcoal (or any abrasive medium) is rubbed across such a roughened surface, minute particles are filed away and lodge among the hills and valleys of the paper's surface (Figure

Figure 8.2
Charcoal and chalk media. From left to right: compressed charcoal stick, soft chalk, conté crayon, hard chalk, sanguine red conté crayon, soft charcoal block, and white conté crayon. At bottom, stick charcoal.

8.3). Being extremely friable, stick charcoal needs only light pressure to mark a surface. Its particles are not usually embedded deeply into a paper's grain, and they erase or dust off easily.

Charcoal can be repeatedly erased and reworked. It can, when sharpened on a sandpaper block, produce quite delicate lines. When used on its side, stick charcoal makes bold, broad tones. Because of its easy application and removal, and its wide range of effects, it has been used for centuries to make the preparatory drawings that underlie many oil paintings. Such drawings, when they are developed to the de-

sired degree, can easily be isolated by spraying with a weak solution of shellac or lacquer, called *workable fixative*.[1] For all these reasons, too, in about the beginning of the nineteenth century charcoal became the standard drawing medium in the European art academies. Its easy handling made it an especially popular medium for making sustained, closely observed studies.

Although charcoal was and continues to be

[1]Spraying fixative or any other studio substance should be done in a well-ventilated room or even outdoors for reasons of health.

Figure 8.3
Bold, heavy strokes drive charcoal stick particles into the "valleys" of a paper's surface texture. Light strokes deposit the particles only on the "hilltops."

used for final drawings, its fragile hold on the paper, until fixed, makes it difficult to retain dark tones upon the page or to avoid smearing. Unwary students who sneeze toward a drawing heavily laden with charcoal may find their drawing suddenly faded, the particles "exploded" on the page. Fixing the drawing prevents this, but then erasure becomes almost impossible. One solution to the problem is to use fixative as the drawing progresses, at stages when there are not likely to be any substantial changes of major tones or lines. Workable fixative does not prevent additional drawing over fixed areas. In fact, it helps produce darker tones because the earlier charcoal layers, now encased in the fixing material, form a new, firm tooth and can hold new charcoal particles better.

Although stick charcoal's tonal range does not extend as far as the rich black possible with chalks and crayons, it permits a wide enough range for most drawing purposes and styles. It can be used for subtle tonal and line drawing, as in Figure 8.4, or for bold, brooding ones, such as Figure 8.5. Unlike most of the other abrasive media, which can hold on surfaces with a very fine tooth, stick charcoal's weak holding power will fail on such smooth surfaces. Even some of the smoother types of newsprint do not take charcoal well.

Compressed charcoal, made by pulverizing charcoal, adding a binding agent, and compressing it into small cylinders or square-sided sticks, produces richer dark tones, has good holding power, and is less easily erased than stick charcoal. Charcoal in this form is sometimes regarded as black chalk. It is manufactured in varying degrees of softness, and its character is controlled by the amount of binder added. The hardest compressed charcoal sticks have some of the characteristics of the natural black chalks in use from the fifteenth to the nineteenth century, when good quality natural black chalks became less available. (See Holbein's *Portrait of Cécily Heron*, Figure 8.6, for an example of a work containing some natural black chalk.)

Compressed charcoal, available in various degrees of softness, is also manufactured in pencil form referred to as *charcoal* or *carbon pencils* (Figure 8.7). Fashioned into slender "leads," it is also sold in packets for use in holders.

The thin lines possible with a charcoal pencil allow for delicate line use. Although this can provide handsome results (Figure 8.8), it can

Figure 8.4
PIET MONDRIAN (1872–1944)
Chrysanthemum (c. 1908–9)
Black conté crayon with graphite, charcoal, and brown crayon. 23¾ × 15⅛ in.
Smith College Museum of Art, Northampton, Mass.
Purchased 1963

have inhibiting effects on the handling of large drawings. It is generally used for works of a small scale, or in conjunction with the broader charcoal media when linear or tonal statements of a more precise nature are required.

All members of the charcoal family are intermixable and frequently used together. Compressed charcoal is often used to deepen values and add accents to stick charcoal drawings. Charcoal media work well with water-based ones in mixed media combinations, as in Figure 8.1.

The term *chalk* has been freely applied to a wide variety of friable media, including those of

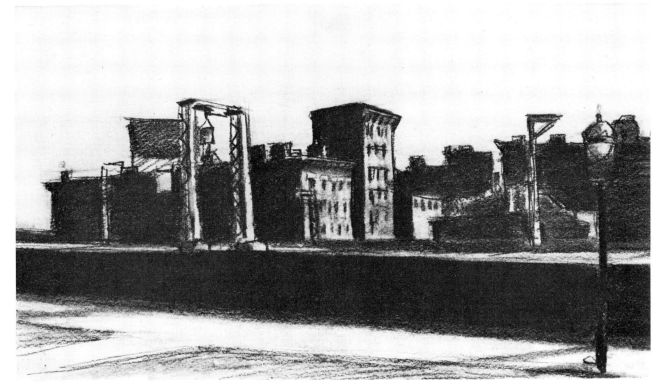

Figure 8.5
EDWARD HOPPER (1882–1967)
Sketch for "Manhattan Bridge Loop"
Charcoal. 6 × 11 in.
Addison Gallery of American Art, Andover, Mass.

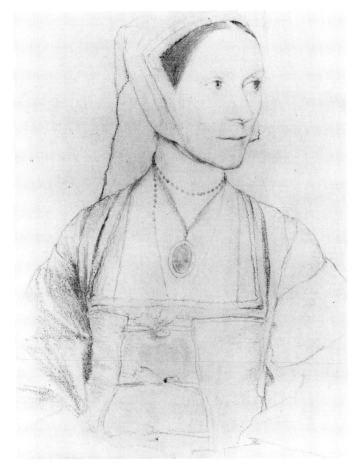

Figure 8.6
HANS HOLBEIN, the Younger (1497–1543)
Cécily Heron
Natural black chalk. 15 × 11⅛ in.
Royal Collection, Windsor Castle

205

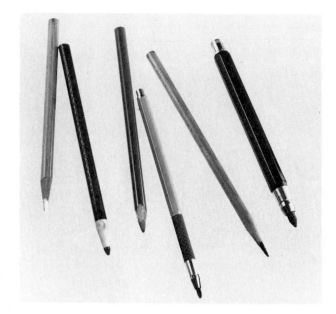

Figure 8.7
Chalks in pencil form. From left to right: white conté crayon pencil, compressed charcoal pencil with string for exposing additional chalk, sanguine red conté crayon pencil, mechanical holder with thin chalk sticks, hard compressed charcoal pencil, mechanical holder with broad chalk stick.

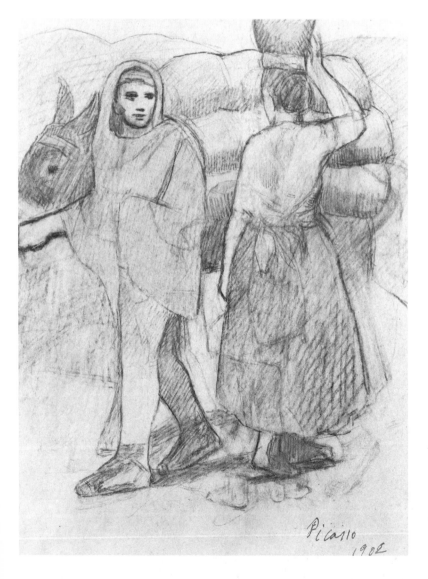

Figure 8.8
PABLO PICASSO (1881–1974)
The Donkey Driver
Carbon pencil. 10⁵⁄₁₆ × 7⁷⁄₈ in.
The Cleveland Museum of Art, Bequest of Leonard C. Hanna, Jr.

a fatty-based composition. The term *pastel* has come to be associated with the great variety of colored chalks, but black pastel is generally made of ivory-black pigment (charred bone), gum arabic, and ball clay.

Harder to classify are those chalks that have a slightly waxy binder but are, in use, much closer to the more friable chalks than to crayons. All chalks can be erased to some degree, but those having a waxy base are far less erasable. The popular conté crayon is such a medium. Its slightly fatty, smooth flow (especially pronounced in the several earth red colors) still retains some of the look and feel of the more erasable, drier chalks. Conté crayon seems to bridge the division between chalks and the family of waxy-based media called *crayons* (see Figures 2.15, 4.28, and 4.42).

Chalks range from the very soft and "painterly" ones (as used in Figure 4.30) to those of quite hard consistency that require some pressure to produce dark tones (see Figure 2.28). Because of the various types and colors of chalks available, the student should experiment with several. Their differences in behavior are often subtle, and any type of chalk is capable of quite different effects when used on papers of various grains. Today, an excellent choice of colored chalks is available.

Fragonard's drawing (Figure 8.9) in red chalk shows a sensitive understanding of the broad, painterly qualities that the softer chalks are capable of. Fragonard utilizes chalk's capacity for suggesting light, establishing planes, and conveying strong calligraphic statements. The rich texture of soft manufactured chalks is apparent in Degas' *Woman with a Towel* (Figure 8.10; see also Figure 7.24). Their rugged power lends itself well to such bold statements. Note that the artist achieves many subtle tonal harmonies by hatched lines, and that the blending of chalk tones, so favored by the beginner, is seldom relied on in the chalk drawings of old or contemporary masters, although the fusing of tones can be an effective tactic, as Ipousteguy's drawing shows (see Figure 2.15).

Chalks are often used in combination with other media. Moore's drawing of miners (Figure 8.11) is a mixed-media work in black, brown, tan, yellow, and white chalks, pen and ink, gray washes of ink, and with some surface scratching to reveal lower layers of tone and color. Here the chalk's texture is revealed by the rough tooth of

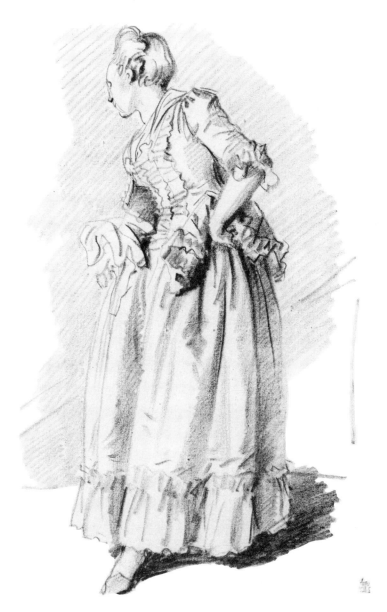

Figure 8.9
JEAN HONORÉ FRAGONARD (1732–1806)
Woman Standing with Hand on Hip
Red chalk on white antique laid paper. 15¾ × 9¾ in.
Courtesy of Fogg Art Museum, Harvard University, Cambridge, Mass. Bequest of Meta and Paul J. Sachs

the paper, the repeated applications of chalk, the scratching through, and the use of washes which settle in the valleys of the surface, darkening them and leaving the chalk covered hills lighter.

As in the case of chalks, there is a wide range of wax or other fatty-based *crayons* available, from those of a rather dry, chalk-like nature to the greasy and viscous ones, not unlike chil-

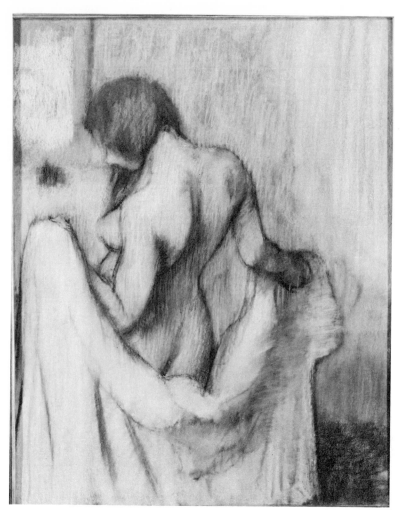

Figure 8.10
EDGAR DEGAS (1834–1917)
Woman with a Towel
Pastel on paper. 37¾ × 30 in.
The Metropolitan Museum of Art. The H.O. Havemeyer Collection. Bequest of Mrs. H.O. Havemeyer, 1929. All rights reserved, The Metropolitan Museum of Art

Figure 8.11
HENRY MOORE (1898–)
Miners at Work on a Coal Face
Black chalk, pen and ink with gray wash heightened with white chalk and body color. Surface scratching and yellow and brown chalk. 13⅛ × 21⅜ in.
Whitworth Art Gallery, University of Manchester

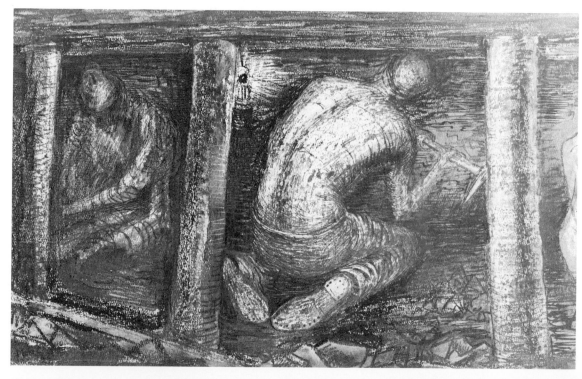

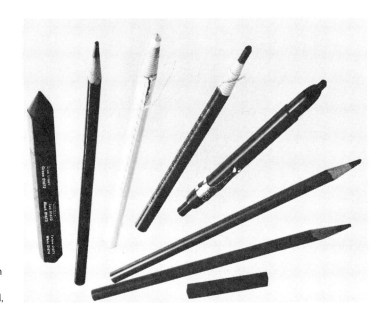

Figure 8.12

Crayon media. From left to right: carpenter's marking crayon, black crayon pencil, white crayon pencil with string for exposing additional crayon, black litho crayon pencil with string, mechanical holder with soft crayon "lead," sanguine red crayon pencil, sepia crayon pencil, and square stick of litho crayon.

Figure 8.13

PABLO PICASSO (1881–1974)
Head of a Young Man (1923)
Grease crayon. 62.1 × 47.4 cm.
Courtesy of The Brooklyn Museum

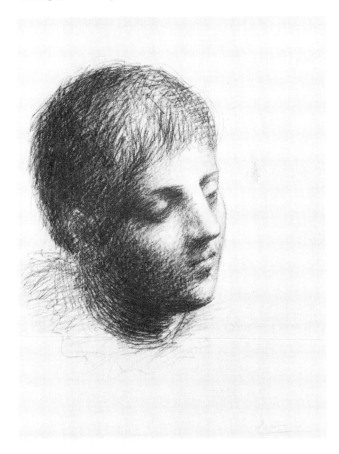

dren's crayons. The type of binder used in the manufacture of crayon media determines the degree of viscosity. Those that retain some chalk-like characteristics, such as conté crayon usually contain soap, ball clay, and sometimes small amounts of beeswax. The greasiest ones contain high amounts of wax and tallow. Most crayon media are available in stick and pencil form (Figure 8.12) and are available in a wide assortment of colors. Some can be dissolved in turpentine, providing painterly effects, and are compatible with oil paints.

Toulouse-Lautrec's drawing (see Figure 1.11) well illustrates the flowing, linear freedom possible with crayon. Picasso's *Head of a Young Man* (Figure 8.13) shows the rich blacks and the sharp focus of crayon lines. These tend to exceed even the strong darks and clarity of chalk lines. Because of the adhesive strength of the binder, crayon is almost impossible to remove from the page. For the same reason, the blending of tones is not possible. Tones must be achieved by hatching, as in Figure 8.13. Many artists are attracted to crayon's sharp, rich lines and to the challenge of its permanence, which, like pen and ink, demands resolute decisions and handling.

One group of fatty-based materials was developed for use in the graphic process of lithography (Figure 2.21). Black lithography crayons and pencils (a waxy-based ink called *tusche* is also available) come in varying degrees of softness but are, as a group, fattier than most

other crayons. They are a versatile and popular medium for both short and sustained drawings.

Because the fatty-based media do not require fixative and do not smear in the sketchbook, they are a useful medium for drawing out of doors. But their water-resisting binders make them less compatible in certain mixed-media combinations.

Perhaps the most familiar writing and drawing tool in use today is the *graphite pencil* (Figure 8.14), erroneously called a lead pencil. The confusion in terms probably resulted from the common, earlier use of the various metallic styluses, of which lead and lead alloy metals were the most popular. These had the important advantage of not requiring a specially prepared surface to write on—usually a lead white base—as was necessary when silver, gold, brass and other metals were used. But many artists preferred the other metals, especially silver, because of the darker lines that resulted through oxidization (see Figures 6.39 and 8.15).

Although similar to graphite lines, metalpoint lines (usually silverpoint) are lighter, are not erasable, and cannot vary in width or value. While excellent for delicate drawings of a small scale that do not depend on such variations of line, metalpoint drawing has been largely superseded by the modern graphite pencil.

Graphite pencils are available in over twenty degrees of softness. The harder pencils usually carry an H designation, plus a number indicating the degree of hardness. The 1H pencil is the least hard of this group, the 9H the hardest. The softer pencils are marked B, and the higher the number the softer and darker the tones; these extend up to 8B. There are three pencil grades between two categories, usually marked (from softer to harder): F, HB, and H. All the hard pencils can produce lines similar to the fine lines of the metalpoint instruments. The various degrees are determined by the mixtures of graphite and clay. The more clay present in the mixture, the harder and lighter the line. The less clay present, the darker the line.

Like the slender compressed charcoal sticks, graphite "leads" are available for use in mechanical holders and in flat-sided sticks or blocks (Figure 8.14). The many degrees of graphite available provide a versatile range of linear and tonal possibilities. The beginner too often strains the range of a single pencil. It is of course unnecessary to have the entire range, but four or five degrees of softness are sometimes needed in extended tonal drawings (Figures 8.16 and 8.17). A good all-purpose selection might be 3H, HB, 2B, 5B, and 8B. Although the harder degrees are omitted here, some surfaces (and styles) may require their use. In general, though, their limited value range and hard, fine lines too often pro-

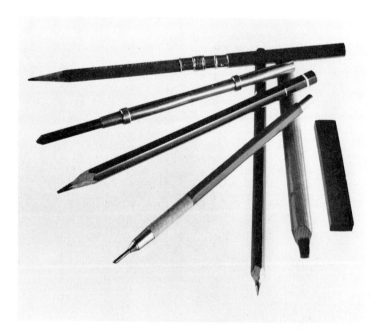

Figure 8.14

Graphite media. From top, counterclockwise: graphite pencil in pencil extender, thick graphite "lead" in double-ended extender made to hold any wide abrasive medium, an 8B graphite pencil, mechanical pencil holder for thin "leads," pencil made of graphite-carbon mixture (for very dense, black lines), flat graphite pencil, and broad, square-sided graphite block.

Figure 8.15 (*student drawing*)
Carolyn Zarr, Arizona State University
Silverpoint heightened with white on toned ground.
7½ × 9 in.

mote a tight, timid result. The softer pencils can still give great exactitude and more tonal range than the hard ones (Figure 8.18).

If one's choice were limited to a single pencil, a 2B or 3B would serve most needs best, unless the drawing was to be large scale, in which case a 4B or 5B would be more useful.

Although graphite is easily blended, most artists prefer the texture and freshness of massed graphite lines (Figures 3.27 and 8.19). Graphite's easy erasability (less so in the very hardest and softest degrees) leads many students to overwork their drawings. Graphite's freshness is fragile and easily lost. Extensive erasure, blending, and reworking of tones and edges cause an unpleasant shiny, "tired" surface.

Graphite is a frequent participant in mixed-media works (Figures 8.1 and 8.20). Its ability to be used in faint wisps or powerful accents, its easy application over layers of almost any other medium, and its pleasing character as a dry "counterpoint" to wet media make it a versatile member of almost any combination of media. Graphite can even be made to function as a fluid medium by washing over layers of the material with turpentine or alcohol.

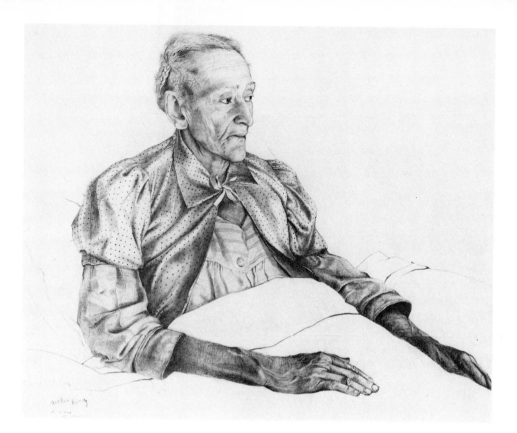

Figure 8.16
ANDREW WYETH (1917–)
Beckie King
Pencil. 28½ × 34 in.
Dallas Museum of Fine Arts, Gift of Everett L. DeGoyler

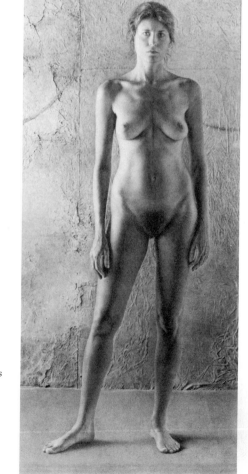

Figure 8.17
KENT BELLOWS (1949–)
Angela, Full Standing (1988)
Pencil on paper. 30 × 12 in.
The Toledo Museum of Art; National Endowment for the Arts Museum Purchase Plan Program and matching funds from the Friends of Roger and Gayle Mandle, The Toledo Modern Art Group, and Dorothy M. Price. © Kent Bellows 1988

Figure 8.18
SIDNEY GOODMAN (1936–)
Dead Figure
Pencil. 23 × 29 in.
Collection, Moravian College, Bethlehem, Pa.

Figure 8.19 (*student drawing*)
Thomas Ouelette, Art Institute of Boston
Graphite on Bristol paper. 14 × 17 in.

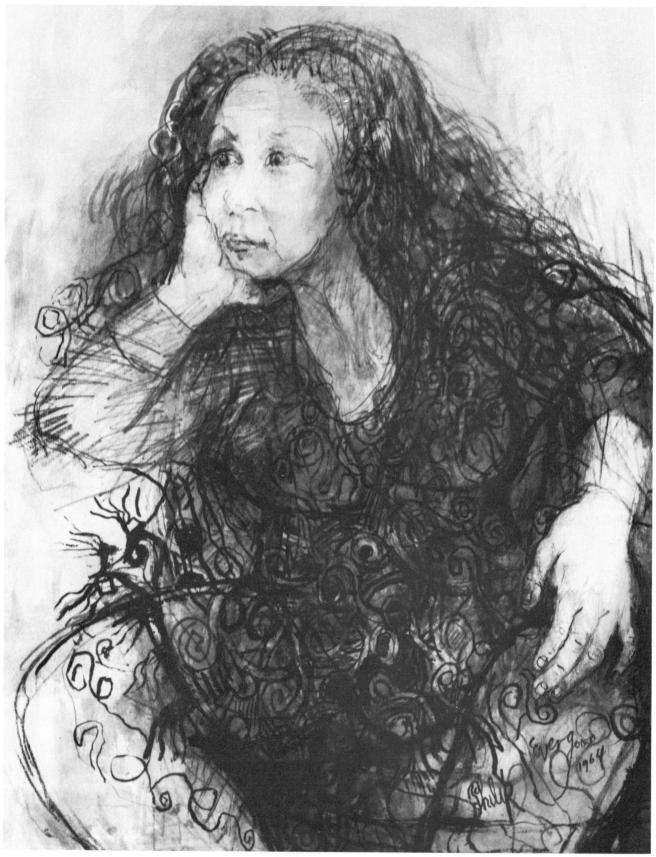

Figure 8.20
PHILIP EVERGOOD (1901–1972)
Girl in Brocade Chemise (1964)
Pencil, crayon, brush, ink. 24¼ × 19¼ in.
Collection of Mr. and Mrs. Joseph Akston

214

THE FLUID MEDIA

Whatever their differences, all dry media, because of the friction of the abrasive process, are relatively slow to produce a line or tone. Whereas an energetic calligraphy in chalk or graphite involves some effort, the absence of resistance in applying wet media makes this group harder to control. The chalk or pencil may have to be prodded along; the pen or brush must be restrained.

The designation *pen and ink* is sometimes freely applied to drawings made with tools other than, or in addition to, the pen. Twigs or sticks of various kinds, especially balsa wood; feathers used as brushes; sponges, rolled paper, even cocktail stirrers or eye droppers, and other unlikely objects have been used to produce certain textural and linear characteristics.

Ink, applied with brush or pen, was used as a drawing and writing medium in most ancient cultures. It retained its popularity in the West even after the introduction of manufactured chalks, crayons, and graphite, and it continues to be one of the most appealing and adaptable of drawing media. Ink has the ability to produce strong or subtle value contrasts; it can be used with painterly force or delicate finesse; its range of linear, tonal, and textural characteristics is virtually endless. Because of its great versatility, ink has been a favorite drawing medium in almost every age for a variety of expressive or stylistic purposes.

Today, many kinds of inks in many colors (including white) are available for many uses. There are inks made of dye solutions for use in ball-point pens; there are the traditional fountain-pen inks and inks made especially for etching, for lithography, and for the commercial printing industry, as well as the several kinds of ink used for drawing. Inks may be transparent or opaque (when used full strength), waterproof or water-soluble, and come in liquid, paste, or solid form.

One of the oldest and most versatile inks is the Oriental *sumi* ink. Made of carbon and a water-soluble binder, it is formed into small blocks which are rubbed on a slate inkstone containing a small amount of water, to produce either a paste or liquid, depending on the ratio of pigment to water. Sumi ink is now also available in liquid and paste forms, as well as the traditional cake form. In a liquid state it produces a rich, black line as good as the best of the contem-

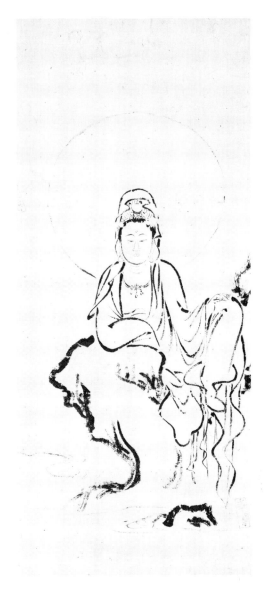

Figure 8.21
Late Kamakura Period (c. 1200)
White-Robed Kannon from Kazan-Ji Temple
Brush and ink. 36 × 17¾ in.
The Cleveland Museum of Art Purchase,
John L. Severance Fund

porary inks (whether water-soluble or waterproof) and better than some (Figure 8.21).

Another early drawing ink, *sepia*, is olive-brown in color and is made of the inky substance from the sacs of squid and cuttlefish. An ink called sepia is available today, but many manufacturers do not use the original material. Like another early ink, *bistre,* yellowish-brown in color, sepia ink was and is favored for its suggestions of color. Bistre ink is not commonly available commercially.[2]

[2]For those interested in making bistre and other inks, I recommend James Watrous, *The Craft of Old Master Drawings* (Madison: University of Wisconsin Press, 1957).

India ink is a generic term for a contemporary drawing ink, usually made of carbon or lampblack pigment, and a shellac binder which renders the finished drawing waterproof. It tends to have a heavier consistency and a more velvety feel than most black water-soluble inks because of the solids in its composition. Because of these solids and the shellac, the user must from time to time scrape or wash from the instrument the dried ink which accumulates during usage. At the end of a drawing session, all instruments that have been in contact with India ink must be thoroughly washed in soap and water. India ink solvents are available, should one be necessary. A wide selection of brands offers several densities of India ink for various purposes. All produce dense blacks and all are excellent drawing inks.

Although India ink can be diluted for tonal washes, these usually appear granular when compared with similar ink washes. Also, India ink washes often end in rather abrupt shapes when compared with the more feathered edges of a sumi wash. However, the paper used, the manner and instrument of application, and the density of the wash all affect the appearance of any ink wash.

Less frequently associated with drawing are transparent *watercolors*, in cake, tube, or liquid form. Of particular interest to the artist are the blacks, the many browns (including bistre and sepia), and the various earth reds. Although other colors are sometimes used, these are more compatible with the inks described above. Watercolors are often used in conjunction with inks and other media.

Watercolors are made of dry pigment and gum arabic. Additionally, those in tube form contain an ingredient such as glycerin to retard drying out in the tube and to help dissolve the paint in water. Liquid watercolors are usually made of dyes, or dyes added to pigment. Often they are described as *concentrates*, and such colors *do* have very strong tinting power. But the permanence of many of these colors is doubtful. Some of those in cake form contain an agent that retards drying out in storage; others (usually the less expensive brands) do not.

The composition of watercolors does not permit their easy application in heavy layers—at least not over large areas. Watercolors can be made opaque by the addition of any water-based white paint. The one most often used is called *Chinese white*. When watercolors are used in this

way, the medium is referred to as *gouache*. Several manufacturers offer gouache paints in tube or pan form. In full strength, gouache colors are strong in hue, but when gouache is thinned with water the washes appear less clear than do those of watercolors.

Lampblack watercolor (Figure 4.21) is similar in its characteristics to sumi ink and is compatible with it and other carbon inks. Often it is used to lay in washes of tone over India ink lines, which of course will not dissolve and spread on the page. *Ivory black* is a cooler, bluish-black and, when used alongside warmer blacks, imparts a subtle note of color to a drawing's tones.

Although the liquid watercolors can be used for pen drawing, the tube and cake forms are not normally thinned out for use in this way. The process of diluting them is tedious, and their faster drying properties make their use with pens difficult. When strong, colorful lines are desired, colored inks (though many are of questionable permanence) produce fresher lines of richer hues. When heavy layers of paint are desired, opaque water-based media such as gouache, casein, tempera, and acrylic paints will serve better.

Casein is a strong binder made from the curd of milk. Because of its brittleness, gum and other additives are combined with it and the dry pigments to produce a more flexible paint film. Even so, casein is too brittle to use on any but the heaviest of paper supports. It is the most opaque water-based paint available and surrenders this quality with reluctance. When used transparently, it handles poorly and produces washes of a mottled and clouded appearance. As an opaque paint, its matte finish and excellent brushing properties are suited to large, bold drawing and make it a desirable component in mixed-media combinations with the drier abrasive media and others of a matte nature. When dry, the paint film is insoluble. Because of its powerful opacity, casein white is sometimes used to cover unwanted lines and tones in other media.

The term *tempera* has been freely applied to many water-based paints. Today it is often used to describe poster paint, but some manufacturers offer a tubed tempera paint that behaves somewhat like casein but has the advantage of producing clearer washes. Its composition is not unlike that of gouache, but it differs in being a more viscous paint, capable of being more heavily applied over larger areas. Like casein, it is rather brittle when dry and must be used on stiff

supports to avoid cracking. Manufactured temperas should not be confused with *egg tempera*, a medium popular between the twelfth and fifteenth centuries (and currently enjoying a renewal of interest), which uses raw egg yolk as a binder with dry pigments. Because it spoils quickly in storage, egg tempera is seldom available commercially.[3]

Acrylic paints, a fairly recent addition to the media now available, use a synthetic resin as a binder. This imparts a remarkable pliancy to the paint film that prevents cracking. Somewhat less opaque than casein and tempera, it nevertheless can be applied heavily enough to achieve total opacity. Acrylic paint is extremely fast-drying. This feature makes it necessary, while working, to place brushes not in use in a container of water. Left lying on the palette, the paint will dry on the brush within minutes. Dried acrylic paint

is insoluble in water and is hard to remove. Its stubborn resistance to soap and water makes it necessary to wash brushes thoroughly immediately after use. Most manufacturers offer an acrylic extender for thinning the paint. This material can, when added to casein or tempera paint, impart some added pliancy, broadening its range of use and character.

Acrylics can be applied more heavily than either casein or tempera with little danger of their cracking or peeling. Unlike any other water-based paint, acrylic paint films can be drawn upon with pen and ink without the ink spreading, blotting, or mixing with the paint, and with no danger of the paint chipping off. Some of the media we have been discussing are generally associated with painting rather than with drawing materials. However, as we saw in Chapter 7, it is impossible to say just where drawing ends and painting begins. Moore's *Miners at Work* (Figure 8.11), despite its color, is not a painting. Nor is color the only criterion. Constable's wash drawing (Figure 8.22) in sepia ink is monochromatic but seems to possess painterly qualities.

[3]For those interested in making egg tempera and other paints, a useful source is the succinct and accurate text by Reed Kay, *The Painter's Guide to Studio Methods and Materials* (Englewood Cliffs, N.J.: Prentice-Hall, Inc., 1983).

Figure 8.22
JOHN CONSTABLE (1776–1837)
Stoke by Nayland
Brush and sepia ink. 12.7 × 18.5 cm.
Victoria and Albert Museum, London

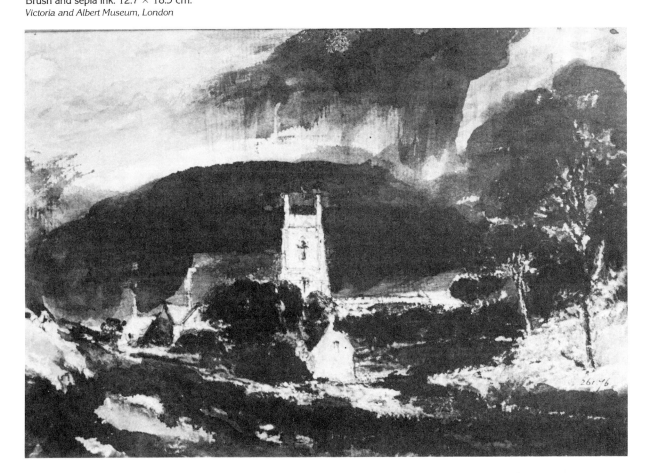

Figure 8.23
HENRI DE TOULOUSE-LAUTREC (1864–1901)
The Dog
Oil on cardboard. 61 × 63.5 cm.
Toulouse-Lautrec Museum, Albi, France

Therefore, the several paints discussed here should be considered as additional ways to increase options in drawing. Oil paints are omitted here only because the addition of a medium requiring its own thinner, varnishes, oils, and the like would complicate the mixed-media possibilities and restrictions. But drawing in oils, or combining oil paint with other drawing media, is a common practice of long standing (Figures 8.23 and 8.24). The use of paints in drawing tends to promote a broader, often more daring approach on a larger scale, which can act as a healthy corrective for those who tend to make tiny drawings in a timid manner.

Figure 8.24
DOMENIC CRETARA (1946–)
Seated Nude Figure
Sepia chalk and oil washes. 14 × 18 in.
Courtesy of the artist

THE DRAWING INSTRUMENTS

Most of the abrasive media, except for the thin and fragile compressed charcoal, crayon, and graphite leads, do not normally require any mechanical implements or holders. However, some artists prefer holders or extenders for all the abrasive media, to permit them to stand farther back from large drawings, or to extend the drawing life of a medium worn too short to be comfortably held in the hand (Figure 8.14).

Some mention has already been made of the many improvised drawing tools that can be used with inks or paints. In this section we will examine the various pens and brushes designed for use with these media.

Pens. Probably the oldest instrument for applying ink is the *reed pen*. Found at many river banks and marshes, the tubular reeds are cut to a comfortable length and sharpened to a point at one or both ends. Splitting the shaft at the point provides a steadier ink flow and a slightly more flexible point (Figure 8.25). The reed pen, with its thick, tubular body, naturally produces broad, "plain spoken" lines. Although quite thin lines are possible if the pen is sharpened to a fine point, the fibers break down quickly. Even the blunt point wears away after a short period of

Figure 8.25

Cutting a reed pen. Using a sharp blade, make a 45-degree cut (A). A second cut (B) is then made at a more oblique angle than the first. Sharpen to a dull point, as in C. On the back, with a nail or pin, drive a hole through the wall of the reed. Using a knife blade, slit from hole down to the end of the reed, as in D.

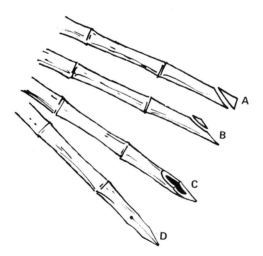

drawing and needs to be recut. Also, some ink is taken up into the pen's tip through capillary action in the fibers, making the point rather spongy after about twenty minutes of drawing. It should then be set aside to dry. Many artists use two or three reed pens in rotation.

The reed's ability to take up ink in its fibers has one useful advantage, however. When the pen is fully charged, the lines will of course be dark and dense. But as the ink is used up, it can be forced from the fibers through increased pressure on the pen to produce various toned lines (see Figure 1.12). These can be extremely light and dry-looking, making possible very delicate tonal nuances.

Reed pens may not work well for long or complex curvasive lines. Their ink flow is usually too heavy to sustain such lines. Nor do they glide along the surface easily, except when fully charged. The user feels a decided friction between the pen and paper and may tend, therefore, to make slower, shorter lines with a reed pen than with any other. Many artists consider these restrictions a challenge that encourages a concise and vigorous approach to drawing, instead of ornate facility (Figures 6.16 and 8.26).

Art stores offer bamboo reed pens, sometimes with a brush at one end. Reed pens work well on most surfaces, but their character is best revealed on surfaces with a moderate to rough tooth. Very smooth papers may promote a heavy flow of ink that is hard to control.

The *quill pen*, which was popular until the introduction of the steel pen, is made from the heavier pinion feathers of the goose, crow, or swan. Unlike the reed pen, it requires almost no pressure to use. The thin tubular wall of the feather (a horn-like substance) allows a much finer and more flexible point to be cut. Because it glides easily over even the roughest grained paper, the point does not wear away as fast as the reed's. Like the reed pen—and for the same reasons—the quill pen is split up the middle, as shown in Figure 8.27.

The quill pen responds to the slightest inflections of the hand. It produces extended fine lines or lines that can be varied in width by a change in pressure on the pen. The quill's flexible point can ride the hills and valleys of a rough-grained paper better than the modern steel pen, which is more likely to tear through the paper, causing the ink to spatter. The quill's tip can be shaped to suit the user. Cut at an oblique angle, it

Figure 8.26
VINCENT VAN GOGH (1853–1890)
Corner of a Park at Arles (*Tree in a Meadow*) (1889)
Red pen and black ink over charcoal. 49.3 × 61.3 cm.
Collection of The Art Institute of Chicago. Gift of Tiffany and Margaret Blake. Photograph © 1990, The Art Institute of Chicago. All Rights Reserved

Figure 8.27
Cutting a quill pen. Make the same two angled cuts as for a reed pen (Figure 7.28). To split the point, press thumbnail down hard at the point where slit is to end (about ¾″ from tip of quill), and forcing a brush handle into quill opening, press upward toward the thumb (A). The quill will not split beyond the point where the thumbnail presses against the quill. Sharpen the point to the desired angle and degree of fineness (B).

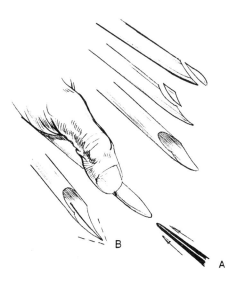

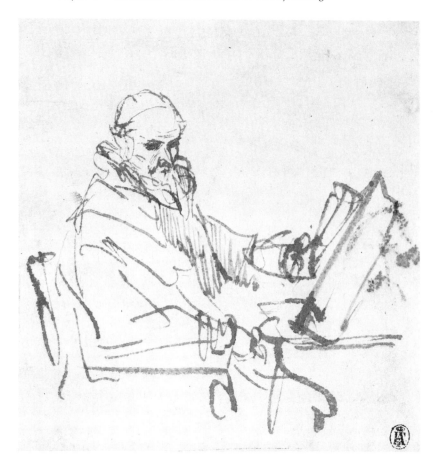

Figure 8.28
REMBRANDT VAN RIJN (1606–1669)
Jan Cornelius Sylvius, Preacher
Reed and quill pens and ink. 13.3 × 12.2 cm.
National Gallery of Art, Washington, D.C.
Rosenwald Collection

produces a script-like line as the pen is turned in different ways. Cut with a blunt point, it can produce some of the effects of the reed pen. Uncommon in most art stores, goose quills can be obtained from meat markets, farms, and some novelty shops. Crow and swan quills perform about as well but are much harder to obtain.

The quill provides a delicate and ornamental counterpoint to the reed's more blunt statements. In Rembrandt's spirited sketch (Figure 8.28), the quill's lines in the drawing of the head and on the figure's robe and sleeve create a delicate, lace-like tracery in contrast to the reed pen's more rugged broad strokes.

The *steel pen* appeared in the early 1800s. Providing several degrees of flexibility and styles for use in a holder, it quickly superseded the reed

and quill pens because of several advantages. Their uniform manufacture ensures the availability of a particular type; they usually hold more ink; they never need sharpening; and they can produce sharper, cleaner lines than either of their precursors, as Figure 8.29 indicates.

Today, the wide assortment available ranges from extremely flexible pens that produce lines varying in width from an almost invisible thread of ink to over one-eighth of an inch thick, to stiff pens that make uniform lines of mechanical exactness. Some pens are made for use with a holder, others are made to fit into a fountain pen (Figure 8.30).

Despite these advantages, many steel pens lack the warm, animated character of the reed and quill pens. Few will function as well on the

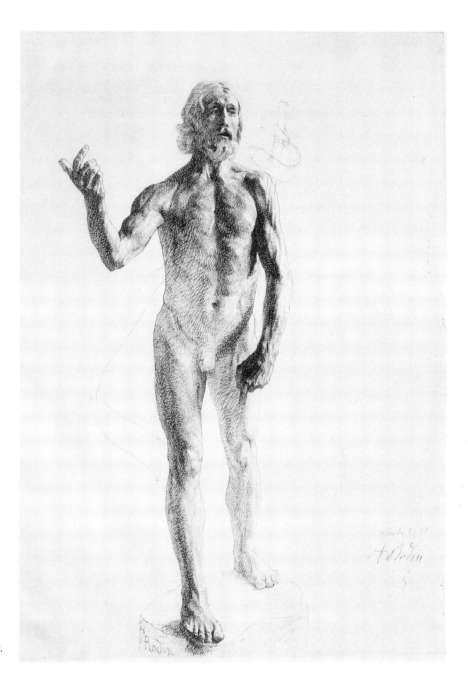

Figure 8.29
AUGUSTE RODIN (1840–1917)
St. John the Baptist Preaching
Pen and black ink on light tan paper. 12¾ × 8¾ in.
*Courtesy of Fogg Art Museum, Harvard University,
Cambridge, Mass. Grenville L. Winthrop Bequest*

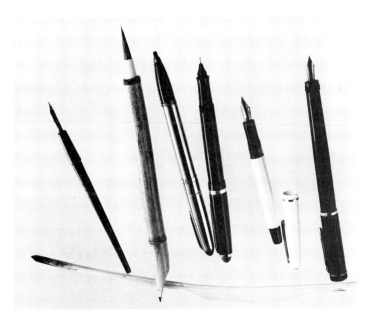

Figure 8.30
Some pens. Clockwise, starting at bottom: Goose-quill
pen, crow-quill steel pen, Japanese reed pen with
squirrel-hair brush at opposite end (brush retracts into
handle when not in use), felt-tip pen, stylus type foun-
tain pen for use with washable inks, traditional type
fountain pen for use with washable inks, and India ink
fountain pen with nib that lowers into barrel when not in
use.

rough-grained papers that so well suit these older instruments. The reed and quill pens make a more sensitive union with such surfaces. That is, they are more affected by, and accommodating to, the paper's terrain than are most steel pens.

The wide selection of steel pens and types of paper, and the differing needs of the user, make it impossible to recommend specific combinations of pen and paper. In general, moderately flexible steel pens—on papers of a moderate tooth and absorbency—can approximate much of the character of the earlier quill pen. On smoother papers, and when precise or fine lines or delicate hatching is required, the steel pen's free-flowing, incisive character has no equal.

The several kinds of drawing pens designed to use drawing inks are most convenient instruments because they hold a generous ink supply and can be easily carried about (Figure 8.30). Many are made to take a wide assortment of threaded nibs, allowing the user to change the kind of point being used. Those used with water-soluble inks work quite well if thoroughly washed every few weeks. Another type of drawing pen, for use with India ink, is more prone to clogging, but again, periodic cleaning will keep it functioning. A completely trouble-free India ink pen may not exist because of the drying properties of permanent inks, but several durable and versatile ones are available.

Still another type of fountain pen is often used for technical or mechanical drawing purposes or where a line's width must be unchanging. These have stylus-like nibs, made for use with water-soluble inks. The near uniformity of the lines has an etching-like quality, unlike any other kind of pen line (Figure 8.31). These instruments also take interchangeable nibs in several line widths.

The *ball-point pen* is another serviceable addition to the range of drawing media. Its very limited line variation and the relative weakness of the black ink, compared with carbon blacks, are considered disadvantages by some artists. Others enjoy the "clouds" of almost invisible lines that hatchings with a fine-point ball-point pen make possible. On hard surfaces its easy flow and maneuverability are excellent for producing intricate linear or tonal delicacies.

The artist's felt-tipped fountain pen, a recent development, allows for interchangeable nibs and uses a special dye-based ink, available

Figure 8.31

in several colors. The best pens allow the artist to continue to feed the ink, or to let it run dry, producing effects not unlike those of the reed pen (Figure 8.32).

Nylon-tipped pens are useful for some drawing purposes and are favored by those who like a bold, quick-maneuvering line. Their line variety is limited, however, and they are incapable of the fineness possible with most other pens.

Brushes. There are two basic types of artist's brushes: the stiff, coarse-haired *bristle* brush—generally hog bristles but also of nylon "hairs" (for painting in acrylics); and the soft-haired brush made of various animal furs—especially sable and squirrel (Figure 8.33).

The term *sable* is sometimes applied to any soft-haired brush, and that can be confusing. When selecting a sable brush, be sure it *is* sable. The best sable brushes, generally called *red sable*, have a golden-reddish color and are very springy and resilient. Less expensive "sable" brushes may contain squirrel hair, which is somewhat less lively in use.

Bristle brushes are used for painting and drawing with any wet medium, but their use with transparent watercolors is rare. When using them on paper, one must avoid too vigorous scrubbing movements because the stiff bristles

Figure 8.32
HAROLD ALTMAN (1924–)
Matriarch
Pen and ink. 16½ × 10 in.
Philadelphia Museum of Art Purchased: Harrison Fund

Figure 8.33
Some brushes. Clockwise, from bottom: portable sable brush with cover which serves to extend handle when in use, French quill brush taped to a stick, number 2 round bristle, flat red sable, number 5 filbert bristle, Japanese squirrel-hair brush, portable fountain brush, number 4 round red sable, large flat red sable with a beveled handle tip for incising lines and removing paint, common paste brush of nylon "hairs."

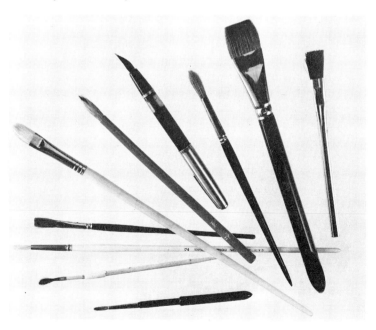

will damage the surface—unless the paper has been prepared with a foundation coat of paint, called a *priming*.

There are several classifications of bristle brushes, determined by shape. *Flats* and *brights* are square-ended brushes, usually available in eighteen sizes, differing only in the somewhat greater length of the flats. *Filberts* are rounded at the ends and fuller in body. *Rounds* are rather long, with pointed tips and round bodies. Both are usually available in twelve sizes. Bristle brushes are sized on a scale from 1 (smallest) to 18 (largest). Other stiff-haired brushes sometimes used include the stencil brush, helpful in producing certain textural effects, and the common house-painting brush, for preparing surfaces and for very broad washes.

When used with opaque paints, bristle brushes are stiff enough to push their way through heavy concentrations of paint without splaying out, becoming bogged down, or wearing away quickly, as any soft-haired brush will. The round bristle brush works well as a line instrument when used with thinned paint or ink.

For drawing, however, the soft-haired brushes have always been preferred. Made from hairs of various animals, these come in a large selection of shapes and sizes. In the Orient, where the brush is also a writing tool, the hairs commonly used are goat, rabbit, and badger. Wolf and horse hair are also used for larger, stiffer brushes, as is hog bristle. For writing and drawing purposes, the hairs are set into a bamboo shaft, the hairs coming to a point when moistened. Some larger brushes are set into wooden handles. The beautiful calligraphic results possible with the Oriental brushes have long attracted Western artists. Softer and somewhat less springy than the sable brush, they work best when held at a right angle to the paper. Very slight pressure is required for the release of ink. The variety of strokes possible with the Oriental brush rivals that of the best round sable brushes.

The round sable is one of the most versatile brushes for drawing in ink and watercolor. It also works well with casein or tempera, especially when these are slightly thinned, but like all soft-haired brushes, it performs poorly with acrylics. This paint must be applied with a stiff brush, preferably of nylon.

Sable brushes come with short handles, for drawing with ink or watercolor, and long handles, for use in easel painting. Their sizes commonly range from the tiny 000, less than $\frac{1}{40}$ of an inch wide, to size 12, which is almost $\frac{1}{2}$ inch wide. Some manufacturers offer even larger sizes. Because the larger round sable brushes ably do any work the smaller ones can—sometimes better—it is best to buy fewer but larger brushes. Good quality round sables—even the largest ones—can produce lines finer than those of any steel pen.

In addition to the round sable, there are full-bodied oval-shaped sables and another group of flat, square-ended ones. Both are designed for broader handling—the largest ones for brushing in large washes of tone or for wetting the paper.

Brushes in all shapes and sizes are available in squirrel hair, camel hair, or mixtures of hairs that possess some of the qualities of the expensive sable ones. Other brushes used in drawing are the group called *quill brushes*. These are long, round squirrel-hair brushes intended for lettering and various decorative purposes. Their longer bodies and pointed ends allow for very delicate drawing.

Many other types of brushes are available in a wide selection of shapes, sizes, and materials for use in sign writing, lettering, or other special painting functions.

As brushes wear down, they can be assigned other duties. In fact, brushes often wear down to shapes that suit an artist's purpose better than new ones. The wear and tear with use ages a brush in a "healthy" way. But letting brushes dry without washing them thoroughly, or standing brushes—especially soft-haired ones—upright in containers of water can render them useless. With proper care the delicate and expensive sables can last for many years.

Brushes are fast-moving tools that require steady practice to control. In the case of the soft-haired brushes, their sensitive responses record the slightest hesitations and idiosyncratic behavior of the user's hand. Once familiarity is gained, a limitless range of calligraphic and depictive nuance becomes possible.

THE SUITABLE SUPPORT

The character of the surface drawn upon also helps form the image. As artists transfer their responses to the paper, its submission or re-

sistance to a particular medium—the paper's tooth, absorbency, and tactile properties—influence tactics and even the expressive nature of the work itself. Beginners seldom reflect on a paper's physical composition, weight, absorbency, or surface character, although they are sometimes amazed at a particular paper's influence on their drawing. They may also be amazed by the many kinds of paper in the art stores. Some are permanent papers that will not yellow and crumble with age; others will begin to darken and fall apart in a year or two. Some can take rough handling; others are quite fragile. Each has certain uses; some have quite specialized uses while others are adaptable to a variety of uses and media.

The most permanent papers—usually the toughest and most capable of accepting a wide range of media—are made of linen rag. They are also the most expensive, particularly the handmade papers. The least permanent papers are made of wood pulp, untreated by any chemical preservatives.

Papers are classified according to weight and surface character. The figures designating a paper's weight refer to the weight of 500 sheets, called a *ream*. Thus, a 30-pound paper is one that weighs 30 pounds per ream. Newsprint, the paper used in the publication of newspapers, is a 30- to 35-pound paper. Some of the heavier papers, those used primarily for watercolor painting but also very well suited to drawing, weigh from 140 to 400 pounds a ream and are nearly as stiff as cardboard.

Rag papers are classified into three basic types:

1. *Hotpressed.* These are the hard-surfaced, smooth, and sometimes even glossy papers, best suited to pen-and-ink drawing of an exact or delicate kind and wash drawings that do not require repeated overpainting of tones. Hotpressed rag is the least absorbent of the three types.

2. *Coldpressed.* These papers have a moderate tooth and absorbency, accept all media well, and are the most frequently used. They vary somewhat according to the manufacturers' formula, but it is hard to find a coldpressed paper that is not an appealing surface for drawing.

3. *Rough.* The papers with the most pronounced tooth, these are least accommodating to fine or exact pen-and-ink drawing, although some artists enjoy working on such surfaces. They give ink and watercolor washes a brilliance and sparkle not possible with other surfaces.

Rag papers are sold in single sheets and blocks. The sheets in the blocks are attached on all four sides in order to flatten out any buckling that may occur when water-based media are used. Water by itself, or as part of ink or thinned paint, swells the fibers, causing ripples in the paper. Although the ripples are not generally noticeable in pen-and-ink drawings unless the lines are densely massed on a lightweight paper, not much water is necessary to cause them on most papers. The heavier the paper, the more water it can tolerate before buckling. Papers lighter than 140 pounds will buckle even with a quite restricted use of water. Papers of 200 pounds or more will not buckle no matter how wet.

To prevent buckling, the paper should be soaked for a few minutes and then secured to a stiff board such as particle board by taping it on all four sides with a gummed tape. If a second paper is similarly stretched on the back of the board, warping of the board is less likely, and a second sheet is ready for use.

For extensive use of opaque paints, only the heaviest papers or paperboards should be used. Unless, like illustration board, such supports are faced with drawing or watercolor paper, they may require priming to provide a more receptive tooth to hold the paint and to reduce absorbency. An acrylic *gesso*, or primer, designed as a base for paints, makes a good surface for both wet and dry media.

Illustration board is available in the three surface designations for rag papers. These boards are made of an inexpensive backing of pulpboard upon which is mounted a thin sheet of drawing or watercolor paper. Some are made with all-rag surfaces.

Oriental papers have a distinctive absorbent character. Often called rice paper, they are actually made from the inner bark fibers of a mulberry plant. Oriental papers contain none of the clay additives of many Western papers that reduce absorbency, and they are therefore far more absorbent and more prone to blotting. Often used in the graphic process of woodcut printing, such papers offer an unusual receptivity to sumi ink washes and brush drawing.

The term *bond* refers to a wide assortment of papers often used for writing and typing purposes. Bond papers vary in weight from 13 to 35 pounds, and in surface from the slick to the moderately grained. They may be made of either wood pulp or rag, or various mixtures of both.

All are excellent for pen or pencil drawing, and those manufactured for general drawing purposes are receptive to most media. However, their light weight makes extensive use of water-based media impractical.

Many drawing pads and sketchboards do not identify the paper's ingredients. Advertised as "white drawing paper" or "all-purpose drawing paper," many are like bond papers in character. Most are heavier, weighing between 30 and 90 pounds or more. Their qualities vary according to their price. At their best, they are made of 100 percent rag materials.

A serviceable paper for practice drawings with dry media is newsprint, mentioned earlier. It is an impermanent paper of a warm, light gray tone and can be either smooth or moderately rough. The rough-toothed paper has a more interesting character and is generally heavier. It is especially receptive to conté crayon and compressed charcoal.

Bristol and *vellum* are heavyweight papers, often made of wood pulp but available in the all-rag state. Of postcard weight, they offer fine surfaces for pen and ink, brush and ink, and graphite. Often sold in pads of various sizes, they are a serviceable paper for almost any medium. These papers are usually treated with preservatives and chemically whitened. They are tough papers; all are long-lasting, and many are permanent. The Bristol paper has a hard, glossy surface and may take the softer abrasive media less well than vellum, which has a slight tooth.

Charcoal paper, usually between 60 and 70 pounds, is a fairly substantial paper, capable of the rough treatment that drawings in charcoal, chalks, and the other dry media often entail. Its rough tooth and tough "skin" take erasures well. These papers always have some rag content, and the best are 100 percent rag. It is available in various light colors as well as white.

Tracing paper is a semi-transparent, lightweight paper used for drawing or for developing a drawing placed beneath it. It is sometimes useful to place a sheet of tracing paper over a work in progress in order to experiment with drawing ideas or to check on the design and structure of a drawing in progress, by tracing its main characteristics and, by turning the tracing paper over, see the drawing reversed. Changes can be made on the tracing paper and easily transferred to the original drawing.

There are, of course, many other types of paper suitable for drawing. The various kinds used in the printing of etchings and lithographs; the common kraft, or wrapping paper; cameo paper, especially suited for graphite; and even papers recently developed of spun glass, plastic, and recycled paper products—all serve various drawing interests and needs.

For the beginner, a serviceable selection of papers could include an 18 inch × 24 inch pad of rough-toothed newsprint paper; an 18 inch × 24 inch pad of any good grade of bond or other white drawing paper; a medium-sized pad of Bristol or vellum paper (11 inches × 14 inches or 12 inches × 16 inches); several large sheets of charcoal paper, of which one or two may be colored; and several sheets of the heavier, cold-pressed, all-rag papers. A sketchbook, no smaller than 8½ inches × 11 inches, is also basic.

For the student, as for many artists, the sketchbook should be a kind of private visual journal. It is also a portable studio, a place for private visual speculations and experiments. With no one looking on, we try things we would hesitate to try in a classroom, or on a large drawing pad, which feels more public. The sketchbook is a place to experiment with whatever interests us in the subject, in the processes of drawing, or in ourselves. It is a useful tool in developing a better grasp of our strengths and susceptibilities, and for exploring the world around us (Figures 8.34 and 8.35).

One convenient form of the sketchbook permits the user to fill it with any combination of papers and to remove complete drawings. Normally found not in art stores but in larger stationery stores, they are called *spring binders* and are available in several sizes. In effect, they are permanent, spring-operated book covers, filled and changed as needed (Figure 8.36).

MIXED MEDIA

As was noted earlier, some mixed-media drawings are planned and others evolve from the interactions between the artist, the subject, the emerging drawing, and the limits of the medium in use. When planned, the media should be necessary to a work's expressive meaning. They should not be combined arbitrarily or just for a show of technical facility. Earlier it was pointed out that limitations on the use of media imposed by custom or tradition are unnecessary. These

Figure 8.34
NATHAN GOLDSTEIN
Page of Sketches (1990)
Black chalk. 9 × 12 in.
Courtesy of the artist

Figure 8.35 (*student drawing*)
Art Institute of Boston
Conté crayon, 9 × 12 in.

A

B

Figure 8.36
Filling a spring-binder sketchbook. Any combination of drawing papers are cut to size and placed in the inner folder. Covers are folded backward, as in A, the folder is inserted and covers released. This type of sketchbook has the additional advantage of lying flat when open, as in B.

two extremes—freewheeling show, or unquestioning obedience to past practices—intrude on the quality of responses that extract and intensify a subject's meanings. If, in Émile Zola's words, "art is life seen through a temperament," then it is the quality of our responses to the *subject*, and not our attitudes of play or duty toward the materials of drawing, through which nature—life—is interpreted.

For some artists a medium's limits are an exciting challenge. Some notable artists have achieved deeply expressive results in a single medium. Such artists see a medium's limits (not the "rules" concerning it) as an aid in promoting inventive visual choices and judgments that produce more satisfying results. For them, part of the challenge in drawing is to see how much a particular medium can be made to do. This is a valid and even praiseworthy goal, as long as it does not stifle necessary responses that cannot be expressed by the medium in use.

Students should also try to explore and push each medium to its limits, and they must be slow to decide that its limits have been reached. They should use it in every possible way and on a variety of surfaces before turning to other media. How a medium behaves—what it will and will not do—affects our drawing and stimulates meaningful innovations in the medium's use.

However, when certain visual or expressive intentions demand more than a medium can give, other media should be utilized.

Often only two or three media are used in mixed-media combinations. Considering what any one medium can do, using more than three suggests inexperience more than need.

As was mentioned earlier, any combinations of media and materials can be used except those found to be incompatible. Acrylic paints cause some inks to curdle when mixed with them; casein paint on flexible supports will promptly crack; oil paint can rot the fibers of unprimed papers; charcoal media and some chalks drawn upon dense layers of graphite will not adhere; ink lines drawn upon any dried water-based paint except acrylics will spread and blot. There are other incompatible mixtures. Unfortunately, most are discovered the hard way.

The thick brush strokes in Bageris's *Infanta—after Velázquez* (Figure 8.37), interacting with the lean, fast-moving graphite lines, are basic to the drawing's enigmatic theme. Lines or paint strokes alone could not convey the overlapping, darting, "hide and seek" quality that the artist's responses to the Velázquez painting demanded. This interplay between thick and thin, fast and slow, and the drawing's overall shimmering immediacy convey the impression of the Infanta

forming and fading. The way we are teased by the forms welling up and subsiding into the background's light values is part of the artist's interpretive aim. Here the choice of media and the way they are used are not arbitrary; they are essential.

Similarly, Feininger's drawing *Block Houses* (Figure 8.38), in chalk and black and gold washes, economically conveys the fusion of a group of houses with their cloud-like surroundings. Ap-

plied to a wet surface, the washes blend into each other, their softness contrasting with the rough chalk lines. Here again, the choice of media is necessary to the artist's intent.

Also, in Aronson's *Transparent Figure Study: Bent Woman* (Figure 8.39), it was the need to draw sharply focused skeletal parts seen through already established forms that led her to a combination of conté crayon, pencil, and ink washes. Note that the use of conté tones in the hair and

Figure 8.37
JOHN BAGERIS (1924–)
Infanta—after Velázquez
Tempera and pencil. 11¼ × 14 in.
Collection of Lucy G. Stone

Figure 8.38
LYONEL FEININGER (1871–1956)
Block Houses (1952)
Pen and India ink, black and gold wash. 11½ × 18½ in.
Courtesy, Museum of Fine Arts, Boston
Gift of John S. Newberry, Jr.

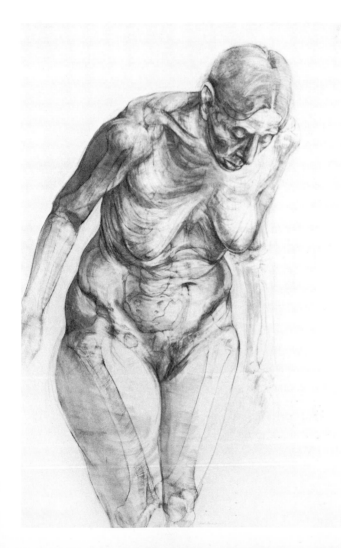

Figure 8.39
CAROL ARONSON
Transparent Figure Study: Bent Woman (1975)
Conté crayon, graphite, and ink wash. 30 × 40 in.
Collection of the artist

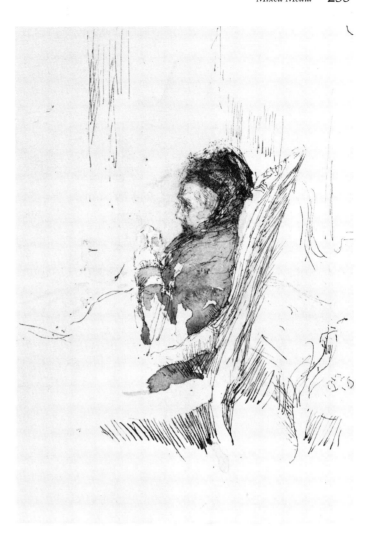

Figure 8.40
JAMES McNEIL WHISTLER (1834–1903)
Study of Mrs. Philip (c. 1900–1901)
Pen and wash. 5⅛ × 3⅝ in.
*Courtesy, Museum of Fine Arts, Boston
Helen and Alice Colburn Fund*

elsewhere enables the artist to use the eraser in a creative way, to produce lighter lines and to model both the bony and surface forms.

The possible combinations of media, tools, and surface are almost endless. Any group exhibition of drawings shows a wide variety of mixed media. Some are unusual combinations, such as lithographic crayons and ink with watercolor or colored paper; brown wax-based pencil and sepia ink; casein, graphite, and conté crayon; fatty-based crayon, turpentine (as the crayon's thinner), and ink; white chalk and white ink on black paper; and white acrylic, compressed charcoal, and sepia washes on gray paper. Others are familiar combinations such as ink or graphite and watercolor washes, or charcoal and ink. Some combinations are not of mixed media but of instruments, as in Whistler's gentle drawing of

a seated woman (Figure 8.40). Here the light and dark tones in the woman's head, the tone of her shawl, and the light tones in the background and on the chair are broadly brushed in with ink washes that contrast with the ink lines. These tones soften the figure and hold the drawing together. Whistler could have achieved most of these results with just the pen, but not the contrasts of wet and dry passages, actual and optical grays, or the splashy treatment of the woman's left arm.

Experiencing the feel of a medium, instrument, or surface is best accomplished in the act of drawing itself, but some free exploration helps you to become familiar with many characteristics, limits, and combinations you might not otherwise encounter, and which can play important roles in your subsequent drawings. The follow-

ing exercise is intended as a general approach to the study of these matters.

exercise 8A

MATERIALS: Here, you will use only a few media, surfaces, and tools. The several experiments described suggest a style of media exploration adaptable to the study of virtually any medium, tool, and surface. Even so, possibilities for extensive exploration are too numerous to examine here, but the several offered below should point the way to fuller experimentation.

For these three drawings you require the following papers: one sheet of Bristol paper (or any comparably smooth surface) approximately 14 inches × 20 inches; one sheet of 18 inch × 24 inch white charcoal paper, the heavier the weight, the better; and one coldpressed or medium-toothed illustration board, 20 inches × 30 inches. In addition, you will need:

stick charcoal, soft or medium

6B graphite pencil

black wax-based pencil or crayon

black acrylic paint

black water-soluble ink

white acrylic paint

Chinese white paint

a fine, flexible steel pen, and holder

number 4, round soft-hair brush, preferably sable

number 5, flat bristle or nylon brush

number 3, round bristle brush

a graphite eraser

SUBJECT: Explained in each exercise.

PROCEDURE: Before beginning, get somewhat familiar with these materials by free manipulations. On some scraps of paper, preferably of different types, draw with these media in any way that interests you. Try to feel their different tactile characteristics. To fully appreciate their differences, alternate media and tools every few minutes.

Do not attempt to draw anything in particular during this manipulation period. Just try to observe their differences in touch and handling. Draw long lines and strokes. As you do, change the pressure on the tools to feel the kind of response they make. Pens and brushes will react more to changes in pressure than abrasive media, but all show the effects of such

pressure—each differently. Try erasing some charcoal, pencil, and crayon lines. Cross-hatch with each medium, going from dense hatchings to open ones. Draw the smallest circle possible with each. Write your name with each. At this stage it is not necessary to mix the media, but it is often hard *not* to experiment with one medium over another. Let your curiosity guide you.

These first few experimental efforts are important. Just playing with these materials is instructive play. You will have already made some judgments about them.

drawing 1 Divide the sheet of charcoal paper into four even, horizontal parts, and three vertical ones, making twelve divisions, as in Figure 8.41. In box 1A, use the 6B pencil to draw an even tone of approximately a 50 percent gray. Drawing lines adjacent to each other should produce an optical gray that needs no smudging. But here it will be instructive to blend one-half of the lines in the box, to study the effects on value and texture. Next do the same with the stick charcoal in box 2A, also blending the lines in half of it. You may find the blended halves have changed value. Rework them until each matches the tone of its other half. In 3A, using the wax-based medium, again establish exactly the same value as now appears in 1A and 2A. Here, you will not be able to blend extensively, if at all, nor erase, and this limitation should be borne in mind when you try to match the value of the first two boxes.

When you have filled all three boxes, use these media freely to draw additional lines in these same boxes. For example, you should use charcoal and crayon in 1A, and so on. These new lines may intermix with each other as well as with the original lines in any given box. Some mixtures will work better than others. Note that the order in which they are drawn is important. Graphite may do well over charcoal, but charcoal may do poorly over graphite. It depends in part on how much the paper fibers have been filled. Continue to add (or erase) lines in any order. You can even try to scrape some of the crayon off with a penknife and rebuild the tone of 3A with a combination of

Figure 8.41

these media. Use your imagination freely. The original medium of each box may be partially or completely covered by such additional drawing. Now you may wish to draw some simple form or texture in each, or try to establish some gradual transitions in value with differing mixtures. Continue until you cannot think of any other combinations or drawing tests to put these media to.

In 1B, using graphite, start with the darkest tone the pencil can produce and gradually lighten it as the tone moves across the box from left to right, ending just short of the box's edge, leaving a bit of the white paper on the far right side. This should be a very gradual value change. Rework until the dark on the left appears to fade away at an even rate, and end just short of the right side of the box. Do the same in 2B, using charcoal, and in 3B with crayon. Do not erase to establish these graduations of tone. Notice the differences in the value and texture of the three dark areas, and note that each medium requires a decidedly different handling to produce the tonal change from dark to light.

In 1C, make a tonal drawing of any simple object, such as an apple, shoe, or mitten, using the 6B pencil. Draw the same object, from the same view, in 2C using charcoal, and again in 3C with crayon. Again, note the differences in handling required. Because the 6B pencil cannot produce darks as easily as the crayon can, more pressure is required. Because the crayon so easily produces strong darks, less pressure must be used for the lighter tones. Because stick charcoal is a soft tool that tends to make heavy lines, small details are not as easily drawn as with the other two media. Take advantage of what each medium offers. If crayon produces stronger darks, use them to show a more dramatic range of values. If charcoal can be manipulated on the page in ways that the other media cannot, do so to extract from the subject qualities that charcoal can state by these manipulations, including smudging and erasing. If graphite can state details with more precision, use this feature to explain smaller planes and tones. Let the limits and characteristics of the media guide your tactics.

Leave the bottom D row blank. You will complete these boxes after the next drawing.

drawing 2 Using the Bristol paper or its equivalent, again divide it as in Figure 8.41. In 1A, draw a gray tone of about 50 percent, using pen and ink. The lines can go in any direction or be cross-hatched. In 2A, draw the same value with the sable brush and ink diluted in water. Again, use hatched or cross-hatched lines only, *but fill only one half of box 2A.* In the other half, use the number 5 bristle brush and undiluted ink to match the value in 2A as follows: dip only the tip of the bristle brush in the ink and, with light back-and-forth brushing on a scrap of nonabsorbent paper, remove almost all the ink from the brush. When the brush is almost dry, it will produce a stroke of very fine, black lines that can be brushed into the other half of 2A, producing an optical gray. Naturally, this should be practiced first on a scrap of paper similar to Bristol. This process is called *dry-brush* and can be seen in the painting of the Flemish primitives as well as in many tonal brush drawings (Figure 4.20). The brush strokes of fine lines so produced look somewhat like chalk strokes. They permit a gradual building up of values (Figure 8.42). This can also be done with soft-hair brushes and ink, or thinly diluted paints, but acrylic is less adaptable to dry-brush handling than other paints. You may wish to use this manner of application later in this second drawing.

In 3A, mix ink and Chinese white with enough water to allow for easy brushing, and apply the 50 percent gray tone by using any of the three brushes. This should be an opaque layer of paint, but a quite thin one. Now, as in drawing 1, rework these boxes in any way you wish, mixing media to produce volumes, textures, and tonalities.

In 1B, use pen and ink to make the same kind of tonal change as in drawing 1. Do the same with brush and ink in 2B, *after* you have moistened the box with clear water applied with a clean brush. This will make the ink spread. The more water, the more the ink will spread—and the harder it will be to control. Therefore, do not lay in any washes until the area is only faintly damp. If a segment becomes too dark, a clean soft-hair brush can pick up much of the tone while it is still wet. In 3B, draw the same kind of value transitions, using opaque mixtures of Chinese white and ink. This time use only sable brush, and draw fine lines with the thinnest opaque mixture. If the mixture is the correct consistency, the paint should easily glide upon the page with no sense of "drag." Dry-brush will work well here.

Figure 8.42

Examples of drybrush. The strokes in A were made with a bristle brush; those in B, with an Oriental squirrel-hair brush.

A **B**

In 1C, using pen and ink any way you wish, make a tonal drawing of any simple object. Using brush and water, draw the same object in 2C. This can be done in the wet-in-wet manner used in 2B, or in any combination of wet and dry brush strokes. In 3C, the same subject should be drawn in any opaque manner with ink and Chinese white. The experience of the first two rows should help you decide how you wish to handle these three drawings in the C row. Again, leave the D row blank.

Now return to the D row of drawing 1. In 1D, using brush and ink and Chinese white, try to *imitate* the drawing in 1C exactly. That is, your drawing in 1D should look as if it had been done with the 6B pencil. In 2D, use brush and ink (and water if needed) to reproduce the drawing in 2C exactly. Again, try to imitate the medium used in 2C. In 3D, use only pen and ink to reproduce the drawing in 3C. If you are working with other students, drawings can be exchanged at this point, so that you can try to reproduce someone else's C row of drawings.

When the D row of drawing 1 has been completed, return to the D row of drawing 2. Again, drawings can be exchanged. Now, use only the crayon to reproduce the drawing (and the medium) of 1C of drawing 2, using only the charcoal to do the same with the drawing in 2C, and the 6B pencil for the one in 3C.

In both sets of drawings in the D rows, you are straining the media by trying to get them to imitate each other. In most cases you can only get close to the original texture and character, but it may surprise you to see *how* close.

In drawings 1 and 2, you experimented with the various media and materials and tried to feel and see their character, strengths, and limits. You worked within those limits, taking advantage of their strengths, and finally worked against their limits, forcing them to "become" another medium. It is this full testing of a medium's range that provides us with the sense of its nature, its range, and its potentialities.

drawing 3 Turning the illustration board vertically, divide it into three horizontal sections of 10 inches each. Divide it vertically in half (Figure 8.43). Using black acrylic, the number 5 flat bristle brush, and water, make a gradual tonal change from black to white, allowing the white board to be visible on the far right side of 1A, as in the earlier tonal changes. Thus, as the tone lightens, you will use less paint and more water. In 2A, do the same, but use both black and white acrylics, keeping the paint film opaque. When completed, both should be smooth graduations of tone. This will be less easily accomplished in 1A. Once they have dried, dark areas cannot be removed. Therefore, adjustments in 1A must be made quickly. Here it is best to start with the lightest tones and work toward the darks on the left. If, after drying, 1A or 2A need

Figure 8.43

further tonal adjusting, use both Chinese and acrylic white to touch up, and notice the better covering power when these paints are mixed. After completion, use these two boxes for further experiments with any of the other media.

Use 1B as an area in which to experiment on this new surface with all of the media you used in drawings 1 and 2. In 2B, wet the illustration board lightly with clean water. When it is just slightly damp, lay in a thin, semi-opaque wash of 50 percent gray. When this has dried, use both of your bristle brushes in whatever way you wish to draw any simple object in black and white acrylic. In 1C, using black acrylic, any or all of your three brushes, and water, lay in the volume summary of another observed object. This should be done within five minutes. Continue to develop the drawing in any one of the abrasive media used earlier. In 2C, using any combination of these media but omitting acrylics, and using any tools except brushes, try to duplicate the drawing in 2B exactly. In place of brushes, you can use your fingers, rolled-up paper, cotton swabs, sponges, or anything else. You may want to try duplicating 2B with abrasive media alone—perhaps using only charcoal.

In the preceding exercises you explored some materials by going with and against their character. This of course does not exhaust the possibilities. Acrylics can be used to imitate the various abrasive media; one combination of media can be made to imitate another; different surfaces would affect the behavior of both media and tools; different tools would affect the media, and so on. The possibilities are virtually endless.

At the beginning, it is better to probe a few media and materials and go deeper. Here, a suggested approach for the study of any medium, tool, or surface is offered to help you when you seek them out. Although all our materials continue to reveal their nature as we use them, the few hours spent in testing, forcing, probing—in discovering—can provide an understanding that may come only in bits and pieces over a long

period of time. It may be years before we try some unusual combination of media in a drawing, only to find the combination works better than anything else we have tried for establishing the images we intend. But if, when first encountering these media, we take the time to experiment, we can learn this sooner.

The media and materials of drawing are the physical agents of our intentions. They do not themselves discover or invent, but they *do* suggest and influence results. To understand their important role in drawing, we have to learn to understand as well as enjoy our tools. One without the other will not yet produce control.

In the act of responsive drawing, our media and materials either help or hurt our interpretive efforts. They serve us well if we know them well—but they are never neutral.

9

VISUAL ISSUES

*the forming
of order*

A DEFINITION

We have seen that in responsive drawing, *what* is drawn and *how* it is drawn are interdependent considerations. Each mark on the page does two things: it helps define a subject's structural and spatial characteristics and, by its physical properties, it conveys a particular kind of dynamic meaning embracing both energy and mood. The marks produce *expressive actions*. Furthermore, by their interactions, that is, by the way the lines and tones relate and affect each other, they create the visual forces that give a drawing its own pattern of abstract, formal order, as well as its expressive character, and consequently its esthetic worth. To expand an earlier observation about line, *all* the marks that constitute a drawing *define, act,* and *interact*. Each mark is a part of the drawing's *compositional and emotive* condition.

This chapter concentrates on those factors that influence a drawing's organizational as-

pects—its abstract compositional order. Because each mark, of course, simultaneously affects a drawing's visual *and* expressive meanings, to separate a drawing's organization from its expression risks distorting our understanding of both. Nevertheless we have separated these factors temporarily, focusing upon the compositional ones in this chapter and on the expressive ones in the next, in order to help clarify our understanding of each and deepen our understanding of their interrelated nature.

Some cultures have always understood drawings as systems of *design*. The single Italian term *disegno* describes both drawing and design, as does the French *dessin*. In fact, it is impossible to regard any drawing as *only* descriptive, even when nothing more was intended. Seeing and sensing the visual relationships and forces generated by the lines and tones are unavoidable.

Such dynamic behavior is intrinsic to any collection of marks and is thus a given condition of drawing.

In a good composition, the marks produce relationships, contrasts, and energies that convey a sense of *balance,* of equilibrium between its parts, and between them and the page. Additionally, all of the design's components—its lines, shapes, tones, colors, textures, and masses—have strong interacting bonds of dependence and association that create an overall sense of oneness, or *unity.* But both of these conditions can exist in very dull drawings. A drawing of a brick wall or a Venetian blind, unless the overall sameness is relieved by some variety, is boring. A drawing's stability and unity must emerge from the stimulating action of contrasts, as well as the union of similarities. We need diversity as an antidote to monotony. General principles in art are best approached cautiously, but it seems safe to assume that whatever else art is or may be, it will not accept visual disorder or boredom as goals. In good drawings stability and unity are achieved by interesting contrasts, similarities, and energies. Moreover, we sense that their order is *necessary,* that *any* change will weaken their organizational resolution.

RELATIONSHIPS AND ENERGIES

The preceding chapters examined the measurable relationships of shape, placement, length, scale, direction, value, color, and mass, in order for the reader to learn to see more objectively and to state volume and space more inventively. In doing so we touched briefly on design considerations concerning rhythm, movement, and continuity among a subject's parts. In this section we will expand our investigation of design to include other kinds of energies that emerge from these relationships, and to consider the balanced distribution of the subject's parts within the bounded limits of the page in ways that engage the entire page.

We have seen that all of a drawing's marks must be made of *line* or *value* and that these in turn form the several graphic factors of *shape, color, volume and space,* and *texture.* All of the visual issues that concern a drawing's abstract, or *formal* design result from the behavior of these six basic factors. They are collectively called *visual elements.* To discuss the relational possibilities

that can occur in a drawing's composition, we will need to examine these elements further. As we do, remember that the term "element" refers to anything from a line or tone or a chalkmark's texture to the color or mass of a house. Remember too that, unlike the visual relationships between elements, the various abstract (and emotive) energies that these relationships generate are themselves invisible. We only sense or intuit them.

The possibilities for relationships based on similarity or contrast between the elements are limitless. In fact, in the best drawings the elements seem capable of endless interactions. Great drawings are never "used up." Relationships can be obvious or subtle. Each element in a drawing participates in at least a few, and sometimes many, different visual associations, producing different visual forces. These forces are as varied as the relationships that create them. Being so much a matter of sensed impressions, they elude verbal descriptions of more than their general kind of behavior.

Relationships are always based on comparisons of some kind, but they depend on contrasts to be effective. A shape may be large in relation to the page—its scale is *similar* to that of the page—but will appear even larger if it is seen in *contrast* to smaller shapes upon the page. Likewise, we do not usually regard a white sheet of paper as being bright, we regard it as blank. Not until dark tones appear on the page does its tone have any quality of light or any other visual meaning. Where everything is bright, nothing is.

A single vertical line drawn on a page creates a contrast with the "emptiness" of the page. The line is unlike any other part of the paper (though it is similar in direction to the vertical borders of the page). When a second line is drawn parallel to the first, obvious similarities of scale and direction exist between them. Two more lines, drawn at right angles to the first pair, are like them as lines but contrasting in their position. If the four lines form a square, they are related to the page *and* to each other by the shape they make. Thus, elements can show contrast on one level of relationship and similarity on another. When similarities overpower contrasts, the result is boredom. When contrasts overpower similarities, the result is chaos. A successful design must avoid both of these extremes. Its contrasts may threaten but should never succeed in destroying balance and unity.

The artist must organize contrasting elements into some greater system of formal order.

Although unlimited in their visual interactions, relationships among the elements can be roughly sorted into thirteen categories. These categories of relational activity and some of the energies they generate are as follows.

1. Line—the similarities and contrasts arising from their direction, length, weight and value, handling (or character), and their straight or curved nature, as in Figure 9.1. Note that some lines, despite their contrasting lengths, directions, thicknesses, and so on, relate by intersecting, location, or texture. Additionally, similar lines can contrast in their weight, color, direction, or handling.

2. Direction—the sense of movement or of striving for change, as when any like or unlike elements relate because of a continuity of their positions on the picture-plane or in the pictorial field. Direction is also sensed when similarities of length, shape, value, color, scale, or texture among various elements cause us to recognize common alignments among them. Such elements seem to move in various straight or curved paths, and even suggest their speed. Elements can "amble" along or can convey powerful velocity. The more unlike are the elements moving in a direction, the weaker and slower the sense of movement; the greater their similarities, the stronger their directional thrust. For example, note the strong fan-like energy of the long lines in Figure 9.1, and the weaker directional energy that unites the shorter straight and curved lines at the bottom of the drawing.

All elements except shapes and masses whose boundaries are equidistant from their centers, such as squares and spheres, are *inherently* directional; they move in the direction of their straight or curved long axis. This being the case, directional cues, and the movement energies they generate, *pervade all other relationships.* Thus, visual associations based on direction, and the sense of moving forces at work in a drawing (and in the observed or envisioned subject), are at the heart of any system of visual order. The importance in recognizing the dominance of directional relationships cannot be overstated. Just as directional forces activate the lines in Figure 9.1, so can we see them at work in the following illustrations of relationships among the elements, and in *all* drawings.

3. Scale—the similarities or contrasts of size between like or unlike elements. When other visual factors are alike or in balance, the larger of two elements will dominate the smaller one. For a strong sense of dominance to occur, the larger elements must relate clearly with those they dominate, as in Figure 9.2, where the scale differences between the houses, and between the trees, are more evident than the similarities of scale between the large house and tree, or the small house and tree. But note that, in sharing long, vertical axes and chevron-like endings at their tops, all four units relate by directional cues (including the horizontal direction of their alignment).

4. Shape—the similarities or contrasts of shape between elements. In Figure 9.3, the elements form one set of relationships based on shape

Figure 9.1

Figure 9.2

character, another based on scale, and still another based on moving energies. Because all planes, masses, and interspaces have shape, it is important to be aware of the shape groupings that form in any drawing.

5. Value—the similarities or contrasts of value between elements. In Figure 9.4, the elements, in addition to relationships based on scale, shape, and direction, relate by similarities and contrasts of value. Note that in their doing so, new directional forces emerge, as in the "line" of light gray tones that runs obliquely along the lower portion of the illustration. Value is an important unifying factor. As a comparison between Figures 9.3 and 9.4 shows, value, when added to line drawings, can affect visual groupings of elements on the picture-plane and in the spatial field of depth. Value, when used to show light striking forms, unites them by darkening the sides turned away from the light. Each form

is affected by the light in the same way. Cast shadows also produce contrasts and bonds based on their dark tone. Both of these functions of value can be seen in Figure 9.5.

6. Color—the similarities or contrasts of color between elements. Color similarities make for strong visual relationships, creating bonds between highly unlike elements or parts. In Figure 7.5, apples and towel stripes connect through their common color. Conversely, the relationship between like elements or parts can be sharply reduced by contrasting their colors, as in Figure 7.14, where shapes are joined to others more by color than by their similar configurations.

7. Rhythm—the sense of a regulated pattern of movement or visual occurrences between like or unlike elements. Rhythm can be thought of as a kind of visual meter, a system of moving or pulsating activities among the elements or

Figure 9.3

Figure 9.4

Figure 9.5 (*student drawing*)
Carolyn Honetschlager, Arizona State University
Glasses(1980)
Ink and white on toned ground. 9 × 12 in.

among their properties of scale, location, or direction. And, like a musical meter, such relationships occur within some pattern of rigid or loose intervals, as in the "beat" of shapes and values in Figure 9.5. Like directional relationships, the presence of rhythmic ones can be sensed throughout the best drawings, where every line and tone, and every one of the forms, textures, or spaces they produce, is a member of one or more rhythmic systems. Often, rhythms are sensed most among elements repeating a similar movement or interval. The more often such activities are repeated, the stronger the sense of rhythm. Whether they are the "beat" rhythms of Figure 9.5 or the moving ones of Figure 9.6, the sense of rhythm is one of the stronger forces in unifying a drawing, weaving together many otherwise weakly related elements. When, as in Rembrandt's *Saskia Asleep in Bed* (Figure 9.6), strong rhythmic and directional forces are combined, intense movement energies course through a drawing, enveloping and uniting every part.

8. Texture—the similarities or contrasts of textures, whether of a tactile or media-induced nature, between like or unlike elements. In Figure 9.7, dots unite walls, flowers, grasses, and fields. Additionally, Van Gogh used the reed pen to make broad, short, jabbing strokes which invest each shape, mass, and value with a common pattern of marks. Textures can create passages of surface activity that give other, more "restful" passages, greater meaning. Notice in this drawing how the dense concentrations of texture in the foreground give the more simply stated boulders a stronger sense of weight and mass, and the sky a greater tranquility.

9. Location and proximity—when like or unlike elements are seen as belonging together because they occupy positions equally near or far from the center of the page, or when unlike elements are yet more alike than surrounding ones. Both of these conditions are seen in Figure 9.8. Delacroix relates the archway and the door beyond it to the large door and the figure on the right by

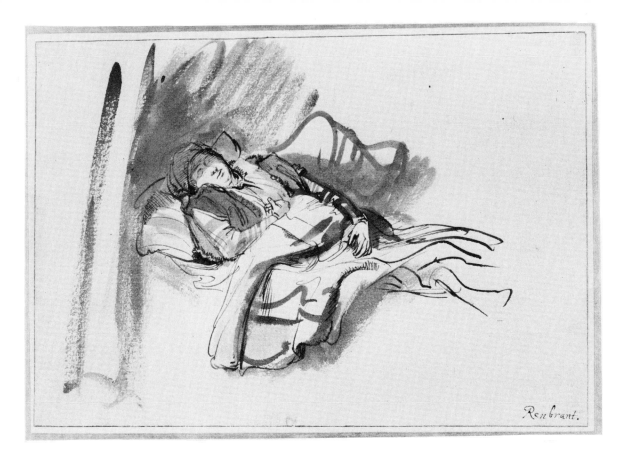

Figure 9.6
REMBRANDT VAN RIJN (1606–1669)
Saskia Asleep in Bed
Brush, pen, bistre ink. 13.7 × 20.3 cm.
Ashmolean Museum, Oxford

Figure 9.7
VINCENT VAN GOGH (1853–1890)
Montmajour
Reed pen and ink. 48.5 × 59 cm.
Rijksmuseum, Amsterdam

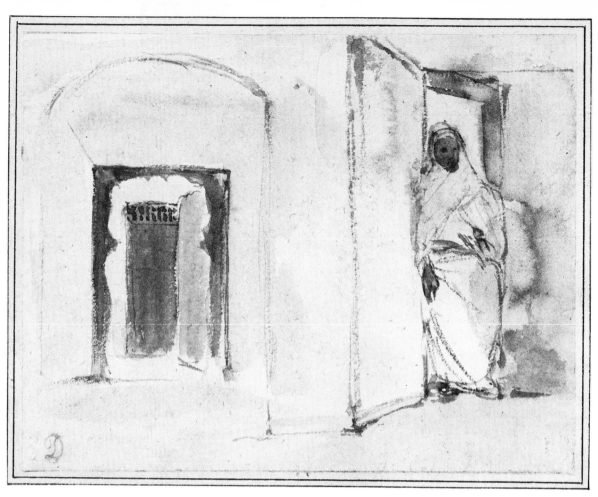

Figure 9.8
EUGÈNE DELACROIX (1798–1863)
Arab at the Door of His House
Watercolor. 10.8 × 14.5 cm.
Rijksmuseum, Amsterdam

centering each segment in its half of the page and by surrounding these concentrations of small shapes, values, and forms by large, light shapes, values, and forms. In a drawing of forms as unlike as leaves, locks, and cups, they will appear related if encompassed by forms, spaces, shapes, values, and colors unlike any in the cluster. It is difficult to overcome the unity of dense groupings. We cannot see an orange in a bowl of fruit as separate from the rest. However, through other relational forces, and by relating the orange with a symmetrically located form, color, or tone, it can be made to join with elements far across the page. When elements are located very close to each other or to a border of the page, they produce a sense of striving toward contact, toward the completion of the suggested action. This is called *closure*, and it is a compelling force. It is impossible, for example, to disregard the circular "shape" a ring of dots suggests. Although no line delineates the circle, we sense its presence.

10. Handling, or character—the similarities and contrasts of elements because of the forceful or delicate style of graphic expression. By changes in the handling, two otherwise similar lines, shapes, or tones can be made to contrast. Conversely, in a drawing where everything is broadly suggested and the medium's characteristics are pronounced, two or more elements, even located far apart on the page, may relate if they are more delicately handled and more precisely stated. In Figure 9.9, Bishop's changes in handling, from painterly generalities to more precisely noted areas, create associations between parts of the drawing that would not be present if every part had been executed in the same manner. Such areas of emphasis not only lend variety to a work, they help guide the viewer's eye to places that emphasize a drawing's theme.

11. Visual weight—the degree of visual importance or impact on the design of elements *on the*

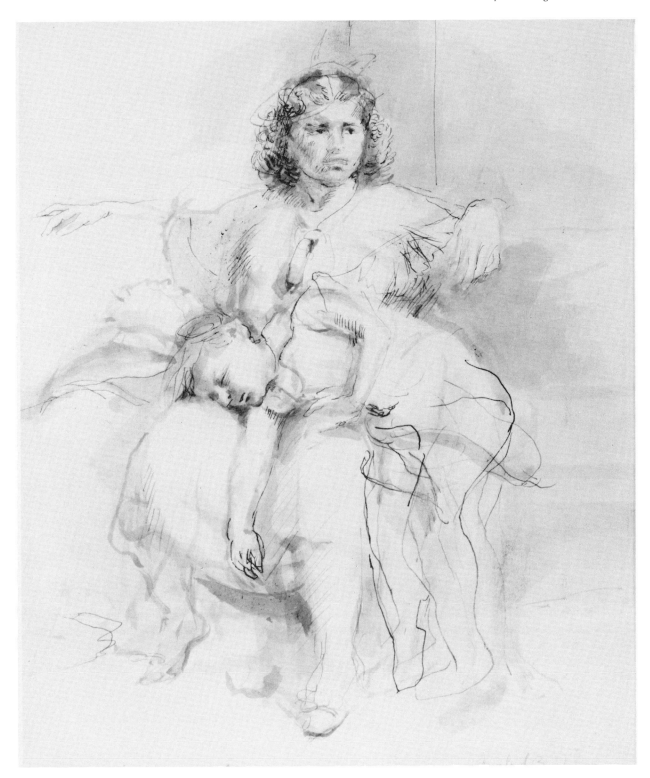

Figure 9.9
ISABEL BISHOP
Waiting (1935)
Ink on paper (pen, ink, and wash). 7⅛ × 6 in.
Collection of Whitney Museum of American Art,
New York. Purchase

picture-plane. Visual weight can be thought of as an element's or part's attracting power—its eye appeal. Visual weight is determined mainly by an element's location on the page, by its contrast to other elements in the drawing, and by its direction. Although an element's directional energy (or, in the case of a volume, its suggested physical weight) strongly influences its visual weight, an element's visual weight is to a considerable degree independent of these factors. And while the visual weights in a work generally tend, like physical weight, to balance by a sensed pulling downward to the left and right of an imagined fulcrum, they *can* suggest movement in any direction. For example, in Figure 9.8 the unit comprised of the large door and the man, in "reaching" for a point at the top of the page, seems to "fall" up rather than down. This feeling is especially pronounced in the man's upper body, where its overall wedge-like shape and dark tones strive obliquely upward. Again, on the left, the archway and the shapes within it seem upward-, not downward-bound.

That the visual weight of an element will vary with its location on the picture-plane can be seen by comparing Figure 9.10A with its three following variations in the figure. In Figure 9.10A, the centrally placed square seems balanced within its frame. Here, balance is not so much a state of absolute rest as it is a neutralization of invisible forces that move between the square and the boundaries of the picture-plane. We sense a strong alignment between the parallel lines as well as between the corners of the square and the frame. The square seems suspended in its position because of "magnetic" forces acting with equal energy on all sides. Here, the square is not weightless, but its visual force is controlled—it does not upset equilibrium. In Figure 9.10B, the sense of balance, while still strong, is of a more tenuous nature— the square is less securely held in check. This is so partly because the total configuration *and* the forces at work are more complex, and partly because a diamond shape is inherently more active than a square, offering diagonal lines everywhere, instead of the more stable verticals and horizontals of the square. In Figure 9.10C, the square takes on more visual weight; there is an increased degree of tension, a need for balance between it and the frame. The square strives for centrality *and* for union with the left vertical side of the frame. Nor is the frame entirely passive.

We sense it "pulling" the square toward the left. Here the square has more visual impact, is of more arresting attraction to the viewer, because its condition is more unresolved. In Figure 9.10D, the visual weight of the square is even greater. This is the result of three conditions: the square is now nearer to two edges of the frame, thus increasing the force of closure; it is positioned at an ambiguous angle, not quite upright nor obviously tilted, creating an even greater "wish" in the viewer for some simpler alignment; and it is located at the far lower right corner of the frame, the area where all elements will seem heaviest. It is not altogether clear why this last fact is so, but Gestalt psychologists have shown this to be the case.[1] As these examples indicate, a striving for directed movement increases as visual weight does. Additionally, the energies emerging here from relationships based on location, shape, and scale also play a part in determining visual weight, as does the influence of physical weight, which is never altogether absent in evaluations of two-dimensional matters. Indeed, visual weight is affected by, and in turn affects, *all* relational phenomena. Figure 9.6 provides an example of visual weight at work in a design. The visual weight of the two broad brush strokes on the far left helps balance and vary the otherwise largely horizontal configuration. Although these strokes suggest a curtain, their main function is to add visual weight on the left, to keep the configuration from tipping into the lower right corner. To appreciate the phenomenon of elements weighing more on the right than on the left side of a picture-plane, hold this drawing up to a mirror and note how the figure, the bedding, and the broad brush strokes of the curtain and the wall rush toward the lower right corner, destroying the drawing's balance on the page. The avoidance of heavy visual or physical weight on the right side can be noted in most of the drawings reproduced in this book.

12. Physical weight—the contrasts and similarities of forms based on their structural nature and their suggested or known weight. For example, given two forms similar in scale, shape, structure, and value, such as the vase and hammer in Figure 9.11A, their differences in physical weight will cause them to contrast in their bal-

[1]See Rudolf Arnheim, *Art and Visual Perception*, 2nd ed. (Berkeley and Los Angeles: University of California Press, 1974), Chapter 1.

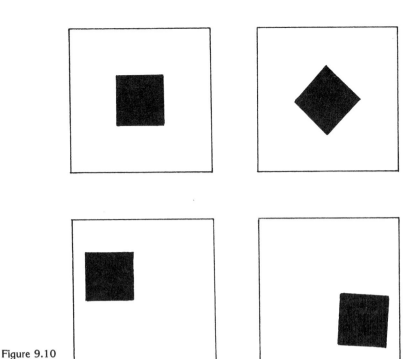

Figure 9.10

ancing functions in the drawing's three-dimensional design. Conversely, different forms of the same weight will tend to associate through this similarity, as the rock and hammer do in Figure 9.11B. A more stable balance of physical weight exists here than in Figure 9.11A. However, note that Figure 9.11A succeeds more in its distribution of visual weight, whereas Figure 9.11B suffers a serious imbalance of visual weights.

All drawings of volumes in space convey a sense of gravity at work among the forms, but a form's physical weight can be considerably increased or decreased by its visual weight in the composition. Thus, a form's position in the pic-

torial field is a factor in establishing both its two- and three-dimensional role in the design. That each type of weight can modify the other can be seen by holding Figure 9.11 up to a mirror. Now Figure 9.11B seems less unbalanced by *visual* weight, and Figure 9.11A seems less unbalanced by *physical* weight. The suggested or known physical weight of recognizable forms, being an important modifier of visual weight, can greatly affect a drawing's overall design.

In Goya's powerful drawing (Figure 9.12), the physical weight of the suspended figure (made even heavier by the visual weight that results from the figure's isolation against the back-

Figure 9.11

A

B

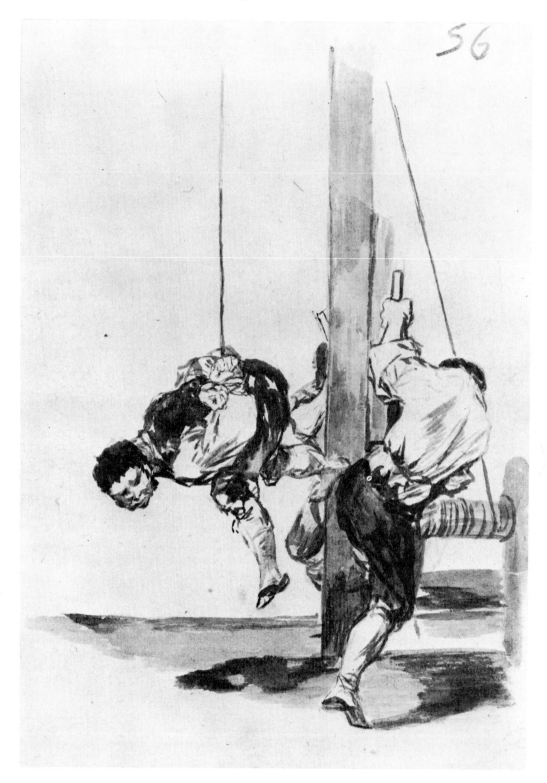

Figure 9.12
FRANCISCO DE GOYA (1746–1828)
Torture by the Strappado
Sepia wash. 20.5 × 14.3 cm.
Courtesy of The Hispanic Society of America, New York

ground and by the forceful diagonal thrusts of the shapes) is necessary to the balance of masses in the composition. Were the figure to be replaced by a bundle of similarly shaped and toned drapery, the design would be far too weighted on the right side. Indeed, as it is, there is a greater physical weight on the right side. But Goya's increase of the victim's total pictorial weight compensates for this. Additionally, by stressing the upward movement of the wedge-like "super" shape of all the forms on the drawing's right side, Goya causes the visual weight of these forms to be directed up, further decreasing the physical weight on the right side.

As this example suggests, the forms in a drawing must balance visually at both the two- and three-dimensional levels, and at their depictive and abstract levels. While it is absurd (if more humane) to torture a bundle of draperies, it is equally (if less evidently) absurd to defeat a drawing's psychological and social message by destroying its balance on the page. For, when our attention is diverted by a basic imbalance in what we are looking at, the particular activities of the scene are less important, and even less understandable.

13. Tension—when two or more elements, or parts of the same element, opposed or attracting in some way, suggest a sense of impending action or change. The elements participating in tension often share strong similarities in other respects but seem poised and about to attack or pull away from each other. Elements in tension suggest an "awareness" of each other. Although opposition is often their basic stance, they always suggest a magnetic attraction. This dual relationship makes elements in tension seem to pulsate. Often the members of such a relationship are roughly equal in their visual importance in the design. Tension can be sensed between elements nearby or far from each other, and between confronting groups of elements. Tension is also sensed between elements that seem to support or unbalance each other, or when elements are engaged in contrasting relationships, such as opposing directions. Tension is possible between parts of a single element, as, for example, the tension we sense in the heavy, rounded bottom of a water-drop shape. There is tension inherent in diagonal lines and complex shapes, in elements that almost touch, and in ambiguities between figure and ground shapes (Figure 9.13).

Figure 9.13

As these thirteen categories suggest, elements are always engaged in multiple relationships. For example, an association between two values must necessarily extend to include their *shape* relationship, and these shapes of tone have *location, scale, direction,* and *visual weight,* are *handled* in a certain way, and so on. A drawing's balance and unity depend on the artist's ability to *sense* and control these relational bonds. For, after the first few marks of a drawing, the relational possibilities, growing by geometric progression, are too many to be seen; they must be sensed. The artist is guided toward equilibrium and unity by an overall sensitivity to a drawing's "rightness" of balance and cohesion—as much a matter of intuition as of intellect. Like all other aspects of responsive drawing, good compositional solutions are formed by facts *and* feelings.

THE CONFIGURATION AND THE PAGE

When the artist begins to draw, relational energies begin among the elements and between them and the page. These relationships exist as two- and three-dimensional events simultaneously. Sometimes two-dimensional relationships "work" with the drawing's design on the picture-plane but they conflict with three-dimen-

Figure 9.14

in so large a field of space, but the blocks *are* clearly presented as forms in space. Additionally, the sense of weight adds a second force. Acting somewhat as a counterforce, the pull of gravity starts a downward tug. This "promise" of a downward movement of the blocks, especially of the one on the right, seems to lessen the imbalance between the blocks and the page. If we turn this illustration on its side, the sense of gravity, plus the forces of direction and tension, unite to create an even stronger diagonal pull. When it is seen right-side-up again, we sense the moderating effect of physical weight on the diagonal position of the blocks.

Although responsive drawings always convey some impression of the third dimension, they are formed by flat lines and tones upon a bounded, flat surface. Their design as two-dimensional *facts* must be compatible with their three-dimensional *impressions*. These facts and impressions must work with each other and with the shape of the page.

Many drawings are quick sketchbook notations or brief, preliminary investigations. Such spontaneous, on-the-spot efforts generally try to capture a subject's essential character and action, study some particular structural or textural aspects of its form, or serve as a preliminary design strategy for a work in another medium. We have seen examples in Figures 1.10, 2.32, 3.7, and 9.9. Often such sketches are not intended to be integrated with the page. Even here, though, an intuitive sense of balance between configuration and page, of the influence on the thing drawn by the shape of the surface, affects decisions about the placement of the configuration (or the several independent studies) on the page.

It is clear from Gericault's sketches of soldiers and horses (Figure 9.15) that the artist is absorbed in study and not (intentionally) with creating a balanced arrangement of forms on the page. Even so, it is difficult to imagine rearranging this group of studies into some better pattern.

However, other drawings, even when they do not fill the page, *do* intend a bond between the configuration and the page. Such drawings are conceived (or resolved) as arrangements of forms in spatial environments that depend on, but do not touch, the limits of a page to make sense as a design.

In such drawings, visual issues actively involve the entire page. The outer zones of drawings that do not extend to the limits of the page

sional meanings, and vice versa. For example, the eight shapes in Figure 9.14A relate in a balanced, unified way. There is a gradual progression in their scale; their several directions and abutments offer interesting variety; and the design of the two large shapes embracing six smaller ones form a discernible theme. But, regarded as blocks in space, the abutments between their planes and the borders of the spatial field, as well as the abutment between the blocks, weaken the impression of volumes in space. Such tangential connections make it difficult to know which of the blocks is ahead of the other or which is larger.

The six small shapes in Figure 9.14B are, from the standpoint of two-dimensional design, too small to relate to the large shape of the picture-plane. Instead of the interaction between *all* the shapes, as in Figure 9.14A, here the little shapes form two isolated clusters, and the shape of the picture-plane remains passive. Additionally, the tension and direction between the two clusters of shapes create a diagonal "tug" that disturbs the vertical-horizontal orientation of the picture-plane. For, the first diagonal direction in a drawing, unlike vertical and horizontal directions, which always run parallel to two of the picture-plane's boundaries, is obviously "alone." Therefore, diagonals are usually counterbalanced by other diagonals, as in Figure 9.14A, where sets of oblique lines cancel each other's movements.

In Figure 9.14B, no good compositional end is served by the placement of such small volumes

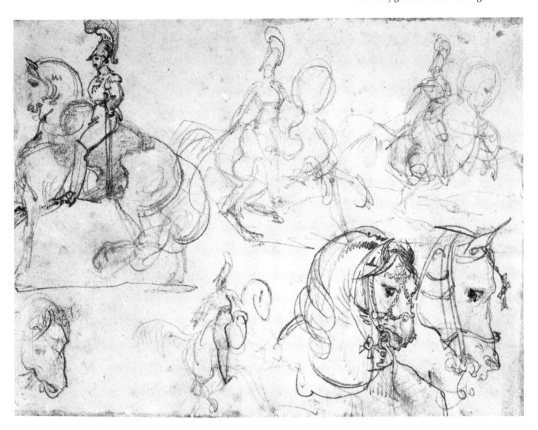

Figure 9.15
THEODORE GÉRICAULT (1791–1824)
Sketchbook: Sketches of Mounted Carabinieri,
Heads of Horses
Graphite. 17.4 × 23.2 cm.
Collection of The Art Institute of Chicago. Margaret Day Blake
Collection. Photograph © 1990, The Art Institute of Chicago.
All Rights Reserved

may be empty of drawing marks but not of visual meaning. They always have shape, scale, and value, convey direction, and are similar to, or in contrast with, various parts of the configuration. They are always part of the drawing's design. These "empty" areas influence the configuration's *representational dynamics*, that is, what the things depicted do as actions (falling, running, bending, etc.), and what the *visual and expressive dynamics*, the abstract design and emotive energies, do as actions. These figural, formal, and expressive states together are called a drawing's *content*.

Because so many responsive drawings are spontaneous, brief, and alive with energy, artists often use such a design strategy. It permits a strong concentration on the subject. Often the surrounding, empty area of the page acts as a "shock absorber" against which the drawing's forces are turned back upon themselves to start

the cycle of moving actions over again. Then, too, this strategy allows a fuller concentration of responsive powers on the subject than when they are divided between it and demands of a full-scale compositional scheme. This does not mean that such drawings are less united with the page than are those that fill it entirely. It means only that the encircling, undrawn area is assigned the less active, but no less important, role of containing and modifying the dynamics of the configuration.

In Rembrandt's *The Mummers* (Figure 9.16), the configuration is well within the limits of the page but strongly interrelated with its shape and scale. The drawing "opens up" in several places to admit the surrounding empty area of the page, physically fusing with it. The frequent reappearance of the white page within the drawn areas helps unite them. But the strongest bond between the configuration and the page exists in

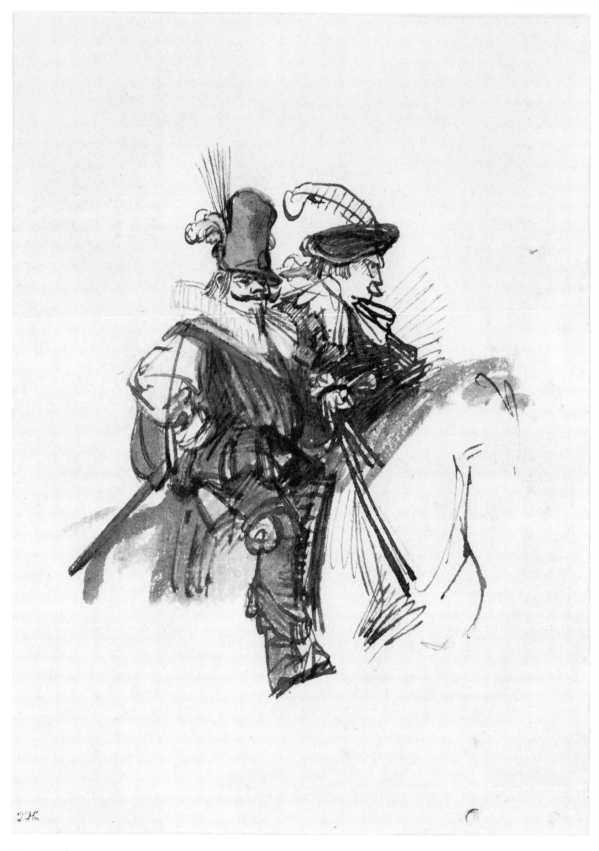

Figure 9.16
REMBRANDT VAN RIJN (1606–1669)
The Mummers
Pen and ink with wash. 21.2 × 15.3 cm.
The Pierpont Morgan Library, New York

252

the organizational dependence they have for each other.

Near the drawing's exact center, the hand holding the reins marks the center of an expanding burst of lines, shapes, and tones of such power that we sense its radiating force in the hat, collar, elbow, leg, and reins of the figure on the left. This force is continued in the neck and chest of the horse, and in the lines near the man on the right. The release of such explosive energies warrants the thick, surrounding buffer of space (Figure 9.17). We can sense an "implosion" too. The empty area absorbs the "shock waves" and sends them back again. These sensations keep alternating as we look at the page. Both the drawn and empty areas contribute to and share in these pulsations.

Had Rembrandt continued to draw the entire horse, the empty area would have been cut in two, destroying the surrounding buffer and weakening the radiating force as well. Had he made this drawing on a larger sheet of paper, the impact of the explosive pattern would have been greatly reduced and the subject overwhelmed by the scale of the empty area. No "echoes" would return from the limits of the page, because they would be beyond the range of the drawing's energies, and thus no visual interplay between the drawn and empty areas would exist. The configuration would be isolated in a sea of paper.

Every type of relational activity is present in this drawing. We see how powerfully line and direction are used, and how they pervade the entire composition. The rhythm of the many directional "spokes," radiating from the drawing's center owes much to line, and to those invisible "lines" of force that relationships of direction produce. An almost equally powerful visual theme that also moves through the drawing is

generated by other directions, rhythms, and tensions (Figure 9.17).

In Figure 9.16, beginning with the near man's lower leg, a vertical movement spreads left and right in a fan-like manner. The angle of the near man's lower arm and the repeated lines of his waistcoat convey one half of the fan's spread; the other half is carried by the lines in the far man's coat, by the several brush strokes defining the horse's mane, and by the lines of the background near the man on the right. This fan-like action creates one tension between its two halves and another between it and the inverted V-shaped counterforce formed by the directions of the sword and the reins. The V shape is reinforced by some lines in the near man's saddle and by some of the lines between the leg and the reins. Tensions between the various lines and brush strokes of the horse make these marks seem to attract each other. These tensions, and the sense of closure between the marks, help us to "see" the largely nonexistent animal. The proximity of the two figures, and the dominant dark value between them, unite the men into one great diamond-like shape that is centrally balanced on the page in the same tenuous and provocative way as the diamond shape in Figure 9.10B. Visual and physical weight are also centrally balanced in this design. Note that Rembrandt reduces the physical weight of the horse's neck and head, lest the weight of so large a mass undo the drawing's equilibrium. Rembrandt's handwriting—its consistent, animated energy—further reinforces the power of the actions described above and helps to unite the drawing.

These are only *some* of the drawing's relational activities. There are many more. Indeed, each of the marks has some function that contributes to the drawing's organization and unity. As we have stated, each defines, acts, and interacts.

Beginning students often question whether an artist consciously intends each of the force-producing relationships in a drawing. They doubt that the drawing's dynamics always represent deliberate judgments, and they suspect that many of the relationships pointed out in a particular drawing never entered the artist's mind—and they are right! It was observed earlier that after a drawing is well under way, there are just too many bonds of association, too many abstract actions for the artist to see and consciously control, and the drawing's resolution depends on intuition as much as intellect.

Figure 9.17

A B

This holds true for an examination of any particular drawing. As we study other drawing strategies in this chapter, we should remember that any analysis of a design reveals only some of its relational activities (probably those reflecting the analyst's own instincts about organization)—and that many of these may well reflect the artist's intuitive impulses *and subconscious interest*. For, the content of any drawing contains certain intangibles that express the artist's personality and philosophy that are not only subconscious, but resistant to any attempts by the artist to be free of them.

Also we must recognize that even if a drawing's relational life *could* be fully and objectively known, a key if impalpable ingredient would still be missing. This mysterious "something" plus certainly concerns a drawing's design and expression but is not limited to them. It is an elusive vital spirit that permeates the drawing, transforming the marks into active forces and meanings. If we regard responsive drawings as graphic equivalents of living organisms, then whatever gives the graphic organism "life" is as mysterious as those powers that animate and sustain living things in nature. Therefore, intellectual dissection can no more determine this "something plus" that separates art from competence than the character of a person can be learned by surgery.

What *can* be learned about the relational activities that form a drawing's design strategy makes analyzing drawings an important source of information and insight. Although the beginner rightly senses that drawing is not a wholly conscious activity, a more pertinent question would be: are these relationships really present? In the analysis of Figure 9.16, the several relationships and forces discussed occur too consistently, are too critically established, and are too self-evident to be mere chance or exaggerated claims on their effects. Moreover, the absence of visual discords and non sequiturs—of elements *not* engaged in the several actions discussed or not otherwise contributing to the drawing's order—is, again, beyond chance. Whatever an artist's personal "formula" between reason and instinct may be, the fact remains that in great drawings a great many questions and needs have been well answered.

Although very different in style, mood, and subject, Diaz de La Peña's drawing *Landscape* (Figure 9.18) shows a use of the empty areas of the page similar to that in Rembrandt's drawing. Here, a "ground burst" of radiating directions spreads out on the horizontal plane of the field as

Figure 9.18
NARCISSE VIRGILE DIAZ DE LA PEÑA (1807–1876)
Landscape
Black chalk. 6 × 11 in.
Sterling and Francine Clark Art Institute, Williamstown, Mass.

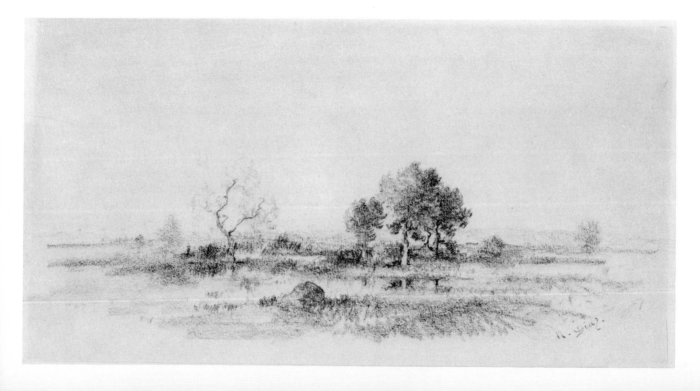

Figure 9.19
BARBARA APEL (1935–)
Umbrian Hills, II (1980)
Monotype, black ink. 12 × 16 in.
Collection of the author

well as on the picture-plane and almost fades away at the edges of the page, retaining the encircling, single shape of the rest of the page. Again, the plan is the use of the outer portions of the page as a force-absorbing belt of space. The trees, rising from the center of the burst, take on more contrasting force from it. But, unlike the vigorous energy in Rembrandt's drawing, the forces in Diaz de La Peña's are more muffled. The horizontally located configuration, the pronounced texture of the chalk medium, the restricted value-range, and the soft edges of the forms make this a quiet design, compatible with the subject's restful mood. The surrounding space, especially that above the landscape, reducing and absorbing the configuration's ener-

gies, helps to suggest the drawing's pastoral nature.

In Apel's *Umbrian Hills II* (Figure 9.19), the configuration reaches to the left and right boundaries of the page, creating two large, "empty" shapes that echo the shape of the drawn landscape area. Here, too, as in Figures 9.16 and 9.18, openings in the central shape link it to those large shapes that surround it. Note that other, smaller open-shape subdivisions in the drawn area also suggest their parent shape as well as those above and below it. Note too that by increasing the scale of each of the three large horizontal areas, Apel creates a sense of progressively approaching masses. We sense the vast space of the ground plane, the hills, and the sky.

Figure 9.20
KENNETH CALLAHAN (1906–)
Summer Bug
Sumi ink. 23¹⁄₁₆ × 35¼ in.
Worcester Art Museum, Worcester, Mass.

And, despite the drawing's seemingly effortless handling, each mark, while strongly suggesting trees, houses, roads, or embankments, is attuned to the abstract play of moving forces that activate this subtle work. Even the drawing's boldest passage, the darker, denser, and more animated strokes at the left and center of the hills, contributes to the drawing's overall balance as it provides an area of variety to the otherwise delicate treatment. Such fusions of visual and physical weight and utilization of directional and rhythmic energies enable the artist to more fully organize and convey her responses to this demanding panoramic subject.

The surrounding buffer in Callahan's drawing *Summer Bug* (Figure 9.20) does have some light washes of tone near the insect, but again, the space serves to contain and contrast with the actions generated by the configuration. A sense of the bug's slowly moving legs is conveyed by

the rhythms between them. Callahan uses the visual weight and dominance of the dark tone on the last segment of the bug's body to counterbalance the physical weight and downward tilt of the form and, by this single, strong contrast, to heighten the drawing's fragile delicacy.

While the Diaz, Apel, and Callahan drawings are widely divergent in subject, time, and style, they share a similar organizational strategy. This encircling of a horizontal image by white space, an overall gentle handling, pronounced textures, and energies radiating from a central point in the image are tactics common to all three works.

A somewhat similar abstract theme organizes still another kind of subject in Cretara's *Sleeping Woman* (Figure 9.21). Here again an encircling buffer of space "fits" the configuration's moving energies, emerging mainly from the center of the image. Again, shapes in the configura-

tion open up to merge with the surrounding space.

As these examples show, drawings of differing subjects can utilize a common design plan which gives them a kind of family resemblance. Conversely, drawings of the same or similar subjects, even when a common set of abstract patterns is used, can also be markedly contrasting. This can be seen by comparing two drawings, by Hokusai and Rodin (Figures 9.22 and 9.23). Both

use a broad "pedestal" of curvilinear lines, shapes, and volumes to support the animated behavior of their subject, both emphasize the rhythms of drapery and figure; and both shape the configuration into a rough C-shaped curve (reversed in Hokusai).

Hokusai places the figure to the right of the page while Rodin places it almost centrally. These differences in location are due mainly to the tilt and actions of the figures. In Hokusai's

Figure 9.21
DOMENIC CRETARA (1946–)
Sleeping Woman
Red chalk. 14 × 18 in.
Courtesy of the artist

Figure 9.22
KATSUSHIKA HOKUSAI (1760–1849)
A Maid Preparing to Dust
Brush and ink. 12½ × 9 in.
Freer Gallery of Art, Washington, D.C.

in the same basic design themes, these two drawings differ in far more obvious ways, chief among them being a linear versus a tonal basis of expression. Although the drawings we have been examining do not fill the page, they *use* the page as an active part of the design and not merely as a blank area unrelated to the configuration.

Other themes require other solutions. Often, as in painting, artists draw to the borders of the page when the nature of their subject or of their design strategy for a particular work demands it. Although all responsive artists regard as interdependent the subject and the organizational system it calls for, artists vary widely as to which of these receives primary emphasis.

If we compare Figure 5.15 with Figure 3.3, we see that Campagnola's primary interest is in the subject, and Toulouse-Lautrec's is in the drawing's design. Although neither artist em-

Figure 9.23
AUGUSTE RODIN (1840–1917)
Nude
Graphite with watercolor on cream wove paper.
17⅝ × 12½ in.

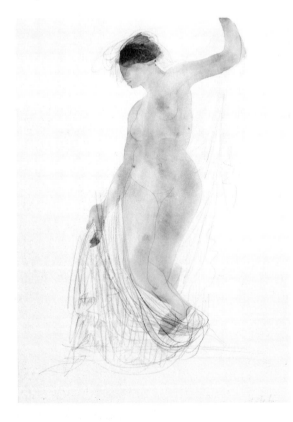

drawing, the extended material at the top and the swirling robe at the bottom of the page swerve abruptly from the figure's nearly vertical direction to move forcefully to the left. Had the artist placed the figure to the right, it would have left a very large pocket of empty space on the left, out of scale with the other shapes on the page and crowding the figure unnecessarily to the right. Her slight leftward tilt also permits Hokusai to place the figure near the right side. Were she exactly vertical, there would be too much weight and attention on the right.

In the Rodin, though there is not a single vertical line in the drawing, the design of the figure is vertical. Placing the image nearer to the right side would upset the drawing's balance on the page; moving it to the left would make the background shapes monotonously alike. Notice that the background shapes echo the triangular shape of the woman's drape.

In addition to these nuances of differences

phasizes one consideration to the neglect of the other, the difference in their responses to each is evident. For Campagnola the balance between directions, the contrasts and tensions between elements, and the rhythmic play between straight and curved edges are subdued. The forces are there; the drawing functions as a handsome system of order, but the design is below the surface—an intangible presence of pattern. In Lautrec's drawing the directions, contrasts, and rhythms are pronounced. As with all good compositions, neither drawing can be cropped or added to without destroying its balance and unity.

Hopper's drawing *Burlesque Theatre, Times Square* (Figure 9.24) conveys an even-handed interest in both narrative and formal considerations. He captures the massive scale and baroque flavor of the theater—we sense its spacious interior and false grandeur. But Hopper is equally interested in the forces that convey these qualities as visual events in their own right.

Many of the drawing's parts are designed to suspend at oblique angles from the centrally

Figure 9.24
EDWARD HOPPER (1882–1967)
Burlesque Theatre, Times Square
Charcoal. 30.2 × 22.5 cm.
In the collection of The Corcoran Gallery of Art, Washington, D.C. Museum Purchase, Membership Fund

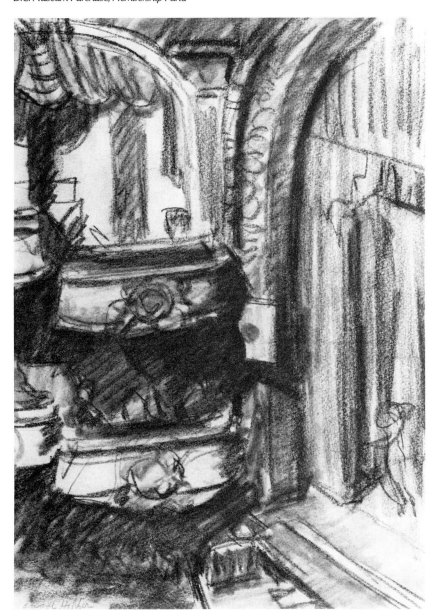

located columns that curve to the left and right near the top of the page. To the columns' left, the theater boxes tilt down toward the left; to the columns' right, the curtains and stage tilt down toward the right. Together, these tilted forms—and the shapes, lines, and values that comprise them—act like chevron marks across the page. These oblique directions and the rising, double-arching vertical action that counters them comprise the drawing's basic design plan. The design works with the shape of the page and is as much a part of the drawing's content as the page is part of the design.

Hopper's use of bold contrasts of direction, value, and rhythms intensifies the tensions between the obliquely suspended forms. Note that Hopper increases the visual weight on the drawing's left to compensate for our tendency to sense things on the right as being heavier. Note, too, that some of the force of the various directional thrusts gains momentum from Hopper's consistently loose, energetic handling of the charcoal.

Although the style and handling in Parker's *Ram* (Figure 9.25) are not at all like Hopper's, both artists place moving energies high on their

Figure 9.25
ROBERT ANDREW PARKER (1927–)
Ram (1969)
Watercolor on paper. 29¾ × 21¾ in.
The Arkansas Arts Center Foundation Collection:
Gift of the artist, 1969

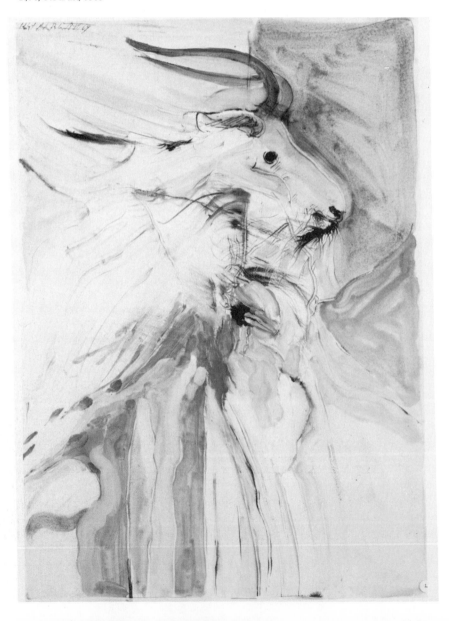

list of priorities. The elegant curvilinear action of the Hopper and the windswept patterns in the Parker show moving energies to be at the heart of both works. One of the dependable common denominators of responsive drawing is the sense of motion—and consequently, of aliveness—at work in the image. Such drawings, no matter how different in style and purpose, indicate that directed actions and rhythmic play are forces that contribute greatly to both organization and expression.

Most artists turn to drawing to state linear rather than tonal ideas and to explore and note essential actions and edges, usually with pointed instruments. Perhaps that is why direction and rhythm are two of the more important relational forces in depicting and designing. To more fully experience direction and rhythm at work within and among a drawing's parts, it will be helpful to analyze a few of the drawings in this book by making some drawings that extract these relationships.

exercise 9A

MATERIALS: Tracing paper, any soft graphite pencil, and any colored chalk or crayon pencil.

SUBJECT: Select any three of the drawings reproduced in this book that show strong directional and rhythmic actions.

PROCEDURE: In a three-phase progression, you will make three drawings that will extract the moving energies of the drawings you have selected. There is no time limit on these analyses, but you should try not to spend much more than fifteen minutes on each phase per drawing.

first phase Using the colored pencil, draw the directional activities first. This is done by placing a sheet of tracing paper over each drawing and selecting those straight, curved, or undulating directional actions that you regard to be the major ones—those having the most evident impact and energy. Begin by searching for those directed actions that unite parts of forms, unite interspaces and parts, and even the lines, shapes, and tones that form them. Depending on the drawings you have selected, these directed movements may correspond to the axes of forms, shapes, values, or textures. They may also be along the edges of any of these (but be careful not to turn your analysis into a contour drawing only), or they may be found in a "purer" state in a route of independent lines. When several forms, shapes, interspaces, and so on appear to continue a direction, even though such like or un-

Figure 9.26

like units may be separated in the drawing, your directional lines should continue from one to the other without stopping, as in Figure 9.26. In the drawings you are analyzing, such directional movement is felt as energy. You are making these energies visible. Therefore, try to feel the force of these moving energies. Although you are looking for directions that continue between larger units, you may find that directions first seen as independent ones join up with the flow of others. When a direction is conveyed by a form's edge, do not copy the contour, but draw its *general* character, its moving action. As in gestural drawing, seek out the drawing's main movements.

second phase When you feel you have established each drawing's major system of directional forces, begin to extract its rhythms, using a graphite pencil. As was mentioned earlier, the sense of rhythm

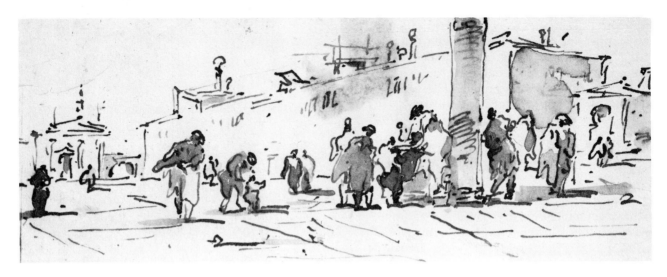

Figure 9.27
FRANCESCO GUARDI (1712–1793)
A Venetian Scene
Pen and brown ink, brown wash on cream paper.
2¹⁵⁄₁₆ × 7⅝ in.
Courtesy of Fogg Art Museum, Harvard University,
Cambridge, Mass. Bequest of Charles A. Loeser

occurs as repeated movements or "beats." Like all relationships, those based on rhythm can exist between any of the elements. Unlike the major directional forces that require strong or extended actions to have compositional significance, flowing rhythms are often built up by repetitions of smaller directions among the elements as well as among the major ones. "Beat" rhythms are generally seen in the spaced reappearance of any element. Sometimes both kinds of rhythm will be present in the same formations, as in Guardi's *A Venetian Scene* (Figure 9.27). Here, the figures offer a system of fence-like vertical directions that relate with other short vertical movements throughout the drawing to create a rhythm of up-and-down motions that animates the scene. Additionally, a "cadence" of small, dark and light value "beats" moves across the figures, as does a moving rhythm of wriggling lines. Notice that, collectively, the figures also form the strongest directional force in the drawing.

As you analyze each of the three drawings for rhythm, you can expect to be shunted onto a directional tract now and then. Flowing rhythms frequently merge with directional actions because both are concerned with movement, as can be seen in Figure 9.28, where rhythms and directions cannot easily be sorted out. But, because a drawing's pattern of directions is made up of *major* movement actions and its pattern of rhythms generally of lesser ones, we might regard the system of undulating edges of the forms in Figure 9.27 as rhythmic actions but regard the axes of the forms as

directional ones. Keep the lines and tones representing rhythms general and simple, as in the analysis of the rhythms of Pascin's drawing in Figure 9.29.

Because you have been using two different sheets of paper, by placing this second analysis over the first it is easy to see which parts of the drawing emit both kinds of forces. There may be a few passages of a drawing that do not provide much of either force. Such segments may have other relational functions and will be relatively dormant as carriers of directional or rhythmic action.

third phase Now, with the reproduction nearby as your model, place a third sheet of tracing paper over the two analyses, enabling you to see them both, and, using a graphite pencil, begin to copy the reproduction. It will not matter that you may be using a medium different from that of the original. You need not go on to make an accurate copy of the drawing, but just far enough to flesh out the forms around your extracts of the drawing's directional and rhythmic patterns. As you do, note the interrelated nature of the drawing's "what"—its figurative matter (arms, torsos, trees, drapes, etc.) with these two aspects of the drawing's "how"—its abstract design. In the best drawings, all of the elements that form the image form the design. No lines and tones are used *only* for depictive or dynamic purposes. Your goal in the third phase is to produce a version of the original that permits its directional and rhythmic qualities to be more in evidence.

Figure 9.28
EGON SCHIELE (1890–1918)
Two Girls Embracing
Charcoal. 18⅛ × 11⅝ in.
The Dial Collection

Figure 9.29
JULES PASCIN (1885–1930)
Girl in an Armchair
Charcoal, some yellow chalk. 55.9 × 43.1 cm.
Collection of The Newark Museum. Gift of Mr. and Mrs.
Bernard M. Douglas, 1957

Therefore, redraw any of those lines or tones from either of the first two analyses which will help strengthen these moving actions in your "copy."

When you have completed these analyses, compare them with the three drawings you selected. Often the lines and tones of an analysis form a balanced composition, revealing some of the artist's design strategy. They also indicate something about each artist's visual (and expressive) interests and suggest the quantity and vigor of such forces necessary to create the kinds of moving actions these drawings possess.

For an additional helpful exercise, analyze some of your own drawings this way. You will probably find that strengthening or adding the interweaving, animating, and unifying qualities of direction and rhythm will improve your drawings.

Analyzing the drawings of master artists for these or any other relational patterns, such as those based on value, shape, or texture, helps us to understand more fully the necessary union between the perceptual and conceptual aspects of drawing. There are two common hazards of such analyses. The first is the assumption that all of the artist's responses to his or her *constant* subject and the *evolving* drawing are conscious and deliberate; we have seen that many are essentially intuitive actions. Second is the assumption that such analyses fully explain a drawing—or an artist. Not until we have experienced the existence of such forces as universal, integral, and inescapable factors in the act of drawing, will a sensitivity to bonds of visual association become a largely subconscious and intuitive part of our comprehension and response.

THE ELEMENTS AS AGENTS OF DESIGN

The central theme of this chapter is that the quality of a drawing's organizational system and the visual dynamics that express it are never expendable niceties but are fundamental to its meaning and worth as a creative, visual statement. If we regard a drawing's composition as the artist's strategy for organizing his or her visual and expressive responses, then the relational behavior of the elements can be regarded as the tactical means used to effect that strategy. And, as we have seen, relationships begin with the first few marks. Perhaps that is why so many gifted artists, even in the briefest of preparatory notations, not only intuitively organize independent-

ly drawn sketches into some pattern on the page, but reveal an awareness of each mark in a sketch as being a unit of energy. They seem unable to regard a line or tone as exempt from some kind of relational function, nor can they accept the imbalance and randomness that inevitably result from unrelated segments or arbitrary drawing. The sensitive artist reacts to visual disorder with anxiety-producing tensions. Such drawings simply do not "feel right." When stability and unity are achieved, there is a release of tension, a sense of rightness. Drawings developed without an organizational strategy always disclose a kind of wandering, a lack of visual bearing or purpose. When an overall strategy is absent, the interrelating and unifying activities of the elements are absent. Whatever else such drawings may convey, disharmony and ambiguity are always parts of the message.

In this section we will examine a group of drawings that provide examples of some elements' organizational activities not yet discussed, or only touched on earlier. As was previously noted, their possibilities for visual associations and activities are unlimited. But, seeing some of the ways in which they relate and act may stimulate the search for others.

Ingres' *Study for Drapery* (Figure 9.30) reveals his sensitivity to two- and three-dimensional matters at the same time. We are as aware of the structural nature of these forms as of the swirl of black, gray, and white shapes forming them. They are simultaneously seen as planes and shapes. Ingres' main strategy is to organize the drawing by stressing the animated rhythms that result from repetitions of line and shape. Many lines, some of them really thin shadows, follow the same routes, each adding force to directions and rhythms. Most of the drawing's variously toned shapes are strongly related to the lines in their action. Note that a majority of them are variations of a boomerang shape. They range from narrow V-shapes to very open, rounded Vs. Most of these below the horizontal midline are placed right-side-up; above the midline, most are inverted. The more we examine the drawing, the more evident it is that almost every line, shape, and tone is a variation of the boomerang idea. The main thrust of the volume—where it seems headed—is toward the lower right corner of the page. Ingres has built up quite an energetic sense of visual and physical weight moving in that direction. He checks its

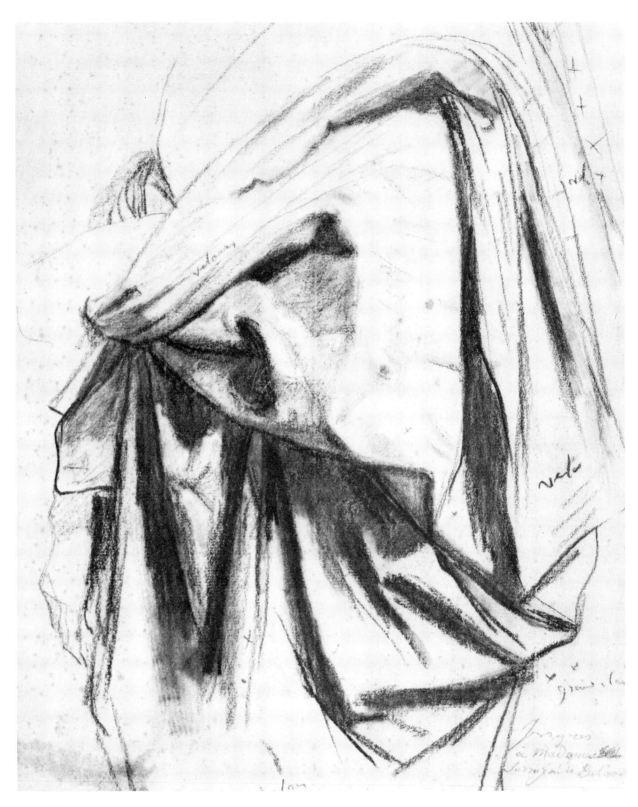

Figure 9.30
DOMINIQUE INGRES (1780–1867)
Study for the Drapery of Molière in the "Apotheosis of Homer"
Black chalk with stumping. 12 × 9¹³⁄₁₆ in.
The Metropolitan Museum of Art. Rogers Fund, 1937

Figure 9.31
CHARLES SHEELER (1883–1965)
Barn Abstraction
Black conté crayon. 14⅛ × 19½ in.
Philadelphia Museum of Art
The Louise and Walter Arensberg Collection

action by the strong tension at the knotted section on the drawing's left side and by the largest concentration of dark tones in the drawing, below the knot, in the lower left. This "tug-of-war" creates a balance based on the most tenuous resolution of forces. The drawing is continuously in motion. It no sooner achieves its balance than it is set going again. Note how the five or six thick shadow lines in the lower right and center swing up toward the drape's knot to help return the energy to its source. Note, too, that the most inclusive shape we can find, the one that takes in almost every mark on the page, is itself a large, almost page-filling boomerang shape. The elements of line, shape, value, and volume all function at the three levels referred to earlier. Each, in addition to depicting the drape, reinforces the drape's behavior by various dynamic actions, and finally functions in some organizational way.

How very different from Ingres' spirited image is Sheeler's *Barn Abstraction* (Figure 9.31). Here there is a firmly stabilized balance of forces.

The image is formal and deliberate. Each mark counts. The design depends on a grid of interdicting vertical and horizontal lines and shapes of an almost mechanical nature. The impression of volume is subdued, being conveyed more by overlapping shapes than by any other structure-building measure. There is movement here, but of a restrained and stately kind. Even the textures—variations on the density of massed lines—move across the page in three deliberate steps, and the rhythm's movements and beats are in slow staccato. The plane of the page itself moves subtly back and forth, suggesting a sense of deep space above the buildings, becoming the facing planes of the buildings' walls and then moving forward to become the foreground—without a mark being drawn *in* the sky, *on* the walls, or *upon* the foreground. Openings in the roof and walls, and around both sides of the grouped buildings enable the surface of the page to imply these different spatial functions. Note that the drawing's stability is due partly to the roughly equal energies between vertical and

266

horizontal directions. The largest building, which is on the right and contains the visually heaviest black shape, does not tip the drawing to the right. Balance is achieved by the directional thrust and visual weight of the long "overhang" of the lower buildings on the left, urged on by the wedge-like shape's direction and diagonal edge. This diagonal, being the only *drawn* one in the design, possesses a strong attracting power. Other, *implied* diagonals are sensed in the staggered location of the roofs, in the base line of the building on the far left, and in one of the roof lines.

In this deceptively simple-looking drawing, all the elements are engaged. Each helps advance the "weaving" of the vertical and horizontal directions into a stable design. All of the basic kinds of relationships are also here. Direction, visual weight, texture, location, and rhythm have already been mentioned, and the play between lines, values, and shapes implied.

Sheeler utilizes scale differences for purposes of harmony, contrast, and balance and, by his patient and certain handling of the marks,

further strengthens the drawing's cohesive properties. Tensions work between various value shapes and between the drawing's two largest segments, separated by the vertical line running to the left of the large black shape. Even physical weight has a role in this composition, for, despite the two-dimensional nature of the buildings, we understand them as heavy masses whose weights are also in balance when we regard the same vertical line as the fulcrum of a scale.

Sheeler, whose drawings are so frequently concerned with the design of convincing volumes and spatial depth (see Figures 4.42 and 5.8), seems to be reminding us here that drawing is not sculpture, that the dominance of three-dimensional impressions in a drawing is a graphic option, not a fixed responsibility. It is interesting to compare Sheeler's drawing with Tiepolo's *A Group of Farm Buildings* (Figure 9.32). Here, volume is a more active element. Its physical weight counterbalances the design's overall tilt to the lower left. Notice Tiepolo's use of value to create tonal accents of white within the grays of the buildings. These do more than strengthen struc-

Figure 9.32
GIOVANNI BATTISTA TIEPOLO (1696–1770)
A Group of Farm Buildings
Pen and brown wash on cream paper. 6⅜ × 10¼ in.
Courtesy of Fogg Art Museum, Harvard University,
Cambridge, Mass. Gift of Dr. Denman W. Ross

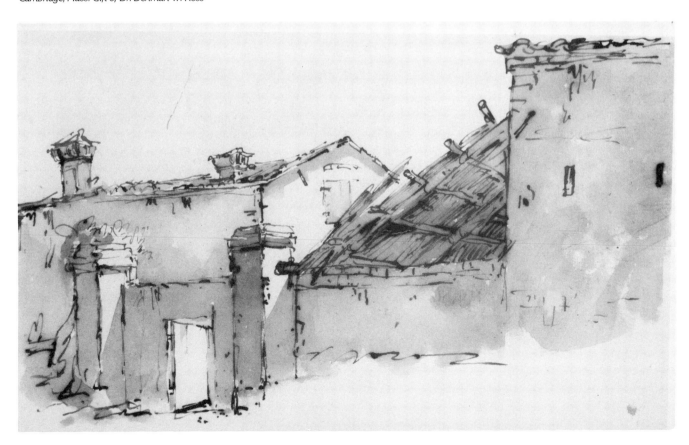

tural clarity; they add tonal variety to the design, and by their contrasting value (but similar shape) give the darker pitched roof more emphasis in its balancing function by providing small counter-shapes against which the roof's bold scale, value, and texture have more visual meaning.

Unlike Sheeler, who uses the elements for a balanced awareness of the drawing's two- and three-dimensional life, Tiepolo relies on every element mainly to convey volume—but each does have a two-dimensional function. Note again that the strongest concentration of line, value, and texture fall just where their combined direction, shape, and scale are most needed—in the pitched roof.

In still another drawing of buildings, Wiley's *Novato* (Figure 9.33) seems to avoid a clear commitment to either two- or three-dimensional clarity. Unlike Sheeler and Tiepolo, who rely strongly on closed shapes, strong directions, and tonal clarity, Wiley utilizes textures of all sorts to purposely impede both volumetric *and* flat readings of the image. Instead of being invited in to move among structures in space, or to judge and feel the behavior of elements on the picture-plane, we are held at a distance by contradicting visual cues and "clouds" of texture. These planned ambiguities guide us toward what the artist intends us to see: the *whole* panoramic view and the *total* page. Note how the

Figure 9.33
WILLIAM T. WILEY (1937–)
Novato (1974)
Watercolor. 9 × 12¼ in.
Courtesy, Allan Frumkin Gallery, New York

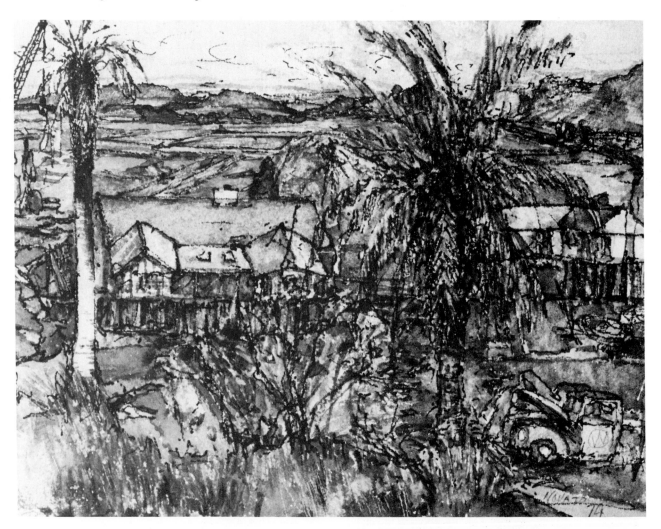

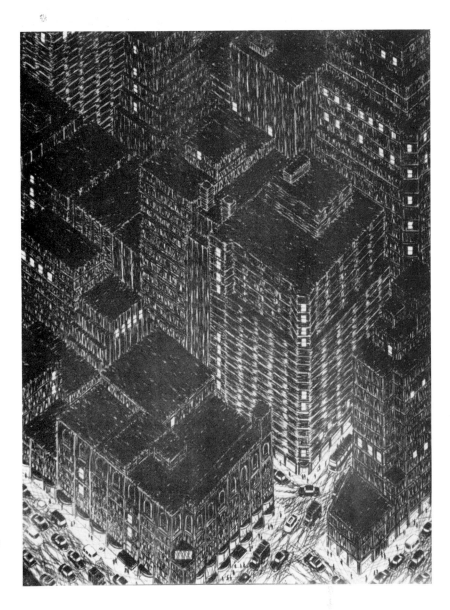

Figure 9.34
YVONNE JACQUETTE
Northwest View from the Empire State Building (1982)
Lithograph. 50⅜ × 34¾ in.
Collection of Lois B. Torf

artist's use of textures that describe foliage merge with those resulting from the paper's rough tooth and the artist's vigorous handling of the materials.

An artist can also devise a liberal use of texture, along with a wish to lead us to a panoramic view, that places as much clarity on a work's two-dimensional order as on its three-dimensional one. Jacquette's solution (Figure 9.34) is to show an aerial view of a downtown area. From this height, diagonals and diamond shapes create a strong two-dimensional pattern, while the strong perspective and an emphasis on illumination produce an equally strong three-dimensional effect.

In another "all-over" view, Johns, in Figure 9.35, demonstrates the powerful effect of directional cues by having us easily see the lines of a wire coat hanger in what amounts to a storm of lines by drawing the background lines in every direction *but* those of the coat hanger. The lines of the background function collectively as a toned texture but are not merely scribbled in an arbitrary way. These tonal and textural variations alternately suggest deep and shallow space and, by their energetic calligraphy, animate what is, after all, an area devoid of form. Only the coat hanger interrupts this enigmatic field, and, by its very ordinariness, seems to hover like a strange bird in strange foliage. Here, lines are busily en-

Figure 9.35
JASPER JOHNS
Coat Hanger I (1960)
Lithograph. 25¼ × 21 in.
Collection of Lois B. Torf

gaged at both the depictive and dynamic levels in a way that calls equal attention to the subject and the life of the marks.

Picasso's *Three Female Nudes Dancing* (Figure 9.36) shows an interesting example of the "dual life" that the element of line is capable of. By drawing these figures in unconnected, rhythmic lines, Picasso calls our attention to an abstract harmony among the lines that is almost independent of their depictive relation. Despite being unconnected, the lines still suggest volume. But the shapes and planes that build these volumes are hinted at rather than plainly declared, while the dynamic character of the lines is plainly de-

clared instead of hinted at. This is not to suggest that these two conditions of the lines are weakly presented or confused, but rather that Picasso's plan requires such teasing suggestions and that, in fact, these two themes are engagingly interdependent. There is the *exact* degree of volume present to convey Picasso's linear motive: the simultaneous life of a line as an edge in space and as a line on paper. This idea is supported by the function of the paper's surface which, as in Sheeler's drawings, occupies several depth levels at the same time that it continues to exist as picture-plane. This dual impression of the second and third dimension (and of figural and abstract

270

Figure 9.36
PABLO PICASSO (1881–1974)
Three Female Nudes Dancing
Pen and ink. 13⅞ × 10⅜ in.
Copyright SPADEM 1972 by French Reproduction Rights, Inc.

states of order) is further enhanced by the fact that there is not a single enclosed shape in the drawing. Just as we begin to sense several "shapes" forming masses, the openings between the lines remind us that we are looking at ink lines on a flat, bounded surface. But the moment we register that fact, the lines begin to make shapes, planes, and forms again. In this way Picasso creates a tensional life between the lines that merely descriptive lines cannot produce.

In the drawing by Wen Cheng-Ming, *Cypress and Rock* (Figure 9.37), we can read all the drawing's elements of line, shape, value, and texture as both flat occupants on the picture-plane *and* as forms in space. Here, there is no mark that fails to depict, act, and interact. The theme is an explosive eruption that spreads out from the center of the configuration's base. Note the clarity of the negative white shapes, and the strong rhythms activating every part of the drawing. The artist places the main thrust of the forms

to the left of the page, countering the configuration's location on the right.

A similar strategy is used by Degas in his drawing *Three Dancers* (Figure 9.38). Located in the lower right, the figures are balanced on the page by their united, powerful thrust to the left. The visual and the physical weight of the dancer in the foreground, and the direction of the bench she is seated on, act as additional counterbalancing factors. Note that the other two dancers "run off" the page. This snapshot treatment has the effect of making us more aware of their shape-state than we might otherwise be. And Degas uses shape to reinforce our sense of the second dimension. His emphasis on heavy contours intensifies their shape-state and the force of their leftward movement. This repeated use of heavy lines also serves as a unifying rhythm. Note how all the limbs stand out—a pattern of arcs moving to the left.

Schiele's *Portrait of Marie Schiele* (Figure 9.39) is a daring fusion of figural and abstract meanings. To call forward the harmonious play of the planes, patterns, and rhythms of the forms shown, the artist simply omits the torso. In doing so, he amplifies the abstract actions among the elements. And these shapes, lines, textures, and tones, in their animated and tactile properties and in their collective encircling action, reveal the artist's sympathetic feelings for the sitter, his mother. "Tender" and "tough" lines and tones become the graphic equivalents to the hard and soft surfaces in the subject, and serpentine lines suggest sensual undertones. Schiele, in finding engaging, graphic solutions to these form-revealing lines and tones, not only reinforces his representational message, but invents a fresh and provocative "treat" of visual themes and variations that has esthetic worth in its own right.

In Diebenkorn's drawing of a reclining figure (Figure 9.40) value shapes are the main elements in establishing the forms and the design. Again, we are made aware of the multiple activities of the elements, and of their bold, two-dimensional life. The sense of volume is sometimes strikingly convincing, especially in the figure, by a great economy of means and without any lessening of vigorous dynamic actions among the elements. In the figure's upper body the lines, values, and shapes defining the forms of the head, shoulder, and breasts also enact a handsome abstract event that strongly supports

Figure 9.37
WEN CHÊNG-MING (1470–1559)
Old Cypress and Rock (Ku-pot'u) (1550)
Handscroll, ink on paper. 19¼ × 10¼ in.
Nelson–Atkins Museum of Art, Kansas City, Mo.
(Nelson Fund)

Figure 9.38
EDGAR DEGAS (1834–1917)
Three Dancers (c. 1889)
Charcoal and pastel. 23¹³⁄₁₆ × 18⅛ in.
Courtesy, Museum of Fine Arts, Boston
Bequest of John T. Spaulding

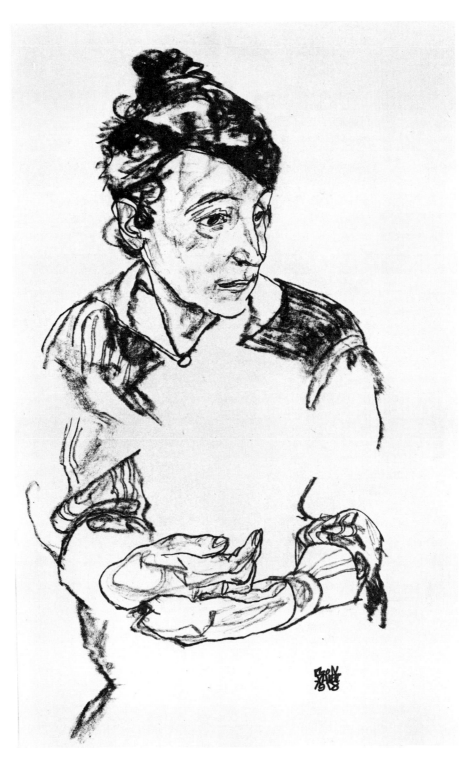

Figure 9.39
EGON SCHIELE (1890–1918)
Portrait of Marie Schiele
Black chalk.
Albertina Museum, Vienna

Figure 9.40
RICHARD DIEBENKORN (1922–)
Untitled (1962[?])
Ink and wash on paper. 17 × 12⅜ in.
San Francisco Museum of Modern Art, Purchase

274

figural meanings. The large white diamond shape of the light portions of the figure, in contrasting with the large black rectangle in the upper right area of the drawing, poses a seemingly irreconcilable difference. But these contrasting shapes are related by their scale, their participation in directional forces forming a large X that extends from corner to corner on the page, and even by their polarity in an otherwise textured and largely gray field of smaller shapes. Then, too, their differences are overcome by their respective visual weight function in the design. Neither is stabilized on the picture-plane without the other's counterbalancing action. They are also, and importantly, related in their representational function, each clarifying the other's position in the spatial field of the room. Finally, these two shapes relate by a sameness in their handling, and by black and white shape "envoys" that encircle each of these large segments. And, by appearing elsewhere in the design, these small tonal "shards" weave all the other elements together. As in all good designs, the arrangement of the elements here is *necessary*, not haphazard.

This necessary solution is evident again in Figure 9.41, where a balanced composition of value shapes is the primary design strategy. And, while Loring's realistic treatment of a seated figure (Figure 9.42) is in sharp contrast to Figures 9.40 and 9.41, here, too, equilibrium and unity emerge from the tonal order among the shapes. Notice, though, that Loring uses representational textures to vary *and* unify the design, as when he echoes the stripes of the blouse and the tiny organic glyphs on the wall by similar textures in both maps on the wall.

A survey of the drawings in this book will show that the elements of every one exist on the several levels discussed. The two- and three-dimensional design of each is not the result of chance. Each tries to contain and resolve the energies within it, and in each, representational and dynamic meanings reveal an interworking accord that makes them come alive.

The following exercise consists of brief suggestions for challenging your sense of balance and unity through the way you use the elements' ability to depict, act, and interact.

exercise 9B

MATERIALS: Graphite pencil, black chalk, brush and ink; bond, tracing, and watercolor papers.

Figure 9.41 (*student drawing*)
Steve Sasser, Portland State University
Oil wash/pencil, 18 × 24 in.

SUBJECT: Described in exercises.

PROCEDURE:

drawing 1 Using any medium and paper, and selecting any subject, make a drawing that is contained well within the limits of the page, as in Figures 9.16 through 9.23. Begin by making a light gesture drawing that emphasizes the subject's main directional and rhythmic forces. Seeing these actions, decide on a design strategy that will utilize them. At least some of what you have extracted from the subject's actions and forms already represents a kind of subconscious design strategy. You have stressed certain relationships that other artists drawing the same view might not stress. They might find other systems of directional and rhythmic associations that reflect *their* interpretation of the subject's arrangement. But seeing what energies have emerged from *your* responses to the subject, decide how they might best function as a major theme for your subsequent interpretation of the subject's forms and the drawing's balance and unity. As you draw, think about the role of the encircling space of the picture-plane. How far can the configuration spread on the page before its forces are too strong to be contained by the outer regions of the surface? Is there too much space? Does the image merely float on the page, leaving its empty areas unengaged? Are the shapes of the picture-plane actually part of your draw-

Figure 9.42
WILFRED LORING
Portrait of Pam T. (1980)
Aquatint. 24 × 16 in.
Courtesy of the artist

ing's design? Does the image seem too heavy on one side, or seem to form a large, unanswered diagonal "supershape" on the page? In this drawing (and in those that follow) try to utilize the various kinds of relationships discussed earlier. It may be that a particular segment of your drawing requires a contrast (or sameness) of handling, scale, value, or visual weight to make it compatible with the rest of the design, or to have it strengthen or subdue another part of the design.

drawing 2 Select one of your directional analyses from Exercise 9A (or make another from one of the drawings in this book). Using the analysis as the basis for your design strategy, arrange a still life that re-enacts the same general directional actions. For example, in Rembrandt's drawing (Figure 9.16) the explosive spread of its directed energies and its second

directional theme discussed earlier should guide your placement of the components of the still life. Your completed drawing should suggest the same directional actions as those of the original drawing's design. Where possible, use the same medium, and even try to approach a similar handling of the materials.

drawing 3 Using tracing paper, carefully trace the major linear and tonal aspects of the Toulouse-Lautrec drawing *Equestrienne* (Figure 9.43). Turning your paper over, you will notice the reverse drawing is no longer balanced on the page. The drawing now seems to rush down toward the lower right corner. Taking any liberties you wish, make any necessary changes, additions, or deletions that you feel will balance the drawing and maintain its unity. If you wish, transfer the reversed view to a more durable paper before you begin to rework it.

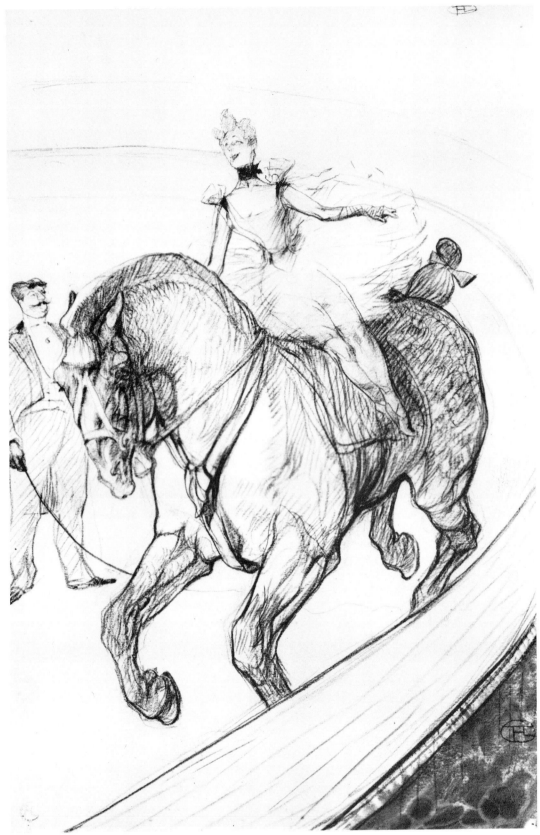

Figure 9.43
HENRI DE TOULOUSE-LAUTREC (1864–1901)
Equestrienne (1899)
Crayon, wash. 19¼ × 12⅜ in.
Museum of Art, Rhode Island School of Design.
Gift of Mrs. Murray S. Danforth

drawing 4 Arrange any subject in a way that you feel suggests an interesting design plan for a *horizontal* format. The drawing should fill the page, as in Figures 5.15 and 9.33. Intentionally place a heavy object where it will appear in the drawing's lower right side, then counterbalance it by any combination of the basic types of relationships discussed earlier.

drawing 5 Without changing the subject or your view of the subject used in the previous drawing, draw it again to make an equally good design in a *vertical* format. Now you may need to increase or decrease the scale of the image on your page to help you develop a workable composition. Again, the physically heavy part should be located in the troublesome lower right.

drawing 6 Using line only, make a drawing that is just as active two-dimensionally as it is three-dimensionally, as in Figure 9.36.

drawing 7 Using black chalk, make a drawing in which line, tone, and texture are as active two-dimensionally as they are three-dimensionally, as in Figure 9.39.

drawing 8 Using only brush and ink (thinned with water as necessary), make a tonal drawing that is as active two-dimensionally as it is three-dimensionally, as in Figures 9.40 and 9.41.

drawing 9 Using Figure 9.30 as a rough guide, arrange a drape in any way that suggests an interesting play of directions, rhythms, shapes, and values. Working large (perhaps 24 × 30 inches or so), make a bold, twenty-minute drawing that stresses both the drape's structure and those dynamic energies that suggest the drape's limp weight, as well as its resolution on the page.

drawing 10 Select any drawing in this book that has a vertical format and, taking any liberties you wish with its forms, make a drawing that redesigns the image to work in a horizontal format. You can, of course, redesign a horizontal drawing to work in a vertical format.

In this examination of visual issues we saw that each mark adds a unit of energy to the drawing's depictive and dynamic meanings, and that the resulting configuration's design is dependent in part on the dimensions of the page. To disregard these fundamental *given* conditions of drawing prevents our seeing the means by which an image's order and unity are achieved and its representational content is clarified and strengthened. But self-consciously planning the visual behavior of each mark is, as was noted earlier, impossible. Both judgments and feelings must negotiate the drawing's final form. The exploration of force-producing relationships can extend our responsive options in developing this final form. A drawing's visual resolution as a system of expressive order is as much the result of subconscious knowledge and need as of intentional strategy. A study of the visual means that can stimulate such knowledge, need, and strategy informs both our intellect and our intuition.

To broaden the options of both is essential, because our responses to the relational life of the elements on the page involve the same kind of comprehension that determines our responses to the subject. Increasing sensitivity to drawings as design systems adds to our perceptual skills and interests. It also adds to the expressive range of those intangibles of temperament and idiosyncrasy that meet the last requirement of a good drawing: the sense of a genuinely personal—and thus a genuinely original—view of what it is about a subject that makes us want to draw it.

10

EXPRESSIVE ISSUES

the forming of meaning

A DEFINITION

A common thread through the previous chapters is the view that responsive drawings are formed as much by intuition and feeling as by intellectual motive and analysis. We *need* as much as *want* to draw in a certain way. And even our conscious intentions, our desire to make certain visual inquiries and order systems, are themselves shaped in no small part by intuitive knowing and subconscious need.

We might then further define responsive drawing as the *personal* ordering of perceptions. *What* and *how well* we draw are determined by the nature of our responses to both the visual and emotive conditions in the subject *and* in the emerging drawing, and by the character of our temperamental and creative attitudes and concepts. For some artists these concepts may be concerned mainly with visual considerations; for others, with expressive ones. But our *total* in-

terest in a subject is always concerned, to some degree, with both. Some concepts affect the way we see the subject. Other concepts are influenced by the subject's effect on *them*. Still others affect, and are in turn affected by, the changing states of the emerging drawing. Hence we bring certain perceptual and personal concepts to, and gain others from, each drawing. In responsive drawing, perception and conception are interdependent and mutually supporting considerations, and consequently so are the design and expressive aspects of the resulting works.

As was noted in Chapter 9, to separate the deeply interrelated issues of organization and expression risks the mistaken impression that they are independent, whereas in fact every mark added to a drawing adds to its expression as well as to its design. In the previous chapter our attention focused on the ways elements and

279

relational energies shape and animate drawings. Here we will explore how elements and energies convey feelings and moods. But we should bear in mind that the same relational forces that express also organize.

Like the predominantly expressive lines examined in Chapter 3, *all* the elements can convey predominantly emotive themes—not only by what they depict, but through their inherent nature. That is, they can express at the depictive and dynamic levels simultaneously. Expressively motivated lines, values, shapes, and other elements can be sensual, reserved, aggressive, sportive; they can create relationships with other elements that stress such expressive qualities throughout the drawing. A drawing's expressive character, its emotive theme, like its design strategy, is produced through the relational behavior of the elements, beginning with the very first marks. Therefore, whether an artist tends toward themes that concern order or expression, neither theme can have universal meaning except in the presence of the other; these are fundamentally interworking concepts.

Expression, however, should not be understood as willful or arbitrary emotion. Genuine expressive meanings are not sought out at all, but come as a natural by-product of a genuine empathy with a subject's form and content. Nor must expression be understood only as passion. Expressive qualities can be contemplative, humorous, or serene.

Cézanne's sketch of two heads (Figure 10.1) is concerned primarily with the analysis and organization of volumes through a selective use of planes. Structural interests are dominant. But the search for and the satisfaction in the discovery of structural keys to an economical realization of the subject's volumes is a major source of Cézanne's excitation—and the lines express this. To be sure, the artist's study of his own features and those of his young son is influenced by his unflinching appraisal toward himself and by a more tender attitude toward his child, and the lines express this too. The authority and earnest nature of the lines reveal both the artist's depth of commitment to his visual inquiry *and* his feelings about it.

Guercino's *Head of a Man* (Figure 10.2) is not visually less active than Cézanne's drawing. Indeed, the drawing in the head has something of the same interest in planar construction, but it is

Figure 10.1
PAUL CÉZANNE (1839–1906)
Sketchbook: Self-Portrait and Portrait of the Artist's Son, Chappuis 615(1878–82)
Pencil, stains. 21.7 × 12.4 cm.
Collection of the Art Institute of Chicago. Arthur Heun Fund. Photograph © 1990, The Art Institute of Chicago. All Rights Reserved.

more dramatically forceful. Here the lines and tones endow the man's character with some of their own energetic power. But Guercino's expressive interests are not limited to psychological or humanistic matters. He calls our attention to the similarities of the curvasive actions of the collar and hair by a bold calligraphy that organizes as it expresses, and even continues such lines into the background. The cumulative energy of so many swirling lines cannot be read with

Figure 10.2
GUERCINO (1591–1666)
Head of a Man
Pen and brown ink, washed, on paper. 13.7 × 15.2 cm.
The Metropolitan Museum of Art, Harris Brisbane Dick Fund,
1938.

the calm that is possible in viewing the Cézanne drawing. Guercino succeeds in conveying his felt impressions of the subject, but he is equally successful in creating a field of strong visual and expressive energies. The man *and* the marks that depict him both express strength, authority, and intensity. The drawing's design supports its expressive theme.

Again, in Kollwitz's drawing (Figure 10.3), dynamic energies reinforce expressive (and organizational) matters. The artist's first drawing of the woman's head (upper left) is a more objective recording of what she saw. It may even be a more faithful likeness than the larger version, but it lacks the latter's assertive modeling and emotional impact. Perhaps Kollwitz also decided that the first drawing did not express her feelings fully, for the second one is a far more powerful evocation of a weighty head surrendered to ex-

haustion. The bolder value changes, the more ruggedly carved planes, and the sensitivity to gravitational pull all help to make it so. Organizationally, the diagonal alignment of the two heads, generating a pull toward the lower right corner of the page, is countered by our prior knowledge of which way these heavy forms would move if not supported by the unseen plane that supports them. This is a good example of visual weight and physical weight holding each other in check, as Figure 10.4 illustrates. The second version shows the artist, more driven by her expressive theme, to be more incisive and daring, and even the handling in the larger version reveals this feeling.

For Rembrandt, design and expression are not only inextricably fused considerations—they are almost always equally active properties of each form he draws. His drawing *Young Woman at*

Figure 10.3
KÄTHE KOLLWITZ (1867–1945)
Two Studies of a Woman's Head (c. 1903)
Black chalk. 19 × 24¾ in.
*The Minneapolis Institute of Arts. Gift of
David M. Daniels, 1971*

Figure 10.4

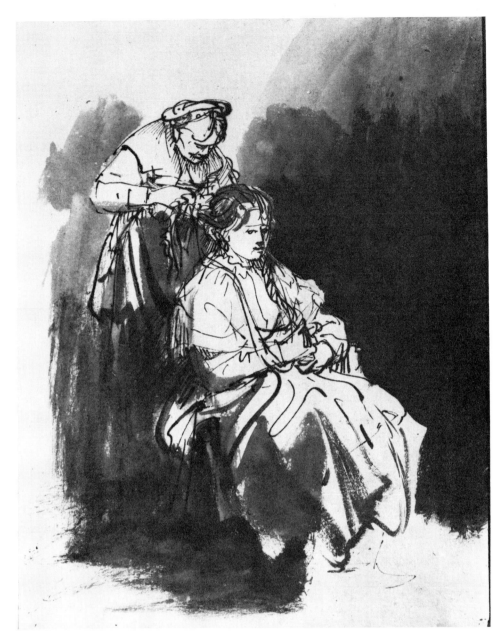

Figure 10.5
REMBRANDT VAN RIJN (1606–1669)
Young Woman at Her Toilet
Pen, ink and wash. 23.8 × 18.4 cm.
Albertina Museum, Vienna

Her Toilet (Figure 10.5) strongly conveys his equal interest in order and empathy.

Visually, the alternating light and dark tones that splash across the page, by their contrasts, movements, and tensions, produce a bold design. The oblique direction of the two figures is countered by the direction of the two large dark masses of tone, subtly repeated in the seated woman's folded arms, in some of the folds in her skirt, and in the sloping shoulders of both figures. Radial energies beginning in the hand of the seated figure seem to give the flower-like shape of her configuration the power to "hold off" the enclosing dark tones. The similarity between the positions of the arms of both women, and the slashing, downward brush strokes at their waists, unify and animate the two figures while, in becoming lost among the dark tones on

the right and in adding visual weight to the left side, they unify and animate the drawing. Note how the light tones, flowing down through both figures toward the lower right corner, enter the foreground and sweep to the left, rising along the left side of the page to begin the cycle of action again. This is not a placid design. Its overall stability is based on barely contained forces of considerable power.

Expressively, the design is no less powerful. The energies creating the visual activities are, of course, themselves expressive forces. But there is another emotive quality that pervades this drawing. An ordinary domestic scene is here transformed by an atmosphere of expectancy. The light does not merely illuminate the women, it dignifies them, giving their forms and actions an indefinable grace and importance. This almost spiritual presence is created as much by the nature and behavior of the elements as by the depictive matter. The sudden shock of value contrasts, the bold sonority of the tonal shapes, the controlled turbulence of the lines, and the sweeping directions result from Rembrandt's intuition and empathy. A largely subconscious need and knowledge led him to believe that such harmonies and contrasts, at play among such forms, could generate just such a transcendental mood.

The interplay between the formal and expressive dynamics of drawing can be seen even in our reliance on expressive terms for describing visual issues (as in Chapter 9, and in our foregoing analyses of Figures 10.3 and 10.5), while expressive themes are conveyed by describing the visual behavior of the elements. To better understand the expressive nature of the elements, let us examine each of them in several moods.

THE ELEMENTS AS AGENTS OF EXPRESSION

Line. Although the expressive use of line has already been discussed, it will be helpful here to see some clearly different expressive states of this key element. In Figure 10.6 the five groups of lines shown, while not representative of its entire expressive range, do demonstrate some general types of expressive line. Group A are slow, earnest, and searching lines. As in Pascin's drawing (Figure 3.15), they are sensual and tactile. Group B are bold, energetic lines. Playful, sensual, or urgent, they are fast-moving, even frenzied, as in Van Gogh's drawing (Figure 3.34) or Guercino's (Figure 10.2). The harsh, slashing lines in Group C are aggressive, even explosive. Sometimes, as in Matisse's drawing (Figure 4.27), their thickness and the density of their clashing assaults on each other form tones. Group D are gentle, caressing lines. Not as slow and precise as Group A, or as animated as Group B, they move gracefully, as in Picasso's drawing (Figure 3.18), or in the late Kamakura Period drawing (Figure 8.21). Group E are relatively mechanical and businesslike, but suggest certainty. They can be cold, as in Sheeler (Figure 9.31), be delicate, as in Saenredam (Figure 5.9), or show a surprising energy and warmth, as in Papo and Goodman (Figures 3.8 and 3.29).

But few drawings are restricted to only one kind of expressing line. As was noted in Chapter 3, a line begun in one emotive mode can end in another. For example, note the differing kinds of line in Figure 10.5, and those that change character as they move. Of course, any kind of line can be used to enhance expressive meanings. Depending on the context in which a line occurs,

Figure 10.6

A B C D E

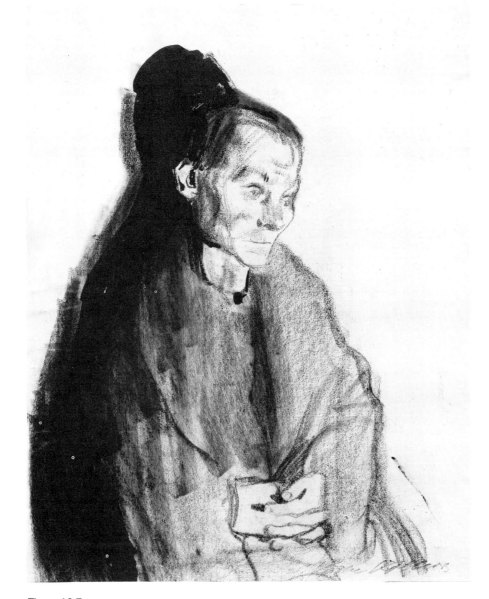

Figure 10.7
KÄTHE KOLLWITZ (1867–1945)
Woman Seated with Folded Hands
Charcoal touched with India ink. 24½ × 18¾ in.
*Courtesy, Museum of Fine Arts, Boston. Helen and Alice
Colburn Fund*

even a short, straight line can evoke powerful expressive meaning. In another Kollwitz drawing *Woman Seated with Folded Hands* (Figure 10.7), the slight, short charcoal stroke depicting the woman's mouth more eloquently reveals the woman's purse-lipped, introspective mood than any extensive rendering of the lips could. The "knife-slit" nature of the line intensifies the art-

ist's expressive intent. It not only depicts the gesture, it enacts it.

The Kollwitz drawing also conveys its mood through shapes and values that evoke feelings. The black cast shadow that "overshadows" the rest of the drawing is not large, dark, and unfocused by chance. Its dominance in the drawing is expressively necessary. Kollwitz seems to

suggest it as a symbol of tragedy. Our universal apprehension of dark, unknown, ghost-like shapes and forms is awakened by the shadow. Kollwitz blurs its sharply defined and blackest segment with an outer dark tone, further suggesting an apparition-like presence in shadow. The woman's right shoulder, almost lost in shadow, seems to be caressed by the broad strokes of dark tones that fuse the woman to the cast shadow. All of the drawing's shapes, and the lines that define their edges, flow toward the shadow as if attracted to it by some force. Only the folded hands, their stark whiteness contrasting with the shadow, seem free of this attraction. This directed movement, whether supplied by the artist's intellect or intuition, seems necessary to the drawing's expressive meaning. To adapt an old saying: "Expressive need (like love) finds a way."

In this drawing the relational energies of the elements, their differences of scale, weight, and location, and their various directional, rhythmic, and tensional forces are in strong alliance with the artist's expressive goal. Directions and moving rhythms leading from all parts of the figure to the cast shadow's "head" amplify the opposing direction of the woman's gaze—a countering action as necessary to the drawing's design as to its mood. The sense of the woman's fragility, relative to the massive dark shadow, adds strength to the emotive force of both, while the ambiguity and tension in the fusing of their forms are equally necessary to the drawing's order and emotive tenor.

Shape. Like line, shapes conform to general types. In Chapter 2, we saw that all shapes can be finally grouped into two basic categories: geometric and organic. These categories are too general in discussing expressive uses, however. Figure 10.8 shows five groupings that typify some frequently used shapes. Those of Group A are stately; when oriented on vertical and horizontal axes they are stable shapes that suggest a dignified or calm air, as in Seurat's drawing (Figure 4.28). In Group B the shapes are active, agitated, and rather complex. Their action is strongly directional, but it is largely contained within the animated behavior of the shape itself. Rembrandt's and Guardi's drawings (Figures 4.15 and 9.27) show the intense activity of this type. The shapes of Group C are rhythmic and sensual in their movements. They may suggest fast motion, as in Renoir's drawing (Figure 2.32), or, when more convoluted, slow movement, as in Schiele's drawing (Figure 9.28). The angular, jagged shapes of Group D are active, even explosively so, as in Schiele's drawing (Figure 3.16), or Wen Cheng-Ming's drawing (Figure 9.37). Group E are relatively stable shapes and suggest slow or weak movement. They have a rather firm, dependable feel, as conveyed in Holbein's and Picasso's drawings (Figures 8.6 and 8.13).

As in the case of line, all shapes are emotive, including those that combine different type characteristics. In Seligman's drawing *Caterpillar* (Figure 10.9), undulating and angular shapes struggle and resist each other but are united by the design's rhythmic strength. The absence of sudden or extreme value changes and the precise, restrained handling suggest a quiet contest rather than a dramatic struggle. As this example indicates, some of a drawing's expressive character is revealed by the nature of the shapes, and some by their collective behavior.

Figure 10.8

We should recognize that shapes, or any of the other elements, may complement or conflict with a drawing's representational dynamics—the action and character of its identifiable forms. Where the things depicted are to be understood as stilled, as, for example, in a drawing of a sleeping figure, the presence of many shapes such as those in Groups B, C, or D of Figure 10.8 would

work against the sense of stationary forms. Those in Groups A and E would tend to support such a stable and arrested state of motion.

The four arrangements in Figure 10.10 show some of the limitless possibilities for shapes' expressive activity. Those in A move toward a common point in the design, as in the Kollwitz drawing (Figure 10.7). In B, the upper,

Figure 10.9
KURT SELIGMAN (1900–1962)
Caterpillar
Varnish, black crayon and wash on white paper.
28 × 22 in.
*Courtesy of Fogg Art Museum, Harvard University,
Cambridge, Mass. Bequest of Meta and Paul J. Sachs*

A B C D

Figure 10.10

Figure 10.11
MEL STRAWN
Rodent Skull
Charcoal. 18 × 24 in.
Courtesy of the artist

Figure 10.12
EDVARD MUNCH (1863–1944)
Self-Portrait with a Cigarette
Lithograph. 22⅛ × 18 in.
The Dial Collection

active shape appears about to attack the placid one below, while the shapes in C seem to strain toward each other, as in Strawn's forceful drawing (Figure 10.11). Notice the sense of tension at the point of impending contact in these arrangements. In B and C there is also tension between the shapes themselves. We experience a back-and-forth recognition of each shape's situation. The shapes in D unite in a circular movement around the page. Shapes engaged in such rotating actions can generate strong emotive energies, as in Ingres' drawing (Figure 9.30) or in Munch's lithograph (Figure 10.12).

Volume. The expressive nature of volumes is revealed by their weight and scale, as Figure 10.3 suggests; by their physical characteristics, which, like those of line or shape, range from the passive and stilled to the aggressive and active;

Figure 10.13

and by the nature of their interaction with other volumes. In Figure 10.13, the types of volumes in A (and the shape-state of the planes that form them) combine in a balanced arrangement of great stability. In B the same volumes, rearranged, create tensions and instability. Masses possessing complex contours, such as those in Leonardo da Vinci's drawing (Figure 3.5), seem more animated and intense than those with

289

Figure 10.14
FRANCISCO DE GOYA (1746–1828)
Peasant Carrying Woman
Sepia wash. 20.5 × 14.3 cm.
Courtesy of The Hispanic Society of America, New York

more simple contours, such as those in Picasso (Figure 8.8), or Goya (Figure 10.14). Like the volumes in the Picasso, gently rounded forms, especially when they are simple and delicately modeled, can express gentleness or quietude. When more angular in nature, and especially when harshly carved, they suggest more aggressive states.

The volumes in Lebrun's drawing *Kneeling and Standing Figures* (Figure 10.15) behave somewhat like those in Groups A and B of Figure 10.13. Compare the relative stability of the figure

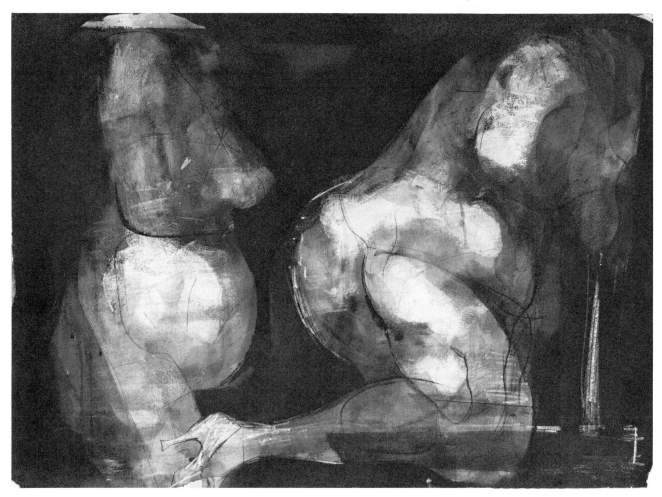

Figure 10.15
RICO LEBRUN (1900–1964)
Kneeling and Standing Figures
Brush and ink. 27⁹/₁₆ × 39=½ in.
*Philadelphia Museum of Art. Given by
Dr. and Mrs. William Wolgin*

on the left with the tumbling forms of the figure on the right. In this provocative drawing, Lebrun uses sharp, slashing lines, brooding tones, slow-moving shapes, and ponderous volumes, each of which contributes to the drawing's haunting atmosphere of both coarse and spiritual forces. But it is the strange floating quality of these heavy forms that is most provocative. This becomes evident if the drawing is turned upside-down. When the volume is less convincing, the drawing's overall mood is somewhat lessened.

Lessening the impression of physical weight and structure can itself be an expressively powerful tactic. In Mazur's drawing, *Study for*

"Closed Ward Number 12" (Figure 10.16), the skeletal-like forms of the figure and the chair are sometimes left open to fuse with other parts of each other and the page, dulling the impression of volume. The resulting angular "shards" of harsh and torn shapes, their clashing directions, and their overall pattern of angularity, as well as the intense light and cruel shadows they produce, suggest at the abstract level the same desolate mood conveyed by the depictive content.

Again, in Polonsky's monoprint *Child with Rat* (Figure 10.17), dulling the subject's structural facts sharpens its expressive tenor. Here, the psychological contrast of a pensive boy nestling a

Figure 10.16
MICHAEL MAZUR (1935–)
Composition study for "Closed Ward Number 12"
(1962)
Brown wash, brush, pen and ink. 15¾ × 19½ in.
Collection, The Museum of Modern Art, New York
Gift of Mrs. Bertram Smith

giant and somewhat agitated rat in his arms is intensified by the artist's gentle treatment of the child's forms and his more urgent handling of the rat. The elements that form the boy all suggest stability and graceful rhythms. In the rat, the elements, especially texture, and the rela-

tional energies, especially those based on directions and physical and visual weights, suggest unrest.

But a volume's weight can be a powerful expressive force. We are not usually conscious of the force of gravitational pull unless we sense its

Figure 10.17
ARTHUR POLONSKY (1925–)
Child with Rat
Monotype. 9 × 12 in.
Courtesy of the artist

Figure 10.18
RENZO VESPIGNANI (1924–)
Hanged Man(1949)
Pen and ink, wash. 15⅞ × 7¼ in.
Collection, The Museum of Modern Art, New York. Purchase

absence, or unless it suggests danger. Vespignani relies on our appreciation of the meaning of its force in his drawing *Hanged Man* (Figure 10.18). The artist does not abuse our sensibilities by emphasizing the victim's agony, or by exaggerating the impression of heavy volume. Here, to our relief, volume is somewhat subdued. The implications of its weight are clear enough. Instead of a sensational description of one man's execution, Vespignani asks us to consider the indignity and tragedy of Man as a thing. Here, the expressive meaning points to Man's universal inhumanity. The victim's isolated, labeled, and broken body is felt as an obscene act, a senseless loss rather than a repellent sight.

Vespignani intentionally keeps the divisions of the page simple. There is even some ambiguity between the second- and third-dimensional state of the background. This has the effect of frustrating our wish to concentrate our attention elsewhere on the page; only the figure provides a visually logical and "comfortable" haven (and thus, an additional irony). The absence of a single white tone casts a gloomy pall over the entire scene, its stillness conveyed by the simple, block-like character of the design's large divisions. The most active movement is in the oblique edge of the shadow, pulled away like a curtain. The figure's overall light tone, and the thin dark tones upon and around it, in being both lighter and darker than any other tone in the drawing, further isolate the figure and call our attention to it. Vespignani contrasts the simple purity of the man's forms with the clothing's tangled state and with the harsh, scarred and lettered poster. The awful stillness of the figure is intensified further by this contrasting activity of the lines, shapes, values, and textures upon it.

Texture. Textures, too, carry expressive meanings. The possible kinds of textural activity in drawing are unlimited, but all can be divided into two basic categories: the controlled and sometimes regularly patterned textures; and the more active and usually unregulated ones. The textures in Sheeler's drawing (Figure 9.31) are an example of the regulated kind; the strident texture of the lines and tones of the seventeenth-century Venetian drawing (Figure 4.2) is an example of the loose and active kind. As the textures in these two drawings show, each is consistent with, and contributes to, the emotional tenor of the drawing. But, as we saw in Ves-

pignani's drawing, textures that contrast with a drawing's psychological tone can also provide important expressive meaning.

In Chapter 4, textures were seen to be any kind of discernible grouping or repetition of colors, values, shapes, or volumes, any distinguishing surface characteristics of a form or a spatial area or the nature of the marks that media produce—the rough grain of chalk or crayon, the fused stains of ink washes, and the like, and, as in Figure 4.2, the textures formed by a matrix of

shapes, lines, values, and volumes on the drawn page.

The textural life of volumes can be highly expressive, as in Leonardo da Vinci's drawing of stratified rock (Figure 6.4). The expressive role of a medium's texture can be seen in another da Vinci drawing, *A Storm over a Mountain and a Valley* (Figure 10.19). Here the chalk's rough texture helps to suggest the charged atmosphere. The rugged grain of the chalk's particles envelops the components of this panoramic scene in tones

Figure 10.19
LEONARDO DA VINCI (1452–1519)
A Storm over a Mountain and a Valley
Red chalk. 19.9 × 15 cm.
Royal Collection, Windsor Castle

that unify them and evoke the feel as well as the look of a rainstorm.

Leonardo utilizes the expressive power of textures throughout the drawing in creating its tumultuous mood. He divides the page into four horizontal bands of differing textures. First, the storm clouds' churning turbulence is in marked contrast to the straight lines of the rain that form the second band of texture. Below this, a generalized impression of the distant town is suggested by the short vertical and horizontal lines, by the trees, and by lines describing the letter C at various angles. Finally, the looser, complex texture formed by the circular lines, structural hatchings, long and rhythmic curved lines, and small, block-like forms conveys the impression of the rolling hills of the foreground. Except for the texture that represents the town, all are loose and active. The drawing's turbulent mood is emphasized by the top and bottom bands of texture. Both suggest strong curvilinear movements that "bracket" the area of the storm, adding dynamic pressures to meteorological ones.

When a medium's texture is compatible with the textures it describes, emotive force is increased. In Bloom's drawing *Forest #1* (Figure 10.20), the naturally fine lines and small interspaces of dense pen-and-ink hatchings are in accord with the artist's emphasis on the texture of leaves, bark, and branches. The mysterious mood of the forest, enhanced by the stress on its wild, dense web of flora, is further amplified by the dense and vigorous web of the lines themselves. But note that Bloom orders this "disordered" scene. Subtle associations and patterns of large and small, light and dark, simple and complex, and straight and curved segments provide harmonies, contrasts, and movements that unify the image. And, by subtle modifications of some textures, tones, and forms, the artist suggests some barely discernible hints of strange forms hidden among the shadows and branches. These passages add to the sense of the forest's forbidding but enchanting mood.

Value. We have seen value's power as an agent of expression in most of the drawings in this chapter. Values are bolder and more charged with energy when drawn with abrupt changes between them, as in Mazur's drawing (Figure 10.16). They evoke more dramatic or brooding moods when such changes involve large areas of dark tones, as in the Rembrandt and Bloom

drawings (Figures 10.5 and 10.20), or when forms emerge from dark backgrounds, as in Figure 10.15.

Again, in Courbet's *Landscape* (Figure 10.21), intensity of light has dramatic impact. The value variations are gradual, but the framing of a large square of light tones by the darker trees and their cast shadows makes the light on the trees and field within this frame radiate an intense glow.

Just the opposite tonal arrangement is used by Goya in *Al Mercado* (Figure 10.22), but the child's upturned face is made to radiate light by the surrounding dark tones. The virtual absence of moderating gray tones gives this drawing an air of intensity and drama. Here the shapes match the values in boldness, adding to the drawing's sense of expectancy.

The expressive force in the shock of strong value contrasts is seen in Raffael's *Eagle* (Figure 10.23), where the dark, hooked shape of the eagle's head and neck (echoed in the shape of the eagle's upper bill) suggests the animal's power and grace and alludes to its unseen claws. Although the original work shows some washes of color, it is in the dramatic impact of the near-black and white contrast of tones that the drawing gains its main emotive strength. When such extreme value contrasts work to suggest the effects of a light source, then light itself becomes an agent of expression (Figure 10.24). When the impression of illumination is conveyed by gradual tonal changes, such changes can not only suggest volume and space with great clarity, but suggest a mood of introspection and serenity, as in Murch's sensitive study (Figure 10.25).

OTHER FACTORS OF EXPRESSION

The medium always participates in a drawing's expressive character. It does so by its intrinsic traits and by the way it is used. But the same medium can augment many kinds of emotive meaning. In Chapter 7, we saw that the intrinsic characteristics and the limits of most media permit a wide range of use. Still, depending on the expressive theme, some media will be more adaptable to the artist's intentions than others.

The selection of a medium should be based on its congeniality with the intended expressive mode. Lebrun, in his drawing of two figures (Figure 10.15), might have achieved similar re-

Figure 10.20
HYMAN BLOOM (1913–)
Forest #1 (1971)
Pen and ink. 23½ × 18½ in.
Collection of Mrs. Sophie Goldberg

Figure 10.21
GUSTAVE COURBET (1819–1877)
Landscape
Black chalk. 19 × 30.5 cm.
Museum Boymans-van Beuningen, Rotterdam,
the Netherlands

Figure 10.22
FRANCISCO DE GOYA (1746–1828)
Al Mercado
Brush and wash. 20 × 14 cm.
Prado Museum, Madrid

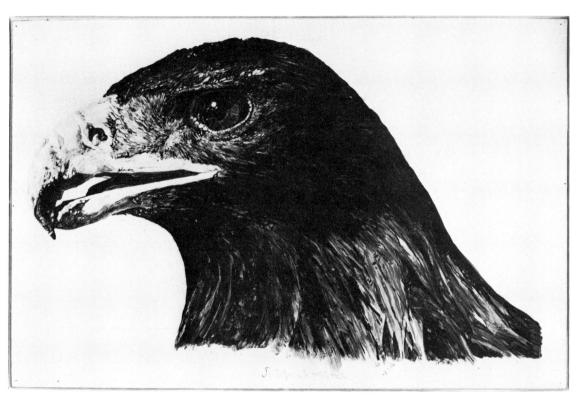

Figure 10.23
JOSEPH RAFFAEL (1933–)
Eagle (1972)
Watercolor over pencil, framed with pencil lines on
white coated poster board. 35.6 × 55.8 cm.
Private collection

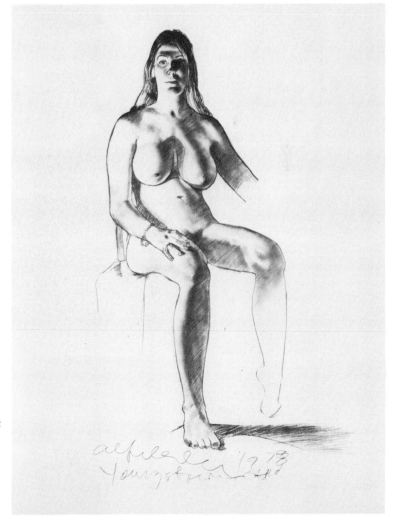

Figure 10.24
ALFRED LESLIE (1927–)
Untitled (1978)
Graphite on paper. 40 × 40 in.
The Arkansas Arts Center Foundation Collection: The Barrett
Hamilton Acquisition Fund, 1982

Figure 10.25
WALTER MURCH
Study for "The Birthday" (1963)
Pencil, wash, and crayon on paper. 23 × 17½ in.
*Collection of Whitney Museum of American Art. Purchase,
with funds from the Neysa McMein Purchase Award*

sults with chalks, but it is obvious why he did not use pen and ink. The quiet delicacy of tone in Figure 10.25 results in part from the use of soft graphite on a moderately grained surface. Here the medium enhances the artist's engrossed study of his subject's forms; the mood is one of quietude. But the same medium, producing similar values and changes, in Mullen's *Study for Sculpture* (Figure 10.26), supports a powerful and threatening image. Unlike Murch's drawing, its angular shapes, sudden value changes, strong directions, and machine-like volumes all suggest aggressive action.

Mullen uses another device to intensify meaning: *distortion*. This term should be understood not only in its dictionary definition—"to twist out of shape or change the appearance of"—but also in its broader sense—any kind of intentional exaggeration of a subject's proportions or properties by addition, deletion, or other changes. To some extent, all responsive drawings can be regarded as distortions of the subjects they depict. Not only because, as we saw in Chapter 5, the transposing of real volume and space into marks on a flat surface makes some distortion unavoidable, but because responsive drawing is a process of selection, of relating, omitting, emphasizing, and otherwise "essaying"—interpreting—the subject's actualities. But the term is generally applied to pronounced changes in a subject's proportions, surfaces, or other physical characteristics, or in its perspective, illumination, or clarity. The figure in Mullen's drawing, or those in Lebrun's, would

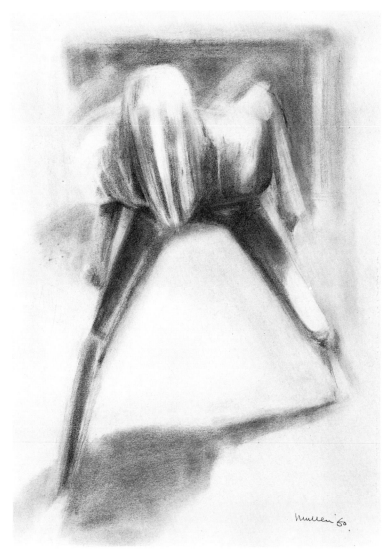

Figure 10.26
MICHAEL MULLEN
Study for Sculpture (1960)
Pencil. 15⅛ × 11⅛ in.
Collection, The Museum of Modern Art, New York
Ethel R. Scull Fund

be regarded as distorted, but the figures in the Rembrandt or Goya drawings (Figures 10.5, 10.14, and 10.22) would not.

Mullen's treatment of the figure's head distorts it into a threatening, mask-like form. The arms and legs are reduced to hard, tubular volumes; hands and feet almost disappear; the torso is reshaped into a heavy "battering ram." Such distortions are, of course, very effective intensifiers of human forms and can all too easily be carried to absurd or even comical degrees. But Mullen's distortions produce forms that are inherently threatening. Because this is so, the drawing continues to convey aggressive action even when it is turned upside-down.

Any of a subject's measurable or emotive aspects can be distorted. In the Mullen drawing, the proportions, perspectives, values, and clarity of human forms are all affected by the artist's expressive themes, but the forms are still volumetrically logical and human-like. This begins to be less the case in Bageris' *Two Seated Figures*

(Figure 10.27). Bageris carries the distortion of human forms to the brink of disintegration. Furious brush strokes lash and wind upon the forms, reshaping them into expressions of convulsive energy. But more than enough survives this highly subjective interpretation to permit us to identify with these two figures, and thus to be caught up in the image's frenzied temper.

A very different kind of distortion occurs in Tchelitchew's drawing *Tree into Hand and Foot with Children* (Figure 10.28). Here, distortions not only add to, they constitute most of, the drawing's expressive message. In this richly imaginative drawing, the "realistic" metamorphosis of a tree into human form is, of course, impossible without resorting to distortions. But the artist does not depend only on figurative content to convey the drawing's ominous tone. The expressive nature of the elements contributes almost as much to its emotive force as do the figurative surprises they produce. This drawing, too, carries its meaning in the inherent nature of the

Figure 10.27
JOHN BAGERIS (1924–)
Two Seated Figures (1960)
Gouache, ink, and graphite. 12 × 18 in.
Collection of the artist

Figure 10.28
PAVEL TCHELITCHEW (1898–1957)
Tree into Hand and Foot (*Study for "Hide and Seek"*)
(1939)
Watercolor and ink. 14 × 9¾ in.
Collection, The Museum of Modern Art, New York
Mrs. Simon Guggenheim Fund

marks, as can be seen by turning the drawing upside-down. Now, even with the figurative clues impeded, the drawing's spidery, brooding mood can be sensed in the elements, in their relational activities, and in the character of the handling.

ADDITIONAL EXAMPLES OF EXPRESSIVE RESPONSE

The possibilities for expression in drawing are unlimited. Not only does every responsive artist tend toward some general personal style of expression, but in each of his or her successful drawings some original variant on the possibilities for expression occurs. The several expressive themes and strategies that follow are offered here as helpful examples from the un-

limited possibilities available to the searching, sensitive artist. Exploring some of the vast possibilities for conveying such meanings encourages a more daring employment of the elements, the medium, and our uncensored impressions.

Sometimes distortions are so well integrated or subtle that we are not always aware of them, but the emotive power of such subtle amplifications can be considered. Manet, in his drawing *A Man on Crutches* (Figure 10.29), only slightly exaggerates the figure's bulk by subtly stressing the balloon-like nature of the sleeves and coat. These rounded forms seem even fuller and more weighty by their contrast with the rather weak-looking and spindly crutches. Manet's emphasis on the figure's bulk gives added meaning to the empty space alongside the figure's right leg. The artist shrewdly guides our attention to this space by using a more or less

Figure 10.29
ÉDOUARD MANET (1832–1883)
A Man on Crutches
Brush, black ink, and tan paper. 10⅝ × 7¾ in.
Metropolitan Museum of Art, Harris Brisbane Dick Fund,
1948. All rights reserved, The Metropolitan Museum of Art

and expressively, they *are*. Closer examination shows that all the forms are only generalized, very free suggestions—pillars do not reach their bases; ledges, stairs, balustrades, and walls wander out of alignment or disappear altogether; shadows start and stop suddenly; the drawing's perspective seems in places to go awry. But this *consistent* instability in the structure of the scene's forms creates an animated, tension-filled air. Guardi, using splashes of tone and a darting, nervous line, adds to this mood by transforming what we know to be hard, architectural forms into vibrating, gestural ones. Spirited "ripples" of energy move among the forms, changing inert structures into almost organic ones. Note how the differing expressive goals affect Manet's and Guardi's use of brush and ink.

In Delacroix's *Forepart of a Lion* (Figure 10.31), the artist's interest in the structured volume of the lion is shared with an appreciation of the animal's self-assured air of power. Delacroix amplifies the lion's physical weight and strength by simplifying and thickening the volumes of the animal's mane and head and by arranging their contours to form a continuous, massive block of volume. The mane is drawn by bold structural lines, most of which are placed more or less vertically, further increasing the sense of heavy mass. To suggest even more weight, the lion's mane is shown as quite dark throughout, and darker still in its lower parts. The feel of great weight is so convincing that we sense the strain on the sturdy legs. Note how the assertive handling of the black crayon echoes the subject's temperament. Note too that Delacroix locates the animal in such a way as to prevent the head's contact with the right side of the page and to permit the legs to fall to the left of the format's vertical center, thereby offsetting the physical weight on the right by visual weight on the left.

The influence of expressive interests upon the treatment of volume is interestingly revealed in comparing Guardi's "softening" of geometric, inert volumes and Delacroix's "hardening" of organic ones. This is clearly evident in Delacroix's block-like treatment of the mane and head, and in the squared-off contour of the lion's face. Guardi's expressive intent would have been stifled by solid, stable forms, but Delacroix's is enhanced by it.

That differing expressive meanings affect an artist's "line of attack" is clearly demonstrated by comparing two Kollwitz drawings. In her

symmetrical pose and view. Because we see two roughly even halves of the figure, two arms, and two crutches, only the missing leg upsets the completion of this simple system of paired forms. Additionally, the figure is located on the page where the missing leg would have occupied the picture-plane's central vertical axis—the most stable and balanced vertical position possible.

In the context of the broad, loose handling of Guardi's *Architectural Capriccio* (Figure 10.30), the highly distorted figures in the drawing's lower left corner, and those on the landing and staircase higher up, seem perfectly "correct,"

Figure 10.30
FRANCESCO GUARDI (1712–1793)
Architectural Capriccio
Brush and wash. 7 × 5⅛ in.
Victoria and Albert Museum, London

Figure 10.31
EUGENE DELACROIX (1798–1863)
Forepart of a Lion
Black crayon. 2.55 × 2.5 cm.
The Art Museum, Princeton University.
Bequest of Dan Fellows Platt

305

Figure 10.32
KÄTHE KOLLWITZ (1867–1945)
Losbruch (*Black Anna*)
Charcoal. 51.3 × 38 cm.
Kunsthalle, Bremen

Losbruch (*Black Anna*) (Figure 10.32), an exploratory sketch of a figure for a group of striking miners, the artist's need to convey the woman's anger and excitement leads her to a use of line not unlike Guardi's in its emphasis on gestural energies. Here, too, shapes and forms are left open, and tones are not restricted to the boundaries established by lines. But in Figure 10.3 the artist's expressive interests concern the limp weight of a weary woman, collapsed in sleep at her table. Now Kollwitz approaches the subject in a manner not unlike Delacroix's treatment. Again, structural lines, block-like masses, and bold, tonal modeling help suggest the artist's emotive theme.

In Daumier's drawing *The Lawyer* (Figure 10.33), shapes and masses are simplified, but not to increase the sense of weighty mass. Here they

cause a steady *lessening* of volume, as we read the drawing from top to bottom. In fact, covering the top half of the drawing shows the remainder quite without any suggestion of structured mass. Instead, the lower half of the image seems to suggest torn, ruffled value shapes. The further up we look, the more volume develops until finally, in the head, structured volume is strongly conveyed.

By making the figure's shoulders and head the most convincingly three-dimensional of the forms, by placing the strongest value contrasts here, and by provocative, somewhat caricatured expression of the face, as well as by the animated quality of the lines and tones that produce it, Daumier fixes our attention on this part of the drawing. The broader, lighter, and flatter char-

acter of the drawing's lower half contributes to the crescendo of attention upon the lawyer's malicious smile and the loose, energetic behavior helps to convey the impression of his movement. Although we do not see his legs, the figure's overall tilt and the "windblown" nature of the shapes and tones suggest that he is walking quickly. Notice that the head, although its structure is more fully developed than that of any other part, is no less vigorously drawn.

As this drawing demonstrates, the commitment to a particular expressive attitude, partly reflected in a drawing's handling, is important. The best drawings always show such a consistent expressive strategy.

Another drawing by Daumier, *The Song* (Figure 10.34), shows a consistency of intent sus-

Figure 10.33
HONORÉ DAUMIER (1808–1879)
The Lawyer
Black chalk, pen and wash. 20.7 × 13.9 cm.
Museum Boymans-van Beuningen, Rotterdam, the Netherlands

tained throughout a more extensively developed work. As in the previous drawing, facial features (and the body of the centrally placed figure) are slightly caricatured. Here, contrasts of value are intensified, creating a strong light that plays across the group, boldly sculpting the forms as it gives them a sense of dramatic importance Daumier deletes all extraneous detail. The clothing and hands of the figures are broadly stated—even the heads are simplified toward the back of each, away from the expressive features of their faces. The background is simply a darkened spatial container for the group. The facial features are developed with a strong interest in the details of careworn folds and wrinkles. Daumier's sym-pathetic treatment of these weathered faces, temporarily enlivened by drink, suggests that the group's impromptu song is as sudden and as temporary as the intense light is to the darkened scene—that the usual state of both is more somber.

Note how the artist combines light and dark tones with clear and vague edges to help guide us to areas of emphasis. Notice also how the thick, rounded character of the forms, whether of a body or a finger, is everywhere the same. Even the volume-summary of the group itself forms a monumental, rounded half-sphere, its curved upper edge conveyed by the arc of the heads.

Figure 10.34
HONORÉ DAUMIER (1808–1879)
The Song
Black chalk, pen and black ink, gray wash, and watercolor. 9⁵⁄₁₆ × 10⁷⁄₁₆ in.
Sterling and Francine Clark Art Institute, Williamstown, Mass.

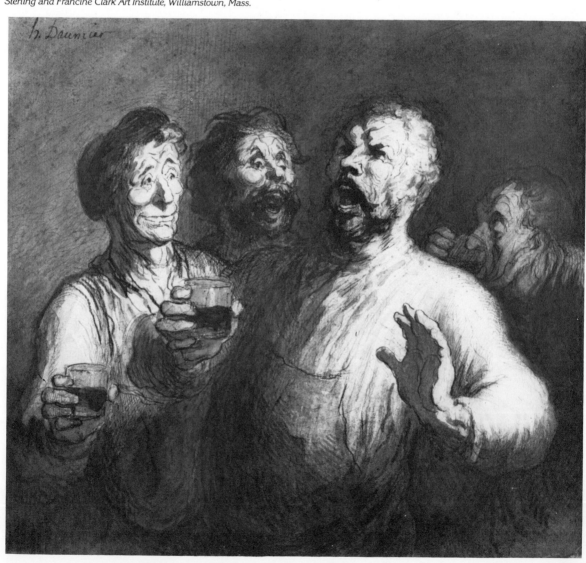

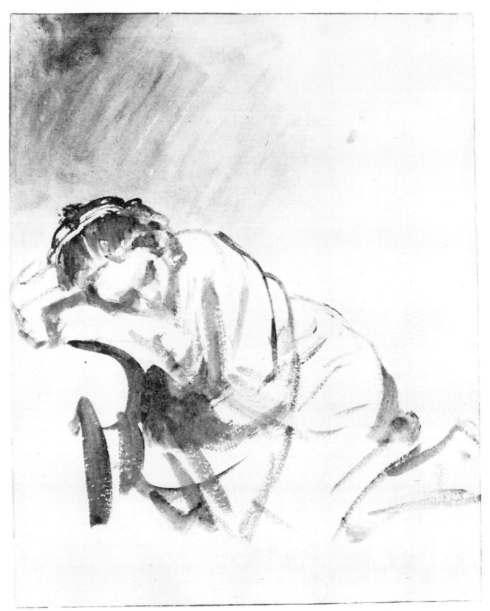

Figure 10.35
REMBRANDT VAN RIJN (1606–1669)
Girl Sleeping
Brush and wash. 24.5 × 20.3 cm.
*Reproduced by courtesy of the Trustees
of The British Museum, London*

Daumier's mastery of facial expressions is evident in these four faces. The lines and tone of each not only model form, they also enact the gestures that animate these faces. Note especially the pulling action of the eyebrows and folds of the forehead of the man on the far right. There is not a line or tone that does not convey the drinking action. The shapes, forms, and directions of the head even suggest the movement of the head backwards. Such eloquently expressed human actions do not emerge merely from patient scrutiny, but from perceptions guided by humanistic interests.

As Daumier's and Leslie's (Figure 10.24) drawings indicate, light can be a strong agent of expression. Rembrandt's mastery of light's emotive force is evident in his brush drawing *Girl Sleeping* (Figure 10.35). Despite the spontaneous and largely linear handling, Rembrandt's profound grasp of structural essentials enables him to suggest planes turned toward and away from a strong light source, falling from the upper left side. The unusual intensity of this light, especially when seen against the retreating dark tone in the upper left corner, suggests a supernatural presence. The brush strokes appear to

309

hover between a linear and tonal role, their spirited abstract energies transforming the girl and her bed into swaying, restless lines and shapes that contradict her passive state. This contrast between her inaction and the driving energy of the elements also suggests that the forms are being acted on by some force.

The influence of felt responses on perception and strategy can be seen by comparing the different expressive moods of three drawings of trees. Figures 4.9, 4.10, and 4.11 show increased states of departure from studious objectivity toward more emotionally conceived images. Still another emotive theme emerges from Grosz's *Trees, Wellfleet, Cape Cod* (Figure 10.36). The rugged forms and tortuous movements of the trunks and branches; the occasional silhouettes, shaded areas, and gray tones of the pine needles and grasses; even the misty tone of the page—all allude to a somber melancholy.

An intensified handling of any approach to drawing intensifies its expressive force. The lines and tones of Grosz's drawing, and the drawing's somber state, when carried further to comment on human emotions, can be powerful indeed, as Baskin's *Tormented Man* (Figure 10.37) indicates.

But recognizable subject matter is not necessary to strong emotive force. Kline's *Untitled* (Figure 10.38) and Lotz's *Illuminated Coils* (Figure 10.39) reveal how keenly these artists feel and reflect the mood of their inner world.

Although in examining these drawings we have been concentrating on expressive factors, it must by now be evident that the artist's organizational and expressive interests are deeply interlaced matters, and that any drawing action generally involves both considerations. However, recognizing the differences between selections and changes based on formal visual issues and those that serve expression helps us to govern and integrate both kinds of response.

The drawing exercises that follow are intended to help you experience the role of the elements, of media, and of distortion in conveying expressive meanings.

exercise 10A

MATERIALS: For drawings 1 through 4: pen, ink, and chalk; no media restrictions on the remaining exercises.

SUBJECT: The human figure, landscape, still life, and imagined images.

PROCEDURE: Genuinely felt responses to a subject cannot often be summoned on demand, and there is no really adequate substitute for such emphatic sensations. The best test of the ability to freely utilize expressive factors must occur in drawings of subjects that strongly engage your feelings. But, here, by aiming pairs of drawings toward clearly opposed expressive goals, you may, if you can enter into the spirit of these differing goals, invest them with some degree of meaning, and begin to experience new attitudes toward the uses of the elements, your media, and the devices of distortion or exaggeration.

There are no time limits on any of the following drawings. Except for the first four drawings, you can use any medium (or combination) you wish, on any suitable supports, of any desired size or shape. Because of a medium's influence on a drawing's emotive nature, it is advisable to vary these, but in each drawing the primary consideration in selecting a medium should be its compatibility with your expressive goal.

drawings 1 and 2 Using a nude or simply clad model as your subject, make two drawings of the same pose, from the same position. In drawing 1, use pen and ink and any suitable paper 10 × 14 inches. Your expressive goal is to depict the model as passive, at rest. Try to convey a sense of tranquility and stillness. Here (and in *all* of the drawings in Exercise 10A), consider an overall design strategy (before you begin to draw) that you feel will stress your meaning. Because expression is conveyed by the elements as well as the character of the forms they produce, think about their use before getting started. A tentative, general plan should of course be based as much as possible on responses to the subject. In all of the drawings from the model, the subject should include at least some of his or her immediate environment. Once you begin, however, do not feel bound by any prior strategy but let any visual or expressive ideas or opportunities suggest a new plan for achieving your expressive goal.

In drawing 2, use black chalk, the softer the better, and any suitable paper, approximately 10 × 24 inches. Now your expressive goal is to depict the model as powerful, aggressive, and active. Again, consider a general approach before you begin.

Having just selected very different qualities from the same view of the same pose, you will have to search for those actualities or potentialities in the pose that will serve this new goal. In this admittedly arbitrary search for clues to support expressive themes that the model may not easily suggest, you can more fully appreciate the many choices possible in the raw material. The more you study the forms and consider what choices and changes would help convey your expressive theme, the more they will appear. It is obviously helpful to pose the model in a way that will

Figure 10.36
GEORGE GROSZ (1893–1959)
Trees, Wellfleet, Cape Cod
Charcoal, ink and watercolor. 19⅝ × 15⅜ in.
The Cleveland Museum of Art. Purchase,
John L. Severance Fund

Figure 10.37
LEONARD BASKIN (1922–)
Tormented Man (1956)
Ink. 39½ × 26-1.2 in.
Collection of Whitney Museum of American Art, New York
Purchase, with funds from the Living Arts Foundation Fund

Figure 10.38
FRANZ KLINE (1910–1962)
Untitled (1960)
Ink on paper. 8½ × 10½ in.
Collection of Whitney Museum of American Art, New York
Purchase, with funds from Mr. and Mrs. Benjamin Weiss

Figure 10.39
STEVEN LOTZ
Illuminated Coils (1974)
White chalk on black paper. 24 × 34 in.
Collection of the author

suggest some possibilities for either of these opposing goals.

Do not, in these first two drawings, rely on bold distortions. Indeed, try to avoid any but the most essential exaggerations, and keep these restricted to minor adjustments. As you begin to *feel* an expressive intent, subtle exaggerations will occur without your awareness. These unbidden changes are at this stage far preferable to any deliberate changes on your part. In general, drastic distortions make subsequent responses to a subject more difficult because the constant subject and the evolving drawing pull farther and farther apart.

drawings 3 and 4 Select a new pose that will again allow some possibilities for the two opposing expressive goals of drawings 1 and 2. This time, exchange media: using chalk, try to make drawing 3 convey gentle passivity; and using pen and ink, try to make drawing 4 convey aggressive power. With this exchange of media, new possibilities and restrictions occur, requiring new strategies and perceptions. Again, distortions should be few and minor.

drawings 5 and 6 Place the model in a new pose that offers some possibilities for depicting it as transfigured into a wraith, or cloud-like form in drawing 5, and into a machine-like form in drawing 6.

In drawing 5, show the model as being almost weightless. You may want to regard the forms as somewhat translucent and ethereal. Here you can either extend this mirage-like image to include the figure's environment, or use the substantiality of the surrounding forms as a contrast to those of the ghost-like figure. In drawing 6, using the same pose, try to regard the model as robot-like. You want to evince the sense of the figure's heavy weight and unyielding rigidity.

In this pair of drawings, distortions can become bolder but should be stimulated by the model's forms and grow from them as exaggerations of observed actualities, rather than being tacked on arbitrarily to the image. For example, in suggesting the model as transformed into a machine, you may logically want to exaggerate the various interlocking unions of the forms (especially at the joints) to suggest machine-like fittings, or simplify forms into more severely "tooled" forms; deciding, however, to add gears and shafts here and there is not invention stimulated by observed potentiality, but rather the influence of prior concepts about what machines should look like.

drawings 7 and 8 Pose the model in a standing position that displays some rhythmic movements. In drawing 7, *subtly* suggest that the forms are made of some soft wax-like material that has just begun to melt. Here, distortions are built into the situation, but

they should be employed with some finesse. Try to feel the pull of gravity straining the softening, projecting or supporting limbs, how they have begun to yield to their own weight, their form beginning to alter. *Make these masses structurally convincing.*

In drawing 8, use the same pose to subtly suggest the figure has begun to be transformed into a tree. Try to believe that this is actually happening, *must* happen; it will help you make inventive changes stimulated by the figures' folds, tendons, and muscles rather than by memory. Be sure that these changes occur gradually. Again, structural clarity, *especially* in the passages where "metamorphosis" is in progress, is important.

drawings 9 and 10 Make both drawings from the same view of the landscape. In drawing 9, convey the scene as forbidding, mysterious, or dangerous. In drawing 10, the same scene should suggest a peaceful, welcoming mood. This time, resist *any* tendencies toward obvious distortions of the proportions, perspective, or contours. That is, try to record the subject's physical forms with a reasonable degree of objectivity. Rely instead on your use of the elements, especially value, and your handling of the media to convey your intent. This will influence the physical state of the forms anyway, but here the selections and changes you make should result from use of line, value, texture, and the other elements to express your meaning, rather than from pronounced additions, deletions, or other drastic changes in the subject's actualities.

drawings 11 and 12 Make two drawings of the same view of a simple still-life arrangement. In drawing 11, suggest a serene and monumental air; in drawing 12, a feeling of turbulence and action. Here, emphasize two-dimensional activities as much as three-dimensional ones. Rely on shapes rather than on extensively modeled forms; and on relational energies such as rhythmic, directional, and tensional ones, rather than on drastic distortions. However, do not hesitate to make whatever deletions, additions, and distortions you feel are necessary to amplify your expressive themes.

drawings 13 and 14 Make two drawings based on different kinds of imagined forms in space. Using Figures 10.38 and 10.39 as rough guides only, think of the title of the first of your drawings as *Great Structures in Vast Space,* and the second as *Movement and Light.*

In this chapter we have emphasized examples by artists who are strongly expressive in order to identify the expressive factors at work. It is really impossible, however, to imagine a drawing without expressive meaning. This may be subconscious and unintentional in some; in others, the desire to express may be held in check to help unselectively duplicate a subject's surfaces. But this restriction is itself expressive of holding back intuitions and feelings that permit the fullest realization of a subject's essential character and mood. Such drawings often reveal the artist's dissatisfaction with the act of drawing itself. In still other drawings, expressive meanings, left unregarded, make their emotive themes confused and contradictory. They reveal an aimlessness of meaning, a wandering of purpose. There are drawings that are largely bravado—bold flourishes that convey little form or feeling—and drawings that are evasive, timid, or uncertain. All these characteristics are expressions of their authors.

All drawings reveal something of the artist as an individual: his or her greatness or smallness of character, wit and resourcefulness, view of what is worthwhile, and philosophy of life. To disregard *the given condition* of expression as part of a drawing's content dissipates forces that could endow our drawings with greater meaning, impact, and life.

11

ENVISIONED IMAGES

improvisations of form and space

A DEFINITION

A sound knowledge of vocabulary is important to communication in any language, and the language of vision is no exception. For this reason the main theme of this book concerns the strengthening of our power to see and respond to the world around us by first learning about, and then organizing, the visual elements in ways that transmit our perceptions and feelings. Also, just as written communications can relate not only to things witnessed but also to things envisioned, so visual communications can tell of encounters with the people, landscapes, and specters of our imagination.

In this chapter we will briefly examine a crucial but often overlooked consideration in the creation of imaginary images, namely, the importance of *insight*. The dictionary defines insight as "the ability to see and understand clearly the inner nature of things, especially by intuition."

Applied to drawing, this means the ability to penetrate analytically and to become involved empathically with the subject. For, in choosing to turn inward for our subjects, we encounter even greater structural and dynamic challenges than when we draw in the presence of our subject.

Unlike the model, landscape, or still life before us—its masses rich in nature's inventive structural variants, bathed by form-revealing light, and yielding to unhurried inquiry—the forms of our imagination are vague and elusive. They shift and change even as we consider them. And because of the demands and opportunities in the emerging work, they continue to change while we draw them. All the more reason, then, to be able to follow their permutations, to be able to seize upon their essential structure and spirit from the shifting and shadowy stage of our imagination.

For beginners contending with the perceptual challenges of drawing the subjects placed before them, it would seem that the greater complexities involved in the realization of imagined or remembered forms are simply beyond their ability. And so they are, if their first attempts are figures, forests, or any other kind of complex form arrangements. Indeed, drawing such subjects from imagination is, for many mature artists, an extremely demanding challenge. But in drawing *simple* forms such as the block, the sphere, and the cone, we "prove" our ability to understand the structural nature of the masses that underlie *all* forms, and we are more likely to recognize their presence, in variously interjoined combinations, as the form-summaries of observed subjects. Once we *can* draw simple form concepts, it becomes readily possible to combine them to produce more complex solids, as in Figure 11.1.

This ability is of the greatest importance for two reasons. First, because we cannot draw a form whose structure we do not understand, the more skill we develop in the invention of forms based on combinations of simple solids, the easier it becomes to decipher, clarify, and even alter the complex forms of our observed subjects. Second, without the structural understanding that

Figure 11.1 (*student drawing*)
Mary-Jo Lane, Art Institute of Boston
Masses in Space
Graphite. 14 × 17 in.

comes from a wide variety of experiences with inventing structurally lucid forms, our ability to create envisioned images is severely restricted. After all, because the forms in our envisioned drawings are *ours,* are products of our past visual experiences, they are necessarily limited to the structural experiences we have had with the forms of our inner as well as outer world. Conceiving forms we have never encountered in our daily lives (at least not in the combinations we may desire) is the stuff that invented images are made of, but we cannot draw those we cannot visually *conceive.*

Nor is the problem in invented imagery one of structure only. For responsive artists it is equally important to "see" the gestural nature of their inner vision and to sense its dynamic conditions. Here again, the artist's stockpile of earlier visual and expressive experiences, gathered from nature's limitless supply, serves as the main resource of engaging dynamic inventions. Forces, like forms, must be experienced.

But to have such experiences in store requires more than functional seeing, more than seeing forms as obstacles to avoid as we move about in space. For example, we are all familiar with a variety of trees, but can we draw one, even one that conforms to no particular species? To have known trees as tall, leafy masses, larger above than below, is clearly not enough information to go on. We may have planted them, decorated or climbed them as children; we may have been scraped, sheltered, or nourished by them. These experiences help us to *know* trees in ways important to our representations, but they do not help us to *draw* trees. However much we may admire their grand scale and color, their changing appearance through the seasons, and their general form characteristics, this is not yet enough information to serve our improvisations of these forms.

To draw a tree from our imagination, we must have analyzed the structural nature of many trees. We need to have explored and measured their masses, studied their surfaces and textures, and noted how their forms are arranged. But we also need to have experienced their dynamic and organic forces. Without deeply felt remembrances of their rhythmic energies, of the "calligraphy" of their branches, of their roots clawing deep into the soil, we cannot call forward a convincing sense of "treeness." It is from the dedicated study of nature's forms and

forces that the responsive artist's fund of structural and dynamic insights is nourished.

To appreciate how these insights can be developed and used, we will examine some invented images. In studying these drawings, notice that the artists consistently apply the same processes and disciplines as for drawings made from observed subjects.

APPLYING GESTURAL INSIGHTS

Many of the drawings of this chapter are preparatory sketches. Artists confronted with major undertakings in another medium have often approached their envisioned subject by making drawings that, in exploring the general state of the intended work's form and content, seize on certain large moving actions, structural traits, and relational patterns from the still indefinite image. A gestural "attack" is one of the most effective means of snaring these vague, visual notions, and for much the same reasons as discussed in Chapter 1. Indeed, the more clouded the image on our "inner screen," the more necessary it is to get at its essence by the penetrating nature of a gestural approach.

Reni does this in his *Allegory of the Dawn, The Aurora* (Figure 11.2). The artist's initial efforts go toward laying hold of the image's overall gestural behavior: a most active whorl of the many lines on the left forming a wedge and converging to a long, diagonal movement to the format's upper right corner. Reni's interest in the plastic actions of the intended work outstrip his concern for its masses. Yet the volume-in-forming contours, the curved hatchings that define the drapery, and the somewhat simplified masses suggest his first choices about the volumes of the intended work. Such a concentration on sheer energy, as an opening probe, makes it far less likely that the resulting image will bog down into a dull cataloging of isolated segments, for its directed actions and rhythms are an integral part of the initial compositional idea.

Guercino's gestural approach in his *Four Figures* (Figure 11.3) takes on the additional consideration of illumination. By doing so, he includes an important influence on the final work's dynamic character. Value, as we have seen, is a potent graphic force. As in Reni's drawing, the primary goal is the establishment of at least the principal characteristics of the actions of his sub-

Figure 11.2
GUIDO RENI (1575–1642)
Allegory of the Dawn, The Aurora
Pen, brush and ink over chalk drawing. 12.5 × 25.7 cm.
Albertina Museum, Vienna

Figure 11.3
GUERCINO (1591–1666)
Four Figures
Pen and brown ink and brown wash. 8 × 10⅜ in.
*Cooper-Hewitt Museum of Design, Smithsonian
Institution, New York*

ject and of the elements themselves. No doubt a painting based on such a broadly stated sketch would find the splashes of tone modified, the volumes more defined, and subtler relational activities developed. But its overall pattern of forms and forces, established at the outset, would, as in the previous example, strongly influence the results. What is of primary interest in both of these drawings is that the artists elect to approach their subject, not by a patient solving of each part's final form, not by a scanning of its principal dynamic properties.

Then, too, sometimes a drawing rich in gestural energies is necessary to the drawing's expressive theme. Such drawings are little more than the artist's gestural "strike" and can very effectively make a narrative point. For example, in Figure 11.4, the animated fervor of the speaker

and the skeptical attitude of his listeners are eloquently conveyed in Gropper's fast sketch. But to effect this, he first had to strip his subject down to its essentials of form arrangement and form character. When Gropper's pen made its first saber-like thrusts, he knew he was after the spirit of a form—its essential structure and (exaggerated) form character. Note that this drawing, effective in its own right, would make a serviceable preliminary sketch for a more fully realized work in another medium.

Too often students drawing an imagined subject will revert to a tedious, piecemeal approach to their subject, "finishing" each segment before moving on to the next—and they may do so long after they would no longer consider drawing an observed subject in that way. This may occur for several reasons. First, there is the

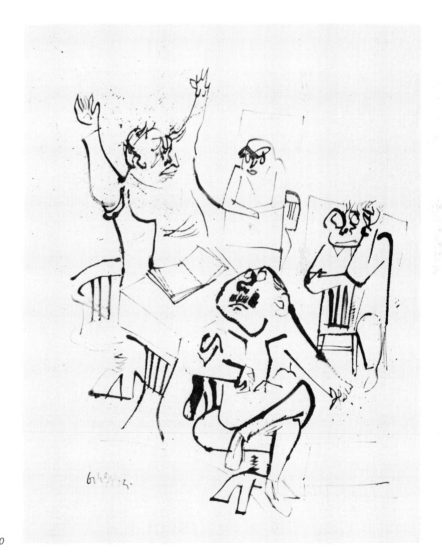

Figure 11.4
WILLIAM GROPPER (1897–1977)
Political Drawing (c. 1930s)
Pen, brush, ink. 22½ × 17½ in.
The Arkansas Arts Center Foundation Collection, 1980

anxiety-producing fact of being responsible for the realization of forms they do not actually see. In the absence of real forms to draw, their attention is divided between first inventing and holding an image steady in the mind's eye, and then trying to react to its salient characteristics. Unable to hold on to the entire subject, they settle for a conscientious description of parts. Unless they do have an adequate store of prior visual experiences with such parts, those they summon up are likely to offer meager graphic fare. Indeed, some of the most gifted artists on occasion show a slight lessening of inventive daring in their envisioned works in comparison to those made in the presence of their subject.

Second, without the forms before them, students fear that their imagined subjects will elude them and feel impelled to pin it down, piece by piece. But the results here are no more likely to succeed than when observed forms are described in sequence.

Third, the student's struggles with the difficulties of form realization make it all the harder to take on the search for unifying relationships and energies. But those given bonds and forces in nature must, of course, be sensed in those subjects he or she invents.

In concentrating on gestural expression at the outset, Reni, Guercino, and Gropper "capture" their imagined image's overall behavior and mood. In this way each establishes an expressive statement that holds the envisioned image alive in the artist's mind and guides both the drawing's order and its emotive force.

APPLYING STRUCTURAL INSIGHTS

As we saw in Chapter 1, a gestural approach naturally leads to more specific structural and dynamic considerations. The artist's emphasis, in gradually shifting from a sensual-schematic exploration of what the forms are doing, to what they look like, also moves from an emphasis on the subject's arrangement and energies, to an emphasis on the planar nature of its surfaces. Most artists form their envisioned images in this general way.

In Poussin's *The Nurture of the Infant Jupiter* (Figure 11.5), the gestural drawing still dominates, but the artist has gone on to establish some general structural judgments and to enlarge upon the drawing's compositional order. In

the drawing on and around the figures and the goat, Poussin begins to establish a few broad planes and shadows and to rework edges, giving substance to these forms and suggesting the space among them. Organizationally, a pattern of undulating rhythms, straight and curved forms, textured and "plain" passages, fast and slow directional movements, and a low, triangular grouping of the forms in the foreground "flesh out" the gestural "skeleton."

Poussin reminds us here that whether we are confronting observed or envisioned subjects, drawing involves both discipline and release. Discipline moderates the animated expression of the forms, especially of the branches and masses of leaves, insisting on structural essentials and a rhythmic rapport among them; release energizes the schematic lines that construct masses and establish tone, giving them the same sense of urgency as the more calligraphic lines.

Invented images rarely exist in the mind fully formed down to the last detail, waiting only to be transferred to the page. Typically, it is not until artists have loosely established the all-embracing but unspecified essentials on the page—generalities assembled from their total structural resources—that they begin to call on their knowledge of the specific forms of the intended image.

As we saw in Chapter 3, structure is a dominant consideration for some artists. It does not surprise us that the drawings of Michelangelo and Cézanne are formed, almost from the start, out of inquiries concerning length, plane, mass, location, and space, for structure plays an important role in their major efforts in other media. For them, gestural considerations accompany a search for their subject's fundamental structural and spatial conditions, rather than the other way around. But that such an approach is often utilized by artists whose works do not stress the constructional interjoining of every plane and form-unit may strike us as unexpected. However, recall that for the responsive artist, even when structural matters do not play a major role in a given work, a sound understanding of the subject's masses is essential to his or her interpretation of them, for whatever creative purpose, as Figures 4.5 and 8.37 indicate. It is at once apparent in these two drawings that, despite their invented and somewhat abstract nature, they show the structural sophistication of the artists. All the more reason, then, when the artist

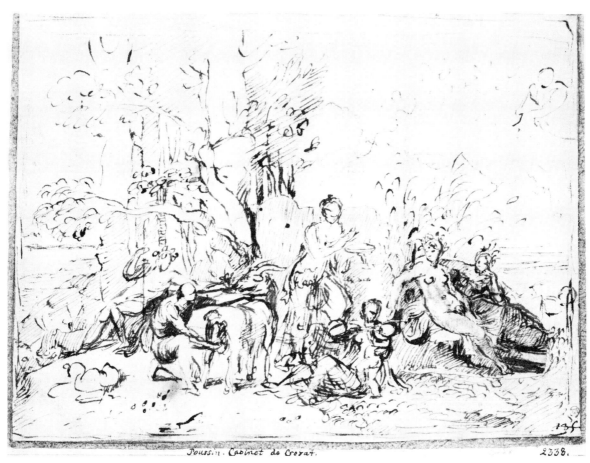

Figure 11.5
NICOLAS POUSSIN (1594–1665)
The Nurture of the Infant Jupiter
Pen and brown ink. 17.4 × 24.1 cm.
Stockholm National Museum
(Statens Konstmuseer)

must invent, interpret, and integrate forms intended as volumes in space, to extract the envisioned subject's salient constructional features.

Raphael does this in his *Two Riders* (Figure 11.6), where gestural and structural interests harmoniously interwork to bring the artist's vision of monumental and fluent forms to the page. The massed lines that define broad, dark planes, and the volume-informing contours, are simultaneously engaged in establishing powerful masses and graceful movements that embody the graphic and temperamental gist of Raphael's invention and intent.

Again, in Figure 11.7, the initial, gestural lines are visible throughout the drawing, where they serve as a kind of scaffold upon which the artist builds the surface forms of an old woman.

Although more than four hundred years separate the Raphael and Bloom drawings—not to mention very different styles and purposes—both artists envision form arrangements and rhythms first, then develop surface planes and contours. The beginner's tendency to start by establishing fixed contours, to be "filled in" later, is thus almost always reversed by master exponents of drawing, who know that contours are the inevitable results of *inner* masses and tensions, and wisely hold off the shaping of forms until they have understood their inner dynamics.

A similar *gesture-to-structure-to-contour* process guides Ricci's drawing *Achilles Gives Hector's Dead Body to Priam* (Figure 11.8). This is not to suggest that in certain passages the order may

Figure 11.6
RAPHAEL (1483–1520)
Two Riders
Red chalk. 28.6 × 20.3 cm.
Albertina Museum, Vienna

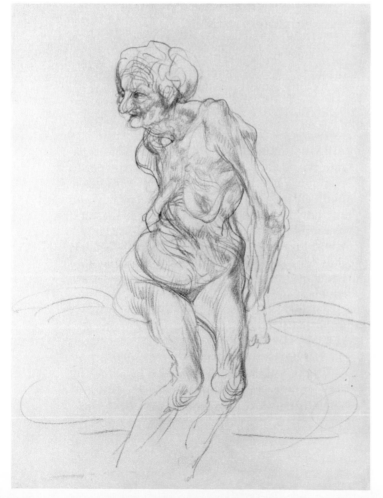

Figure 11.7
HYMAN BLOOM (1913–)
Nude Old Woman (1913)
Brown crayon. 9½ × 7⅞ in.
*Collection of the Grunwald Center for the Graphic Arts,
UCLA, Gift of the Esther Robles Gallery*

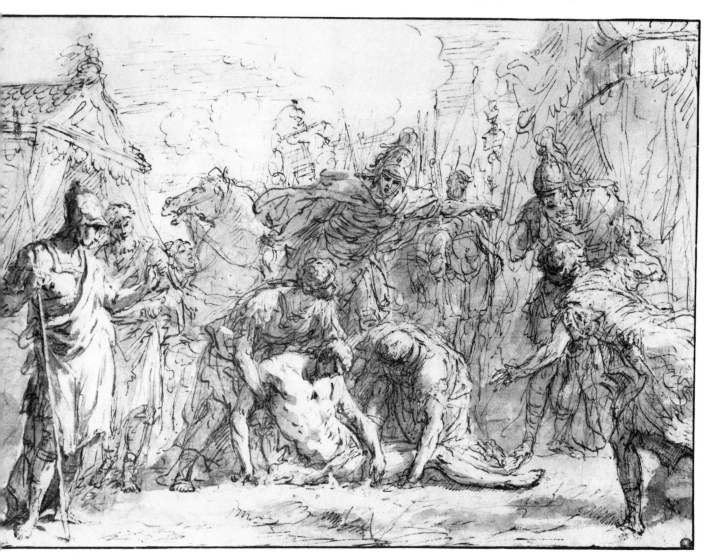

Figure 11.8
SEBASTIANO RICCI (1659–1734)
Achilles Gives Hector's Dead Body to Priam
Pen and bistre ink, heightened with white lead,
on tan paper. 22.4 × 31.1 cm.
Albertina Museum, Vienna

not be altered. But usually, artists hold off draw-
ing final contours until they have a better sense
of the subject's dynamic actions, structural es-
sentials, and figurative conditions. We can, then,
understand the process of many responsive art-
ists as proceeding according to the following
diagram:

$$\text{GESTURE} \rightarrow \text{structure} \nearrow^{\text{dynamic actions}} \searrow_{\text{figurative actions}} \rightarrow \begin{array}{c}\text{final}\\\text{contours}\end{array}$$

And, as has been observed, when the subject is
the indeterminate product of our imagination,
such an approach, in fixing first on a vision's
essential nature, is most suited to its veiled and
elusive character.

A further observation on that point: even in
contour drawings in which a single, deliberate,
and continuous line conveys the image, a form of
this process is at work. In such cases a kind of
"mental gesture drawing" that goes on to take
account of the subject's masses, and its abstract

Figure 11.9
GIOVANNI BATTISTA PIRANESI (1720–1778)
Fantastic Interior
Pen and brown wash over chalk. 4¾ × 7 in.
National Gallery of Canada, Ottawa

and figurative actions, precedes the drawing of the line. The line then records the results of this process, which has gone on in the mind's eye; the line "traces" the mind's contour judgments.

The expressive force of the dynamics that issue from a fascination with structure is amplified when structural relationships exist between massive constructs in a large spatial field. Piranesi, in his *Fantastic Interior* (Figure 11.9), gives his imagination free play to build monumental forms that call to each other across vast spaces. And here, as in the previous examples, analysis and empathy combine to embrace the vision's essential nature, not its details.

That even beginning students, when shown the effects of overlapping, form modeling, and illumination, can devise sophisticated imaginative works is seen in Figure 11.10. Here, a cubist-like abstraction based on the human figure owes much to an understanding of structural factors, developed in part by the study of simple form exercises (Figure 11.1). But Figure 11.10 also

shows a sensitivity to the visual factors discussed in Chapter 9. If our envisioned images are to possess these relational, balancing, and unifying qualities, we need to consider such dynamic matters when we "draw" on our imagination.

APPLYING DYNAMIC INSIGHTS

As Annibale Carracci's page of sketches demonstrates (Figure 11.11), for many artists even the most preliminary exploration of an envisioned theme is conceived of as a system of expressive order. Each of these visual ideas is composed in its own format and considered for its balance and rhythms as well as for its masses and figurative theme. In some, even the basic value distribution is established, and all show the rudiments of relational activities to be developed. For example, in the large, central drawing, Carracci contrasts the shadowed figure in the foreground with the illuminated state of the mother and child, and he

Figure 11.10 (*student drawing*)
Boston University
Vine charcoal. 18 × 24 in.

ous forms, so is his repertoire of organizational and expressive tactics the harvest of earlier involvements with the forces that govern systems of expressive order. That the artist can call to mind the forms necessary to depict these figures is one thing; that he can compose them in a way that has compelling dynamic and humanistic meaning is another.

Rembrandt's envisioned images are among the most moving and original works in the history of drawing. Endowed with profound philosophical and creative insights, his drawings are at once moving human documents and astonishing graphic inventions. More than penetrating structural and organizational solutions are at work in his *The Holy Family in the Carpenter's Workshop* (Figure 11.12). Rembrandt also brings to this image his mastery of light, his ability to make value relationships evoke powerful abstract and psychological events, a skill developed from his many encounters with light's behavior in his portraits and landscapes. Again, we cannot envision what we have not experienced in our responsive involvements with nature.

Rembrandt's pictorial emphasis of Mary and the infant Jesus, unlike Carracci's solution of surrounding the figures with subtly radiating forms, is achieved by the almost blinding light that comes through the window directly above the figures. This light attains a supernatural brilliance, in part because of the room's sonorous shadows that seem strangely unaffected by it. The room's persistent dark tones are expressed by painterly washes of ink that are in accord with the lines' rugged vitality, and they activate areas that other artists might have stated as only dark. Note especially how important the two pulsating, dark tones on either side of the window are to both the design and expression, and how the bold and vibrant reed-pen lines hold up under the drawing's overall dark tones.

But some envisioned images, such as Bresdin's *The Crevasse* (Figure 11.13), are intended as final statements. When this is the case, the earlier gestural drawing, though it is often overlaid by subsequent drawing, is often, as here, visible in places. More important, however, is its influence on the subsequent drawing. Had Bresdin simply begun at one end of the blank page and drawn each part in turn, there would not be the complex relational play between shapes, rhythms, values, and textures, nor the majestic eruptions of form they create. In

reinforces their importance by the radiating nature of the foliage behind them. And, in the group of three seated figures in the lower right, boldly curvasive, S-shaped movements animate and unite the group. Notice, in the several figures only just begun, how Carracci searches first for their gestural character and then turns to the construction of their masses.

Just as Carracci's ability to recall familiar forms and invent others is based on earlier analytical and responsive involvements with vari-

Figure 11.11
ANNIBALE CARRACCI (1560–1609)
Page of Studies
Pen and bistre ink. 20.5 × 27.2 cm.
Rijksmuseum, Amsterdam

imaginary images, where anything may appear, the temptation to create fantastic configurations sometimes leads the unwary into volume formations that are beyond their ability to explain. But intricate volumes in complex interjoinings with others, as occur in Bresdin's drawing, become more manageable when we remember that they are still only unusual juxtapositions of a handful of basic geometric masses.

Lest it appear that anyone drawing invented images is under an obligation to be especially explicit in explaining structure, it should be noted again that drawing is not sculpture and

that the degree of volume-clarity in drawings made from either imagination or observation is determined by the artist. What is important in either case is the artist's *comprehension* of the forms he or she means to draw. Of course, some responsive drawings do contain passages in which volume and space impressions are subdued or intentionally ambiguous.

Indeed, the emotive force in another of Bloom's drawings, *On the Astral Plane: Beelzebub* (Figure 11.14), is intensified by the lessening of form clarity in the drawing's upper half. Rather than try to represent the indescribable evil of the

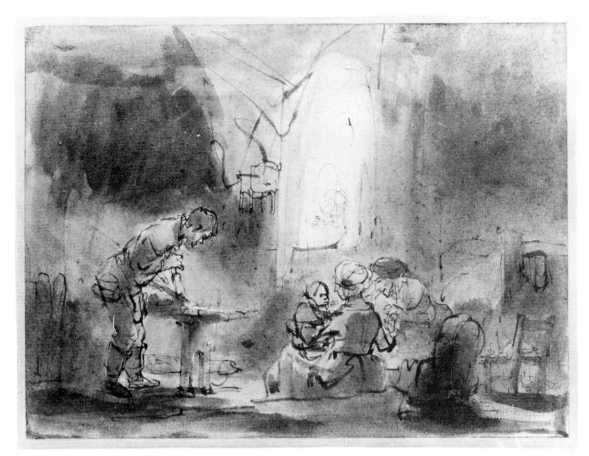

Figure 11.12
REMBRANDT VAN RIJN (1609–1669)
The Holy Family in the Carpenter's Workshop
Pen and bistre ink. 18.4 × 24.6 cm.
Reproduced by courtesy of the Trustees of The British Museum, London

Figure 11.13
RODOLPHE BRESDIN (1822–1885)
The Crevasse (1860)
Pen and black ink. 21.2 × 15.8 cm.
Collection of The Art Institute of Chicago. Gift of the Print and Drawing Club. Photograph © 1990, The Art Institute of Chicago. All Rights Reserved

Figure 11.14
HYMAN BLOOM (1913–)
On the Astral Plane: Beelzebub (1966)
Charcoal. 64 × 36 in.
Courtesy, Terry Dintenfass Gallery, New York

devil-form, and in order more effectively to express its ghoulish activity, the artist holds back in the drawing's upper part, allowing our imaginations to participate. But, where Bloom intends for us to consider the symbolism of his imagery, convincingly structured forms emerge.

But the artist has planned far more than solid volumes in a well-established spatial field. He devises a somewhat symmetrical and even restful design, keeps its forms contained within the format, avoids harsh changes in value or bold directional forces, and envelops the configuration in dark and gently graduated values. In short, Bloom creates a stilled, brooding configuration, against which the strong diagonal thrusts and the sudden light intensity of the two clawing limbs have more expressive impact.

In addition to the intentional structural ambiguities noted earlier, the ones that result from such a dark and muffled configuration, there are other, psychological ones. The artist equivocates between the horrible and the beautiful. The light at the top may be a sunrise or an inferno; the insects crawling over the disembodied heads seem flower-like; and even the creature's limbs, drawn with sympathetic appreciation of their sinewy strength and their rugged structure, seem to both attract and repel us. The more we examine this large, provocative work, the more we find the same profound interworking of structural and dynamic qualities to be seen in the artist's drawings from nature (Figure 10.20).

Again, in Redon's *The Captive Pegasus* (Figure 11.15), large segments of the drawing are not structurally explained. But, where masses come into the strangely selective light, their form shows the results of sound analytical understanding. And, as in the two previous examples, the selection and arrangement of unusual combinations of forms are made to seem more plausible by the artist's conviction in his vision, in its graphic and symbolic worth; and by the knowledgeable construction and ordering of forms that the artist's fund of perceptual insights provides.

The unity of this drawing is especially strong. The shapes, values, and volumes, the overall design scheme, and the emotive tone are all bold and direct. Elements associate and contrast emphatically, moving actions are powerful and balanced, and the drawing's mood is sustained throughout by both the nature of the dynamic actions and the fervor of the artist's handling.

Figure 11.15
ODILON REDON (1840–1916)
The Captive Pegasus (1889)
Lithograph. 13⅜ × 11⅝ in.
Collection, The Museum of Modern Art, New York
Lillie P. Bliss Collection

The subtle dynamic life in Magritte's *The Thought Which Sees* (Figure 11.16) shows an unusual combination of forms and textures in a stilled design based on vertical and horizontal movements. In this way the artist implies a haunting surrealist mood. As this drawing demonstrates, a sound knowledge of what produces mass and space also serves us when we wish to make these matters ambiguous. Like Magritte's drawing, Hentz's *Symbol* (Figure 11.17), a more active design scheme based on diagonal actions, does not show an underdrawing. But, as was noted earlier, even when this is the case, such works don't emerge fullblown. They are evolved by the artist (sometimes by separate preparatory sketches) through some degree of preliminary drawing, if only in the mind's eye. Even spontaneous nonobjective works like Kline's *Untitled*

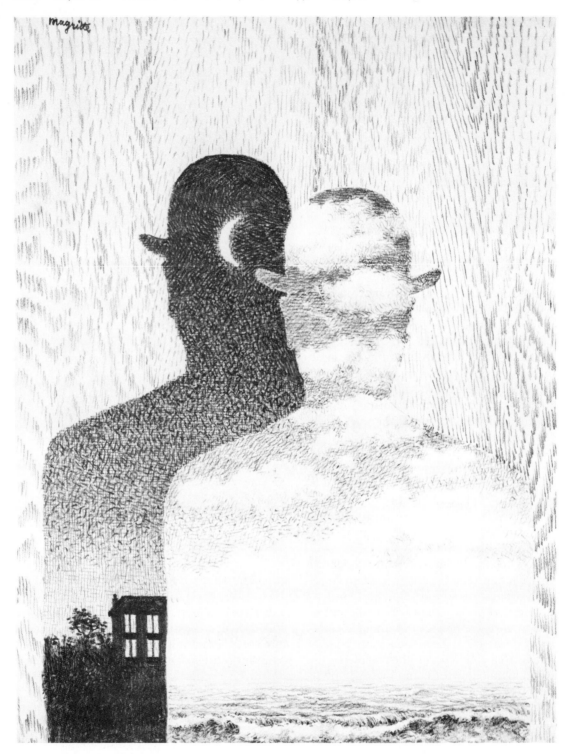

Figure 11.16
RENÉ MAGRITTE (1898–1967)
The Thought Which Sees (1965)
Graphite. 15¾ × 11¾ in.
Collection, The Museum of Modern Art, New York
Gift of Mr. and Mrs. Charles B. Benenson

Figure 11.17
RICHARD HENTZ
Symbol (1970)
Pencil. 22 × 30 in.
The Chrysler Museum, Norfolk, Va.

(Figure 10.38) are the result of numerous attempts to directly organize form and space, and they benefit from the patient study of the world around us.

This chapter does not attempt to be a survey of imaginative drawing. Rather, its purpose is to alert the reader to the need for the same high degree of analytical and empathic involvement that sound, responsive drawing of observed subjects demands. The following exercise is designed to test and guide your ability to call on these structural and dynamic skills in drawing envisioned images.

exercise 11A

MATERIALS: No restrictions except where noted below.

SUBJECT: Imaginary themes.

PROCEDURE:

drawing 1 Using Figures 11.1 and 11.18 as rough guides, and using graphite on a Bristol or vellum paper approximately 14 × 17 inches, draw several complex forms by interjoinings and fusions of simple geometric volumes. Although you will find it useful to select a light source for this tonal drawing, do not feel restricted to it when consistency would leave the structure of certain parts poorly explained. Instead, adopt another light source for such passages. In general, your goal here should be form clarity. A sense of illumination is decidedly a secondary consideration in this drawing.

drawing 2 Using the same materials and attempting the same degree of form clarity, draw a number of everyday objects whose forms you are familiar with and can "see" in your mind's eye. For example, an empty spool of thread, a simple container or cup, an apple, a pencil, and a spoon would make a useful combination of form challenges. Assume these

Figure 11.18

forms to be tumbling about in space. You may draw some of the forms from several views, or overlap them, but do not allow them to run off the page. Because you are interested in a convincing impression of volumes in space, avoid an overconcern with textural effects or other minor surface detail.

drawing 3 Select any two objects that are different in form and function, and have one of them "metamorphose" into the other. For example, have a hand become a tree branch as it approaches the forearm. Or, turn a shoe into a hammer or a horn. The combinations are of course limitless, but again, avoid objects that are overly rich in texture or whose structure you are not certain of. In fact, you might very well make this drawing with the objects now before you, because you will be inventing the transitional passage between the two forms. This area of change from one form into another should be *gradual*, as in Figure 11.19. Now you must decide what changes would occur as one form gradually adapts and gradually flows into

the other. Your goal is to explain, through convincing structural changes, how one object altered its form to become the other.

drawing 4 Using Piranesi's drawing (Figure 11.9) as a rough guide, invent your own fantastic interior.

drawing 5 Select any religious, mythological, or social theme and make three or four brief, preliminary sketches that explore different compositional and structural arrangements. Draw at least one of these in a long, vertical format. Select the one you prefer and, after making further preparatory sketches, working from observed figures, draperies, landscapes, or other subjects as necessary, go on to make an extended drawing in which you may refer to all your preparatory sketches but to nothing else.

drawing 6 Using pen and ink, and with Bresdin's drawing (Figure 11.13) as a rough guide, invent your own fantastic rocky landscape.

Figure 11.19

drawing 7 Using Magritte's drawing (Figure 11.16) as a rough guide, invent your own dreamlike image in which odd juxtapositions of subjects, textures, and space predominate. You may use any medium or combination of media.

drawing 8 Select any reproduction in this book and draw your own version of the scene. Within moderate limits you may add or omit various forms. It is not necessary here to work in the manner of the artist whose drawing you are redesigning, nor is it necessary to make drastic changes from the original. Perhaps taking a slightly different view of the subject is all that you will need to provide you with a new set of relationships and forms. However, you should use similar materials where it is possible to do so.

For some artists (and they include some of the greatest) the process of drawing can begin only with the stimulus provided by an observed subject. For them envisioned subjects hold little interest. Other artists (of equal stature) believe that we cannot draw anything really well until we can create good drawings of at least some of the things we envision. Whichever view we hold, it is clear that the *discipline* of inventing forms can only improve our responses to those we observe. For just as we learn about nature's rich, inventive store of structural and dynamic phenomena by a sensitive study of the world around us, so do we learn about ourselves, our creative strengths, susceptibilities, and needs, when we work from imagination. The best drawings, whether observed or envisioned, come from those artists who know nature and themselves best.

For those of us who find satisfaction and significance in the improvisation of forms and events, the need to understand how nature constructs and orders is essential. Redon had this in mind when he observed, in a letter to a friend, "There is a kind of drawing which the imagination has liberated from any concern with the details of reality in order to allow it to serve freely for the representation of things conceived. . . . No one can deny me the merit of having given the illusion of life to my most unreal creations. My whole originality, therefore, consists in having made improbable beings live humanly according to the laws of the probable, by as far as possible putting the logic of the visible at the service of the invisible."[1]

[1]Quoted in *Artists on Art,* ed. Robert Goldwater and Marco Treves (New York: Pantheon Books, 1972), p. 361.

12

PATHOLOGIES OF DRAWING

some symptoms and defects

A DEFINITION

A good drawing not only succeeds in stating the artist's intention, but does so in ways we regard as forthright, economical, organized, and compelling. When a drawing fails to meet one or more of these criteria, the fault is always in some kind of discontinuity of spirit, inquiry, organization, or commitment. A responsive drawing reflects certain qualities in the observed or envisioned subject that the artist considered essential to his or her creative interests. It also reflects the artist's sense of order and expressive purposes. Together, these objective and subjective responses to the subject's "what" and "how" create the drawing. Such a drawing can be thought of as a graphic "organism," one whose structural and dynamic conditions convey a sense of "life" within and among the marks. Like living organisms, graphic ones depend on an efficient, interrelated functioning of

their parts for life. They can be organizationally and expressively "healthy," or can "suffer" various disorders that weaken and impede their effectiveness.

Regarding drawings as organisms that roughly parallel some of the qualities and frailties of living organisms permits a useful analogy. It helps us understand how important the relational condition of all of a drawing's components is to its artistic well-being. It also helps us apply the same analytical honesty to our examination of the results that the act of drawing itself demands. We look to "diagnostic" objectivity when examining any organism's soundness. In fact, one of an art teacher's essential skills is just this ability to analyze a student's work objectively in order to suggest ways by which the student can better comprehend and manifest what he or she regards to be important stimuli in the

subject. Such constructive analysis, and not coaching in formula solutions or in established schemas, is the art teacher's primary responsibility. Total objectivity in evaluation is not possible, since evaluation necessarily involves the teacher's own esthetic persuasion and temperament. But the conscientious teacher whose purpose is enlightenment, not indoctrination, strives (like all good doctors, detectives, and therapists) to be objective.

Instructors *do* encounter drawings that show an almost total innocence of the fundamentals of perception, organization, and expression. In such cases, the teacher *should* be less concerned with analyzing and correcting each symptom, or with salvaging the student's general approach, however unique, and more with addressing the basic inability to respond visually. One does not help the visually illiterate by directing their interest toward a particular esthetic ideology. The teacher's task is to turn such students away from advanced concepts (that make perceptual, organizational, and expressive failure certain) and toward fundamental visual matters.

We are all limited by the quality of our perceptual comprehension, and by the kinds of responses they stimulate. The beginner's comprehension and range of response will expand greatly as his or her analytical and empathic understanding develop. If beginners develop their skills with little or no professional guidance (and some great artists such as Rembrandt, Cézanne, and Van Gogh had little formal training), the experiences and insights that expand ability must come through their own efforts to study drawings, to continuously make drawings, to learn about the materials and the history of drawing, and to sustain their commitment to drawing during those inevitable periods of little forward progress. If such students are in a program of art study, some, perhaps much, of their ability will reflect good instructional guidance. But, as with students working on their own, the responsibility for their artistic growth is, finally, their own. It is developed through the same initiative to search out their own experiences, information, and interpretations. During the period of study and certainly afterwards, both the self-taught and those receiving formal instruction must continue to develop their own creative sensibilities and diagnostic skills.

In a formal art program students' creative goals are likely to be formed sooner, and the students have greater opportunities to develop the ability to analyze their work, to uncover and correct the factors that hinder them from achieving these goals. The abrasive exchange of ideas both between art students and between them and the teacher, as well as the teacher's own excited involvement in art, help stimulate the formulation of good creative attitudes and challenges. Too often, the student working alone cannot discriminate between the *processes* of drawing, which are universal, and the *techniques* of drawing, which are personal. Without the guidance of a knowledgeable teacher to help overcome fundamental perceptual and technical hurdles, the student may lose much valuable time developing superficial skills instead of analytical, responsive ones.

Both types of student can benefit from studying the drawings of every period and culture, with a view to grasping the universal principles and considerations of artists as far removed in time and culture as cave artists and contemporary ones.[1] All responsive drawings, whether of observed or envisioned subjects, show a sound grasp of structural and dynamic matters, an integration of expression and order, and a compelling economy and authority. But these drawings should be studied primarily as manifestations of various creative sensibilities rather than as sources of skillful techniques to emulate.

An artist's personal "recipe" for drawing is not altogether freely chosen. Part of what motivates the way we draw is determined by our instinctive need to have certain undefinable qualities present in our drawing. Such intuitive and idiosyncratic needs are as insistent as they are intangible. Though we cannot point to the places in a drawing where they manifest themselves, we reject those of our drawings in which these qualities are absent. These unique and necessary conditions are rooted in our subconscious reason and need, and though they cannot be measured, analyzed, or altered, they permeate a drawing. Examples of great drawings demonstrate the artist's acceptance and utilization of these intuitive needs. In such drawings we sense that the artists have accepted themselves—an act as necessary in art as in life.

But students or artists whose drawings are heavily influenced by other artists lose these

[1]See Nathan Goldstein, *100 American and European Drawings: A Portfolio* (Englewood Cliffs, N.J.: Prentice-Hall, Inc., 1982).

qualities of self when they are "speaking" in another's "voice." If these intangibles that reveal an original presence are stifled in their drawings, whatever else the drawings may have gained through such influences and borrowings, they will lack a natural conviction and spirit. These intangibles cannot themselves make a drawing great, but their absence rules out greatness. The serious "malady" of followers, then, is twofold: in denying their *self*-participation they smother vital original meanings; and, like all followers, they stay *behind* the admired artist in both concepts and inquiries, producing dull variations of great themes. But more of this later.

Let us now examine some specific ailments of drawings. The more we learn about graphic defects—how systems of expressive order fail—the more we can do to avoid such pitfalls and to diagnose a problem when it is present.

There is a danger here, however. Absolute perfection is an impossible goal and we should not pursue it. It is wrong to assume that a drawing has failed because one part or one aspect of it is faulty. There is no individual without some blemish or flaw, nor is even the greatest drawing flawless. Many fine works show some minor waverings in organizational or expressive continuity, or some minor discrepancy in perception or handling. The wonder is not that a drawing can be great despite its imperfections, but that so much eloquence and strength is ever achieved with so few flaws. In fact, works of art are incredibly durable, even when quite pronounced problems exist.

As an example, in Millet's drawing *Shepherdess Knitting* (Figure 12.1) the position of the figure's right foot is difficult to understand. We are provided with no clues that explain how it came to be located on the figure's left side or why it is placed at so marked an angle. *In the context of the drawing's overall structural and spatial clarity,* this appears to be an inconsistency. Additionally, the dark shape at the figure's left shoulder, being somewhat independently stated, seems unaccountably heavy and isolated. In relation to the representational "pace" of the rest of the drawing, it seems to be only a weakly integrated member of the design. The several lines from the top of the page to the head seem to define a tree's edge, but their collective tone brings the lines forward where they can also be interpreted as descending into the figure's head. Despite

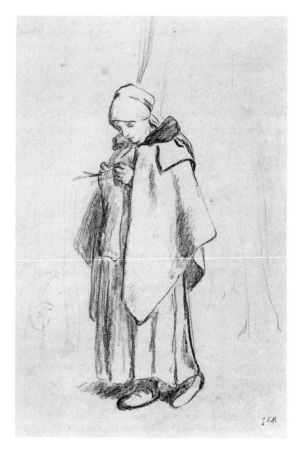

Figure 12.1
JEAN FRANCOIS MILLET (1814–1875)
Shepherdess Knitting
Black conté crayon on wove paper. 12⅜ × 9½ in.
Courtesy, Museum of Fine Arts, Boston
Gift of Mrs. J. Templeman Coolidge

these ambiguous passages, the drawing's gentle charm, and the seemingly effortless way in which Millet conveys the forms and character of the shepherdess, are impressive qualities.

The durability of a work of art can also be seen in the fragments of drawings, paintings, and sculptures from antiquity. The quality of choice and of means is so much a part of every segment that even surprisingly small fragments are able to overcome the absence of the rest of the work to convey esthetic meanings.

The following examination of common defects in responsive drawing is grouped into three categories: perceptual, organizational, and expressive. Throughout the discussion we should bear in mind that what may be a failing in the context of one drawing may be a vital function in

another. More often than not, a response is right or wrong *in relation to the nature of the rest of the drawing* and not in relation to any established conventions. What follows, then, is based not on any particular esthetic ideology, but rather on the universal visual principles of balance and unity of a drawing's representational and dynamic conditions.

Hence, a truck too small for the road, a road too large for the house, and a house too far from the man entering it are errors in scale and placement only in a drawing where all other relationships of scale and location objectively reflect the various sizes and positions observed in such a scene. Conversely, in the context of drawings that intend *themes* of scale and placement distortions, large areas of objective denotation might appear in conflict with the rest of the drawing. Likewise, *random* structural ambiguities in the context of structural clarity, a solitary, "unanswered" diagonal thrust in a design based on vertical and horizontal axes, *or any other break in a drawing's type of design, expression, or handling* will have a weakening effect on the function of these factors and on the drawing's unity.

PERCEPTUAL DEFECTS

Learning to see the measurable actualities, to analyze and relate a subject's essential shapes, values, masses, and other elements is, of course, the basic forming skill. Quite simply, we cannot draw the things we cannot understand. Seeing the generalities before specifics, sorting the gestural and structural essentials from the superficial, being receptive to relational matters of every sort, and feeling the weight, strain, and energies among the parts (and among the marks that make them) are insights fundamental to any serious degree of growth as an artist. The following perceptual defects are among the most frequent and vexing:

1. Weakness in all measurable matters. A poor sense of scale relationships (proportion), placement, direction, or shape-state awareness is generally the result of drawing what we know about our subject instead of what we actually see, or the result of a sequential assembly of parts, and of the failure to recognize the need for demanding, analytical judgments regarding any and all measurable factors. It also indicates a weak grasp of the need for relating activities in

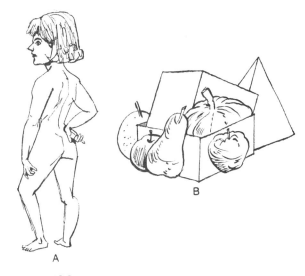

Figure 12.2

one part of a drawing to those in another, perhaps distant, part. Often, especially in figure drawings, the forms will steadily decrease in scale from the top toward the bottom of the configuration, revealing no regard for relating the scale of parts, or for searching out the subject's gestural character (Figure 12.2A). This problem is sometimes the result of the student "crowding" his or her drawing. Many such discrepancies can be more easily seen if a greater distance separates the hand and the eye. This "broad-spectrum" weakness signifies a basic visual illiteracy that requires the careful study of the issues dealt with in Chapters 1 through 6, with particular attention to matters of direction, scale, and shape.

2. Conflicting perspectives. A common result of sequential assembly, this defect is symptomatic of a disregard for relating the positions in space of all the drawing's forms, and for the need to perceive the angle of their axes as well as their edges. When forms have been subjected to a probing search for their structural essentials, and when observations are "proved" by being tested against perspective principles, such defects are far more easily avoided. Failure to do so can result in any of the strange relationships shown in Hogarth's engraving *Satire on False Perspective* (Figure 12.3), the frontispiece to Kirby's book *Perspective*.

3. Overload of details. Again often a symptom of sequential assembly, this problem indi-

Frontispiece.

Whoever makes a DESIGN, *without the Knowledge of* PERSPECTIVE, *will be liable to such . Absurdities as are shewn in this* Frontispiece.

Figure 12.3
WILLIAM HOGARTH (1697–1764)
Satire on False Perspective
Engraving. 14 × 18 in.
Courtesy, Museum of Fine Arts, Boston
Harvey D. Parker Collection

cates an inability to analyze and extract the subject's essential directions, planes, and masses. Such an exclusive concentration upon surface effects generally smothers volumetric clues, thus destroying the very masses whose surfaces are so painstakingly examined. Usually, an overabundance of detail and a scarcity of convincingly structured volume go together, suggesting that scrutiny, not analysis, is at work. When good drawings do show exhaustive detail, as in Figure 5.41, form and space clarity are unaffected.

4. Parts isolated from the whole. This defect reveals a failure to consider the relative visual impact of form-units on the large mass of which they are parts. When small forms or parts receive more attention than the larger volume they constitute, such small segments conflict rather than accord with the large volume. The resulting isolation of such parts reveals an inability to establish a visual hierarchy among the drawing's major forms and those small forms and form-units of which they are comprised. In Figure 12.4, the eyes, nose, and mouth are more fully realized forms than the head as a whole. However, the strong rhythmic energy in every segment of the drawing helps considerably to subdue the discrepancy between the strongly modeled features and the weakly stated head and neck. Some-

338

Figure 12.4
AUGUSTUS JOHN (1879–1961)
Head of a Young Woman
Pencil. 16 × 12¹³/₁₆ in.
Courtesy, Museum of Fine Arts, Boston
Helen and Alice Colburn Fund

times, as we saw in Chapter 9, such studies of particular forms are preparatory notes for a work in another medium (as is the case here). Even so, the fullest understanding of the nature of a larger volume's small parts is better achieved in the context of their structural and organizational relationships to it. In the best drawings, all parts of the image fall short of completeness; they "need" each other to become completed. A part or form that doesn't need the rest of the drawing to have its full effect is, by its very independence, isolated.

5. Unconvincing volumes. A weak sense of volume, when not due to an overemphasis on surface detail or a weak grasp of structural matters, is often the result of timid or confused modeling. A weak range of values, often only a few, small, light tones, sometimes diminishes the impression of volume, as occurs when a photograph is removed too early from the developing tray. Sometimes, having established the subject's structural essentials, the artist fails to

maintain or develop them and turns instead to various effects of illumination or texture, giving rise to conflicting clues by hatchings or tones that run counter to a form's structure or that disregard it altogether. Volumes also suffer when pronounced, continuous contours, with their strong visual impact, overrule subtle inner modeling, converting forms back into shapes. Sometimes, too, volumes are drawn in positions that would have them occupy the same space (Figure 12.2B). That this can occur in the works of gifted artists is seen in Figure 12.5, where parts of the two cows at the far right seem to exist in the same space. Here, too, the placement of the cow at the top of the page makes it appear to be standing on the back of the large cow in the foreground.

6. Monotonous outlines. This weakness stems from the belief that only lines describing the limits of forms or parts can adequately convey a subject's volumetric character. The reluctance to leave the "safety" of the delineating edge to model the interior of a form makes some of these drawings look ghost-like. Usually, when interior modeling does occur, the use of single lines to suggest subtle changes in terrain, as occurs in a figure, produces "scars" on the white shape of the interior rather than an impression of undulating surfaces. Another symptom of such drawings is the sameness of the width and character of the (usually) long and lifeless lines, resulting in forms that seem shaped out of wire coat-hang-

Figure 12.5
CLAUDE GELLEE (1600–1682)
A Herd of Cattle
Pencil, sanguine, and wash. 4³/₁₆ × 7 in.
Courtesy, Museum of Fine Arts, Boston
William E. Nickerson Fund

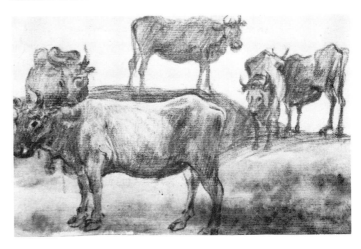

ers. Such drawings reveal a fear or confusion about the use of tonalities to help establish edges and model form. But we should not confuse an inability to let go of line with the intentional use of it, as in Picasso's drawing of three dancing nudes (see Figure 9.36).

7. Stiff or wooden drawing. This suggests an overcautiousness about error and a disregard for gestural and rhythmic considerations. Ironically, the concern over making mistakes, the fear of "matching" energies in the subject by energies in the drawing, and the dread of making changes— of making a mess—have probably ruined more drawings than anything else. Fear is virtually certain to result in drawings that suffer the grave defect of stilted, dead imagery. In responsive drawing there is safety only in perception, analysis, and uninhibited response. Here, caution is dangerous. When we don't enjoy the drawing process, we can be sure the viewer won't enjoy the results. Wooden drawing often results from an overconcern with surface detail at the expense of a subject's essential structure and spirit. Sometimes stiff form also occurs as a result of an overuse of straight lines and hard, right angles, often to the exclusion of all curved lines, as is seen in some mannered techniques.

8. Tonal "anemia." This defect occurs in tonal drawings when there is a fear of using dark tones, especially over large areas, even though a drawing's volumes, composition, or expression require them. Often the forms in such drawings are defined by outlines, making what little tone there is seem even less necessary. Beginning tonal drawings on a toned surface (either a tinted paper or one that is given a coating of charcoal or graphite) is useful in overcoming a reluctance to use bold, dark, values.

9. Formula solutions. When remembered clichés replace responses to any of a subject's actualities, the results are trite. There is a failure to respond because of disinterest in various parts of the subject, an inability to visually comprehend them, or a preference for familiar solutions. Such drawings do not seem convincingly in touch with nature. In part, they are not. When habit displaces analysis, formula displaces experience.

10. Breezy mannerisms. These are usually false flourishes that imitate the economical, authoritative, and always multiply engaged lines

and tones of master artists. Drawings suffering from this defect usually convey little or nothing more about a subject than loose and poorly understood generalities. Often symptomatic of a superficial grasp of perceptual skills, such drawings are often ambiguous about volume and space, design, and expression. At best, they are interesting "promissory notes"; at worst, and more frequently, they are merely flashy pretensions that allude to a fluent control the artist doesn't possess.

To discover perceptual defects in our drawings, we must be willing to go back and look for any measurable discrepancies in direction, scale, shape, and location that we did not recognize during the act of drawing. We must also come to understand that any faltering of concentration will hinder objective analysis.

In the excited involvement with the many interlaced factors of response to the subject and to the evolving drawing, one can easily overlook a scale relationship, misjudge an angle, or make some inadvertent inclusion or omission. Viewed later, unintentional exaggerations of scale, value, and the like, are often glaringly evident; but overworked, monotonous outlines, formula solutions, or an overload of details will remain as more pervasive defects unless they are examined critically. Such perceptual problems are certain to recur in subsequent drawings unless we objectively examine the concepts and procedures of our overall approach to drawing. The ability to analyze a subject's measurable actualities, and to recognize the symptoms that indicate faulty procedures and judgments, is necessary *for any kind of graphic goal.* How we perceive is not the same as what we do about our perceptions. In analyzing the perceptual defects of our drawings and working to overcome them, we also gain insights into our general approach that lead to artistic and even personal growth.

ORGANIZATIONAL DEFECTS

The way we order our responses reveals our esthetic and temperamental interests. It reflects our understanding of the relational possibilities in the subject, and of the relational life of the marks that constitute our drawing. Sound perceptual skills require sound organizational sensitivity if they are to have any creative or even

communicative worth. The following are some of the organizational defects most often encountered. Some are easy to spot, some are insidious and subtle, all diminish a drawing's formal design and, consequently, its dynamic meaning.

1. Labored drawings. Often these result from the fussy embellishment of parts with unnecessary details and "finish," isolating and reducing their relational activity. The problem is sometimes due to a poor choice of medium, where numerous attempts to force a medium to react to the artist's needs cause a general loss of spontaneity. Sometimes there is an almost obsessional concentration on some particular organizational or expressive theme so overbearing that the drawing's overall economy, spontaneity, and unity are weakened. Labored drawings often result from an overemphasis on representational considerations. Such drawings may reveal a high degree of accurate depiction—of illustrative fact—not a high degree of dynamic life. However, dull and overworked results will occur in drawings of any kind when the enlivening and unifying effect of abstract relational play is either absent or self-consciously overstated. Responsive drawings are complete when they cannot be made more visually and expressively exciting and succinct. "Finish," in the sense of photographic naturalism, is often *the finish* of a drawing's relational, abstract life. Accurate representation and inventive graphic design are *not* mutually exclusive, but the more thoroughly objective a drawing's imagery becomes, the greater the demands on our ability to organize the marks that make such images.

2. Redundancy. The use of lines and tones for the same function in a single volume suggests a mistrust of values to convey the impression of volume without the aid of a final, encompassing line. This problem can be seen in Figure 12.6A. Although line and tone may work together in many ways, using both to say the same thing usually destroys a drawing's overall freshness, economy, *and* impression of volume. The duplicative behavior of line and tone is more confusing than clarifying, because the role of each is obscured by the presence of the other. Note that Figure 12.6B is more convincingly volumetric.

3. Random lines and tones. This problem usually occurs when there is no general strategy for the roles of line and tone in a drawing. In such

Figure 12.6

drawings, some parts may be depicted by line only, other parts by tones, and still others by various combinations of line and tone. Although variations in their use are often desirable and necessary (see Rembrandt, Figure 6.3), extreme differences that lack any compelling visual or expressive purpose make it appear that two or more unrelated attitudes are at work in the same drawing (Figure 12.7). Such an erratic use of line and tone suggests a confusion or innocence about basic visual issues, goals, or both.

4. Ostentatious facility. When the dominant goals are cleverness in the use of media, or deft drawing devices, we face the problem of ostentatious facility. Although facility, that is, inventive and masterly control, is a desirable quality, drawings in which cleverness of execution is primary appear to be performances for approval rather than acts of graphic necessity. Such drawings often disclose only a passing interest in dynamic considerations, and a fascination with deft

Figure 12.7

solutions to figurative illusions or imaginative effects. When facility makes a drawing a system of clever representational or abstract mannerisms instead of an organized and penetrating interpretation of nature or imagination, the drawing becomes self-indulgent rather than pictorial, exhibition rather than experience. Often, drawing mastery first shows itself in the artist's no longer choosing to please others.

5. Lack of unifying movements. This suggests a sequential approach. Completing parts in a piecemeal manner seldom permits their being woven together by directional and rhythmic forces that provide continuity between forms. The stilted results of a disregard for the moving energies that course through any group of forms may also stem from a concentration on the structural nature of small forms, to the exclusion of an awareness of their collective gestural, rhythmic character. Such drawings reveal an innocence of what is perhaps the most evidently present quality in the things we see.

6. Random shifts between the second and third dimension. Like any other inconsistency, such shifts indicate the absence of an overall dynamic theme—an uncertainty about the drawing's purpose or goal. Many drawings do have *integrated* transitions of emphasis between two- and three-dimensional matters, as in Alcalay (Figure 5.4) and Diebenkorn (Figure 9.40), where integrated shifts in emphasis occur between events on the picture-plane and events among forms in space. But the random coming and going of volumetric and spatial clarity indicates a disregard for the fundamental need to hold to one frame of reference—one "voice"—in a drawing. When elements in one part of a drawing convey masses and space and those in another do not, there must be some comprehensive design strategy that embraces and unites these parts. Such a strategy is seen in Figure 12.8, where two- and three-dimensional phenomena are engagingly integrated.

7. Random placement of the configuration on the page. This defect suggests an indifference to the format's effect on the image. We have seen that a drawing's design consists of the configuration *and* the page. The impact on the viewer of a visually illogical placement of the configuration

Figure 12.8 (*student drawing*)
University of Illinois at Urbana-Champaign
Black conté crayon on paper. 18 × 24 in.

Figure 12.9

often overrides the drawing's intended impact. In Figure 12.9, the active dark shape in A overwhelms the several white shapes and seems crammed into the picture-plane, straining for release. The same shape in B appears less active and not at all crammed in. In fact, it appears somewhat isolated in so large a field of space. In C, it has been located in a position on the picture-plane that creates imbalance. Besides destroying the equilibrium of the design of the page, such placement can sometimes weaken the overall nature of the configuration. An image that is itself stable, if placed badly on the page, becomes part of an unstable design. An incompatible relationship between the configuration and the page sometimes occurs in the work of capable artists. In Vigée-Lebrun's drawing *Study of a Woman* (Figure 12.10), the lack of "breathing space," around the figure, especially at the top, where the head touches the edge of the page, produces a slightly claustrophobic state in what is otherwise an excellent drawing (although the drawing may have been cropped by another hand at a later date).

8. The divided drawing. This results from strong divisions of the picture-plane by lines, values, forms, or directional forces that isolate one part of a drawing from the rest, destroying the unity of the design. Such divisions, however, when they are offset by other forces in the design that weave them together, are a frequent device in drawing. In Cheruy's drawing of a church interior (Figure 12.11), the columns on the far right cut the drawing vertically, but they are joined to the rest of the drawing in several ways. One of the strongest connections is the unseen but clearly suggested arch spanning the interspace between them and the center group of pillars. The

Figure 12.10
ÉLISABETH VIGÉE-LEBRUN (1755–1842)
Study of a Woman
Red chalk. 9½ × 5¹⁵⁄₁₆ in.
Courtesy Museum of Fine Arts, Boston
Gift of Nathan Appleton

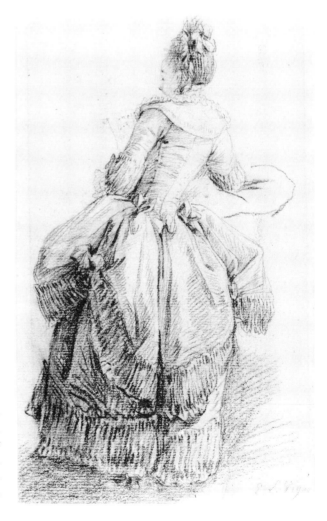

Figure 12.11
GERMAINE ROUGET CHERUY (1896–)
Vezelay, La Madeleine—The Nave (c. 1930)
Ink on Japanese paper. 12¼ × 17 in.
Courtesy of Fogg Art Museum, Harvard University,
Cambridge, Mass. Gift of Edward Waldo Forbes

similarity of value and texture between the two massive pillar groups, and their relationship to a third group on the left as well as to the smaller pillars and arches behind them, all form strong visual bonds of association. When a section is unintentionally severed from the rest of a drawing, the two parts can be strongly joined through direction, rhythm, value, and texture, as in Cheruy's drawing, or by placing one or more forms in a position that crosses the boundary to join the parts together.

9. Imbalance. This defect results from the visually uneven placement, direction, density, weight, scale, or value of the elements, and of the forms and spaces they create. It often results from such an exclusive concern with a drawing's

representational aspects that its intrinsic visual issues go unheeded. Balance is guided partly by intuitive reason, but it cannot be consciously ignored. The artist's design plan should include a tentative judgment about the scale and placement of the configuration on the page that will assist the drawing's balance.

To create a balanced drawing, the artist must cancel out visual forces that cause the design to appear to be falling or crowding to one side, that isolate segments, or that give any other impressions of unresolved instabilities among its parts. There are two basic ways of cancelling out forces. One is to answer a strong force on one side of the drawing with a similar force on the other side, as in Figure 12.12A. This *symmetrical* solution, if too evenly established, can be rigidly

formal and obvious, but when used subtly, it is a dependable way of producing equilibrium. In Rembrandt's *A Cottage among Trees* (Figure 12.13) and Villon's *Study for Farmyard, Cany-sur-Thérain* (Figure 12.14), balance is achieved through roughly symmetrical forms and forces. In both, a gentle curve, horizontally oriented and cresting near the drawing's center, describes the contour of the foreground's shape. In both, the curve's crest is the location of a strong mass that acts as a fulcrum for the rest of the drawing's masses, and in both, the masses flanking the central one bear a strong resemblance to it. Rembrandt continues the symmetrical system in the fences and in the horizon, making them quite similar to their counterparts across the page. Villon repeats the diagonal lines in the sky with the lines in the foreground.

A second way to cancel out strong visual forces is to answer them with different but equally strong forces, as in Figure 12.12B. This is an asymmetrical solution. Asymmetry, being the

Figure 12.12

more prevalent state in nature and offering unlimited design possibilities, more frequently occurs in responsive drawings, as a glance at the drawings in this book shows. In Ingres' *View of St. Peter's in Rome* (Figure 12.15), the placement of the cathedral to the left of center—its great facade and dome producing the strongest vertical

Figure 12.13
REMBRANDT VAN RIJN (1608–1669)
A Cottage among Trees
Pen and bistre. 6¾ × 10⅞ in.
The Metropolitan Museum of Art. Bequest of Mrs. H. O. Havemeyer, 1929. H. O. Havemeyer Collection. All rights reserved, The Metropolitan Museum of Art

Figure 12.14
JACQUES VILLON (1875–1963)
Study for Farmyard, Cany-sur-Thérain
Pen and ink. 6⅜ × 9¾ in.
By courtesy of the Boston Public Library, Print Department

Figure 12.15
DOMINIQUE INGRES (1780–1867)
View of St. Peter's in Rome
Graphite pencil on ivory oatmeal paper.
33.6 × 49.8 cm.
Collection of The Art Institute of Chicago. The Joseph and Helen Regenstein Foundation. Photograph © 1990, The Art Institute of Chicago. All Rights Reserved

movement in the drawing—is answered by the encircling sweep of the buildings, and by the pronounced curve of the roofed colonnade in the foreground. The single vertical direction of the obelisk on the right adds its energy to the drawing's balance and serves as a unifying echo of the vertical forces of the cathedral.

As we saw in Chapter 1, a gestural approach gives the artist an overview of the drawing's general compositional nature and needs. In drawings where imbalance occurs, the failure to establish at the start the design's basic gestural premise is often the cause.

10. The generalized drawing. When the artist is in doubt about how to realize some of the smaller, more specific aspects of the subject and the design, the result may be a generalized drawing. Often students establish quite handsome drawings of the subject's generalities and a good, equally generalized design, but seem unable to apply or sustain the attitudes and commitment that brought these broad states about in establishing the drawing's smaller structural and dynamic conditions. Of course, many artists intend a simply stated image, but all are *concise* rather than general. They may be simply stated, but they are rich in visual and expressive meaning.

By contrast, the generalized drawing only suggests possibilities and hints at conclusions. Its summaries are vague and seem more like uncertain assumptions than convincing assertions. Some students (and artists) make simple and general drawings in admiration of the economy of master drawings—and some of these do bear a superficial similarity to such drawings. But it is perceptual and organizational sensitivity and not simplicity for its own sake that leads to concise drawing. These sensitivities are expanded in drawings that probe and establish small forms and forces with the same sensitive commitment we invest in establishing the major ones, as in Figure 12.16.

Certainly, not all student drawings need be extensively developed to include a host of specific observations. But students need to develop the ability to state any highly specific detail or relationship to overcome *unselective* generality. They should, from time to time, reinforce the experience of applying the same degree of analysis and empathy to smaller matters that is given to major ones, as in Figure 12.17. This is important for another reason. Just as the search for the essential structure and spirit of a subject's differ-

Figure 12.16 (*student drawing*)
Claudia Roberts, private study, Newton, Mass.
Charcoal. 18 × 24 in.

ing parts helps us to see similarities between them, in drawing the smaller forms and actions, we come to see the subtle differences between similar parts and energies. For example, while it would, at the outset, be important to see the similarity of form and direction between, say, the twigs of a branch and the fingers of a hand holding it, it is also important, later in the drawing, to be able to show the differences between each twig and between each finger. Ironically, the insights that come from patiently establishing a subject's smaller forms and actions, and integrating them within its larger forms, is the fastest and surest way to eventual economy.

EXPRESSIVE DEFECTS

Although perception, organization, and expression are interdependent considerations, the expression of our genuinely personal responses to a subject's dynamic and representational meanings is the fundamental role of these considerations. Drawings in which our own ex-

Figure 12.17 (*student drawing*)
Hilary Heyman, Arizona State University
Graphite on hot press paper. 22 × 30 in.

pressive responses are stifled or disregarded, or fail to touch on important facts and inferences about the subject, are either expressively evasive, confused, or derivative. The following expressive defects are some of the ways in which feelings fail to participate in the responsive process.

1. Expressive reticence or blandness. This weakness suggests an over-concern with depictive "correctness" or inhibitions toward the intuitive and emotive responses that influence perceptions. But, as was observed in Chapter 10, even this reticence is expressive. The beholder senses a restraining of impulses that both empa-

thy and intuitive knowledge demand. If the artist does not risk commitment to his or her responses in a direct way, the drawing reveals the hesitancy and constraint.

All art teachers are familiar with the student who makes conscientious drawings that carefully avoid responses to the subject's dynamic potentialities. At one time most art academies insisted on just this kind of disciplined concentration on measurable matters. It constituted the main and sometimes only area of perceptual awareness. But such drawings often appear leaden, lifeless. Drawings that avoid the dynamic energies that create the graphic equivalent of life *are* lifeless.

Here it will be helpful to compare two highly representational drawings. They show the differences in attitude and result between an almost exclusively reportorial approach and one that utilizes expressive impulses. The anonymous Dutch or German School *Study of Ten Hands* (Figure 12.18) shows a great concentration on the observed state of the terrain in each part, with little concern for the gestural, rhythmic flow within or between them. Each finger is drawn with hardly a clue to its participation with others in forming greater units of form—or as engaged in pointing, gripping, or supporting *actions.* In almost every instance, there is no convincing impression that the arms really continue inside the sleeves. For all the concentration on individual volumes, many volume relationships do not convince. For example, in the middle drawing on the

far left the structural means by which the forearm interlocks with the hand is unclear. Although the surfaces of these hands are explicit, the general structure, weight, power, and expressive character of the hands are not. They "describe" various acts of exertion, but they do not "enact" them. The artist is skillful. Many of the small folds and veins are deftly stated, and in some passages the drapery-like character of the skin, moving over bone, tendon, and muscle, is effective. Some hands, such as those of the bottom row (especially the one at the far left) do begin to "live." But the artist's basic theme is the scrutiny of small forms, too often at the expense of the large ones. A clue to the artist's thinking occurs in the beginning stage of the pointing hand in the upper right corner of the page. It is already a carefully delineated record of the out-

Figure 12.18

Anonymous (Dutch or German School)
Study of Ten Hands
Pen and brown ink. 7⅞ × 12⅛ in.
National Gallery of Canada, Ottawa

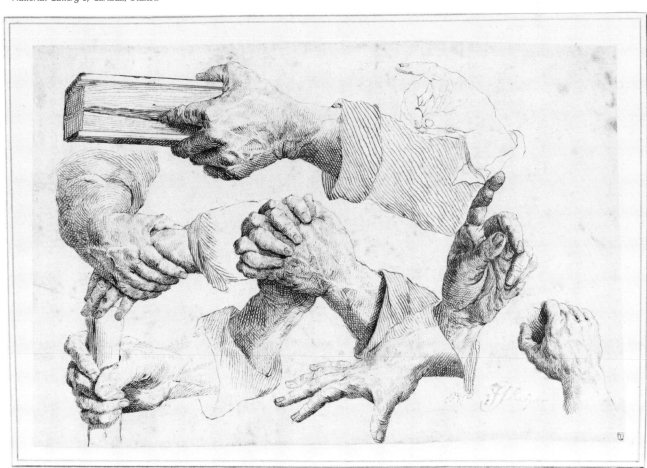

lines of the forms. Nowhere can we find a gestural or analytical line. Nowhere do lines express movement or energy. The artist concentrates on shapes rather than masses.

Compare this beginning state with the early stage portions in Rubens' drawing, *Study of Cows* (Figure 12.19). A different kind of sensibility is at work here. In the upper left and right corners of the page, and even in the more developed drawings in the lower right, lines search for the actions, tensions, and *masses* of the forms *at the outset*. In these beginning stages Rubens is concerned not with careful delineation (although he is equally interested in understanding shape actualities), but with the *feel* of the forms' movements and with their essential constructional nature. The benefits to both the structural and expressive clarity of the forms are evident in the drawing of the large animals. The artist's response to their ponderous bulk and weight, to their slow movements, and to the powerful pressures and tensions created by the inner structural forms supporting and straining against the walls of the supported hide creates convincing, living images of visual and expressive significance. All this is more than the result of scrutiny—it is the result of perceptions selected, altered, and ordered by feelings and intuitions as well as intellect.

It is feelings and intuitions, too, that cause Rubens to select (perhaps subconsciously) an overall design that fans out toward the beholder, with strong, curved movements sweeping to the left and right. Note the great clarity of the forms. Heavy, interlocking, but rhythmically related masses, and hatchings that move sensually upon the changing "topography" of the forms, convey Rubens' profound understanding of the masses. These qualities, like the design itself, are strong, deliberate, and graceful. Compare Rubens' de-

Figure 12.19
PETER PAUL RUBENS (1577–1640)
Study of Cows
Pen and ink. 34 × 52.2 cm.
*Reproduced by courtesy of the Trustees
of The British Museum, London*

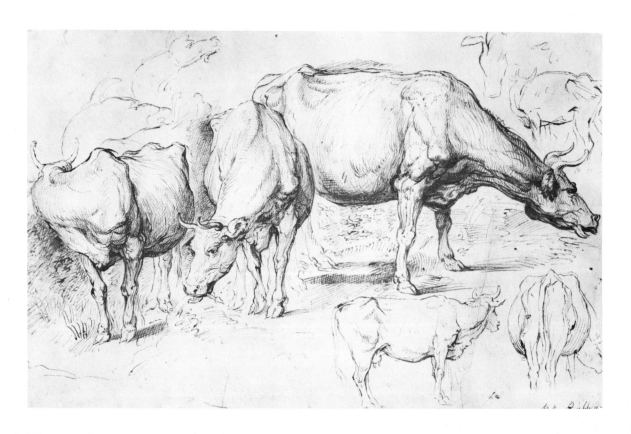

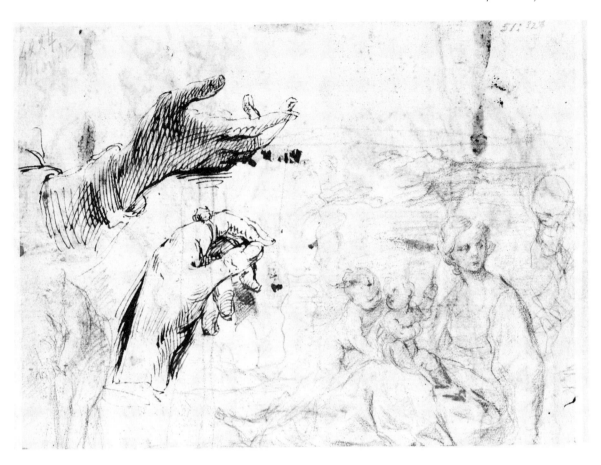

Figure 12.20
AGOSTINO CARRACCI (1557–1602)
Sheet of Studies
Pen and ink, some chalk. 20.5 × 27.2 cm.
Rijksmuseum, Amsterdam

sign with that of Figure 12.18. Again, there is a kind of restrained quality to the arrangement of the arms and hands. They form an overall checkerboard pattern, somewhat mechanical and dull. Unlike the design of the Rubens drawing, which evokes something of the behavior and character of the animals, this design seems unrelated to the character of the subject.

In another comparison, this time with a sketch of two hands by Agostino Carracci (Figure 12.20), we find more spirit and force in this sketch than in the hands of Figure 12.19, despite their more thoroughly explored surfaces. While Figure 12.20 is only a rough exploration and Figure 12.19 is an extended study, the sketch is more responsive to structural matters than the study is to expressive ones.

In drawings that are expressively inhibited, more than the frank expression of felt responses is absent. The drawings appear diminished in the clarity and force of their representational meanings as well. With human forms especially, a failure to support representational actions and energies by abstract ones deadens the results.[2]

2. The literary or illustrative look. When the artist is concerned more with storytelling, or with conveying a message (whether social, political, historical, or religious) through a drawing's figurative matter, rather than with creating a sys-

[2]See Nathan Goldstein, *Figure Drawing: The Structure, Anatomy, and Expressive Design of Human Form*, 2nd ed. (Englewood Cliffs, N.J.: Prentice-Hall, Inc., 1981), chaps. 1, 5–7.

tem of expressive design, the illustrative look occurs. Any storytelling message can be a valid property of any drawing (see Figures 3.14 and 10.18), but it should never reduce the creative depth of a work.

Whether or not it does diminish esthetic worth depends on the artist's ability to govern two quite different kinds of expression. As we have seen, some artists actually need an essentially nonvisual theme. For them, conveying a social, spiritual, or other kind of message, far from competing with the demands of expressive order, stimulates it and is in turn enhanced by it. When there is such a reciprocal relationship between graphic and nonvisual expressions, the results (as many of the drawings in Chapter 10 indicate) do not appear merely anecdotal. It is only when a narrative theme overpowers the artist and compromises his or her creative instincts, or when its demands are incompatible with them, that responses to both the subject and the drawing lead to illustrative solutions. When pictorial and narrative factors clash, the result may be an illustration with some redeeming artistic worth, or a drawing weakened by the burden of nonvisual issues, but in either case there is a lessening of esthetic worth.

To some extent, many of our responses to a subject's physical, dynamic, and psychological states are not directly visual issues. We cannot visually measure dignity, melancholy, or repose. But when such influences on perception expand to become a drawing's dominant goal by emphasizing representational issues at the expense of its abstract graphic life, the result is narration, not art. And though some artists are stimulated by nonvisual ideas and do their best work when spurred on by such themes, other artists, who may feel just as deeply about social, religious, or any other nonvisual interests, create works that do not address these matters through the narrative aspects of their drawings. If such "messages" appear, they are felt as intangible qualities of the drawing's content.

3. The picturesque air. This problem is often sensed in works that, like anecdotal ones, stress depiction at the cost of expressive order. It stems from a usually sentimental or romantic interpretation of the quaint, the strange, and the spectacular. Often such subjects do not belong to the artist's past or present environment but are adopted because of their popularity, their exotic

or unusual nature, or their literary appeal. Sometimes these subjects romanticize an earlier society. Although windmills and covered bridges still exist, it is difficult to see them objectively, because they are no longer connected to the lives most of us lead. Any observed or envisioned subject is always valid, but it is harder to respond to those we have no real familiarity with, or those that have become banal or sentimental because of overuse. The need for squeezing expression out of unusual situations or places subsides as we learn to evoke expressions out of the visual elements and the people, places, and things around us. It has been observed of Cézanne that "he made bowler hats out of mountains, and mountains out of bowler hats."

4. The influenced drawing. The problem here is that the influenced drawing usually lacks the conviction and daring present in the drawings it was influenced by. We are not referring to drawings that show a faint residual influence of a particular artist or style. An artist who by temperament and esthetic disposition finds that he or she shares a point of view with that of a colleague, master, or stylistic period is bound to reflect some superficial similarities. But even when artists are influenced, their work is essentially original if it is not restricted by, or imitative of, the influencing works. It is hardly uncommon in the history of art for some artists, and among them some of the best, to expand upon or even to develop new concepts stimulated by the innovations and idiosyncrasies of others. After all, in being ourselves as artists, it is natural to search out "kindred visual spirits" among other artists, past and present, just as in our social lives we search out friends who strike us as good and wise. In both cases, influences occur. In both cases, our understanding, our abilities, and ultimately our freedom to be ourselves *is increased.*

But *strong influences do not permit the expression of personal responses.* An adopted manner is usually an imitation of a technique, rather than a concept; and whichever it is, its presence always prevents the development of genuine creative ability.

The heavily influenced drawing is often unselectively dependent on the techniques and idiosyncrasies of the admired artist. In his drawing *The Degradation of Haman before Ahasuerus and Esther* (Figure 12.21), de Gelder combines many of Rembrandt's drawing characteristics to sum-

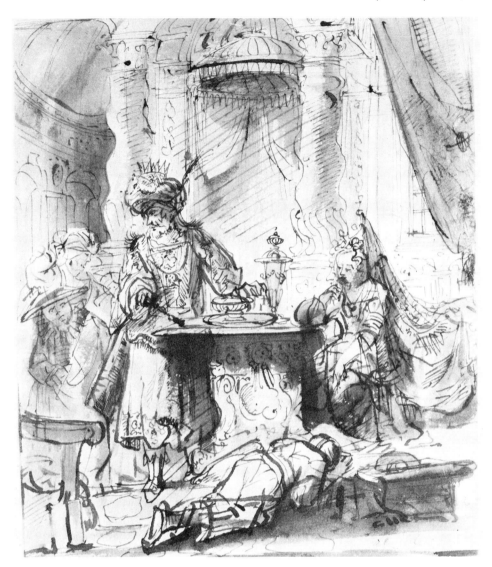

Figure 12.21
AERT DE GELDER (1645–1727)
The Degradation of Haman before Ahasuerus
and Esther
Pen and ink and wash. 19 × 16.5 cm.
Collection of The Art Institute of Chicago. Charles Deering
Collection. Photograph © 1990, The Art Institute of Chicago.
All Rights Reserved

mon up a Rembrandtesque image. But he suc-
ceeds only in imitating Rembrandt's personal
graphic "handwriting." Interestingly, such traits
are sometimes regarded by innovators as being
of little importance to their purposes, or even
detrimental. As the late American artist Philip
Guston has observed about his imitators, "They

all seem bent on exaggerating just those things
I'm trying to get rid of in my work."[3]

De Gelder's marks *are* strongly reminiscent
of Rembrandt's handling, but they fail to convey
Rembrandt's perceptual or dynamic understand-

[3]In a private conversation with the author.

ing. In short, de Gelder's drawing does not convey a Rembrandt-like *content.* How could it? The lines and tones that are *necessities* for Rembrandt—the results of his negotiations between perception, feeling, and intent—all serve to amplify his unique and deeply felt responses. No one can summon up another's sensibility, and no sensibility can conceive and sustain the special demands of another.

De Gelder's understanding of volume and design does not support the kinds of daring that are natural and necessary for Rembrandt. Note the ambiguities in the forms of the figures. None of the heads or hands suggest the quality of structural analysis, the weighty mass, the design, or the expressive power of comparable forms in a Rembrandt drawing.

Compare the bold control of the heads and hands in Rembrandt's *Three Studies of a Child and One of an Old Woman* (Figure 12.22), with those in the de Gelder drawing. Note, too, that where Rembrandt creates transitions between broad and precise kinds of handling, de Gelder's changes in handling are abrupt inconsistencies that serve no visual or expressive purpose. Where Rembrandt's washes of tone convey light and volume with certainty, de Gelder's are uncertain—sometimes rather tightly encased by line, sometimes obscuring volume, and sometimes simply inconclusive and weak. They seem somewhat unrelated to the rest of the drawing. The evenly spaced diagonal lines that cross the center of the drawing, unlike the lines behind the seated child in Rembrandt's drawing, do not stay well back but come forward and hover in space somewhere between the figure of Ahasuerus and the pillars in the background. De Gelder is uncertain about the perspective and the architectural forms on the far left, and some of those in the center background are left unclearly stated as volumes in space.

These defects suggest the limits of his perceptual, organizational, and empathic comprehension. No technique or imitation of technical mastery can camouflage such limits. The attention and energy focused on the imitating of another's point of view obstruct those abilities the artist *does* have, and further weaken the results. But the heavily influenced student or artist who begins to trust and respect his or her own responses soon finds a satisfying creative freedom that imitation will never provide.

5. Conflicting meanings. We sense this defect when a drawing fails to convey a consistent visual attitude, mood, or handling. It is sometimes symptomatic of a disinterest or confusion concerning a subject's structural and dynamic properties. But changes in goals and handling, after a drawing has begun, too often produce conflicting results. Such drawings reveal a weak grasp of those factors that establish unity. The freedom of response to a subject and to its emerging equivalent state on the page does *not* extend to arbitrary changes in attitude toward the subject or to its manner of presentation within the same drawing. For example, in a landscape drawing that is primarily tonal and concerned with aerial perspective, a sudden switch to a linear, diagrammatic exploration of the structural aspects of a house in one corner of the drawing is a glaring inconsistency.

Such conflicting goals are not uncommon in student drawings. This problem often results from experiencing the many new ideas and challenges a good program of art study provides. But conflicting interests and goals violate one of the most fundamental requirements of any art form: the organizational and expressive need to sustain a single, overall purpose.

This is not to say that multiple meanings are impossible in drawing. In the example just mentioned, both tonal and diagrammatic ideas *can* be quite compatible if an interest in both is made an integral and reoccurring theme of the drawing's expressive order. In Treiman's *Study for "Big Lautrec and Double Self Portrait,"* 1974–75 (Figure 12.23) the seeming "errors" in scale and perspective are integrated, intentional changes that enhance the enigmatic mood of this envisioned grouping.

Conflicting meanings may sometimes be noted when the figurative expression is at variance with the expressive nature of the handling and design. For example, in a drawing of a figure performing some dramatic action requiring strenuous physical exertion, a delicate, deliberate handling and a design that stresses horizontal and vertical directions or otherwise appears tranquil or stately may tend to weaken and contradict the figurative action.

Expression and order are the dimensions of an approach to drawing that will yield works that live. Beginners too often become preoccupied

Figure 12.22
REMBRANDT VAN RIJN (1606–1669)
Three Studies of a Child and One of an Old Woman
Pen, brown ink, and brown wash with slight touches of
discolored white body color on white paper.
8⅜ × 6¼ in.
*Courtesy of Fogg Art Museum, Harvard University,
Cambridge, Mass. Gift of Meta and Paul J. Sachs*

Figure 12.23
JOYCE TREIMAN (1922–)
Study for "Big Lautrec and Double Self Portrait"
(1974–75)
Pencil. 20 × 20 in.
Collection of Jalane and Richard Davidson

with the multiplicity of factors in drawing and disregard the general responsive direction of their work. That is, busy learning how to see, they lose sight of what it is they intend to convey. In time this seemingly unmanageable number of considerations begin to come together, to work for the student almost automatically. Then it will be most important to recognize that perceptions and methodologies are servants that perform best when the best demands are made of them. And the demands of a sensitive analytical and empathic sensibility, perceiving and ordering in a personal way, create original style. Style, in fact, indicates the key to our priorities—it reveals both temperament and intent. Therefore a search for style not only is futile, it is beginning at exactly the wrong end. *Intent* must precede a personal form for expressing itself, and it brings with it the conditions that shape style. Style, then, is not arbitrary, not chosen; it is given, inherent in our nature and purpose.

The symptoms of basic weaknesses in re-

sponsive drawing examined here (and there are others) should provide a basis for the evaluation of our drawings that further experience will broaden. In responsive drawing the most pernicious underlying causes of so many defects are the faulty judgments that result from an exclusive concern with imitating instead of analyzing and interpreting nature, and the employment of a sequential approach in pursuing that limiting goal. As Michelangelo's *Studies of Figures* (Figure 12.24) so well demonstrates, beginning with a search for a subject's structural and dynamic essentials provides the comprehension and control that lead to sound drawing.

What engages our participation—as well as our admiration—in a responsive drawing are the activities that suggest choices and energies contending with each other. Their resolution into a system of expressive order invites us into the drawing—not only to admire, but to participate in the negotiations that shaped them into this living system.

356

Figure 12.24
MICHELANGELO BUONARROTI (1475–1564)
Studies of Figures
Pen and ink.
Teylers Museum, Haarlem, The Netherlands

13

FINDING YOUR WAY

options and attitudes

All of our creative activities occur in the context of what we know and what we want. Our personal history in and out of the realm of art shapes our creative purposes. But because what we know is bound to influence at least some of what we want from our drawings, the responsive artist is always interested in new information and new experiences in and out of the realm of art; he or she is always, in part, the responsive student.

The answer, then, when young artists wonder: "What visual and expressive matters should I concentrate on? What will be the nature of my drawings?" or, more simply, "What happens now?" is of course determined partly by the area of visual communication that attracts them and partly by what they must then do to develop their skills further. Those who wish to be illustrators or graphic designers will find their future drawing skills shaped largely by the special demands of clients, deadlines, budgets, and changing modes of commercial visualization. Even here, though, the individual stamp upon our work—our unique style of imagery—will play a leading role in determining how successful (and satisfied) we will be as artists. This is even more the case for young artists who mean to make the fine arts their primary (or only) area of interest. But whatever our personal visual goals may be, the more penetrating our perceptual and conceptual inquiries, the more creatively effective our drawings will be. As the poet e e cummings put it: "Always the beautiful answer who asks a more beautiful question."

And the "beautiful question," as we have seen, asks for more than superficial answers; it inquires about the subject's structural *and* dynamic character, and even probes the possibilities for meanings that transcend the subject.

The best drawings, of whatever culture or era, possess visual and philosophical connotations that go beyond depiction to become universal, timeless expressions.

It has been observed throughout this book that the content of a responsive drawing is the sum of its representational and abstract condition—the total impact of its depictive and dynamic meanings. A drawing's content may be shallow, interesting, or profound, according to the quality of the artist's perceptual awareness and the quality of his or her conceptual, expressive, and intuitive responses. When such responses reach a critical intensity of synthesis and vitality, a drawing's content is experienced as a living force. But the basic skills that lead to drawings of such integrity and spirit are those of analysis and empathy; we cannot interpret what we do not comprehend. And the best route toward our area of visual interest—toward those matters that, in meaning most to us, will more likely mean more to others—is the one that best tests and trains us to see beyond the surface to the heart of the things we draw: the continuing exploration of visual phenomena as revealed in art and nature and, by these efforts, of yourself. We have, then, come full circle from the quote by the great French painter Delacroix at the beginning of this book: "O young artist, you search for a subject—everything is a subject. Your subject is yourself, your impressions, your emotions in the presence of nature."

In this chapter we will look at some ways of continuing art study that—although hardly ensuring high-quality creative results—may keep us from the quality we aspire to if left unregarded. While determining quality in drawing is bound to be a largely subjective judgment, certain criteria such as economy, authority, organizational and expressive clarity, and unity are sure to remain universally important in the evaluation of a drawing's quality, if only because our human sensibilities naturally look for balance and order, meaning and spirit.

There are, of course, levels of quality. Even when the factors of economy, authority, and so on are in ample evidence, we can still discern differing levels of involvement, of inquiry, and of the integration of means and meanings. Figures 13.1 and 13.2 are accomplished drawings, each by a much honored artist at the height of his creative powers. The subject matter is roughly

similar, as is the level of realism. Each shows some admirable features not to be found in the other. Sloan's drawing is the more spontaneous; Sheeler's, the more precisely crafted. Sloan explains the way planes abut and fuse; Sheeler's modeling is more the result of illumination. Their purposes and expressive moods are plainly different and equally valid.

Yet on balance Sheeler's drawing appears to be the more provocative and metaphoric work. There is an intensity of concentration on a few issues—the figure as "landscape," the striking two-dimensional pattern, an air of mystery, and a strong sensual undercurrent that rivets our attention. Sloan's drawing is a handsome example of a somewhat familiar set of issues treated in a somewhat familiar way. It is a more casual denoting of something observed, stated in an assured manner. But if Sloan's drawing is an impressive performance, Sheeler's is an impressive invention. In the latter, each of the elements of line (as edge), value, shape, volume, and texture is asked to perform a more demanding role. This is not so because Sheeler's drawing is more fully developed than Sloan's, but rather an intensity of commitment to a particular set of engaging visual ideas has set off a more engaging set of dynamics, whereas Sloan's less probing inquiries provide less provocative answers.

In developing your way of drawing, it is important to aim for an intensity of commitment, to become so keenly engaged that the drawing's energies lead the way to images that come alive. Sheeler's commitment leads him to an interest in form realization which goes beyond the volumetric condition of the figure's masses. There is a poetic equivocation that plays with scale and identity. The drawing *is* a closeup of a figure, its ample forms implying the fruitful properties of ancient fertility figures; but it suggests a monumental and barren landscape. It is at once realistic and abstract, substantial and illusory. The forms express both strength and pliancy, are both inviting and indifferent. Such contrasting readings attract our interest and, by their universality, will always provoke attention.

Developing the perceptual sensitivity that uncovers lasting visual and expressive qualities requires a concentration on the three main concerns of this book: first, the study of drawing as inquiry into the structure and dynamics of nature and human-made forms; second, the

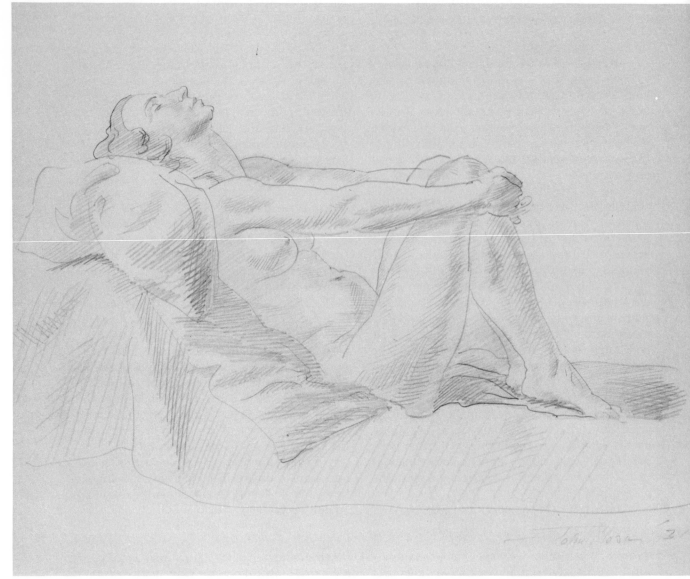

Figure 13.1
JOHN SLOAN (1871–1951)
Nude (1931)
Pencil on paper. 7⅜ × 9⅛ in.
Collection of Whitney Museum of American Art, New York.
Gift of Helen Farr Sloan. Photo by © 1989 Geoffrey Clements,
New York

study of drawing's relational and expressive potentialities; and third, the study of outstanding works of art.

It is by these routes of study that we come closer to our particular way of showing others, through our works, what we find to be valuable in the things we choose to draw. And finding our own means of expression is necessary if we are to create images infused with those energies and inflections that only our unique sensibility can provide. The great American dancer Martha Graham put it this way: "There is a vitality, a life-force, an energy, a quickening which is translated through you into action, and because there

is only one of you in all time, this expression is unique. And if you block it, it will never exist through any other medium and be lost. The world will not have it."[1] But to translate this force into the action of drawing requires an ongoing program of study—of inquiry, trial and error, risk-taking, and practice.

[1]Harold Taylor, *Art and the Intellect,* published for the National Committee on Art Education, by the Museum of Modern Art, New York. Distributed by Doubleday & Company, Inc., Garden City, N.Y., p. 22.

Hence the ongoing need for the artist— both student and professional—to draw continually, to examine the drawings of others, and to be always aware that the study of nature's limitless structural and dynamic patterns is fundamental to personal creative growth. And we must be engaged in all of these studies at the same time. Prolific artists, unless they fertilize each drawing with new structural, relational, and expressive demands, may only produce variants of their present range of skills and in-

Figure 13.2
CHARLES SHEELER (1883–1965)
Nude (1920)
Charcoal.
Collection of Mrs. Earle Horter

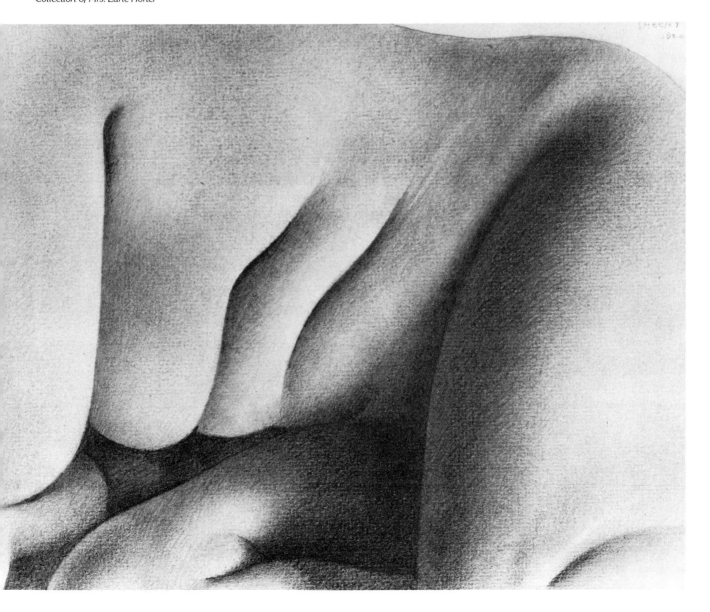

sights. Investigative drawing sheds light on nature, nature teaches us important truths about drawing, and great works of art reveal insights on both drawing and nature—they tell on each other.

In making such inquiries of nature and art, each of us comes upon certain qualities and characteristics we find especially compelling, certain aspects of nature and art that satisfy us enormously and that we want to explore further. These discoveries are likely to be the first of those components that will form our own point of view, for those qualities in nature and art that attract us most are the same ones we mean to show in our drawings.

Responsive artists, then, are the ones who never tire of examining the practices and products of drawing, or the world around them which serves as both teacher and subject. Ingres observed that when he found himself in circumstances where drawing was not possible, he would "draw with my eyes"; the aging and ill Matisse would spend many hours drawing wildflowers in his garden; or Cézanne, when asked where he had studied art, replied, "In the Louvre." Such artists experience an ongoing fascination with the behavior and patterns of the people, places, and things around them and with the finest expressions of creative activity. Responsive artists are always inquisitive. Their perceptions—always both penetrating and innocent—search for new knowledge and new experiences. They have what has been called a "hungry eye." In part, the hunger they satisfy is one of self-knowledge. They seem to know that their growth as individuals and as artists are aspects of the same process. The old adage, "You are what you eat" can be extended to the realm of art: You are what you draw. Your drawings reflect what fascinates you as an artist and as an individual. Responsive artists don't draw as they think they should, but as they feel they must. They do not make drawings *of* their subjects, but *about* them.

In the practice of drawing it is necessary to make drawings of both long and short duration. Although the long drawing—the extended exploration of a subject's smaller forms and surface features—is a most informing kind of study, the developing artist must concentrate at least as much on those shorter drawings that test and expand his or her ability to see, select, summa-

rize, and state important visual and expressive characteristics (Figure 13.3).

The brief drawing, whether its time limit is imposed by the instructor or by ourselves, sharpens our ability to analyze and express, thereby sharpening our perceptual sensitivity to the things around us. Thus the repeated practice in concentrating on structural and dynamic essentials constitutes an important part of our training in searching out other engaging subjects to draw. In this sense our perceptual sensitivity, working as a kind of visual detector, scans our environment for a significant "contact." Our unique creative "receiver" seeks certain kinds of stimuli. Drawing a subject that does not attract usually produces weak results.

When a contact is made, a state of excitation occurs. The artist sees potentialities for creative expression in the subject's actualities and implications and is stimulated to draw. For some artists, almost any random collection of forms can trigger creative ideas. Others, although just as perceptually sensitive, are attracted by only a few subjects. Not surprisingly, as perceptual awareness develops, the range of subjects that attract students usually increases.

An artist's initial interests are stimulated because of a rough, general kind of perceptual analysis. Some general ideas and impulses have formed in his or her mind about the creative potential in a particular subject. These perceptions include general information about the subject's gesture, structure, arrangement in space, and the relational and emotive character of its figurative and abstract states. They also include stimuli that tug at the artist's psychological sleeve. Subjects we strongly want to draw contain something in their arrangement or meaning that attract us, although we can seldom say why. Indeed, it is easier for us to explain why we don't want to draw a particular subject (or in a particular style) than to say why we do.

These considerations and feelings do not occur in a sequential way when we examine a potential subject, but overlap and affect each other. For example, perceptions of a part's direction and shape are simultaneously perceptions of its representational, expressive, and abstract conditions, and which of these considerations receives emphasis depends as much on our psychogenesis—on the nature of our *self* as shaped by living—as on anything in the subject itself.

Figure 13.3
HARRIET FISHMAN
Portrait of the Artist's Mother
Black chalk. 9 × 11 in.
Courtesy of the artist

The order of priority of perceptual interests in the completed drawing—how much attention and development each of the above considerations gets—is then, as was noted in Chapter 11, a key to the artist's style. And style is not altogether a matter of choice, but of esthetic and temperamental necessity. One of the characteristics of great drawings is the artist's wholehearted acceptance of his or her own style and character. It is as if such drawings say for the artist, "Here I am."

Just as the brief but penetrating sketch is a useful tool in expanding our overall perceptual interests, so sometimes are the first, general perceptions themselves the main purpose of an artist's drawing. This is, of course, often so in quick preparatory sketches where the artist concentrates on a subject's figurative and abstract essentials.

The initial perceptions that stimulated Baglione's quick sketch *Group of Four Figures* (Figure 13.4) appear to be the dynamic energies of

Figure 13.4
Attributed to BAGLIONE (c. 1573–1644)
*Group of Four Figures (Study for a Presentation of the
Virgin in the Temple)*
Pen, brown ink and brown wash. 3⁵⁄₁₆ × 3⁵⁄₈ in.
National Gallery of Canada, Ottawa

riences that accumulates. The motives that make us draw are nourished by such experiences. Each time we draw we expand our understanding of what drawing might become for us. Each time we draw we add to our unique creative purpose.

Another benefit of such study is the increased awareness of the order, the relatedness of the things we see. If we do not consider the relative direction or length of an edge to other edges, we do not really *see* it; if we disregard the similarity of, say, our model's folded arms and some interlaced folds in her skirt, these segments will remain more isolated from each other; and if we do not respond to the physical or visual weight of one segment in the drawing in comparison to another, the drawing's balance and unity are affected.

That students can be guided toward creating valuable personal statements in the spontaneous mode is demonstrated by a number of the student works reproduced in this book. Figure 13.5 is a good example of a brief sketch that asserts a point of view in its strategies and handling. The power generated by the bold strokes and contrasts of value, the inner tensions among the thrusting lines and shapes, and the drawing's tenuous balance all attest to the young artist's felt interpretation of her subject.

Figures 13.4 and 13.5 are profuse in the visual and expressive considerations of the responsive process, but they show responses only to those visual cues necessary to establish the broad essentials of an expressive design.

But Snyders, in *Study of a Boar's Head* (Figure 13.6), probes his subject's forms and forces more deeply. Part of the almost symmetrical design's energy comes from the smaller forms. Snyders emphasizes the rhythmic movement of forms to the left and right of an invisible border which is the vertical midline of the boar's head. Tusks, ears, and bristles "rush" away from this unseen axis with a force that energizes the entire image. As in Figures 13.4 and 13.5, directed action is a strong dynamic theme, but here structural matters contribute to (and gain from) these forceful movements. Were the animal's head drawn on a horizontal axis, the sense of symmetry might appear obvious and dull. By tilting the head to the right and counterbalancing it with dark tones on its left side, Snyders modifies the symmetry, cancels physical with visual weight, and establishes a more compelling compositional and expressive state.

massed forms that generate the moving action of the forms toward the right side of the page. This movement is further conveyed by the tight enclosure of the format. Its "squeezing" pressure on the forms suggests their being forced toward the only open area within its boundaries, that is, the space on the right. The sense of forms advancing or striving to do so is also conveyed by the positions and gestures of the four heads. Starting on the left, each seems more involved with movement. The increasing tilt of the figures and the directional thrust of the lines that comprise them further add to the sense of impending movement. Note that the figure nearest to the right side is "committed" to the directed action by being in an off-balanced position. This drawing is a good example of the union of figurative and dynamic actions.

The sketchbook (see Chapter 8) is a useful means for expanding our drawing opportunities when we are away from the studio or school, especially for quick notations such as the drawing by Baglione. Among the many dividends of drawing as much as possible is the fund of expe-

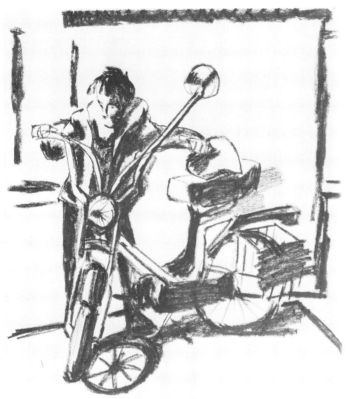

Figure 13.5 (*student drawing*)
Kathy Severin, University of Denver
Charcoal.

Figure 13.6
FRANS SNYDERS (1579–1657)
Study of a Boar's Head
Pen, brown ink, and brown wash. 12.8 × 18.5 cm.
Reproduced by courtesy of the Trustees of The British Museum, London

The challenge for Snyders, in carrying the realization of the forms further than Baglione does, is to find organizational and emotive employment for the smaller forms, the textures, and the values. The more specific and "retinal" our drawings become, the greater the danger of a randomness entering the work, of small parts and surface effects being "rendered" in an isolating and incidental way rather than adding to the drawing's overall figurative and dynamic meanings.

But, advancing a drawing past the first, broad essentials *does* require some perceptions that are different from those used to establish the first general impressions. The initial responses depend on our ability to summarize. Developing a subject's smaller specifics requires an ability to see differences. Snyders is fairly specific in explaining the differences between shapes, forms, values, and textures; but the marks that explain these differences are all simultaneously engaged in various relational activities and in developing the drawing's overall expressive design. To perceive relationships between unlike forms and marks, and contrasts between like ones, requires an ability to differentiate between their measurable facts and their relational behavior. Obviously, sound perceptual understanding is sensitive to both of these considerations.

Good perception must also be sensitive to the needs of the emerging drawing. Chapters 9 and 10 pointed out that responses to the subject, once translated to the page, stimulate new responses—those that meet the depictive, organizational, and expressive needs of the image. Sometimes the initial stimulus comes not only from qualities perceived *within* the forms themselves, but from the artist's ideas about how these forms might be arranged on the page. Baglione's first impulse, as we have seen, is to establish a general system of visual and expressive conditions that takes into account the size and shape of the picture-plane. By contrast, Snyders, although he places the configuration sensitively in the format, emphasizes the relational aspects *within* the configuration. But, to differing degrees, both artists respond to both considerations. Additionally, each artist is aware that his intended emotive theme, if it is to have impact, must participate in matters of organization and handling. Because sensitive perceptual awareness includes empathic impressions, we *can* speak of the perception of expressive as well as visual conditions. As we have seen, relational activities are always both visual and expressive.

The easy stimulation of our creative instincts and the development of both our perceptual acuity and our personal response is best achieved by the practice of drawings that push the limits of our ability to see, relate, and react. The effort to increase our analytical and empathic understanding is a continuing necessity to the growing creative personality. The best artists have always been engrossed students all of their lives. Tiepolo's drawing *A Sheet of Sketches* (Figure 13.7) demonstrates something of the investigative studies that many mature artists continue to make. Here there is no attempt at picture-making—he has no "product" in mind. Rather, Tiepolo is after additional information and experience; he is sharpening his skills.

Such study does improve understanding and fluency. Note the similarity *and* differences between the two centrally placed heads looking to the right. The upper, more carefully developed of the two shows values used sparingly in the face. Here, lines carry the major responsibility for conveying volume. Below, the same forms are boldly brushed in by dark washes and there is almost no use of line. In these heads the artist seems to be testing different responsive solutions to the same forms.

Sketchbook studies such as Tiepolo's, in which no *conscious* compositional design is intended, or preparatory drawings, such as Matisse's *Seated Woman with Hat and Gown* (study for "*The White Plume*") (Figure 13.8) which *are* conceived as designs, are, like all good drawings, attempts to improve perception and response. But, because these are both preliminary studies for other works, they show more clearly the searching, changing nature of drawings that are meant to deepen the artist's own understanding. Note the changes in the hat, shoulder, and chair in the Matisse drawing, and also the probing diagrammatic lines of the underdrawing.

Sometimes it is beneficial to make a few drawings that do not represent a demanding challenge—that fall just short of the limits of our abilities. Making such drawings helps consolidate what we know—and we must always strive to be masters of as much as we know. But more substantial gains in finding our way come best from an open and flexible attitude toward the processes and materials of drawing. Concentrating on an element, on a particular drawing issue

Figure 13.7
GIOVANNI DOMENICO TIEPOLO (1727–1804)
A Sheet of Sketches
Brush and brown wash. 13¾ × 8⅝ in.
*Courtesy of Fogg Art Museum, Harvard University,
Cambridge, Mass. Gift of Dr. Denman W. Ross*

Figure 13.8
HENRI MATISSE (1869–1954)
Seated Woman with Hat and Gown (1919)
Pencil. 21¼ × 14⅜ in.
*Courtesy of Fogg Art Museum, Harvard University,
Cambridge, Mass. Bequest of Grenville L. Winthrop*

such as the calligraphy of the marks, or on the use of a new drawing tool or surface will introduce new challenges and new options. For example, if the element of texture is one that you seldom emphasize, and charcoal is a medium you seldom use, make some drawings that bring these two features together, as in Figure 13.9.

Examine what happens in your drawings when you turn to an issue such as the implication of physical movement in the forms you draw. As Daumier's drawing shows (Figure 13.10), such illusions of movement can have powerful expressive force. A new medium or combination of media will also introduce new conditions that can expand your options of response and trigger new modes of handling (Figure 13.11). Such study practices force us to sharpen our perceptual and conceptual skills.

One of the inevitable characteristics of good perceptual and conceptual growth is the increasing economy of the means that convey meanings. In responsive drawings, as in any other creative process, organizationally unengaged or repetitive elements are illogical because they are unnecessary, and weakening because they are a burden on the completed system.

In drawing, economy reveals understanding—or the lack of it. That is still another reason why short poses are so important to the drawing student (and to the instructor's grasp of the student's strengths and weaknesses). A brief drawing time makes it necessary to be assertive in choosing what to extract from the subject. When a quick sketch shows a penetrating grasp of a subject's structural and dynamic essentials, we marvel at the accomplishment. That so much can

Figure 13.9 (*student drawing*)
Marybeth Motter, Kent State University
Charcoal. 18 × 24 in.

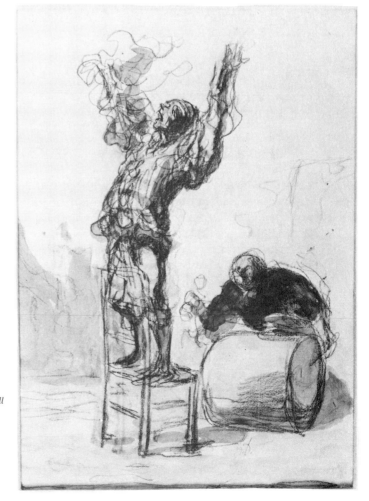

Figure 13.10
HONORÉ DAUMIER (1808–1879)
A Clown
Charcoal and watercolor. 14⅜ × 10 in.
*The Metropolitan Museum of Art, Rogers Fund, 1927. All
rights reserved, The Metropolitan Museum of Art*

Figure 13.11
JUDITH ROODE (1942–)
Dark Guardian (1988)
Oil paint, oil stick, oil pastel. 29 × 44 in.
Courtesy of the artist

be stated in such little time and with so few means *is* impressive. It reveals the strength of an artist's responsive powers. That is why, as Henry James noted, "In art economy is always beauty."

In Cézanne's *A Corner of the Studio* (Figure 13.12), economy plays a part in amplifying the artist's purposes. His telling extractions from the haphazard collection of studio paraphernalia clearly establish his interest in two- and three-dimensional order and movement among its parts. We can more easily appreciate the pattern of these forms receding in a shallow field of space, and the taut surface tension among the drawing's elements, because of Cézanne's in-tense concentration on realizing these structural and organizational essentials of his subject.

A drawing's expressive meanings also are clarified by economical extractions of essentials. There is little in this collection of objects that is really engaging. It is only when we react to Cézanne's economical interpretation of their planes and shapes arranged to suggest both second- and third-dimensional activities, and when we sense the monumentality implied, that our emotions are engaged. Then the lines and tones and the meanings they convey affect our empathic sensibilities—as they did Cézanne's. The integrity of the judgments concerning move-

ments and edges, tones and shapes, and the delicate overall balance of the elements, come from a profoundly acute and personal comprehension—the kind that makes such evocative summary possible.

Again, in Rembrandt's brief sketch of a young boy (Figure 13.13), extractions of essentials clarify. The patterns of abstract two- and three-dimensional forces clearly communicate the artist's judgments of what this subject's

structural and dynamic essentials come down to. And, as we saw in the previous example, such a penetrating and thus concise "essay" amplifies rather than lessens a subject's emotive nature.

But as with any other quality in art, when economy becomes a conscious goal—an effect—it obstructs the sensitive perceptual and responsive behavior necessary to its natural emergence in the context of an artist's creative interests. Economy must always be judged in the context

Figure 13.12

PAUL CÉZANNE (1839–1906)
A Corner of the Studio (sketchbook page) (c. 1881)
Pencil. 8½ × 5 in.
Courtesy of Fogg Art Museum, Harvard University, Cambridge, Mass. Bequest of Marian H. Phinney

of a drawing's overall meaning. What is an economical grasp of the *necessary* issues for one artist could be excessive elaboration for another.

In Bloom's *Landscape #14* (Figure 13.14), the subtle transforming of limbs and branches into wraith-like animals and humans, and the straining or windswept action of other branches, hand-like in their movements, convey a bereaved, spirit-haunted mood. Bloom seems to intend the choked, intertwined forms to be everywhere engaged in movement and change. The sense of these foreboding interactions and transfigurations as emerging from, and subsiding into, the matrix of limbs and branches benefits from the amount and complexity of these forms. But *within the context of the artist's intent,* this is an economically stated drawing. It is as directly and as simply stated as the artist's visual-

Figure 13.13
REMBRANDT VAN RIJN (1609–1669)
A Boy with a Wide-Brimmed Hat
Reed pen and ink. 8.5 × 9 cm.
*Reproduced by courtesy of the Trustees
of The British Museum, London*

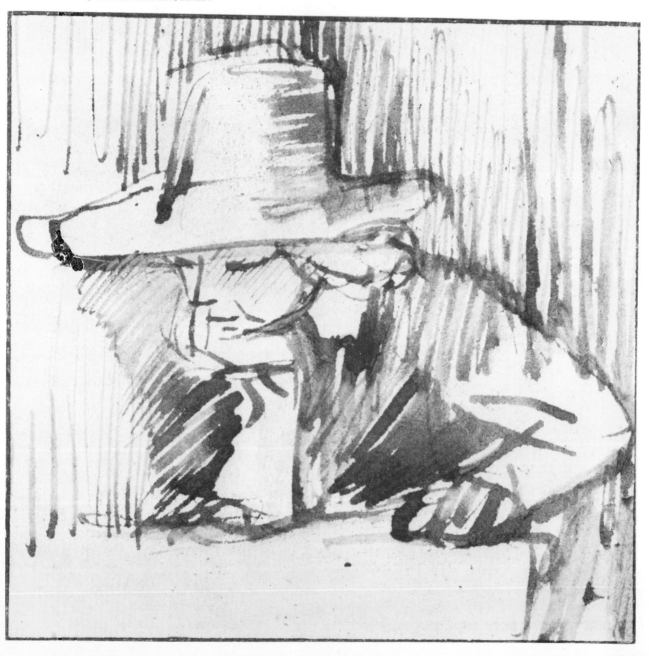

Figure 13.14
HYMAN BLOOM (1913–)
Landscape #14 (1963)
Charcoal.
Collection of Dr. and Mrs. A. Stone Freedberg, Boston

Figure 13.15
GEORGE ROSE (1936–)
Two Seated Figures (1973)
Black chalk. 20 × 28 in.
Courtesy of the artist

expressive needs permit. Although a complex drawing, there are no irrelevant passages, no overworked forms or unnecessary details.

Because intent determines the degree of economy, artists, even in quick sketches, are sometimes lavish in their use of line and tone in exploring a subject's visually expressive essentials, while treating extensively developed states of modeling and illumination with a daring economy. The profusion of lines in Rose's *Two Seated Figures* (Figure 13.15) is as economical a statement as possible, given the intensity and depth of the artist's structural and dynamic search.

Had Rose restricted his means *for economy's sake* to far fewer lines, it would have been as impossible to express the turbulent force he intended as for Picasso, in his *Three Female Nudes Dancing* (see Figure 9.36), to have employed more lines to suggest *his* intent.

Yet in Aronson's *Rabbi* (Figure 13.16), the sensitive exploration of volumes and the play of light upon them, as well as the figure's mood of inner strength and introspection, are established with a remarkable directness and spontaneity. Note especially the spare means used to convey the structure of the head and hands.

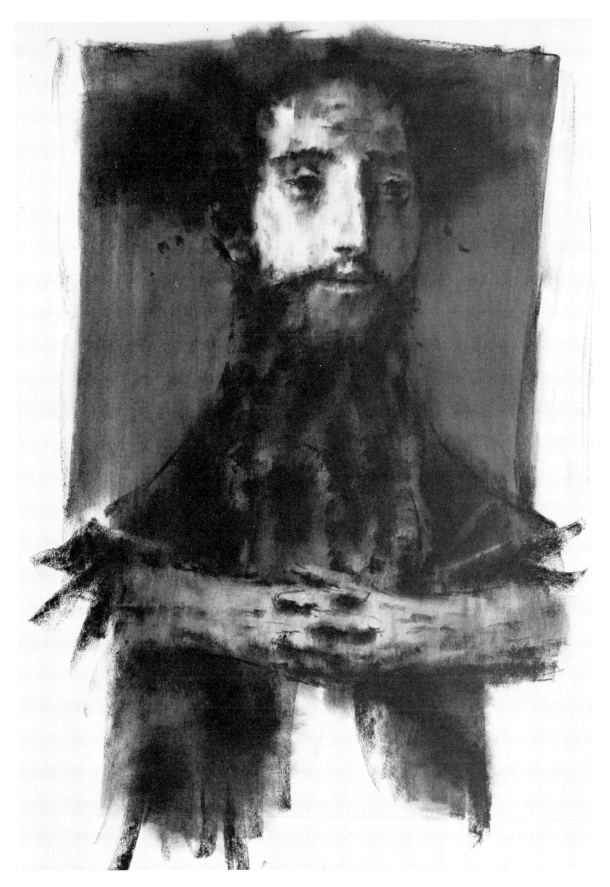

Figure 13.16
DAVID ARONSON (1923–)
Rabbi (1969)
Brown pastel. 40 × 26 in.
Courtesy of the artist

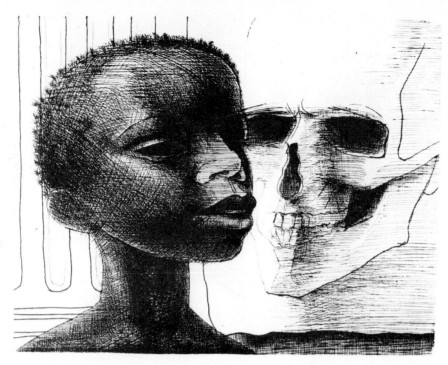

Figure 13.17
JOHN WILSON (1922–)
Dialogue
Lithograph. 17½ × 13½ in.
*Collection of the Museum of the National Center
of Afro-American Artists*

As this drawing so well illustrates, the factor of economy is sometimes extended to include the simplicity of the design concept. The artist, in reducing this configuration to a straightforward system of simple shapes, values, and masses (even the more structurally developed forms suggest their geometric basis), heightens the drawing's expressive power. For, as was noted earlier, an economy of means usually strengthens emotive force.

The bold simplicity of design in Wilson's *Dialogue* (Figure 13.17) adds an important dimension of expressive meaning to the representation. The harsh confrontation of black and white values finds immediate symbolic equivalency. And, in contrasting the gentle modeling of the child's head with the more rugged handling of the skull, the artist takes his stand.

Abeles' lean and penetrating essay of a seated child (Figure 13.18) reveals the artist's sensitivity and wit both to his subject and to the means used in expressing it. There is a kind of visual pun in the undulating of both the chair

and the child. The artist subtly emphasizes this rhythmic similarity by increasing the S-shaped curve of the child's left arm and by the wavelike ripples in her blouse and in the pillow that supports her legs. The effect of all these sly, roller coaster movements is a sense of animation that enlivens the image and underscores the relaxed child's limp weight. Note that while Abeles uses toned planes economically to establish the figure's forms, he doesn't hesitate to boldly tone large areas of the chair. In part, this tactic establishes the nature of the light source, but it also suggests the child's fragility and the chair's sturdiness.

Such selective modeling, organizational judgments, and fluency of handling—and the clarity of expression these skills lead to—are not beyond the ability of the gifted student to control, when guided to such matters (Figure 13.19). In doing so, students acquire insights and skills in the ways of form and space and of illumination, and in the ordering of their images, that make ventures into abstraction rewarding explo-

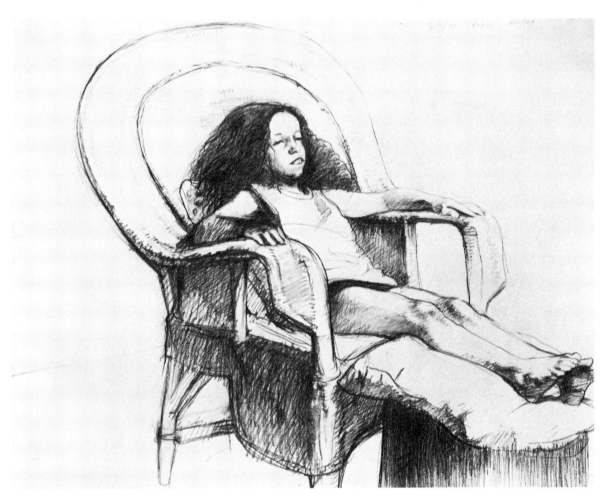

Figure 13.18
SIGMUND ABELES (1934–)
Child in a Wicker Chair (1971)
Charcoal pencil. 22 × 30 in.
Courtesy of the artist

Figure 13.19 (*student drawing*)
Stephan Wing, University of New Hampshire
Figure/Interior (1982)
Compressed charcoal and wove printing. 44 × 30 in.

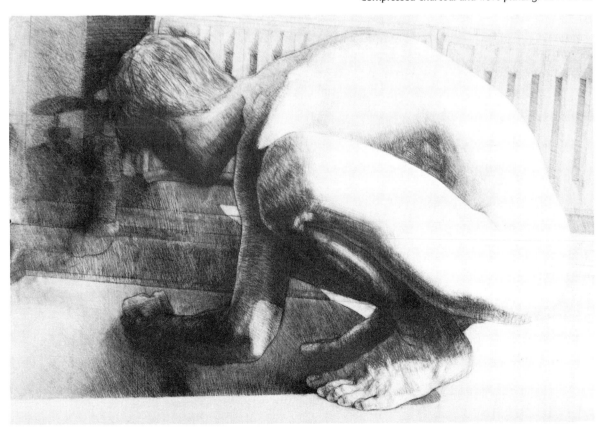

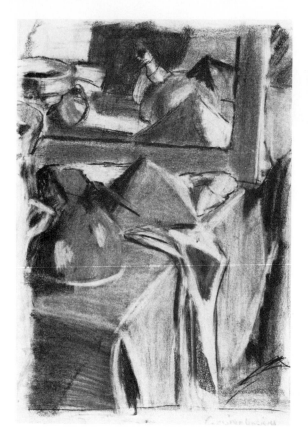

Figure 13.20 (*student drawing*)
Sue Burrus, Art Institute of Boston
Conté crayon. 18 × 24 in.

rations with telling results, as in Figure 13.20 and in the nonobjective imagery of Figure 13.21.

A drawing's expressive purpose should determine how it is formed. But in whatever way our skills are directed, teaching ourselves to get at the heart of what is before us and to shape it in the simplest way that embodies our interests and intentions is the best way to get at our unique point of view. Nor should this be seen as a student's chore. It is harder to simplify than to imitate nature. Consider Tiepolo's *Houses and Campanile* (Figure 13.22), in which, in a spontaneous and certain manner, he reduces the scene before him, its structures, its spatial arrangement, its light, and even its temperature to a spare number of animated lines, shapes, and values.

Turner's drawing *Stonehenge at Daybreak* (Figure 13.23) shows how much can be suggested with a few bold washes of tone. Here, delineating lines are absent altogether. Turner conveys the impression of a dawn landscape in a

broad, painterly handling guided by powerful perceptual skill and a determined expressive objective. Note how clearly this "simple" handling depicts grazing sheep, coach and horses, and a sense of vast space.

Rembrandt's *A Winter Landscape* (Figure 13.24) is a masterpiece of economy. The drawing's design of fast and slow directional movements, enacting the same undulations as the snow-covered surfaces, is completely fused with the character of the representational matter. In a drawing of about a hundred lines and a few washes of tone, the artist creates snow-laden fields, shrubs, road, and rooftops. He even suggests the quality of the light and the feel of a silent, still winter day. Such limitations of means should be understood not as hurdles, but as necessary confines that intensify meanings. Goethe may have had this in mind when he observed, "It is in self-limitation that the master first shows himself." Economy such as Tiepolo's, Turner's, or Rembrandt's demands exquisite perceptual and conceptual apprehension and responses shaped by a lifetime of contemplation and humility before nature, a wonderment in the life of drawn marks, and an ongoing searching of self to uncover those genuinely personal questions, values, and needs that shape originality.

As was noted earlier, one of the best and fastest ways to heighten our perceptual and conceptual powers is, of course, to draw as much as possible. But our drawings must not repeat old inadequacies. If drawings are not formed by a demanding level of inquiry and response, if they do not reflect an engaging dynamic life, if they are not balanced and unified, or if they do not declare our own interests and judgments, they only strengthen the grip of old habits.

This book has been concerned largely with concepts that broaden the range of responsive options and thus with the breaking of older, restricting concepts. Some further suggestions to deepen our understanding of drawing, and consequently to move closer to our own necessary way of drawing, are appropriate here. Classes in sculpture, by enabling you to experience more directly the structural nature of forms in space, and classes in two- and three-dimensional design, by helping to explore more fully the dynamic life of the elements and the organizational possibilities they hold, would be most beneficial. These studies can provide information and insights concerning both structure and design too

Figure 13.21 (*student drawing*)
Barbara Orlowski, Michigan State University
Ink-washed strips of paper. 18 × 24 in.

Figure 13.22
GIOVANNI BATTISTA TIEPOLO (1696–1770)
Houses and Campanile
Pen and brush in brown ink. 153 × 283 mm.
*Museum Boymans-van Beuningen, Rotterdam,
the Netherlands*

Figure 13.23
JOSEPH TURNER (1775–1851)
Stonehenge at Daybreak (c. 1816)
Graphite and brown wash. 7⅝ × 10⁹⁄₁₆ in.
*Courtesy, Museum of Fine Arts, Boston. Gift
of the legatees under the will of Ellen T. Bullard in
accordance with her request*

often overlooked in the study of drawing. And because our attitudes toward sculpture and design are less likely to be hemmed in by our early habits of procedure or prejudice, their study helps to hasten the breakup of old notions about drawing. Old habits are insistent. Beginning a drawing by some manner of search for the subject's gestural character is for most students an uncomfortably daring step. Many hesitate and resist. Although they may accept the logic that a cautious collection of parts cannot succeed, the familiarity of this old habit seems preferable to the anticipated chaos of a more spirited, penetrated search for essentials. Sometimes the first few attempts at gestural drawing *are* chaotic. It is natural to falter in an unfamiliar process. Here, a trust in the basic principle that governs any building process—namely, the emergence of large essentials before small specifics—may help students over their first crucial barrier to responsive drawing. Once it is experienced, the many dividends of the gestural approach make a retreat to a piecemeal assembly unlikely.

A useful and too often overlooked form of

study is the faithful copying of old and contemporary master drawings. This practice was a major activity in the study of drawing for hundreds of years. Lest we put this study method aside as an antiquated one, let us recognize that almost all of the great masters made many such copies as students. Rubens, even as a mature and highly successful artist, continued to make copies of the paintings of the great Venetian artist Titian, just as Delacroix made copies of Rubens' works (Figure 6.8).

Every time a work is copied, a "residue" of information remains to broaden our responsive options. It seems reasonable to assume that the masters, as beneficiaries of this practice, passed it on to their students as a valuable aid to learning. The fear sometimes expressed, that copying masterworks will have the effect of influencing one's way of drawing, is unfounded. Our own creative needs soon reassert themselves but are then assisted by the expanded range of drawing tactics and insights gained from making copies. After all, when we carefully examine master drawings, part of our study has to do with making "copies" with our eyes. That is, we experience, along with the artist, the drawing of a hand

or a cloud, the gentle graduation of a value from dark to light, the refining of a form's edge, or the splash of an ink-loaded brush. Making copies only intensifies this experience.

It is further useful, after having made several copies of a particular artist's drawing, to make several drawings of your own in the general manner of that artist. Having to see your subject through the sensibilities of a Degas or a Diebenkorn can more fully involve you in rethinking certain of your drawing idiosyncrasies and habits, and in experiencing new drawing options.

But having mentioned the subject of influences, it should be noted that many young (and not so young) artists show in their work the influence of one or more favored artists. It is not an unusual occurrence and generally subsides or even disappears as the artist's own creative necessities begin to assert themselves. Such influences are usually helpful if seen as temporary crutches that enable one to enter areas of drawing where further, more personal growth can occur. The danger is in becoming dependent on this aid and avoiding a confrontation with self-expression.

Where possible, get to know other art stu-

Figure 13.24
REMBRANDT VAN RIJN (1606–1669)
A Winter Landscape (c. 1648–52)
Reed pen, brush, and brown ink on cream paper.
2⅝ × 6⁵⁄₁₆ in.
Courtesy of Fogg Art Museum, Harvard University,
Cambridge, Mass. Bequest of Charles A. Loeser

dents and artists. The exchange of ideas about any and all aspects of drawing is of course a very helpful means of gaining information, of testing your views and practices alongside those of others, and of sharing your enthusiasm and enjoying the support of kindred spirits.

In your study of the drawings of other artists, be sure to include an ongoing examination of works by contemporary artists. This study should be undertaken to discover, not novel styles of drawing, but new attitudes, concepts, and expressions in drawing that add to and reaffirm those lasting and universal qualities of drawing that this book has tried to address.

In Chapter 1 it was noted that drawing well is choosing, relating, and risking wisely, but first it is the willingness to experience with the heart as well as the eye. For, as Kenneth Clark has observed, "Facts become art through love, which unifies them and lifts them to a higher plane of reality."[2] We all have something to say. The prob-

lem is finding just what those things are which are dearest to our heart, and having the courage to state them fully. In doing so we only clarify what we are bound to say anyway, for, as Ralph Waldo Emerson put it, "As I am, so I see; use whatever language we will, we can never say anything but what we are."

For the responsive artist, art is a celebration of form. It is also, and importantly, a celebration of life. But these are shifty realities, and the artist's task is to hold on to as much of each as is possible. The American writer Willa Cather said it this way: "What was any art but a mould in which to imprison for a moment the shining, elusive element which is life itself—life hurrying past us and running away, too strong to stop, too sweet to lose."

[2]Kenneth Clark, *Landscape Into Art,* (New York: Harper & Row, 1976), p. 33.

BIBLIOGRAPHY

The books listed below are recommended for general reading, and for further information about perspective, media, and materials. The list does not include those books already mentioned in the footnotes.

GENERAL TEXTS

Anderson, Donald M., *Elements of Design.* New York: Holt, Rinehart and Winston, Inc., 1961.

Bertram, Anthony, *1000 Years of Drawing.* London: Studio Vista, Ltd., 1966.

Blake, Vernon, *The Art and Craft of Drawing.* London: Oxford University Press, Inc., 1927.

Chaet, Bernard, *The Art of Drawing.* New York: Holt, Rinehart and Winston, Inc., 1970.

Collier, Graham, *Form, Space and Vision* (3rd ed.). Englewood Cliffs, N.J.: Prentice-Hall, Inc., 1972.

De Tolnay, Charles, *History and Technique of Old Master Drawings.* New York: H. Bittner & Co., 1943.

Hayes, Colin, *Grammar of Drawing for Artists and Designers.* Studio Vista, London: Van Nostrand Reinhold Company, 1969.

Hill, Edward, *The Language of Drawing.* Englewood Cliffs, N.J.: Prentice-Hall, Inc., 1966.

Mendelowitz, Daniel M., *Drawing.* New York: Holt, Rinehart and Winston, Inc., 1967.

Moskowitz, Ira (ed.), *Great Drawings of All Time* (4 vols.). New York: Shorewood Publishers, Inc., 1962.

Rawson, Philip, *Drawing.* New York: Dover Publications, 1971.

Sachs, Paul J., *Modern Prints and Drawings.* New York: Alfred A. Knopf, Inc., 1954.

ON PERSPECTIVE

Ballinger, Louise, *Perspective, Space and Design.* New York: Van Nostrand Reinhold Company, 1969.

Burnett, Calvin, *Objective Drawing Techniques.* New York: Van Nostrand Reinhold Company, 1966.

Cole, Rex V., *Perspective: The Practice and Theory of Perspective as Applied to Pictures.* New York: Dover Publications, Inc., 1927.

James, Jane H., *Perspective Drawing: A Directed Study.* Englewood Cliffs, N.J.: Prentice-Hall, Inc., 1981.

Norling, Ernest R., *Perspective Made Easy.* New York: The Macmillan Company, 1939.

Watson, Ernest W., *How to Use Creative Perspective.* New York: Reinhold Publishing Co., 1960.

White, John, *The Birth and Rebirth of Pictorial Space.* London: Faber and Faber Ltd., 1957.

ON MEDIA AND MATERIALS

Chaet, Bernard, *An Artist's Notebook: Techniques and Materials.* New York: Holt, Rinehart and Winston, 1979.

Doerner, Max, *The Materials of the Artist and Their Use in Painting.* Eugen Neuhaus, trans. New York: Harcourt Brace Jovanovich, Inc., 1934.

Dolloff, Francis W. and Roy L. Perkinson, *How to Care for Works of Art on Paper.* Boston: Museum of Fine Arts, Boston, 1971.

Kay, Reed, *The Painter's Guide to Studio Methods and Materials.* Englewood Cliffs, N.J.: Prentice-Hall, Inc., 1983.

Mayer, Ralph W., *The Artist's Handbook of Materials and Techniques* (rev.). New York: The Viking Press, Inc., 1970.

Watrous, James, *The Craft of Old Master Drawings.* Madison, Wisc.: University of Wisconsin Press, 1957.

INDEX